Sketching Light

AN ILLUSTRATED TOUR OF THE POSSIBILITIES OF FLASH

Joe McNally

VOICES
THAT
MATTER™

New
Riders

Sketching Light: An Illustrated Tour of the Possibilities of Flash
Joe McNally

New Riders
1249 Eighth Street
Berkeley, CA 94710
510/524-2178
510/524-2221 (fax)
Find us on the Web at www.newriders.com
To report errors, please send a note to errata@peachpit.com
New Riders is an imprint of Peachpit, a division of Pearson Education

Editor: Ted Waitt
Production Editor: Lisa Brazieal
Cover and Interior Design: Charlene Charles-Will
Layout and Composition: Kim Scott, Bumpy Design
Color Production Specialist: Marco Ugolini
Indexer: James Minkin
Cover Images: Joe McNally
Author Image on Back Cover: Michael Cali
Author Image on Spine: Drew Gurian

ISBN-13 978-0-321-70090-2
ISBN-10 0-321-70090-2

9 8 7 6 5 4 3 2 1
Printed and bound in the United States of America

In the storm-tossed seas of freelance photography,
Annie remains a safe harbor, a light on the shore.
Always and forever...

Notes on the Book

This book has been a long time coming. So my first thanks go out to folks who have asked about it, and maybe even waited patiently for it. It took a while to write, in between assignments and life. I also waited a bit to get my head around some new technology that has been swirling about.

That's always a tough game to play, because there's always something new. But I did wait to include certain things—for instance, the new radio TTL systems for small flash—that are beginning to mature, and promise to make things easier for us. I wanted to see where some of the newer bells and whistles might lead.

Mostly, I remain thankful to be a photographer. In the midst of the torrent of technology we swim in daily, the unchanging mission for all shooters is to make pictures that arrest the eye of the viewer and describe our chosen subjects eloquently. We are part of an honored tradition, that of storytelling, which goes back to the dawn of time. Those prehistoric people, painting on their cave walls—were they doing anything different than we are now, with all our pixels and technical wizardry? I think not. They were leaving their footprints, and telling the story of their times, and their lives. With those ancient pigments on those rough walls, they were saying one simple thing: Remember us.

Which is exactly what we're doing. We're just doing it faster, more often, and with more sophisticated tools. And I'm thankful for those tools.

Nikon, my camera system for many years, creates wonderful picture-making technology. So does Canon. I'm thankful for both, because those two competitors spur each other on. Who benefits? Us. The photogs. Thanks are in order for Manfrotto, Elinchrom, Lastolite, LumiQuest, and PocketWizard. And Apple, Profoto, Nik, and Kata. And Lexar, Wacom, Think Tank, Westcott, and Epson. Basically, gratitude to all those technically minded folks who labor and compete with each other to produce photo machinery that makes the life of a shooter in the field easier, more expansive, and more productive. There are

amazing pictures being made today that could not have been made just a few years ago. The current, wonderful era of pictorial adventur-ism is directly linked to technology and innovation. Better tools fuel the imagination, and enable better pictures.

I write about a bunch of those tools in this book. I write about those tools because I use them, plain and simple. And, I use them because they work—for me.

It has been pointed out, and even complained about, that in the realm of small flash, I write solely about Nikon Speedlights. Okay, I do.

Here's why. I use them. I've got nearly 40 years of experience in the field using Nikon gear. I've been through the fire with the stuff, and watched it both soar and fail. I've had it save me, and curse me, the same way any camera system might do for and to anyone who chooses to use it. The point is, I'm qualified to write about the stuff. I've relied on it. I know how it works, and I can offer workarounds when it doesn't.

Thanks to Syl Arena, and his wonderful book, I can work a Canon Speedlite. I could go outside right now and make a picture with one. The reason I don't write about Canon stuff is that I'm not qualified. I've never relied on those lights in the heat of battle, when the chips were down, out there on assignment. I don't have the depth of experience that's needed to offer the reader a nuanced, detailed overview, fortified with the resonance that only comes from time spent using the gear, day in and day out. Just because you read the manual and can work the gear doesn't mean you can or should talk or teach about it. So I don't.

Additionally, while there's tons of basics and tech info and gear discussed in these pages, the conversation—story to story, picture to picture—emphasizes the use of light, not necessarily where it comes from. Big flash, small flash, light shapers, stands, settings, gels—it's all in here. But the much more important aspects of the book are how all that stuff gets used to speak, describe, and inform. How all that machinery boils down to a simple, elegant, appropriate light at that moment, for that subject.

Many people have helped this book along. I'm very grateful to all who have come to workshops and lectures, and then go into the field and passionately find their own pictures. Thanks to those in some classes who were kind enough to snap a production picture or two, behind the scenes. Some of those are in these pages, and they provide enormously helpful information. All the models have been truly wonderful. Kudos for your patience, discipline, expressions, and devotion.

Ted Waitt—and the all-star team at Peachpit. I drove them nuts, Ted especially. But he remained calm, and was always what a good editor should be—a reasoned voice, a collaborative director, an informed questioner, and a resolute shield from some of the ranting that might have occurred (I'm just guessing here) about "Where the hell is that book?!?!"

Speaking of all stars—the folks at my studio. Lynn DelMastro steers the ship. (That's a generous description of the McNally operation. It's occasionally been more of a leaky raft.) But through it all, Lynn has remained the heart, soul, and spirit of our enterprise. The enormously talented Drew Gurian, Mike Cali, Lynda Peckham, Mike Grippi, and Karen Lenz all offered wisdom, guidance, and organization, in addition to their tremendous visual expertise.

Harry Drummer, Jeff Snyder, Monica Cipnic, and the gang at Adorama have remained in our corner and are wonderful collaborators. My Italian and Jewish brothers, Mike Corrado and Lindsay Silverman at Nikon, always come through. Their colleague Trudy Kraljic cuts through the clutter and gets it done. Bill Pekala remains a force for all photogs, and Jeff Cable at Lexar thoroughly supports shooters. (Every digital snap in this book was done on a Lexar card.) RC Concepcion remains brilliant in every way, including his friendship.

Likewise, the creative crew at Lastolite has been terrific in listening and responding to reports from the field. I've actually helped them design some light shapers! (I feel like a pro golfer who's been on the tour for 30 years, and somebody finally asked him to design a course. Very cool.)

Manfrotto, both here in the U.S. and worldwide, pushes creative solutions both in the studio and on location. Dano Steinhardt makes a wonderful bridge for photographers grappling with the printed image. And Moose Peterson taught me how to embrace the natural world through a lens.

Bill Douthitt, my dear friend, off-kilter editor, and madcap compatriot through 25 years and 10 *National Geographic* stories, remains, well, Bill.

I've used cameras and lenses to tell stories for many years, but it was Scott Kelby who opened the door for me to the written word, something I had not thought of using much, during all that time with a camera to my eye. Scott, wonderful writer and shooter that he is, simply said, a few years ago, "You should write a book." He not only encouraged me to write, he lent his considerable skills as an editor. That vote of confidence was much needed, and appreciated. His voice resonates with me today, in this book.

Lastly, and importantly, I thank those who went before. Those photographers of yore who took, by comparison, crude tools into the field and crafted wonderful stories. Their pictures are my memory.

Contents

Notes on the Book. iv

And Now, Time for a Short, Brisk Whipping!. 2

More Light-Shaping Tools! 24

● THINGS I THINK I KNOW: Risking "No" 34

Northern (One) Light 42

But Then, I Just Couldn't Take It Anymore.... 72

One Light, One Window, One Room 84

Of Frosted Glass and Dirty Windows 96

The ABCs 102

Build a Wall of Light 110

Make the Light Jump...and Other Lessons 124

Big Flash, Small Flash, Far Away 132

● THINGS I THINK I KNOW: News Flash 138

Here's Sunshine Up Your Skirt!. 146

Set the Table with Light. 152

The Two-Speedlight Character Portrait 164

Industrial Light 170

Finding Faces. 176

● THINGS I THINK I KNOW: How Do You Get
Fired from LIFE?. 188

Big Light, Small Flash 198

The Aesthetics of High-Speed Flash 204

Up Against the Wall 216

● THINGS I THINK I KNOW: I Thought the Lights
 Would Be On . 226

Radio TTL . 232

The Shape of Light . 244

A Tale of One Face, Lit Two Ways 252

● THINGS I THINK I KNOW: Mamie and Barbara,
 and a Lesson Learned . 264

Lessons from the Acetate Era 268

Finding a Picture on the Edge of the Canyon 282

Sometimes, the Main Light Is in the Back 288

● THINGS I THINK I KNOW: Don't Mess with the Photog 296

Working with D . 302

Light as an Exclamation Point 314

One Light, One Shadow . 326

This Looks Hard, But It's Not 332

● THINGS I THINK I KNOW: Flash Frenzy 340

A Couple of Joes . 352

The Lady, the Light, and Some Luck 362

Lighting the Wind . 370

More Wilma . 376

This Looks Hard, and It Is 390

This Just In... 400

Index . 414

Possibilities

The key word on the cover of this book is not "flash," or even "light." It's the word "possibilities." Because that is, at its core, what this book is about. It isn't about pictures that already exist. It's about what might be possible to create, in terms of pictures, if you experiment with light. The pictures and information on these pages are, hopefully, a prompt to that sense of experimentation.

There's a ton of basic information in this book. There are pictures, sketches, production photos, notes, and metadata. In most instances, I've divulged virtually everything you could want to know about any particular shoot, short of the color of my boxers. They're generally blue, by the way, though I do have a couple of pinstriped numbers, and on really big shoots I wear my lucky thong. Joe make joke.

The book also, amazingly enough, talks about what pictures can be created with one or two lights, or a small grouping of lights that act like one light. In a quick tally as the book heads to press, my count is that roughly 85 images under discussion were made with one light, and another 15 were made with two or three Speedlights or a couple of bigger flashes configured to behave as one light source.

I say "amazingly enough" not because it's impossible make good pictures with minimalist lighting and gear, but because I have a bit of a, ahem, reputation. I guess I'm a bit on the technical side, and perhaps have a reputation for using lots of flashes, and engaging jobs with armies of assistants at my side. There might be folks out there who think that, indeed, a big job for us at my studio is vaguely reminiscent of one of those battle scenes in *Lord of the Rings*, complete with the sound effects. Frankly, nothing could be further from the truth.

It's generally myself and one assistant out there on a job, with a modest amount of gear—a few stands and lights of different types. Sometimes, it's just me, a camera bag, and a couple Speedlights. I wrote a book a while back called *The Moment It Clicks*, which most folks seemed to enjoy, though there were a few summations along the lines of, "You could do this, too, if you had 17 assistants and a couple hundred flashes!" One gentleman even wrote that the book was about "how to use $10,000 worth of flashes!"

I blanched and started thinking to myself, geez, was I over the top? Did I really do that? Did I create the impression that me and an army of strobe-bearing orcs are out there, hacking reality into submission, subduing the very sun with so much flash power that every click causes an East Coast brownout?

Chastened, I went back to the book and started counting.

Of the 126 pictures in *Clicks*, 47 of them were made with available light, 46 were made with one light, and 12 with two lights. The remaining 21 used three or more lights.

Whew! Was I relieved! In that tome, it certainly wasn't the amount of light, but perhaps the way the light was expressed, that might have created the illusion that dozens of flashes were used. The question of volume of light and numbers of flashes popped up again with a book called *The Hot Shoe Diaries*, in which there were actually 113 pages devoted to one-light solutions. Sigh. I guess, as Clint Eastwood said in *The Outlaw Josey Wales*, "Sometimes trouble just follows a man."

That's why the word "possibilities" is so important in describing this book. It's not about one light, or two, or however many. It's not about big flash or small flash. It's about using light—speaking with it, adapting it, subduing it, shaping it—in short, telling stories with it. As it always has been, light remains the language of all photographers, everywhere. And as we all know, a good story has nothing to do with how many words are in it.

It's also not about the numbers behind each exposure, even though there are tons of numbers given here in association with each picture. There's full metadata disclosure, and there are pictures showing the set, the distances, the gear, the light shapers, and the cameras. There are sketches that extend the reach of the stories by offering diagrams of lighting grids, and additional field tips. There is, in short, quite a bit of the "how" of picture-making in this book.

Which is a good thing. Photography is an awful lot about how to do it. The mechanics are always with us. And the immutable and, at first, daunting language of photography is writ by and large in numbers

"As it always has been, light remains the language of all photographers, everywhere."

> "That's really where the heart and soul of this book lives. In the realm of the why."

and symbols. F-stops. Shutter speeds. Three-to-one lighting ratios. Pixels in digits that exceed the national debt. Menu items, options, and sub-options. Arrows and scales. The very machine is festooned with buttons, dials, switches, and levers, all of which apparently have some influence on the final calculation, which used to be a picture, but is now a file, a capture.

It all sounds very dry, difficult, and, truth be told, boring. To me, the numbers are the somewhat foul-tasting medicine of picture taking. Figuring out the numbers can be as hard as a math final, and just as enjoyable. So many times I have cursed the sheer mechanics of this! The camera in my hands can sometimes feel about as supple and responsive as an abacus. Even now, after all these years of jamming my eye into a lens, I ask myself: How do I make this machine work? If I go −2/3 on the camera and program +2 into the flash, is that good? Do all these numbers add up to a nice picture?

Sometimes. At other times, the capricious, mercurial nature of photography catches up to and overtakes math and logic. You are out there, apparently overwhelmed, in uncharted pictorial territory, where no book or manual can really offer guidance, and you think you can't find right or wrong, yes or no, or even a proper f-stop setting, and the result of all this internal and external chaos is...a wonderful photograph.

Think about it this way. Imagine the high-speed camera in your bag is a Formula One race car. All the money, the sponsors, the glitz, the science, the tech, the RPMs, the high octane gas, the champagne in the winner's circle...come down to a pair of hands on the wheel. The guts and savvy of a driver who knows when to lay up, and when to bring the hammer down.

It's the same thing for us in the field. The problem of how to do it, as I said, is always with us, a perennial and occasionally annoying sidekick. The numbers have to be firmly in your head. That technical bedrock is the ground upon which your pictures will stand, and knowledge thereof gives you the confidence to risk it all going after a

good photo. But the how, resolutely, stands in service to the why. Why shoot it like that? Why use a big flash as opposed to a Speedlight? Why take the time to light a background? Is this story best told by run-and-gun shooting, or do we drag all the elements into a studio and control every pixel?

So, even though I give very precise data on each shot, I acknowledge throughout the accounts of each adventure (and misadventure—trust me, there are some of those in here) that my numbers will not be your numbers. Photography is so situational—each face, setting, and job will be different—that seeking the holy grail of the technique or math that always applies is fruitless. But, what does remain, what always lives in the heart and mind of every shooter, is the need to always answer that persistent, absolutely important question of why.

That's really where the heart and soul of this book lives. In the realm of the why. Why shoot a picture a certain way? Why put the camera to your eye in the first place? All the technical solutions drive forward from the singular, audacious act of looking through a lens and trying to sort out and explain the world in front of you within a single, two-dimensional rectangle. It could be curiosity, sympathy for the human condition, intrigue about a face or place, the urge to tell a story, or the call to shoot from a client. Whatever the impetus, the numbers just follow the need to shoot.

And certainly, every number you input at the camera has potentially enormous implications for the way that picture will speak. No doubt about it. I talk about that throughout the book. I discuss why I shot with a 300mm instead of a 14mm. Why depth of field in this picture is nonexistent at f/1.4, or huge in that picture that was shot at f/16. Why a 2400 watt-second big box flash is needed here, but over there you can get by with a battery-operated Speedlight that fits in your pocket. Could they be interchanged? What would be lost or gained by doing that? Why does one face demand smooth light but another absolutely require hard light with an edge? And, I'm direct, too, about the fact that you may well disagree with the answers I show here, in

my dispatches from the field. The answers to the how's and why's of a photo are as different and numerous as there are shooters.

The discussion is important, because talking about this stuff makes us all better shooters. It's just that when the talk starts and stops at the numbers, and the whole world revolves around the precious, soulless hardware in the bag, we miss the point. The point is the picture. The conversation starts there.

So we do need to know the numbers, and that's a beautiful thing because they are, indeed, knowable. There are good, clear, reproducible, precise approaches, distances, f-stops, and shutter speeds here in this book, and elsewhere. Sure-footed knowledge of technique feeds your pictures, and grows your confidence. And that confidence enables you to pursue ever more aggressively the answers to the far more interesting questions that are really the heart of the matter.

So read on, if you will. Study the numbers. Learn the techniques. Ask the questions. Create your own beautiful pictures. Risk failure. Court disaster. Entertain possibilities.

Links

Visit Joe's blog:
 www.joemcnally.com/blog

View more of Joe's work:
 www.joemcnally.com

General studio inquiries and assignments:
 Lynn DelMastro
 Studio Manager—Producer
 lynn@joemcnally.com

Faces of Ground Zero—Giant Polaroid Collection:
 Ellen Price, Inc.
 Curator/Exclusive Representative
 epriceinc@earthlink.net

Fine art representation, print sales, and limited editions:
 Sid and Michelle Monroe
 www.monroegallery.com
 info@monroegallery.com

Join the book's Flickr group and share your photos:
 www.flickr.com/groups/sketchinglight

And Now, Time for a Short, Brisk Whipping!

AS OPPOSED TO A LONG, drawn-out torture, which could be, for instance, reading the manual! It has its purpose, and I bring it with me, but it's not exactly a nail-biting, whodunit page-turner.

There's a ton of information out there about the basics of flash, from numbers and ratios to style and approach. TTL (through the lens) works, but it has its ups and downs, and is influenced by what the camera sees—through the lens! I know this isn't exactly shocking news. The TTL systems work because of an explanatory/communicator pre-flash that the unit pops out, milliseconds before the actual exposure, which gives the camera's considerable brain information and detail to chew on. The camera then pulls all the incoming exposure data into its formidable, super-speed computer, and burps out a solution, all on its own.

And we know that isn't always the solution we seek. So we adjust EV (exposure value) on the flash accordingly. We know that we can avoid the whole

Mike Cali

> "How does the flash we labor to generate accurately look and feel? There's no point in crunching all the numbers and meticulously exposing at –2/3 if the light or the picture isn't any good."

uncertain brouhaha of TTL by programming the unit into manual mode, then controlling the flash absolutely, allowing it to make no decisions on its own, thus giving us consistency that is unavailable, in every instance, in the TTL world.

With some reading, and some testing, the hardcore numbers of flash photography are available to all. Just like splashing around in a pool for a bit, you get used to the water. You start to look for and anticipate things that are going to cause problems. You encounter situations such as serious backlight, or a subject who is small in a frame comprised of mostly dark tones, or outright blackness—like a tiny ballerina on a big stage—and you start to realize that this machine of a camera, no matter how sophisticated it is, is going to have problems giving you a fully accurate, automated result in all situations. There's stuff your camera will encounter that it just can't sort out. Gradually, we get used to stepping in and guiding it. We drive the train with greater confidence with each and every frame, every mistake, and every whoop of a good picture. The real deal is not in the precise numbers, as they always change. It's in the building of the all-important Rolodex of experience and survival. The data and the digits have to be known, but they are not the destination. They are just route signs on the road traveled to a good picture.

Of course, the real deal boils down to this: how does the flash we labor to generate accurately look and feel? There's no point in crunching all the numbers and meticulously exposing at –2/3 if the light or the picture isn't any good. So, for the next few pages, let's take a look at how different light shapers look, and how they interact with a face.

Keep in mind that a quality of flashed light that is absolutely crack-
ling for one face is going to make a different type of face look like it
belongs in a lineup.

Okay, here we go.... Igor! Bring them out of the dungeons for
today's flash lesson!

Straight flash! Light that hits your subject straight as a frozen rope.
Straight flash, straight shadows. Good for events, weddings, car acci-
dents, and perp walks. Has its place in the desperate life and times of
every shooter out there. Whether the ceiling where you're shooting
is the height of the Sistine Chapel and painted black, or you're behind
a velvet rope that keeps you 20 yards from the action, or you're just
getting back at your client for treating you like garbage and paying you
dirt, it works. One good thing about straight flash is that if you're using
it in close to your subject, it's very efficient. You recycle so quickly that
you can really go all sorts of Sonny's-death-scene-in-*The-Godfather*
on your subject if you want to.

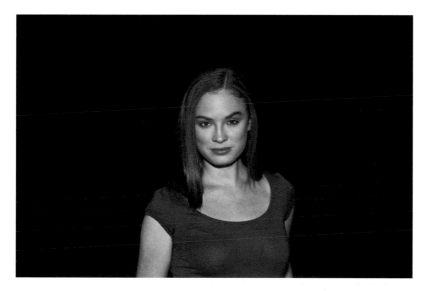

For the straight-flash shot above, by the way, I have my dome dif-
fuser on the hot shoed SB unit, so this could actually look worse than
it does. But I'd have to really try.

Now let's take a quick look at getting the flash at least an arm's
length off the axis of the lens (next page). It's really for left-eyed shoot-
ers, to be honest. I look through my left eye, and hold the flash in

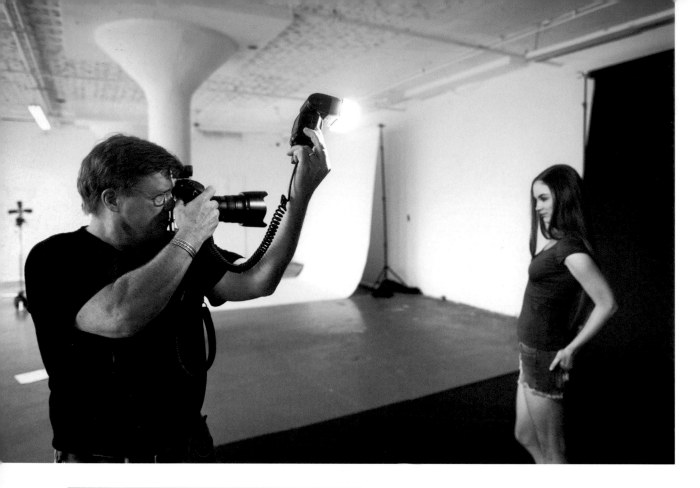

my left hand, crossing it over to the right side of my body, which then pulls my shoulder under the motor-driven base of the camera, supporting it. I can bear some of the weight of the digital machine by doing this. It makes the camera more stable and takes some of the pressure off my right hand and arm in terms of supporting the whole shebang. Which, in turn, makes my tripping the shutter less of a kinetic punch to the button, and slightly more easygoing and genteel. If you are right-eyed, then the more traditional mode of holding the entire weight of the camera in your right hand while extending the flash outwards with your left is pretty much the way to go.

Does getting the light off the camera help in terms of quality of light? You be the judge. A hard shadow is still a hard shadow, whether it goes

slightly right or left. But now there is, technically, a highlight side of the face and a shadow side. Better? Yes, but grudgingly, marginally so.

I'm linking to the flash via an SC-29 cord, because the camera model I'm shooting, a D3X, has no pop-up, or built-in, flash. If I had access to a pop-up, I could nix the cord and use this hand-held flash as a remote light, responding to the commands of the little built-in flash, which can be programmed as a commander. Perfectly good way to go, and it actually gives you a bit more flexibility without dealing with the nuisance of a cord. Know this, though: If you are in close to your subject, that little pre-flash from the pop-up will register in your subject's eyes as a pinprick of a catchlight. Not a big deal, but it will happen—even though that com-mander pulse of light communicating to the light

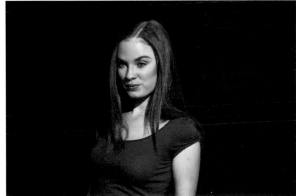

in your hand is supposed to be a pre-flash, a light that fires prior to the exposure. In the manuals, both Nikon and Canon acknowledge this can happen, depending on your proximity and angle to the subject.

Now, we're gettin' fancy! The light's on a stick, and I have dispensed with the direct connection of a cord and am speaking to the light via an SU-800 commander (previous page). There is no magic reason I am using an SU-800 here, as opposed to an actual SB flash unit, to direct this light. It's handy and light, and it works very well. Its light pulse is masked by an infrared (IR) shield, so it eliminates that potentially annoying additional catchlight from the pre-flash I just spoke of.

Let's take a moment to talk about triggering pulses, and having it work at distance, in sunlight, etc. Unquestionably, using another flash as a commander is the most elegant, versatile way to trigger TTL remote flashes. The SB-900, for instance, has great range, which you can increase by a) taking off the dome diffuser, as well as the filter holder; and b) zooming the flash head to its max zoom rating of 200mm. This will gain you an additional 20–30 feet of range. I've tried it in the field, and it works. I have triggered remote flashes in TTL mode between 200–300 feet away. No joke. In bright sunlight, I've easily had good luck in the range of 60–80 feet.

The SU-800 trigger: Because of that IR shield, it's not as power-ful a pulse as the 900, but is very effective up to about 60 feet or so, which corresponds to what the manual says. It's also very directional, so if your lights are behind you (and there's no reflective surface out in front of your lens, such as a white seamless) this is not the unit to use. If you have a blinker for a portrait subject, and their eyes are spring-loaded for the pre-flash, it's a good way to go. Again, the IR shield eliminates the visible optical pulse, so it's easier on your subject's eyes.

The pop-up: Highly effective easily up to 50–80 feet. I have to imagine its spectral, crystalline spark of light is responsible for the range and effectiveness. It's a contrasty little pulse, and hence, it gets the remotes' attention. (That's just field experience talking, not scien-tifically researched engineering fact.) But it's darn effective for a little onboard light. Like the SU-800, it goes one direction, so it's not the

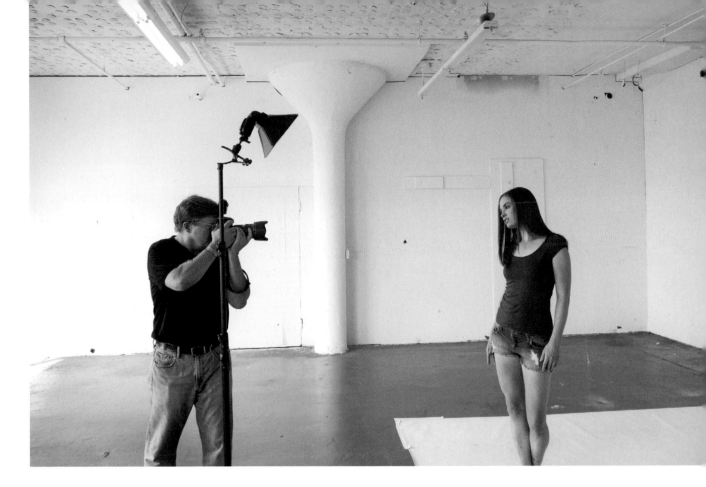

best trigger for lights that are behind you or spread out wide to either side.

Okay, got that out of the way. Back to the light on the stick (page 7). Depending on the size and reach of your light stand, you can maneuver the height of the light, hands-free. Unless your day job is being a power forward in the NBA, holding the light has limitations for getting it up and away from your subject. See the shadow fall? It's quite a fall, relative to the straight-flash solutions seen so far. That directly relates to the height of my light. Still no nuance here. Still hard flash. But the simple light stand gives the beginnings of huge flexibility.

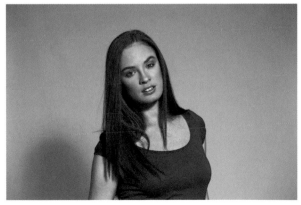

Now let's introduce the simplest of light shapers, the LumiQuest SoftBox III. It weighs 0.44 pounds, it's 8x9" across, with a bit of center density to it that breaks up the hot core of flash just a tad. It's small,

"This shadow has 'rotation,' for lack of better word.
The fall from highlight into shadow, that line of rotation,
is much softer and more forgiving."

but still 20 times bigger than your average Speedlight flash head. Ah, the old size issue. Is bigger better? Yes, if you're looking to soften your light. Here we go: The bigger and closer the light source, the softer and more diffuse the light will be. The smaller and further away—i.e., the more sun-like and spectral—the harder the quality of light.

So now the light is shaped with this tiny softbox, and you can see the result. Take a look at the density of the shadow thrown by her face and compare it to the last shot with the raw light on the stand. That shadow was black and had an edge sharp as a knife. This shadow has "rotation," for lack of better word. The fall from highlight into shadow, that line of rotation, is much softer and more forgiving.

I switched up here to a white background, if you notice. For the first situations—which are all really just variations on hard, straight flash— I went black to emphasize the sharp quality of the light and the quick falloff. Here, as we embark on larger light shapers, it's important to note how they spread to the background.

This little light looks pretty good from an average distance of about 10 feet. Notice the white background goes an even gray. (Outside of the model's skin, we did very little post-production on these. No vignette filters, super saturation, or cross-processing sliders were employed. They're raw files, so they needed a touch of contrast, but that's about it. These are pretty much out of the camera in terms of look and feel.)

So, note to self: Small, cheap, stuffable plastic softbox looks pretty good from an average distance. Note, too, there is a pretty faint sub-ject shadow on the seamless paper, lower camera left side. Not a disaster, but the spread of light to the background carries her shadow with it.

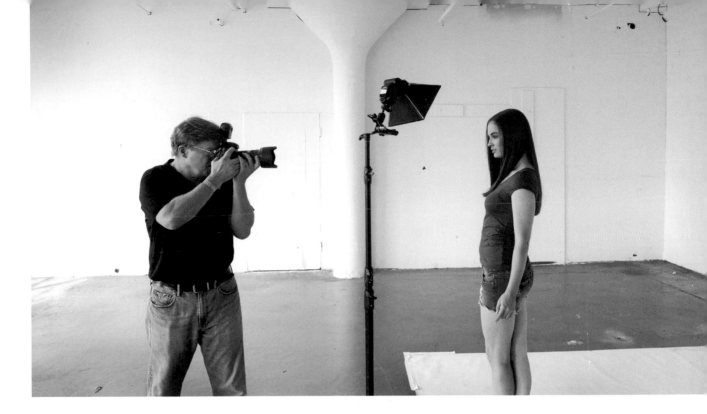

How about closer?

The shadows are more open and forgiving, and the background is a deeper gray. The light, moved in to about four feet away from her, hits the subject and then dies rapidly. Hence the deeper background tones, and there is no subject shadow. Which is a good thing. Think about having a second remote light. With the background being a darker tonality—and clean of shadows—you can place a light back there and influence the look of that background, which is harder to do when it is washed with an overall bright quality of light.

She's also as far away from the background as I can reasonably get her. Generally speaking, the more distance between your subject and the background surface, the more control you have. You then have two physically separate zones in the photo, and you can influence them with light as you see fit, independently of each other. The closer the subject is to that background, the more

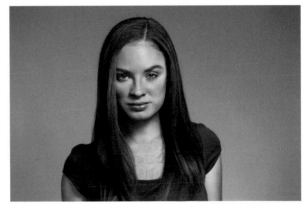

your main light will spray onto it, making it tougher for you to create a distinctly different look for that background.

Okay, let's take it a step up: the LumiQuest III on steroids—the LTp—so named because when it folds down, it will slide nicely into the backpack slot for your computer. It's about twice the size of

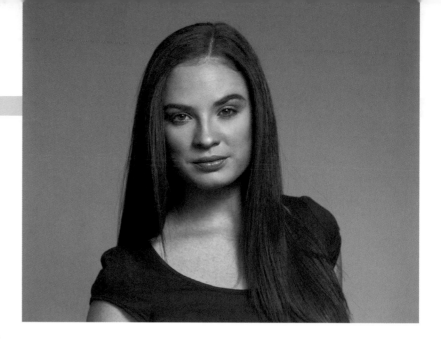

the III (as you can tell from the pic shown). At about 10 feet from the subject, it looks, well, nice (opposite page). Background tones are a touch brighter than when I used the III from a similar distance. There's still the hint of that darn shadow, though. Not completely gone, even though our light shaper is getting a bit more sizable.

The light is smooth on her face, and pretty forgiving. The shadows are there, to be sure, but they are not deep and harsh. It's a pretty clean result for a light this size, and at this distance. As a quick experiment, I cut the distance in half but kept the same angle of approach (above). The shadows definitely open a touch, and the light is richer and creamier. Depending on the look you want, moving the light in is a universally wise strategy. It improves diffusion and softness, which are qualities that directly relate to how flattering the light is for your subject. Corollary benefit? The closer the light, the less severe the battery drain, and thus the faster recycle. Advantages across the board.

Light and shadow are obviously paired. The light source is the conductor, and the shadows play accordingly. Most of the time, the shadows resulting from a light are fairly predictable, and that's certainly the case here. I've had the light consistently up and to camera right, and the shadows come off her face and head down and to the left. For the next iteration, though, I changed up the position of the source, putting it directly overhead of her. Now, instead of a highlight side and a shadow side of her face, there is symmetry. The light comes from

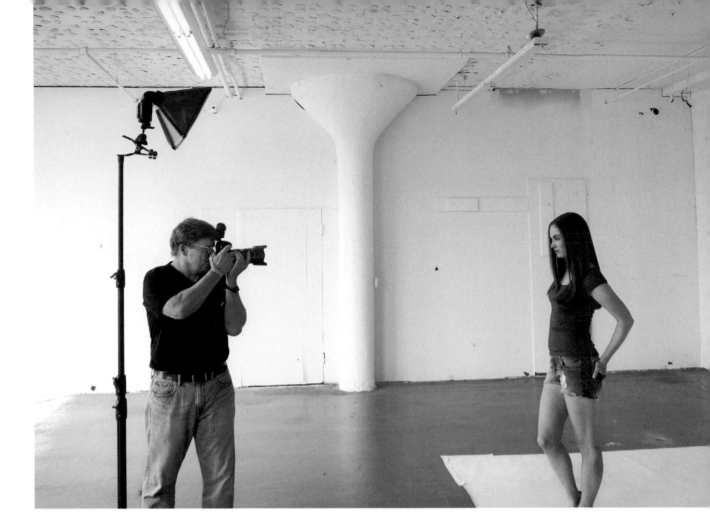

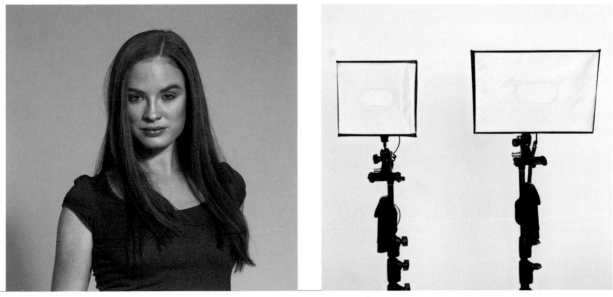

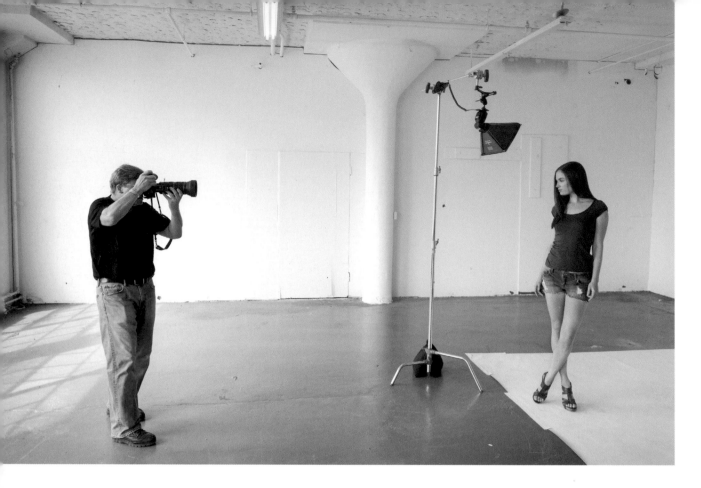

directly overhead and in front of her, and it lights each cheekbone equivalently. The result is that the shadows fall straight and true, emphasizing the structure of her face, which is very even.

Back to the shadows. So far, the moves I've made have all been about softening the shadows by ramping up the size of the light source and moving it close to the subject. Next, I go the other way and use a light shaper—the Flashpoint Q Series 6" Beauty Dish Reflector—that emphasizes the power of shadows and creates a rapid falloff. This light shaper looks, as I say in another part of the book, like a little soup bowl. Floating in the middle of the bowl is a metal oval that literally deflects the light screaming out of the flash head, which is now shorn of its diffuser dome.

Let's talk briefly about the diffuser dome.

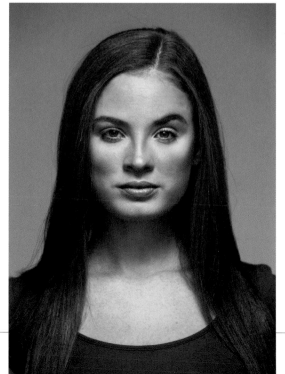

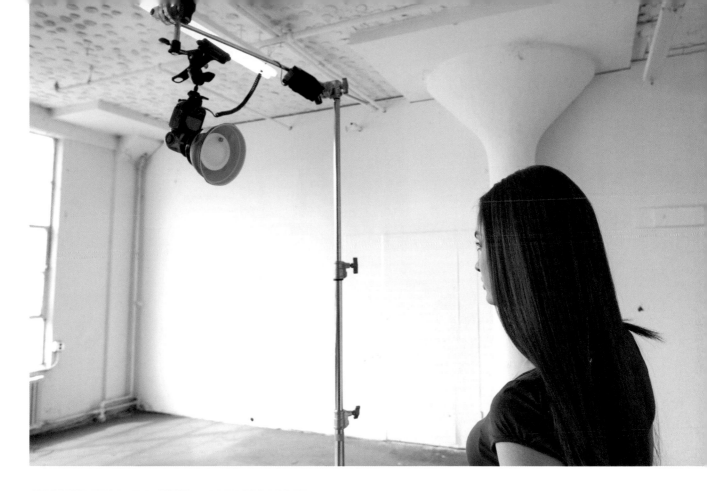

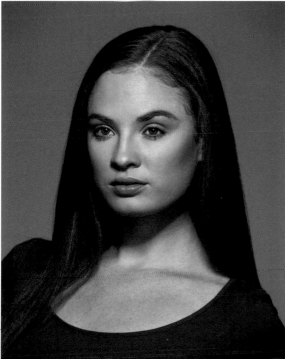

When you place it on most flashes—certainly the SB-900—the flash head automatically zooms to a wide dispersion of light. Logical. The dome will scatter light all about, really in a 360-degree pattern. When you take the dome off, you can then zoom the light around manually, and set it where you please for a remote. Here, because the design of the beauty dish emphasizes direction and punch, I zoomed the light to 200mm to complement that look. There's a tight bundle of photons coming out of that dish.

(It's important to note that when I used the LumiQuest III and the LTp, I left the dome on the light, which again, meant a wide spread out of the flash head and into the softbox. Using the little boxes, I'm looking for the light to be as soft and

"In a small package, this beauty dish does what its bigger brothers do—it emphasizes cheekbones, sparks the eyes, and defines the face."

wrapping as possible, so I leave the dome on and strap the light shaper around it.)

The beauty dish, as you can imagine, is a contraption most associated with the fashion world. There's an enormous range of dishes with all manner of deflectors, socks, diffusers, and dimensions out there. Obviously, this little Velcro-on-the-small-flash puppy is not a big studio item. But, in a small package, this beauty dish does what its bigger brothers do—it emphasizes cheekbones, sparks the eyes, and defines the face.

Let's do the beauty dish even tighter. This light shaper has access to a set of deflectors (white, gold, and silver, which give different intensities and color to the light), as well as sets of colored filters, a diffuser, and a set of honeycomb spot grids. The grids really tighten the light spill and make an already direct light even more direct and intense. Notice the concentration of light on her face, as well as the rapid fall-off (opposite page).

Note to self on these beauty dish treatments: It's not for every face! Match your light source with your subject. A fashion model can handle a raging light like this. Grandma, maybe not.

Let's get bigger now, while staying basic. One reflected umbrella on a stand, from an average distance. Everybody's got a stand and an umbrella, right? These are such common household items I bet even folks who aren't involved in photography have a couple tucked away in a kitchen cabinet, just in case they ever have an occasion to diffuse light.

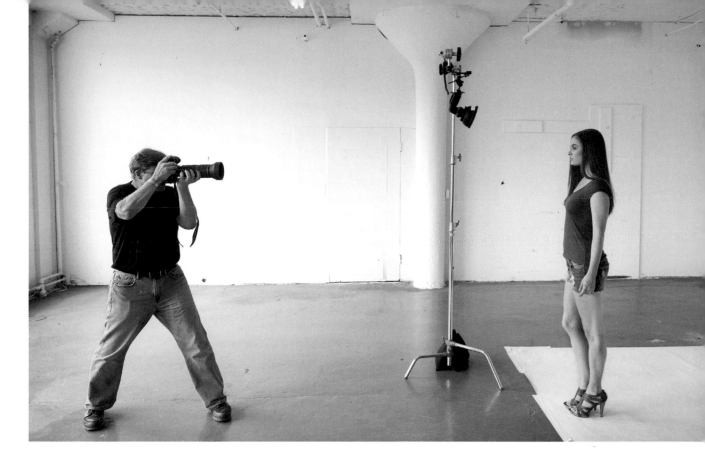

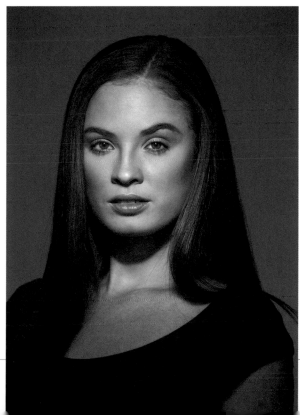

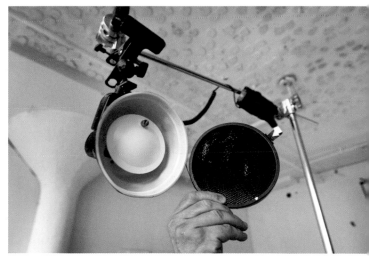

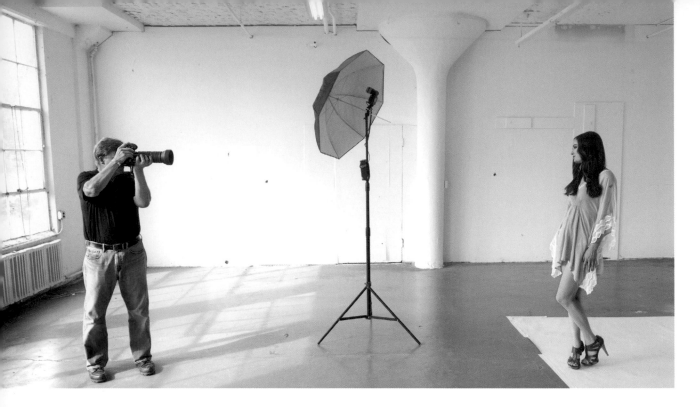

Now the light is slightly high and camera left. What I asked Ashley to do is open herself up to the approach of the light from that direction by turning her left shoulder in and towards camera. That naturally brings her face into a more full encounter with the source, a 34" Lastolite All-in-One Umbrella, which is pretty big.

What can I say about this, other than, "Thank you, we're done"? It's nice light. Simple, clean, and open. It embraces her easily and softly. It's flattering. It splashes to the background in a pleasing way. Done deal. It's nothing notable or special, but it sure is nice. What's even nicer is to know that this type of light, from this distance, works. Always good to remember when you're out there crashing and burning and that complex light grid you cooked up in your head is actually cooking your goose, and

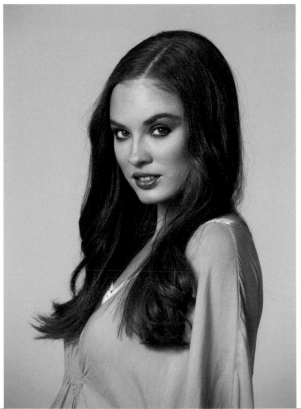

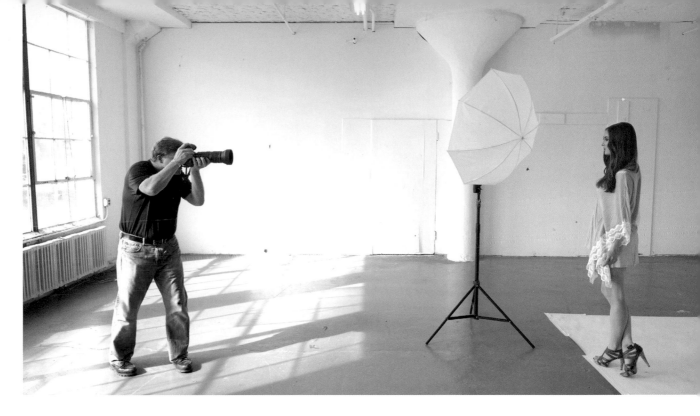

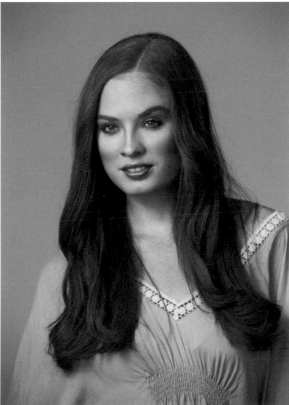

your subject is out of patience and you need a picture pronto. An umbrella from 10 feet looks more than okay.

A big reason to use the all-in-one umbrella is that you can strip off the opaque black backing, and voila! You have a shoot-through umbrella, which is a decidedly different iteration of umbrella light than the reflected style.

If I had to choose, I guess I would use umbrella light in the shoot-through fashion pretty much all the time. That's not to say that the scattered, general light produced by a light that's reflected into an umbrella isn't any good. We just saw it be good. But when you fire a light backwards into a source like a reflected umbrella, that source is de facto a bit of a distance from your subject. Swing that same umbrella around 180 degrees, turn it into a shoot-through, and the actual skin of the light source is

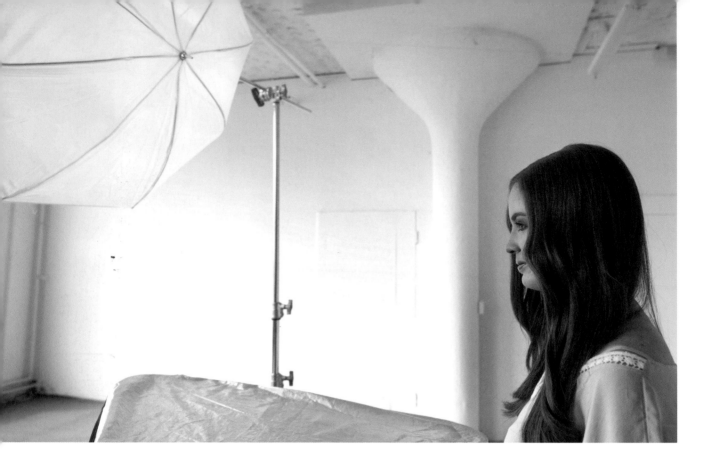

"If I had to choose, I guess I would use umbrella light in the shoot-through fashion pretty much all the time."

considerably closer to your subject. Closer means the source gets bigger—relative to the subject—and the light produced is thus a bit more lustrous.

Here, I swung the source into shoot-through mode and position, and moved it closer to Ashley. The result is apparent (previous page). There's a creamier look and it's soft, but because of its directness, there's a bit of punch to the quality of light, as well. There's good cheekbone definition, and also slightly more rapid falloff to the background, which has less exposure and a little more weighty feel. Again, the model is turned ever so slightly into the light source.

Doing this renders the light as a soft light, but not a scattered light. It has direction and power.

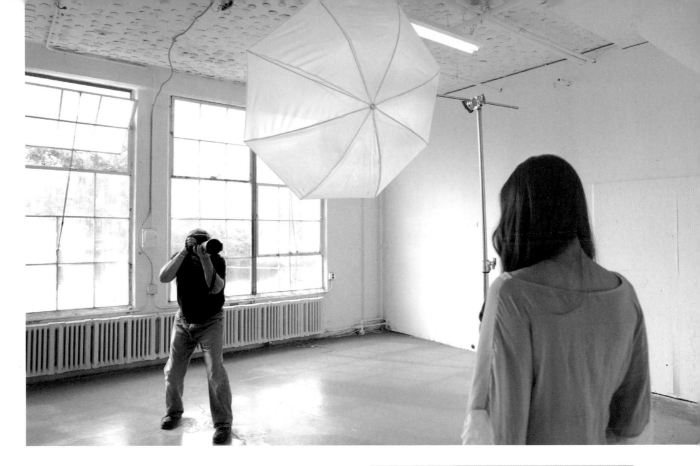

I took a couple more steps here with the umbrella, mostly to wring out of it the nicest type of light possible, given our subject. I moved it directly overhead of her, as you can see in the production pictures, and I also moved a silver TriFlip reflector board just out of frame, underneath her face. And you can now see there are an upper and lower set of catchlights in her eyes.

The effect of this is to create a very quick, no-frills beauty look. A light over a subject, being filled from below—sometimes referred to as clamshell lighting—is almost always flattering. You can see that here. The light is simple, declarative, and softly detailed. Her face and hair are wrapped in beautiful light. If she were a commissioned portrait subject, or a bride, she would be pleased when she got the proofs.

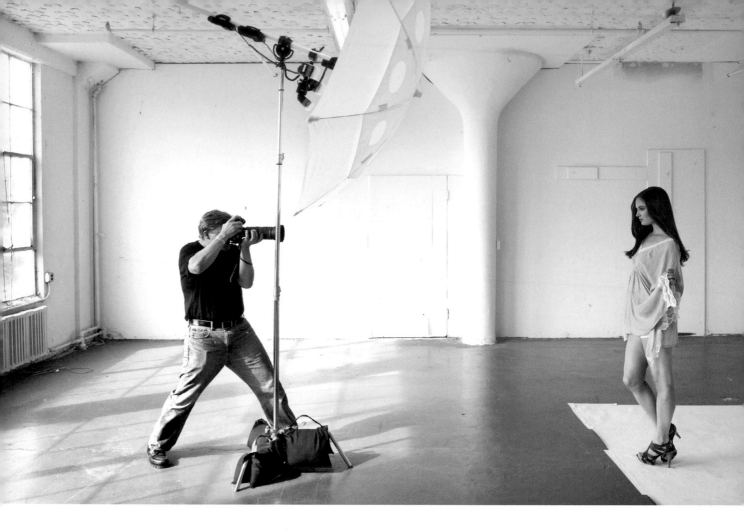

And it couldn't be simpler. One light, shot in TTL mode. Fill board. Straight on to the subject with a telephoto lens. Background is there, but not too dark, or too hot. Nice look, easily done.

Of course, being me, I had a real big umbrella hanging around the set. As a last iteration I hung three Speedlights on it via a TriFlash, all triggered TTL with my onboard hot shoe commander flash, and did exactly what I did in the previous set—put a fill board under the model's face (though that fill board isn't shown in the production pic above). This is really just to show the impact that size has on the softness and scope of the light. Everything gets bigger and brighter, from the background to the light in her eyes. The shadows evaporate. They are just hints of what they were before. Her hair is bathed in rich light; it glows with detail. Big light. It's cool.

A FEW THINGS TO NOTE

Every single one of the pictures shown here was shot at 1/250th at f/5.6. That's not because it's my favorite f-stop or shutter speed. There were windows in the studio, and that combo simply gave me enough leverage to dominate the available light and make sure my exposures were all driven by the flash.

All were done TTL. In certain instances, I pushed or pulled the power of the light, but it was minimal. And pointless to discuss, really. Plus one, minus a third? Those values might have pertained to these pictures I shot on this day, but they won't be the ones I use tomorrow.

But tomorrow—and virtually every day thereafter—I will refer to the general lessons learned here. Hard light, soft light, small light, big light, placement of light, closeness to subject—all offer repeatable benefits and looks. Reflecting on this set of photos, some folks might like the hardness of the gridded beauty dish. Others might run out and buy the biggest umbrella they can find, feeling that nothing beats that big, soft light. What suits you, and your subject, is something you generally only discover once you're on location, sorting it out. The more versatility you've got in your bag— from gear to experience—the more difficulties and curveballs you will be able to cope with, sort out, survive, and surpass during an unpredictable day in the field.

The numbers will change daily. The concepts won't.

The gear was simple. A light stand and a light shaper was about as complex as it got. If you notice, as soon as I brought a light around to the front and

overhead the model in a symmetrical way, I used a C-stand. That lumbering beast of a stand has got advantages when you want to light like that, as it affords you the opportunity, via the extension arm, to swing the light overhead into a central position without impeding the camera angle or your freedom to compose. When in boom position like this, it's always sandbagged.

This has been a quick trip through how a flash looks, not how it works. □

More Light-Shaping Tools!

WE LEFT OFF AT UMBRELLAS. On to softboxes, and a new face. Adventures await!

A softbox is a box of light, contained and controllable. It has direction and punch, as opposed to the umbrella's scatter and forgiveness.

There are a number of small-flash softboxes out on the market, but the Lastolite 24" Ezybox Hotshoe softbox is pretty much a go-to model. Very popular, with good reason. It folds down tight, and stuffs pretty handily into a small bag. You can then clip it or shove it quite easily into just about any duffel or case you might take on location with you. It's light, and it puts out a real nice quality of light.

Traditionally, it has always been made with a silver interior, which gives it spark and a bit of fashion-y panache. Which is all to the good. Over time, though, I found myself softening this light with additional layers of diffusion. I suggested to the Lastolite folks that they make one with a white interior. They said sure, and made me one. One. I used it resolutely, liking the results—but knowing the exact results I was getting and liking would not be generally available, 'cause there were no other white ones...in the world.

But then, after some talks and demos, they said yes! And now they make a white one and a silver one. I shoot with both of them, as there is a time and place for zap and contrast, and also for smooth and rich. Let's have a look at them.

The silver box—the one without the white logo box on the side—moved in close to my subject gives a strong light, with pop and a rapid falloff into a fairly deep set of shadows.

The white interior box is creamier, fades more slowly into more detailed shadows, and seems to spread a bit more to the background. Both approaches have merit, though for me, I would want to manage the slight highlight over Martina's right eye that the silver box produces. It's just a tad brassy. With the white box, there is no real definable patch of highlight, and her hair has more detail.

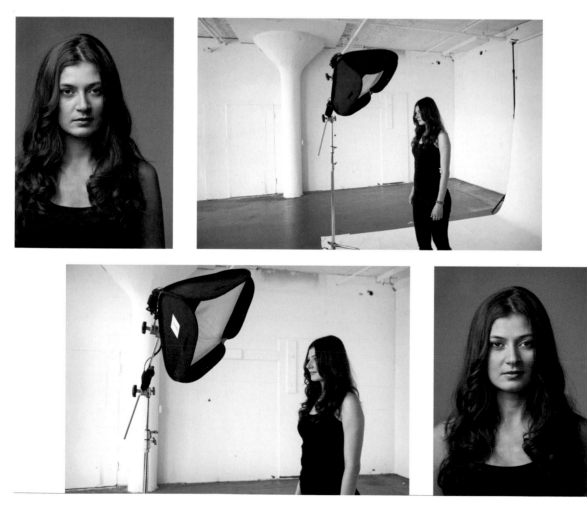

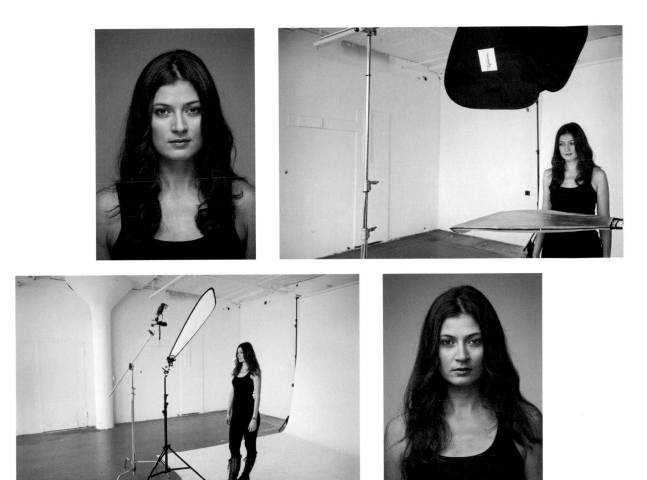

Exactly what you would expect from a light that is marginally less directional and zippy. The silver box punches light, and is a touch more collected. The white box, predictably, has more spread and more diffusion.

I took the white box overhead and, mimicking what I did with the umbrella, did a quickie version of a clamshell lighting pattern with a handheld silver diffuser. Yowza!

Either one is a small, light, portable, collapsible box of nice light. Made for small-flash location work.

TRIGRIPS!

I use TriGrips religiously. They are always in the bag when I go out on a job. I like them better than circular model reflectors and diffusers because the handle and the rigidity of the triangular shape means that, in a pinch, you can shoot with one hand and hold a reflector with the other. I use the big four-footers and the 30" TriFlip kits, with multiple styles of reflectors (silver, gold, sunfire, etc.) that give off different intensities of reflection and color. Examples of the variety of ways I use these puppies are throughout the book. (One use that's

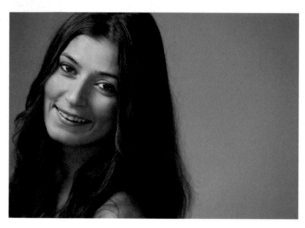

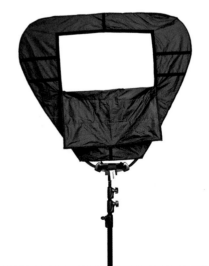

not in the manual—they're pretty good impromptu wind machines.)

I like them so much that I designed one for Lastolite.

TriGrips, being bendy and collapsible, give you a serious sort of "big softbox" feel, even though they collapse flat into a circular bag that is easy to tote around. This 36", two-stop diffuser surface, from an average distance, gives off a very rich, smooth quality of light, turning a lone Speedlight into what looks like a proper studio flash unit.

This version—which (big surprise) Lastolite calls the Joe McNally TriGrip—comes with a reflective sleeve, as most of the kits do, but if you want to turn that big box feel into a small, 21x15" softbox, it also has a black sleeve that creates a small port for light transmission. In other words, you can save a lot of dough on gaffer tape. (Ever go through just about a whole roll of the stuff tightening down a light source and cutting its size?) It also has black panels that can Velcro over that window, which allows you to narrow light transmission to just a sliver.

The light gets sharper and more defined, and the background goes darker because the window transmits less light. Pretty handy—not just for a main light, but also as a hair or background light.

Let's take this tool out of the studio—way out of the studio, to a fishing dock. Dusk is closing in rapidly, and the last thing I want to do is light this seafaring face with some fancy, overlarge light shaper that looks like I dragged it with me from a New York fashion shoot. This is not a face for a "pretty" light, in other words. I also don't want to heat up his orange slicker unduly, and turn him into a walking version of a caution light.

I pushed the TriGrip in close, with the window sleeve on, and used the Velcro panels to tighten the spread of the flash even further. It's a tight, small light source, but still runs through a two-stop diffuser. The result is a light that looks like it could belong on the dock—good quality, but not too good. A little rough, with an edge. Shot this wide open at f/1.4 with a 50mm lens, ISO 400. D3X on Aperture Priority, with an exposure compensation factor dialed in at −1.7. The Group A light is set to −1.3 on top of that, meaning there's just a squib of flash light eking its way through the narrow opening in the TriGrip. Weak light, strong character.

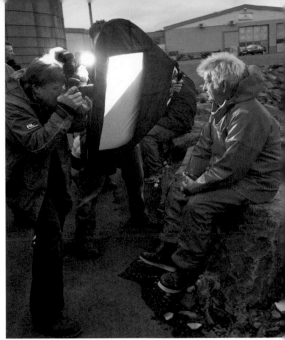

Jay Mann

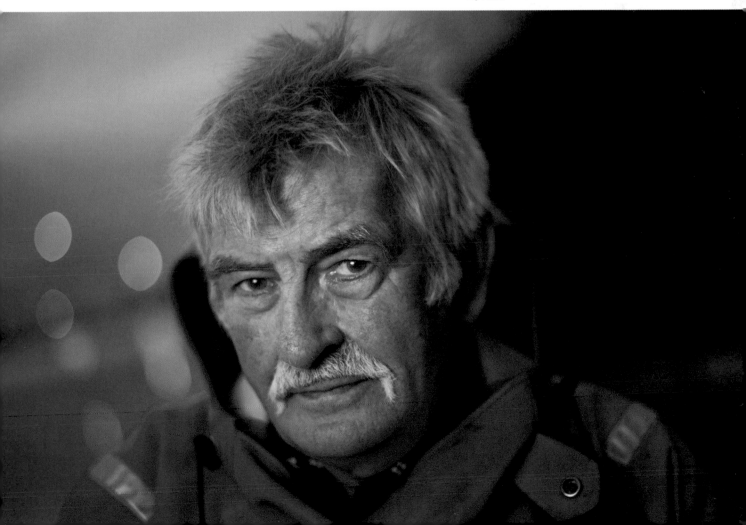

NEED A WINDOW IN A BAR?

Here's a wrinkle on a straight-up diffuser panel. I've always wanted some self-contained contraption that would allow the placement of small flashes a decent working distance from a diffuser panel, just by itself. In other words, it would eliminate the need for the use of multiple stands, which gets a bit messy and congested on the set. So, again, I got together with the good folks at Lastolite and helped them design this 3x3' addition to the Numnuts signature line.

This rig, as shown in the production pic below, has promise. I dragged it into a Nashville bar for a shoot with a rocker, Dean Tomasek. Great face, great location—albeit a touch on the dark side, as bars tend to be. I levered the support arm back away from the panel, and put (as an experiment!) four flashes on it. The diffuser material for this version of the 3x3' is actually a two-sided sleeve that comes down over the metal pipes, effectively doubling the diffuser effect.

Pretty light. As you can see from the production pic, there is a kicker flash off a reflective panel on the floor, and that adds just a touch of light up and under the brim of his hat. The shutter drag of 1/8th of a second gets the bar lights into the exposure, as does the wide-open f-stop of f/2.8. The main lights, because there's a mess of them, run real low, at −2.3 TTL. The floor kick is minimal, at manual 1/32nd power. Auto white balance, ISO 200.

I shot this using Aperture Priority mode, sending a TTL signal to the main lights to tone down their act quite a bit. They responded consistently and effectively. But, as I've said before, the world of TTL can be a strange place indeed, and that stupid little floor bounce kept, well, bouncing on me. All the TTL signals I sent it came back with a strange response. It would pump out too much, and then come back with too little. But the system doesn't care if something is a fluid, automatic TTL light or a manual light. I can send signals to different groups of lights to be one or the other in the context of the same frame. So, growing tired of that light trying to make up its mind, I sent it a manual signal—and, of course, once in manual, it stayed put, power-wise.

AND THEN, IF YOU NEED GOOD, DIFFUSED QUALITY, IN BRIGHT, BRIGHT SUN...

Hang on to your hats—and the light source—in the wind, but again, mounting multiple lights on one source is one way to build f-stop in response to midday conditions in the desert. This is the kind of stuff I occasionally take some heat for, actually. "Hey Joe, why use four expensive small flashes when one big light does the trick?"

Very true. A big Octa, powered by a big battery light, will get you there. No worries or debate.

"There will always be raging, passionate debate about one way being better than another. Which is okay."

(Octa is about $1200, and a good, dependable 1200 watt-second battery pack can be anywhere from $2500 to $4k. The small flashes are five bills a pop, plus the 3x3' light panel outfit. What's better? More logical? Cost efficient? To use a phrase newscasters often speak to close a story, "But one thing is certain...." And that is: you're out some dough.)

Here's the thing. Experimentation is rarely practical, or even sensible. I push the edges of possibility with Speedlights just to find stuff out. Why not? As far as I know, so far anyway, it's not a crime to waste pixels. If it were, trust me, the jails would be much fuller than they are now.

This is ISO 100 on a D3X, with a 14–24mm lens zoomed to 19mm, 1/250th at f/13. My subject, Thomas Wingate, is lit with a strong, smooth light, and that pulls him just about even, exposure-wise, with the brilliant New Mexico sky. Without that very large push of light down on the ground, you force the camera to make a choice—expose him properly and lose the sky, or saturate the sky and turn him into a silhouette. There's a lot of light up there in the heavens, so consequently, you need a lot of light down here on the ground to match it. And this rig is one way, among many, to do that.

There's a world of light shapers out there, from Tupperware salad bowls to football field–sized, motorized softboxes that Detroit car shooters use. As always, light comes in all different shapes, colors, and dimensions, and you can push it through all manner of stuff, from bed sheets to umbrellas.

And, photographers being photographers, there will always be raging, passionate debate about one way being better than another. Which is okay. If you consider the analogy of light as language, we all have our own accents, and manner of speaking. □

Risking "No"

THIS BUSINESS OF TAKING PICTURES is all about risk. Not necessarily physical risk—though that can occur, of course. Right now, though, I'm talking about far more prevalent risks— creative, financial, emotional. The ones photogs court almost every day. Let's face it, when you're a freelancer engaged in a tremendously uncertain occupation, just picking up the phone can be risky. We always joke at the studio when the phone rings: "Could be the big one!" Yeah, true, but "the big one" can go both ways, right?

One of the tougher calls to take occurs when somebody wants you to do a job, and you just can't—or won't—do it. The "can't" part is relatively

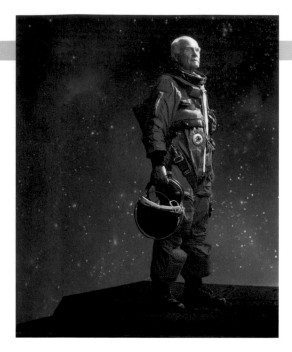

easy. Most assigning editors or art directors will accept a busy schedule, a personal commitment, or the fact that you are bleeding from the ears as an excuse not to take the job they are offering you. Though, to be honest, even though they say they're fine, that they understand, what they really want you to do is alter your schedule, screw your other clients, and tell your children that daddy can't go to Florida to take them on the Hulk rollercoaster because he has to go work for this voice on the phone. And as far as any medical excuses go, well, gosh, can't you just do my job and die later?

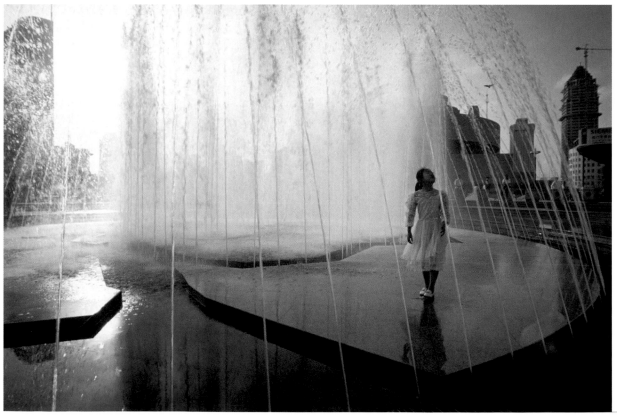

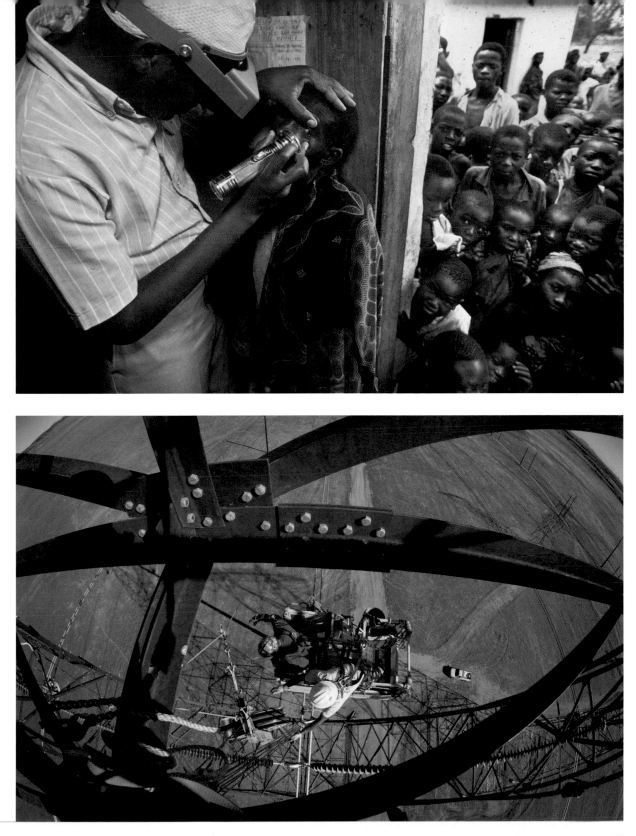

The voice on the phone is under pressure, and they want an answer, usually immediately. When people call with a job, it can be: a) They really want you 'cause you're the right person; b) They're frantic on deadline, working their way through a list, and they will basically take just about anybody with a camera and a heartbeat; c) They've got this job, and it's a corker.

Those calls in the latter category are pretty wonderful to get. I've had a few of them over the years, and when a picture editor unloads a truly sublime, career-altering, life-changing, megapalooza of an

assignment on you, it can take your breath away. You put the phone down after it's over and—in my case, anyway—start skipping around the room and speaking in tongues. Unless, of course, you have to turn it down.

Got one of those calls in 1988. The deputy picture editor of *Sports Illustrated* rang me up and said, "Today's your lucky day." Even back then, I'd been in the business long enough to have that phrase send a chill right down my spine. I calmed myself. "Okay," I replied tremulously.

"We're sending you to the Seoul Olympics. You'll have a go-everywhere credential, but no responsibilities. All you have to give us is one picture a day." Wow. It was, in fact, my lucky day. An open-ended,

freewheeling assignment with unlimited potential. Plus—and this is significant for the lowly freelance wretch—about a month of day rates.

I said no.

The first sound I think I heard was the editor's jaw hitting the table. And, if I'd been listening, I'd have heard a second sound—a deep, rumbling noise, roughly akin to an explosion. Yep, I had just torpedoed my relationship with the biggest, best sports magazine in the world.

The reason I said no was that I had previously committed a week of that month to participate in the National Press Photographers' Flying Short Course, a freebie lecture series that bombed around the country for a week, dispensing photo

wisdom and work experiences for photojournalists. One week. Five cities. No pay. Huh?

It makes no apparent sense, I know, but there was a method underlying my madness. A fellow faculty member on this lecture series was to be Tom Kennedy, then Director of Photography of the *National Geographic*, a magazine that was in my dreams and in my sights, but certainly had not come calling. My thinking at the time was that I would spend a week repeatedly showing my portfolio to Tom, hang with him, eat with him, and at the end of the week, hopefully, have an invite to come work for him. An uncertain plan, at best.

I was at a crossroads. Even though I was not a sports shooter, I had a contract with *SI* and was on their masthead. (I actually couldn't—and still can't—shoot sports worth a damn.) But I did a lot of feature work and portraiture for them, and truly enjoyed it. But it was a look at one world, and one world only, even though that world was widespread and multi-faceted. It was, at the end of the day, the world of sports. And I wasn't cut out to do nothing but sports, all the time.

Had to take a stab at another direction. Had to make a leap. That freebie lecture tour represented a crack at that, albeit a tenuous one.

At the end of that week, Kennedy looked at me and said, basically, to come down and start working for *Geographic*. I started shooting for them in '88. I'm still shooting for them, in late 2011, as I write this. It's been a wild ride, filled with stories about geography—both social and physical—science, space, medicine, trends, personalities, and yes, even sports.

Quick question. If you went out and asked just about anybody to cite a truly important photograph from the Seoul Olympics, would they remember one? How many folks even remember there was an Olympics in Seoul?

By the way, *Sports Illustrated* didn't hire me again for 12 years. □

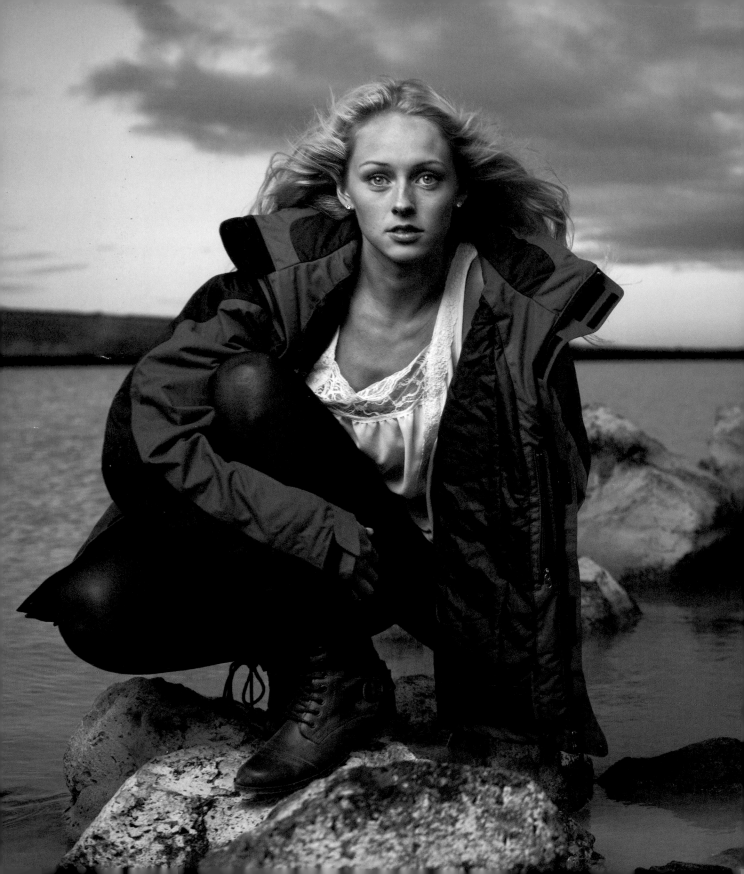

Northern (One) Light

SOMETIMES YOU GET TO USE the light you want. Let's say you're in the studio and have a complete handle on the situation. (Though, trust me, I've had days in the studio—where calm and control are supposed to live—that are just as nutty, in their own perverse way, as a day in the field in the wind and the rain.) But let's live in a fantasy here, and speak about those days where the entire world seems to be your studio, and the light is nice, and there's no pressure, and it seems like the vulture of failure that is perennially perched on your shoulder has been temporarily replaced by the bluebird of happy pixels and good light.

The cameras are working, the subjects are forth-coming and attractive, and you are pushing some of the best frames of your life. Just fantastic. Those are rare and balmy days, indeed. I had one in the early spring of '92 and I still cling to the memory.

Lots of times, it's a compromise out there, right? The environment, the timing, the rush of somebody's schedule, even the ceiling height can conspire against you using the light you want, and putting it where you want. Sometimes, it's really for the best. The art of compromise that location shooting enforces on the fever-racked imagina-tions of photographers everywhere has actually saved some from themselves. I have looked on scenes and imagined what I could do with a few 12k movie lights and some substantial scissor lifts and cranes—not to mention the smoke machines and

the pyrotechnic crew—and seen the colors dance in my head. Then I shake that same head vigorously, give myself a couple good whacks to the face, and realize I ain't gonna do any of what I just imagined. I'm gonna put one light up in the foreground, 'cause that's what I've got, and drag my shutter for the background. And that background is going to be what it's going to be, despite my fanciful yearnings.

Cold weather and wind can really limit your lighting options, that's for sure. You can't put up massive lights in the wind, and the cold makes you and everyone, including your subjects, potentially uncomfortable. In adverse weather, it's best to keep it simple. I learned this in truly epic fashion when I shot legendary dancer Gregory Hines on a pier in the New York harbor.

I foolishly set up a 12' silk on a frame, with stands and sandbags, in what was an almost nonexistent wind. Had my 12' Gitzo tripod, and a ladder next to it. Thankfully, there was no camera on the tripod.

Because, the next thing I heard after I turned my back on the rig (yet another bad idea) was Michael, a big Irish bloke who used to help me around New York, shout, "Oy!" I turned to see him let go of the seriously out of control silk and frame as it literally walked, propelled by a sudden gust, corner over corner, off the dock and into the Hudson River, taking the ladder and the tripod with it. I remember standing at the edge of the dock, watching my gear bubble it's way downward into the Hudson murk, looking at Michael and saying, "I guess I'm going handheld." I was back to basics. Get it done, quick and dirty, in the wind. I got a celeb on a dock for about 45 minutes. Breathe, Joe, breathe.

Which is what I did. I put up one light on a stand. No umbrella. Not even the hint of a softbox. Raw light, just like the sun. I wired it to a radio, and blasted it at Hines, who was just cool enough to pull off a smooth elegance despite the crude nature of my flash treatment. My rosy dreams of big, beautiful light went to the bottom of the river. So did any notion of gradation, or subtlety. Notice the pylons Hines is standing on. Could I have lit them any frikkin' brighter? Drives me mad when I lose the ability to shape light. On the other hand, my watery misadventure caused me to rethink the location. I then put him out of the wind, at the other end of the pier, lit him nicely with one mid-size softbox off to camera right. Nothing fancy. Again, ever the pro, he posed for me, unfazed by my readily apparent idiocy. He was so smooth and graceful, he actually relaxed me, back at the lens. Then he gave me a frame, arching his head back in mirth, which became the picture *People* magazine ran with. (Was this wonderful expression a gift to me of a seasoned artist, used to being in front of camera, and knowing what a magazine wants? Or was he just plain and simple laughing at me?)

Whatever the motivation, it worked, and remains one of my favorite pictures of a performer whose talents we miss.

I got my tripod back, by the way. Nice thing about Gitzos is they've got a lifetime guarantee, and they'll fix it for you, almost no matter what you've done to it. A couple of NY/NJ Port Authority divers were on the dock and witnessed the whole thing. After stemming their laughter, they approached me and told me they knew the river pretty well, and could fish out my gear for $300. Seeing as the Gitzo was over a grand, and had that warranty, I said yes immediately, and they snatched that puppy out of

the Hudson by late afternoon. I sent it into the manufacturer with the simple explanation: "Water damage." (It sounded better than: "Outright stupidity.") They cleaned it and fixed it for me, and I still use it.

These are some hard-won lessons in photography that thankfully stay with me, and certain mistakes I at least try not to repeat. In Iceland, famed for tough weather, working in the wind—raw even in August—I kept it simple. I shot up there for one week last year, had a great time, learned a ton, and used one light. Now, that light took several different forms, but it was one flash, and one flash only, all the time.

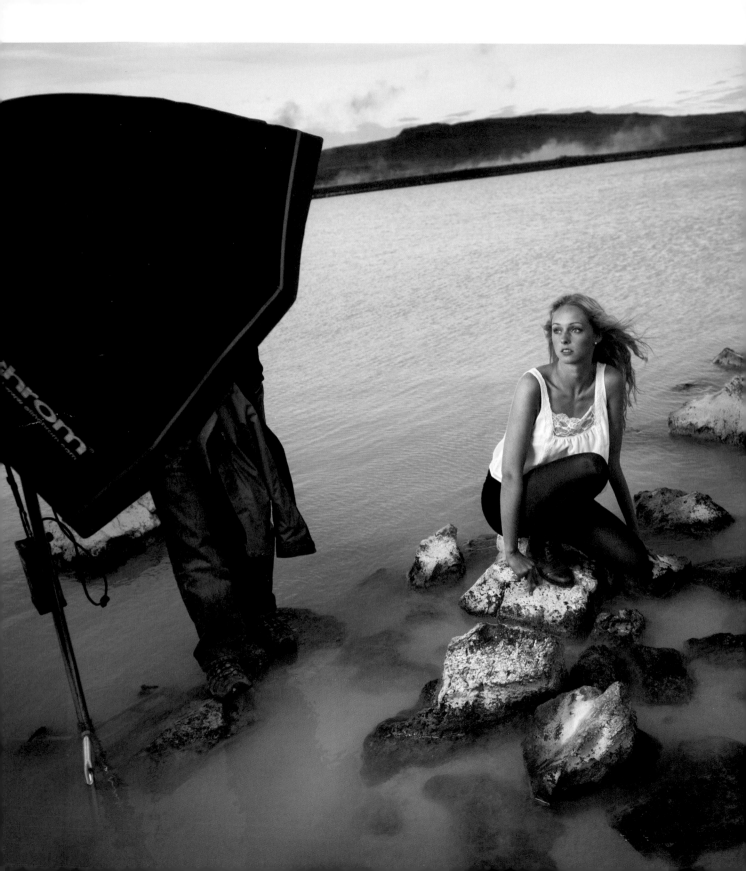

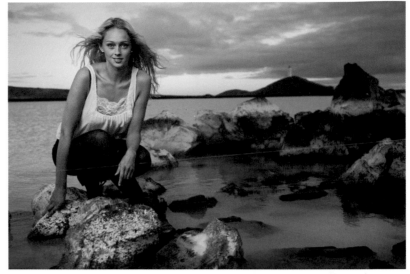

Remember when Iceland recently blew its top and shut down Europe? That little pressure cooker of an island just sits there and vents, all day long. The steamy volcanic guts of this piece of rock in the ocean create startling blue mineral waters, wonderful skies, and slippery, craggy shorelines. And when you have a model out there on those slick rocks, and you are both hovering over water that can potentially scald you, it's time to put the kicker lights, hair lights, and side lights away. Get a main light in a good position, frame it well, and start shooting.

It was also a time when dragging the weight of a C-stand along became oh so worth it. That type of stand, with an extension arm, gave me two things: a solid base for a pretty sizable light source, and the ability, via the arm, to leverage the light into good place for my subject without constraining me compositionally. As you can see from the rather odd production pix, we are tiptoeing on rocks at the edge of a mineral-laden lagoon, using an Elinchrom Deep Octa as our one and only source. Actually, of course, there are two sources: my Octa and the natural light. The natural light is far and away the most important light. It illuminates everything but Sara. The fading sweep of sunset is a global input to the entire photographic equation, while the flash is local, only meant to selectively draw the viewer's eye to my principal subject.

That's the somewhat ironical notion about being a "flash" photographer. Always, always, the first snaps you make on location, before you drag out the cables and wires, should be of the ambient light condition. Even if there is no ambient light, or you don't think there is any to speak of, make some pictures. Digital cameras, increasingly sensitive and detail rich, will surprise you. Where your naked eye sees blackness at its first pass, the digital exposure machine might pick up a glimmer, or more. So, reassure yourself of the darkness or the brightness of the scene. It's only after this process of evaluating the existing light levels that you really know how you might "light" something.

And honestly, out there on wild Icelandic shores, it would be far too grand a claim for me to say, "I lit this picture." It is lit for me. In this situation, your compositional skills as a shooter override the lighting considerations. You first and foremost have to find someplace to settle the camera and your subject. Some things raced through my head.

Comfort of the subject was one thing, and her ability to actually perch on the rocks without appearing to be painfully contorted.

Staying low to the water was another. That allowed my lens to sweep over a big swatch of wonderful color, and at the same time keep her in relative darkness. If she stood up, or if we went to higher ground, I would have lost the immediacy of being on the edge of the famed mineral waters of Iceland, and she would be much more exposed to the brightness of the sunset. Where we were located, down low, I could adequately supply her with my light while the sunset does everything else. With her in subdued shadow, my light doesn't have to fight the sun. I have more control. The lighthouse in the distance also gave me a nice, graphic exclamation point in the deep background, which is still gloriously lit by sunset.

There's a lovely scene, a terrific model, and all sorts of expensive photo gear that does all manner of things for me, automatically and well. So, what's left to me? Well, for starters, try not to screw it up. It sounds like I'm making a joke, but I'm not. Occasionally, we have to force a picture, right? Sometimes—make that many times—we work so hard on location, grinding out a picture, making something out of nothing, we might as well be one

"It is only after this process of evaluating the existing light levels that you really know how you might 'light' something."

of those Irish fellas in the forward compartments of the *Titanic*, shoveling coal like there's no tomorrow, which sadly, for them, there wasn't. (Hmmm... the gang furiously shoveling coal in the lowest, most forbidding sections of a doomed ship...and... photographers. What do these two groups have in common?)

Thankfully, this wasn't one of those grimy, sweaty times in the field. Here, all the grace elements of a potentially good photo came together out there in cold, and relatively quickly. So, my very real mission was to not screw this up with bad camera or light technique.

The Deep Octa is a simple, elegant solution. It's a one-stop-shopping of a medium type of softbox. As its name implies, it has a depth of construction that helps columnate the light and an interior baffle that softens the blast of the flash, deep in its core, before the light even hits the exterior diffuser skin. The result is a richness of tonality few normal softboxes can approach. (When I say "normal," I mean the more standard configuration of a light box, which is much more shallow than the Deep Octa.)

It was a good light for Sara. It embraced her face well, and dropped off into muted shadows in a wonderfully natural way. Soft and easy, with no telltale strobe hits or harshness. Thank goodness. It would have been difficult out there to adjust this light to, say, eliminate a hot spot, or to redirect it in any manner via a cutter or fill board. We were, literally, on the rocks. I positioned the light, triggered it with an Elinchrom Skyport radio—thus keeping connecting cords to a minimum—and started shooting.

The light in the Octa is an Elinchrom Quadra unit, and you will see various notes about the Quadra throughout this book. I use it, and, I have to say, it's pretty good. There are things I look forward to them improving, like the optical sensor eye on the top panel and the overall construction of the unit. (The plastic clips used to couple the battery to the base of the unit need beefing up.) But overall, it's a smart foray into that frontier land between small flash and outright big flash. The unit, no bigger than a small lunchbox, gives you 400 Ws of power through two asymmetrical flash head ports. Pretty cool. Given the asymmetry of the pack, you can ratio a flash head from 6 watt-seconds to 400, which is great range.

It's also got a Skyport radio receiver embedded in the guts of the pack, which is a beautiful thing when it works. (All radio systems are beautiful things when they work, right?) The nifty feature for me—here, out on the rocks, in the wind—is that I can ratio the power pack right from the Skyport transmitter hot shoed to the camera, by tenths of stops. If I look at the LCD (to judge my relative exposure, God forgive me my sins!) and need more or less pop, I can signal it up and down by tenth-stop clicks. Luckily, even after 35 years in the field, I can still count to 10.

The light is beautiful, both background and foreground, and matched up well at a combination of 1/60th at f/4. Lens is at 48 mil, D3X on manual. (I'm not using TTL Speedlights, so manual all the way, both at the light and at the camera.) A nice picture of Sara at what I guess Icelanders would call a beach.

The Deep Octa also follows that old lighting principle of big and close equals soft and diffuse. Take a look at the soft but sharp quality of light on the model's face in the pic on the previous page, as the northern sky catches fire and the lagoon fades into a muted blue. This light works, from two feet, five feet, or ten feet away. Very, very versatile. I would have to say, if my "bigger" lights go out with me, this softbox does too, all the time.

> "My strategy was not to overwhelm the daylight, but just to literally 'fill' Sara's face with a smallish pop of light."

FURTHER INTO THE WILD, AND THE COLD! ICELAND IS A CRAZY PLACE.

When your bikini-clad model is perched at the bow of a boat moving amongst icebergs, and the water temp five feet below her is such that if she falls in, she will be dead within two minutes, you really pare down the light paraphernalia to the absolute minimum. (Not that she was going anywhere. We had an Icelandic safety guide as her spotter and rescue swimmer, clad in an emergency buoyancy suit, standing just off camera, next to her. You can barely see him from the angle of the production picture [following page], but he's just behind me. Not surprising. Clad in a winter coat and wrapped with a life vest, I could easily block your view of an aircraft carrier, should one of those happened to have been in the lagoon.)

It was still a pretty bright, blue sky Iceland day, so power was an issue for small flash here. My strategy was not to overwhelm the daylight, but just to literally "fill" Sara's face with a smallish pop of light. Modest goals, in a difficult logistical situation. Just to keep it simple, and do the one bag o' gear thing on the boat, I didn't bother bringing big flash. I first tried a 24" Ezybox Hotshoe softbox as a light source. No go. Not enough power translation from the small flash to the subject through that modestly sized box. Jumped from there to just a raw flash.

Didn't like it. Too raw, no eloquence. Okay, what's in between? As I mentioned earlier, LumiQuest has been making pretty cool, small, collapsible, cheap light shapers for a long while now, so I grabbed a SoftBox III. Figured if I could maneuver it in close enough to her, it would give me decent light, and just enough of it.

Bingo. Small, cheap, and fast. The paint pole: literally a Shur-Line Easy Reach paint pole, available at Amazon or a hardware store, is simple, easy, light, inexpensive, and indispensable. It can extend the reach of your light and give you flexibility in a nutty situation, such as

a boat floating amongst a bunch of killer icebergs. The LumiQuest SoftBox III: also cheap, small, light, and it stuffs in the smallest of camera bags. Goes with me on every shoot.

Back to the power issue. The final settings are 1/250th at f/14. D3X, ISO 200, 14–24mm zoom, racked out to 24 mil. Flat-out manual, 1/1 on the SB-900: full power, no frills. A place for high-speed sync and a more open f-stop, perhaps? Yes, of course. I could have gone to high-speed sync, but I would have most likely remained at or near high-est power on the flash, given my working distance. (High-speed sync technique is discussed in just a little bit, later in this chapter. And there's a thorough examination of it later in the book, in a story called "The Aesthetics of High-Speed Flash.") Working in high-speed territory, though, with a mega-fast shutter speed, would have required me to use extremely wide-open f-stop settings, such as f/2 or f/1.4. And that would have rendered the icebergs as out-of-focus textures at best, or bluish blobs at worst, and, frankly, I wanted to see the icebergs.

I don't get to Iceland very often, and the juxta-position of the young lady dressed for a tropical beach with the arctic background was the point of the snap. Hence, I stayed with "normal" flash sync of 1/250th of a second, and worked my f-stop into something that would keep the background in bal-ance, and pretty sharp.

On page 54 is a JPEG out of the camera. And next to it is what Drew, my assistant, did to it in post. Simple and clean. Good pop to the light. After post, the railing is gone. Modest goals, simply accomplished.

Jay Mann

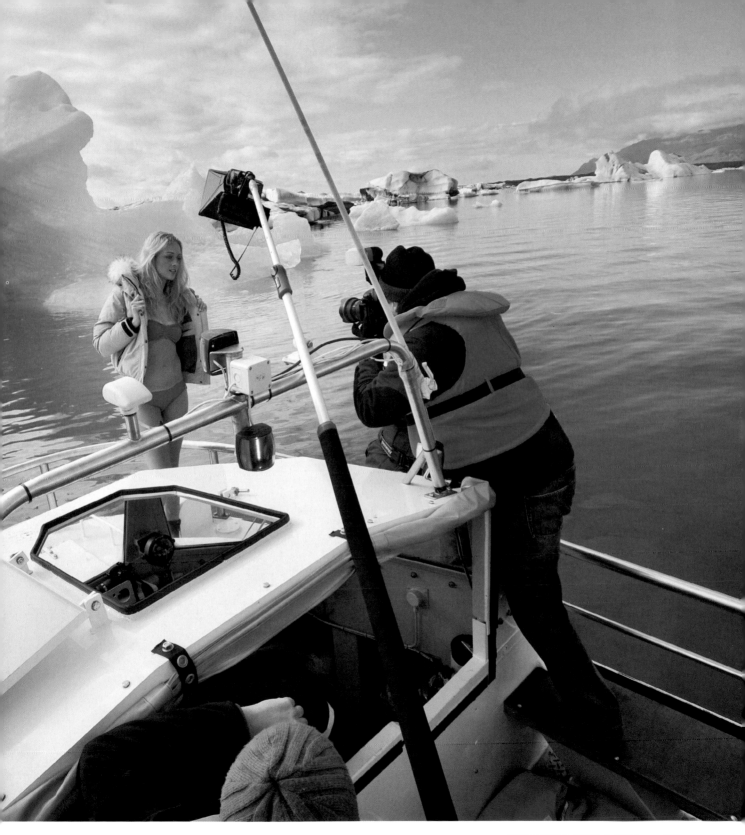

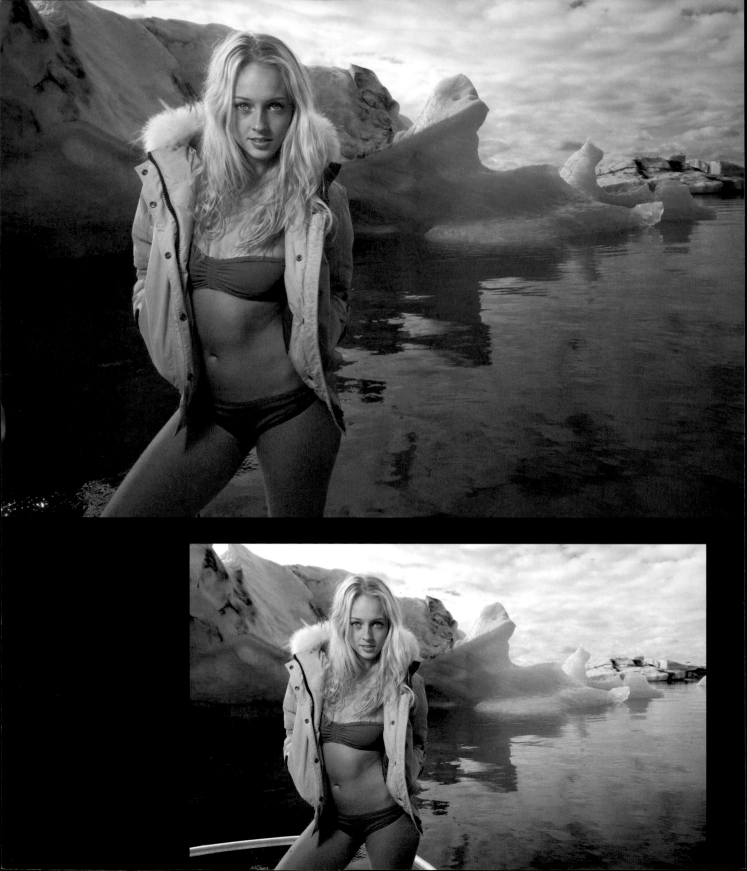

AND NOW FOR SOMETHING COMPLETELY DIFFERENT!

My friend, Einar Erlendsson, who invited me to Iceland in the first place, assured me that it's a place where the mad Vikings roam. He wasn't kidding.

Out there in the hot springs, he introduced me to Ingo, who was going to be our character model for the day—with the emphasis on "character." He was a fun-loving, decent guy, and a non-stop talker. I remember him just peppering me with conversation, and not understanding a word he said. Einar said he was a "real Viking," which, at the end of the day, I just took to mean "flat-out wild man." He was also a photographer. Of course.

No matter. He had a couple of outfits. Instead of the helmet and the broadsword, we opted for the biker jacket and the shotgun. As I recall, he didn't have a leotard and a tutu. Too bad, as it would have been an interesting entry to my dance archive.

I wanted to shoot him with the Northern moon, which was full and bright. Seemed appropriate. To do so, I had to get him to high ground, and far enough away from me to use a big lens. Ever try to shoot the moon? (I mean, photographically?) It's easy to be moon-struck as a photog. This near neighbor of ours in the solar system has oozed enchantment, mystery, and romance throughout human history. We look up at this big, beautiful moon, and then try to shoot it in reference to something earthbound, and it more than likely ends up as a tiny, annoying, bright white bullet hole through our pixels. So annoying and attention-getting that I imagine some shooters—after going all out for a moon shot of a photo—then just blot it out in post-production. That sucker's bright, hard to manage, and small, even through a decent-sized telephoto lens.

So, I knew I had to get my subject up and away, far away. In fact, this was shot with a 1,000mm lens, or the equivalent thereof. (It was a 600mm f/4, plus a TC-17E II 1.7 teleconverter, which makes the overall lens almost an f/8, effectively.)

Given the raw, rough-around-the-edges quality of my subject, I figured a raw flash would do quite nicely. Actually, I'm just saying that. When we finally hit on the fact that doing this pic was going to be

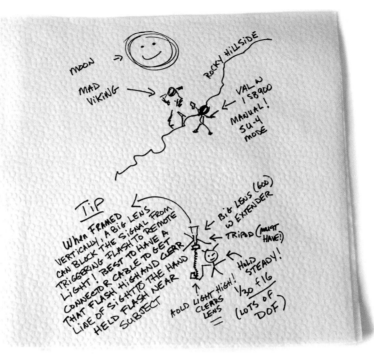

possible, a simple, VAL (voice-activated light stand, i.e., an assistant) hard flash treatment was all that we could manage to throw together in time. The Norseman went up the rocks, next to the moon. Drew grabbed a flash and scrambled up there with him.

Ever go to a lecture where an utterly insufferable photog of note is showing work and waxing eloquently about the nature of the light or the camerawork, and how their wizardly, knowing touch at the moment of exposure imparted magic to the image? Thus, it possesses a certain *je ne sais quoi*, an undeniable power that one can't touch or define, but is truly there, somewhere? That they are actually not wielding a camera, but instead an instrument more akin to a Harry Potter–like wand and the resultant exposure is really more of a spell than a photo?

It's hogwash. Practical concerns, falling light levels, rapidly rising moons, and desperation drive most field solutions. Mysticism comes later.

The one fancy fillip I did add here was to figure this as a perfect testing ground for the relatively newly arrived Flex/Minis, the radio TTL Pocket-Wizards. These promise to take the arcane language of TTL and translate it into radio waves, thus freeing the photog from the shackles of line-of-sight transmission. Great situation to try this out. Clear field from transmitter to receiver, in a remote area, pretty much devoid of competing RF. Fresh batteries, aerial exposed, good to go.

Uh, no.

It didn't work. Tried every which way I could right then and there, but got no transmission. In their defense, the units were still in the beta stage

of things, and thus shy of the myriad firmware updates still to come. We might have easily done smoething wrong, like miss a step in the powering sequence of the Flex/Minis, which is roughly akin to a shuttle launch. Or we didn't do the secret flash radio handshake properly. Or we used the wrong incense for the burnt offerings we made to the gods of radio TTL. Or Drew didn't rub the receiver for luck. I don't know.

What I do know is I went line-of-sight, SU-4 optical slave mode, something that has been with us shooters for a long time. Drew just put the unit in manual, full power, and I triggered it with a flash pop at camera. Easy, and antediluvian.

It worked. Because of the distance from my camera to my subject, the flash at the camera did not affect him at all. It didn't alter or influence my exposure. All the light on him is from the remote flash, handheld, up there on the rocks, to the right of camera. The light sensor panels on the SB-900 are quite sensitive, and very much so when in SU-4 mode. When in TTL mode, they are seeking a specific frequency of light emanating from the commander, and are thus constrained to only fire in response to that frequency. Think of it as a partially open door. When you go to SU-4 optical slave mode, you throw the door wide open. The thing will fire in response to any sudden increase of light, coming from anywhere. I've been on location in the big city where a passing ambulance with the gumball machine on will trigger an 800 or 900 from a couple hundred feet away. Hence, my pop from shouting distance at the camera was more than enough to ignite this flash for my subject.

The final was 1,000mm lens, D3X, ISO 500, 1/30th at f/16, tripod. I went for as much depth as I could find, as I wanted some sharpness to the moon. As you can see, even at f/16, the lunar surface is not detailed; it is more like shadows and textures.

My foreground subject is not texture, however. He's a full-blown, hard-flashed, shotgun-toting, moon-howling man of the north, out there on the rocks.

SO, HERE'S SOME ADVICE: CHEAT. LOOK FOR SOMETHING THAT'S ALREADY LIT.

Out there in the steaming, sulfurous emptiness of Iceland, we were allowed into a thermal plant, which was a really cool place to shoot. I was teaching a lighting workshop, and we did our usual thing of talking about it, scouting the location, dividing into teams, and assigning models. Again, per usual, I told the group I would try to stage some sort of hopefully helpful demo during our stay. Everyone toddled off, lights and models in tow. One of the reasons I enjoy teaching, obviously, is to see the results folks get when encountering a new location, camera in hand. And I do some head tilts, at least occasionally, when I come upon a shooter who's feverishly preparing a shot that appears to me to be so outlandish and nonsensical that I give him or her precisely zero chance of success. Those tend to be inside thoughts. I usually let the proceedings proceed, and I tell them I'll check back in later.

And that's the wonder of it. They'll come back with something truly unique and beautiful, despite the teacher's interior misgivings. They'll come back with something unanticipated. They'll come back with something I never could have seen, because I just don't see in that particular way. And it's wonderful, not to mention instructive, for all concerned, including me.

But then there are those moments when my perplexed head tilt and quizzical look of bovine astonishment at someone's setup is warranted. I'll walk up on a group that, for some reason, has chosen the darkest, most labor-intensive spot within the location that can be found. They will have looked at a beautifully ornate mansion and resolved to photograph their subject in front of a dark, highly reflective piece of polished wood wall that could literally be anywhere, and doesn't have a scintilla of identity or story to it. They will wander into a romantically lush boudoir and use the closet 'cause they want to make shadow patterns out of the hangers. Or something like that.

All to the good! Photography is a wide-open enterprise, and the creative soul has to wander where it wants. Sometimes, you just gotta take a stand and say, "I'm shooting this," no matter the size of the

"So what drives my selection of a spot is often the quality and 'cover the waterfront' nature of the light that's already there, before I even pull a flash out of the bag. Call it smart. Call it lazy. It's okay. Just do yourself a favor and look for light that you don't have to work at supplying."

windmill you're tilting at. But you just have to accept the fact that, in many instances, that windmill's gonna shred you and your picture dreams. It's a learning moment, in a heartbreaking sort of way.

So, as one who has often been the bug splattered by the onrushing windshield of location photography, I at least try to choose my battles wisely. I look for a sense of place so that the photograph has roots and tells a bit of a story. Why drive to/rent/scout/light/struggle with a location only to come out with a photo that has a background that could be literally anywhere? It's not always necessary, but showing environment in an informative way can be vital.

And frankly, one other thing I look for is some thing or some place that is already lit for me. I'm often working with small flash, which means I'm not in a position to light a city block anyway, and I'm relegated to lighting, or formalizing, my foreground, and letting the ambient light do the rest of the heavy lifting. So what drives my selection of a spot is often the quality and "cover the waterfront" nature of the light that's already there, before I even pull a flash out of the bag. Call it smart. Call it lazy. It's okay. Just do yourself a favor and look for light that you don't have to work at supplying.

Wandering the thermal plant, I got intrigued with the silvery quality of the pipes near a set of windows. They made interesting shapes, and fairly gleamed in the daylight. Bathed in natural light, there was little or

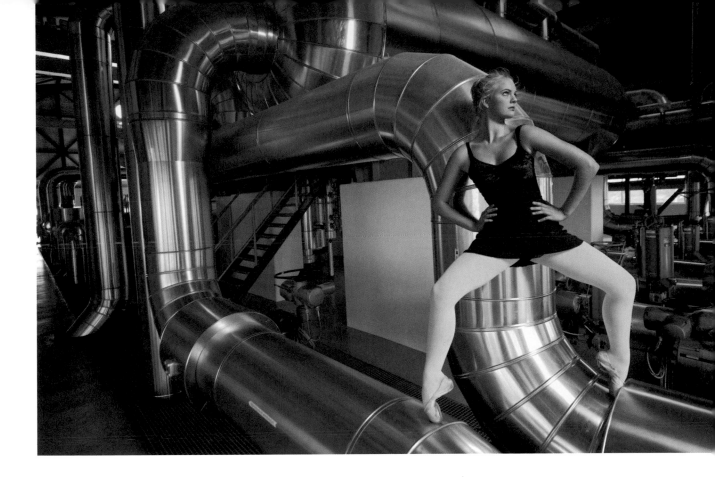

no input from any nasty overhead fluorescent or mercury vapor illumination of the type you often see in industrial environments. By keeping close to the windows, I made sure I had good, clean daylight throughout the frame. All I had to do was coax a ballerina up onto the slippery chrome, and we were almost home.

If the pipes are so well lit, why do I have to light her at all? Introducing a light for her gives me what? A lever of control over the gleam of the silvery scene. In other words, if I put her in there with no supplemental light, then she's just part of the overall exposure. The light on her is the same as it is everywhere else. What I'm looking to do is spark her, just minimally—to clean up and direct the light hitting her face, and by doing that, to richen up (saturate) the pipes and the overall environment. A few sentences ago I used the word "formalize." Indeed. With just a splash of foreground flash, I can make her pop, make her look more the way I want her to look, and thus—by exerting that tiny

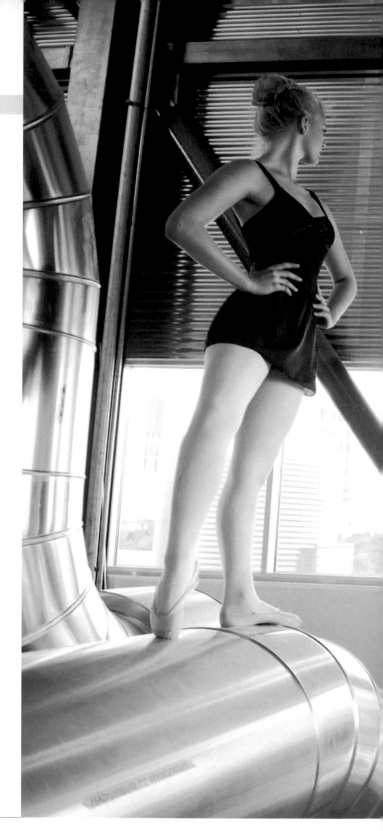

bit of foreground control—I can bring the background to heel.

Just a bit of foreground flash gives you control of the foreground, to be sure. But, very significantly, that measure of control extends all the way through the photo, to the very background.

Plus, she's not C-3PO. She's got skin tone, not a gleaming metal exterior. She needs the extra light. You can see in the production pic that the louvers have the windows at half mast. The sweep of natural light is actually below where her face is, and up around her head and shoulders she is starting to fall out of the sweet spot of the existing light pattern. With my flash, up high where she is, I just replaced that light loss.

That flash came in the form of the 30" Ezybox Hotshoe softbox. It's a big softbox for a small flash. It has a creamier, richer tonality than its smaller, sharper cousin, the 24-incher. Choice of the larger source here was driven by the lustrous quality of the window light. I was actively trying to match the quality of my flash with the quality of the existing light, and make it flattering for my subject and smooth enough so that its feel and look wouldn't be jarring in the context of the scene. Invisible flash, in other words. Flash that disappears under the blanket of the light that's already there. Flash that fits in.

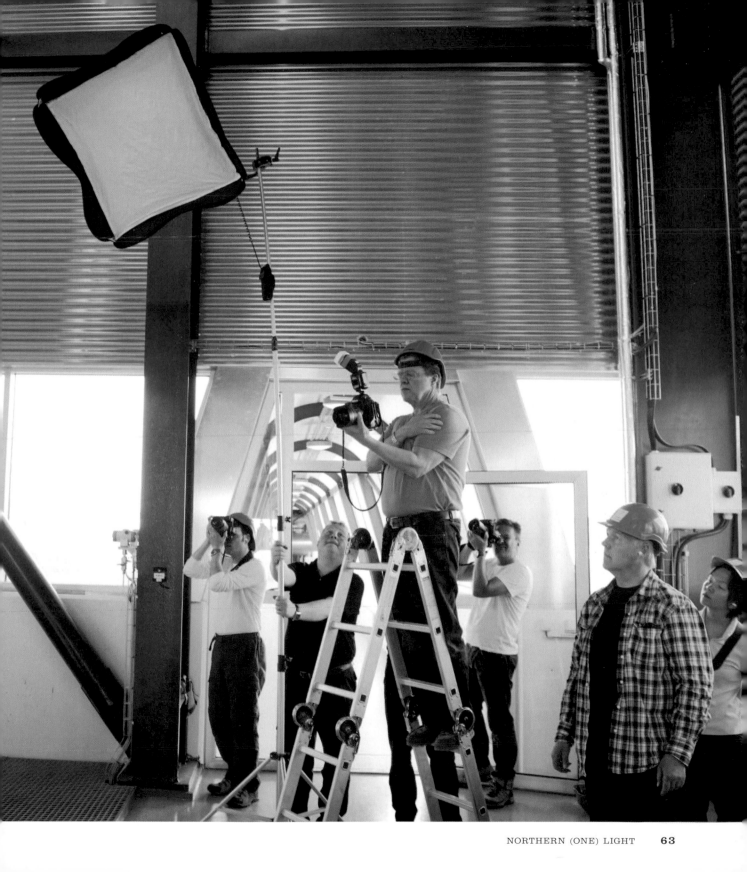

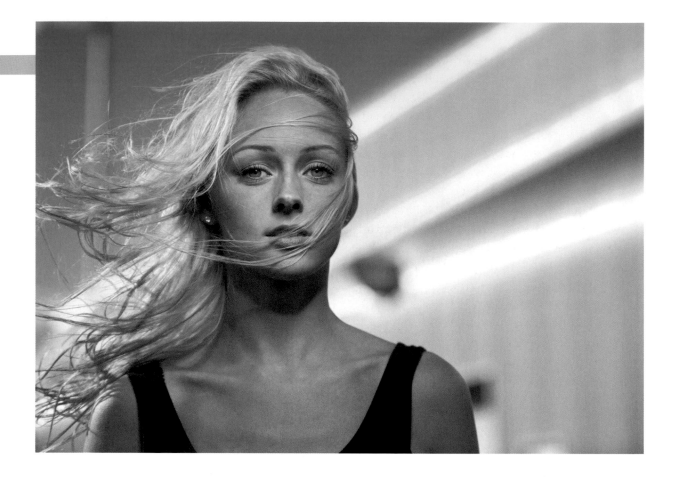

CONTINUING OUR ONE-LIGHT TOUR OF ICELAND...

Let's go from smooth flash that fits in and disappears to flash with an edge. Sharp flash that makes a statement. Small flash that fights off the very sun!

See the wind in Sara's hair? Remember this whole chapter started with a windy misadventure? Remember I said I try to remember those hard-won lessons?

No 12' silk here, thank you. Didn't have one, first off, and secondly, from where I sit, this is a tailor-made situation for small flash and the technological advantages that come with using it well.

Not that you couldn't have done this with a big pop of light from a big flash. Absolutely. But, most likely, you are then dealing with a normal flash sync speed of $1/250^{th}$ of a second or so, and ramping up your f-stop to get proper exposure and saturation. Most likely, you end up around f/11. Cool. No worries. That works. But what's the baggage that comes with f/11? Depth of field. The shiny building in the background gets sharper and much more defined. Again, if that's what you want, go that way. That's easy enough to make happen and, if you are photographing the president of the corporation that owns

that building, it's probably preferable. In annual report, public relations press release mode, you are not unconstrained to, you know, create in wild and feverish fashion. You have a mission. Show the big shot, and show the real estate he or she owns or runs. If you throw the background enterprise so out of focus that it's unrecognizable, you may have one angry art director on your hands.

Showing the person with the establishment or signage nicely framed and sharp in the background doesn't sound off-the-charts creative, I know. In fact, it sounds outright humdrum. But, corporate annual shooting can be thousands of dollars a day. At those rates, they can humdrum me to death. I'll express myself with a tilt-shift lens another day. Hell, at those rates, if I'm shooting a president-type dude, I'll even tell him his tie is pretty darn spiffy. Make him feel good, and the art director feel good, and then you get to feel good when the check shows up.

Given my druthers, though, I'd rather shoot Sara any day of the week.

And here, using high-speed sync, I can turn the building into gleaming, out-of-focus lines and shapes.

My exposure here is 1/4000th at f/2.8, 70–200mm lens, set at 82 mil. D3X, auto white balance, ISO 100. Manual mode for exposure. Via TTL commander mode, I'm sending the flash a message to go manual, and setting the power at 1/1, the most the flash can muster. The light shaper is a Flashpoint beauty dish, that little soup bowl you Velcro to the light. Sitting in the middle of the bowl is a curved piece of metal, called a deflector, which blocks the light coming straight from the flash, and pushes it back into the white interior of the bowl. The light then redirects and pings back towards your subject in a

hard, clean, crisp way. Classic beauty dish mechanics, writ small. (As I mentioned earlier, this unit also comes with a set of honeycomb grids you can pop over the top of the soup bowl, which makes the light really tight and sharp, with very little dispersion. An extremely small, directed, sharp light results.)

My subject has a face made for fashion lighting. She has a very symmetrical visage and great cheekbone structure. The light is thus placed symmetrically, right over camera and her steady gaze. You can tell the position from the catchlight in her eyes. The resultant shadow drop on her face is equivalently even. Logical, right? Light from this hard, hard source travels in a straight line. It doesn't wrap or bend. Place it right over her, and the shadows fall in a pretty identical way on both sides of her face. Effectively, there isn't a highlight side and a shadow side to her face, which is what, for instance, I created for her in the blue lagoon with the Deep Octa to camera left.

Okay, high-speed sync. Let's deal with how you get flash sync at the relatively unheard-of shutter speed of 1/4000th. With Nikons, you make a menu check-off in the camera. With Canons, you turn on the function at the flash itself. I won't go deep into the electronics—because I can't—but what happens when your shutter slides beyond the traditional limits of normal, or regular, flash sync is that the flash starts pulsing. Little bits of light fly through the rapidly moving slits in the focal plane shutter, heading for your subject. The faster your shutter speed, the fewer bits make it through, and, as a result, the higher your shutter speed, the more light you lose. At the really high speeds, a ton of the light the flash is producing is getting lost on the dark side of the shutter and never makes it out there to help make an exposure.

> "The numbers sound like a high school math problem, but the result you wring out of those numbers is more like a creative writing assignment."

So, it works, all the way to 1/8000th of a second! Very cool. The price you pay? Tremendous loss of flash power. This liability, if you will, can translate into an aesthetic strength, though. Hear me out.

I shot Sara at 1/4000th at f/2.8, as I said. What does that translate to in the world of normal sync? 1/250th at f/11. There's a tremendous difference between those two "equivalent" exposure settings. One has major depth of field (DOF), the other has minimum. Which setting suits your purpose? The numbers sound like a high school math problem, but the result you wring out of those numbers is more like a creative writing assignment.

The nice thing is that the high-speed sync option is there. When I started shooting pictures in earnest, the highest shutter speed that would sync with a flash was 1/60th of a second. The only way you could get higher sync was to use a camera with a leaf style shutter, such as a Hasselblad.

Which meant that for indoor, flashed sports action, you couldn't use a 35mm camera. You had to go with a medium format. Ever try to manually follow focus on a fast-moving basketball player peering down through the dark alleyway of a Hasselblad viewfinder? Why do you think they call it "Hassel"?

The wonder of modern electronics has given us the gift of high-speed sync, but at a price: the aforementioned loss of flash power. You can counter this in several ways; some are simple, some expensive:

Move your flash in close. Easy enough, depending on your composition and frame.

Go to the highest power on the flash. Logical. Scotty, more power! But, with a battery-operated small flash, there are obvious limits to that power.

Open up your f-stop. This is where having one of those newly popular, ultra-fast, f/1.4 prime lenses stashed in your bag can be really, really helpful. For instance, the shot of Sara was zoomed to 82 millimeters. I didn't have an 85mm f/1.4, but that fast 85—at basically the same length—would have given me an extra two stops of latitude.

Increase your ISO. That will increase the "power" of your flash, right? Yes, but in this instance, what will it also increase? The power of the sun. ISO step-ups sound logical when you're desperate for flash power, but always remember that it's a global input. You increase everything in the exposure, across the board. Increasing the power and pushing your flash in close are adjustments local to the flash and pertain strictly to its effectiveness only. ISO increase is a high-speed strategy that is only effective in certain isolated instances. There's another story in this book that talks about when that might occur.

And then, there's my favorite—more flashes! But boy does that get expensive, and fast. Figure this. You need another f-stop, which means you have to double your light power. Okay, if you are maxed on the flash currently in use, that means you need a whole other flash. Reasonable. Many shooters out there carry multiple flashes with them. But now let's say you're using two flashes and you still need another stop of light, which again, means you're playing doubles. To grab just one more f-stop is to double the light output of the two flashes, which means—going to four flashes. That's a lot of flashes.

That's where other considerations kick in. Do I spend the dough on four $500 Speedlights or go for a big light? Both paths have strengths and weaknesses.

On the Speedlight side: Multiple flashes can provide versatility. They are light and very portable. Don't need access to electric. Can liaise with external battery packs, thus extending their efficiency and usefulness. Provide access to proprietary camera technologies, such as high-speed sync and TTL control. Also can be used in manual mode, and many models have built-in slave eyes, making them readily available as small kicker or background lights, triggering off a main light—any main light. "Darn handy" is a good term to describe these little hot shoe sons of guns.

On the downside: Limited range and power. Finite battery life. Will heat up and burn out if pushed too hard. Limited array (though ever growing) of light-shaping tools. They are small sources, tending to be harsh in their effect, unless shaped and bounced to achieve the softness and effect you can get pretty easily from a bigger flash and power pack arrangement. No access to a true model light

for pre-judging a shot. Constant maintenance and field planning in terms of always having fresh batteries available, either rechargeables or one-use.

Bigger flashes: Much more power and, to a degree, dependability. Faster recycle. Access to a truly wide range of very sophisticated light shapers. Effective model lights, so you can pre-visualize the quality and direction of the light. One pack and head can often suffice, whereas with small flash you might need multiple units to achieve the same results. Certain types of bigger flashes run off electric, which means they'll work all day, others work off battery packs, which make them good, versatile field units. Manual, precise controls mean you get the same results, frame to frame, as opposed to rolling the dice with TTL. Durable. The better units are really well constructed and hold up over time.

Downside of big flash? Big. Heavy. No truly automated controls, along the lines of TTL small flash systems. Some need access to electrical power and, thus, at least occasionally, yards and yards of heavy extension cords. The battery units are also heavy, given the fact that the lights essentially run off of a power source that's akin to a motorcycle battery. If you have one big flash and it goes down in the field, you are lightless. With multiple small flashes, you have redundancy in case of a malfunction. (You can achieve redundancy with big flash too, for sure, but doubling up big flash packs and heads starts to get into the realm of hand trucks, assistants, larger rental vehicles, higher excess bag charges on airplanes, and the whole big-flash, travel-heavy routine.)

Decisions, decisions. Hey, here's a downside both share—whatever way you go, as I always caution, you're gonna spend some money.

STRIPPING THE LIGHT FANTASTIC!

Sorry, couldn't resist. Back to the remoteness of Iceland. Yet another field foray with just one light, this time back to that gray area between small and big flash, the Quadra. Here you can easily see one of the strengths of bigger flash systems I mention above. The tiny (half pound) flash head of the Quadra couples with the Rotalux 2x6' strip light quite easily. That's a big beautiful source for a really small, light flash head. (Truth be told, the Quadra flash head on its own is lighter than an SB-900.)

This strip source is an indirect softbox, which means the actual flash head is facing directly away from the subject, firing into a big strip of silvery material. The result is a very even, smooth line of light, which I find is often perfect for a dancer. Dancer's moves tend to be linear. They extend. This type of softbox extends with them. Ever been on stage and looked into the wings? There are often vertically arrayed banks of hot lights, baffled by curtains on either side of them. Wing lights, side lights—call them what you will—but the point is they are vertical and skinny. Perfect for rim lighting the shapes of performers. Think of this strip light as your own, portable set of wing lights, stage right or left, as you choose.

Take a look at the production picture, if you would. Couple of things to notice. The diffuser is off the front of the softbox. I wanted a lot of f-stop for this picture, so I was really asking a lot of this still relatively small flash system. Four hundred watt-seconds can get swallowed up pretty quickly inside these real big, voluminous light shapers. What you

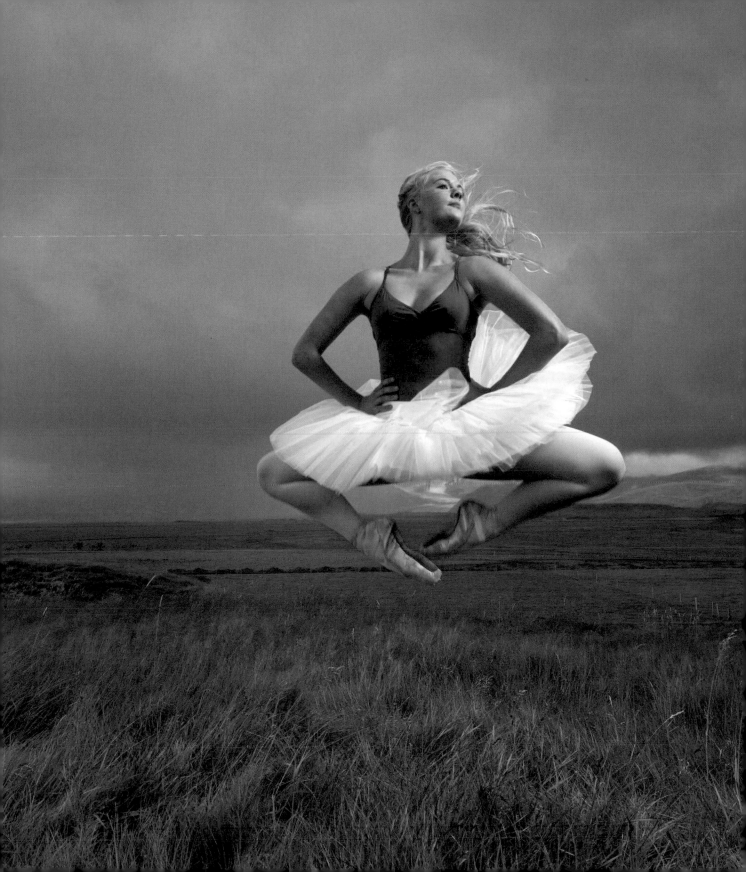

are seeing here is one strategy to cop back some power. When you remove the outer layer of diffusion, generally you'll pick back up at least one f-stop.

And, given the size of this strip, you'll still stay soft. It will be more directional, for sure, but the expanse of silver, and the indirect nature of the construction of this light shaper makes removing that outer baffle doable, without causing a disaster for the quality of your light. (Reason for big f-stop was DOF. I wanted the fields of grass and the sky to be pretty sharp and well defined.)

The finals on this spat out at $1/60^{th}$ at f/11, ISO 200, D3X, lens zoomed at 19mm. Auto white balance. I was not nervous about my subject being unsharp, even given her leap. When you are working with a dancer, and orchestrating his or her gesture, you get into a rhythm with them, and your timing follows along. For a jump such as she is executing, for a very split second, at the apex of that jump, she is essentially motionless, hanging in the air. That fact, coupled with the speed of the flash burst (known as flash duration) will nail the motion, even at a shutter speed such as $1/60^{th}$.

(This is not a universal! I am compelled to say that a $1/60^{th}$ flash mix will not always stop motion, depending on the nature and speed of the motion, the ambient conditions, how much available light is in the final equation, and how much flash. Whew! Would I get nailed to the wall for that one! Like all things photographic, it's a solution for this moment, at this time, in this field, in Iceland. Broad-stroke lessons and experience derive from every time you put your camera to your eye, and those strokes will inform your next shoot, but always, always understand this about shooting on location: What works today, will not tomorrow. You have to take everything you know, everything you've learned, and all information that the mistakes and bad frames have provided you with, and bring them to bear, every day, with every click. It's never the same. What a pain in the ass! At the same time, what bliss! Not everybody gets that wonderful, invigorating opportunity to figure it all out all over again, each and every day.)

Back to the production pic. Notice again, our buddy the C-stand. It is not that high, but it is seriously pitched at an angle towards my subject and her gesture. When she jumps, or even just looks up, she is looking into the light, and a section of the softbox that will be closer to her. This does two things: Makes that area of exposure around her head and shoulders incrementally brighter than the rest of the photo, which is a good thing; and it makes sure that the light that hits her face will be nice light. Remember, the closer the light source, the softer the feel of the light. A she jumps, up and in toward the light source, she is jumping into an area of really pretty photons.

By making sure her upper torso gets the best light, and ever-so-slightly more of it than her legs and the grass, there is a natural gradation—a fall-off—that occurs right at the moment of exposure. By pitching the flash this way, you gather the nicest and strongest piece of it right where you want and need it. The rest of the flash effect just fades away. Which is good. You don't want to over-light the ground and draw attention down there.

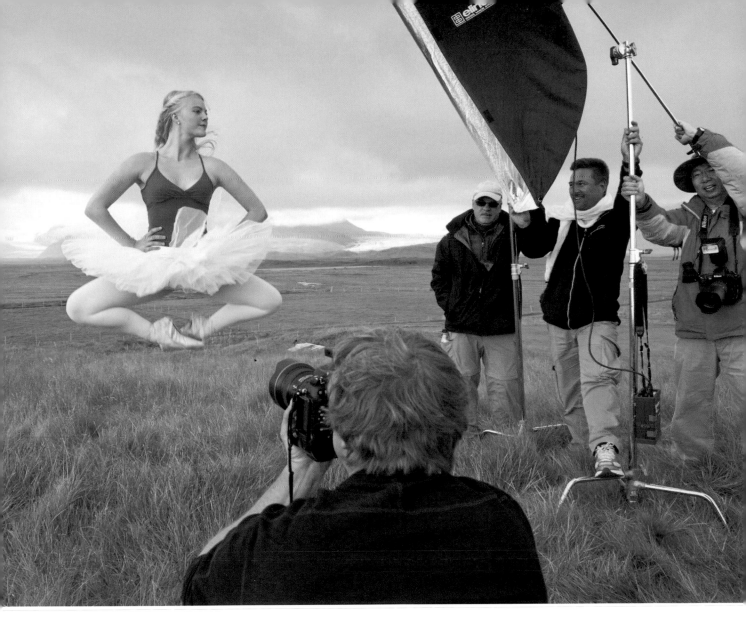

Good thing I had a whole class with me, by the way. Will I never learn? Here I've been saying all along that I respected the power of the wind, and I've offered cautionary notes about using light sources that are just dumb to put up in even the slightest of breezes. And there I am, out on the plains of Iceland, without a shred of cover, and a 6' softbox up on a stand. I've got another stand up to stop the box from spinning in the wind, and I've got half the class holding onto the stand supporting the light.

Oh, well. Photographers. If we were smart, or trainable, or logical, or reasonable, we would have probably stopped doing all this long ago. I guess we just keep hearing the call of a light in the wind. □

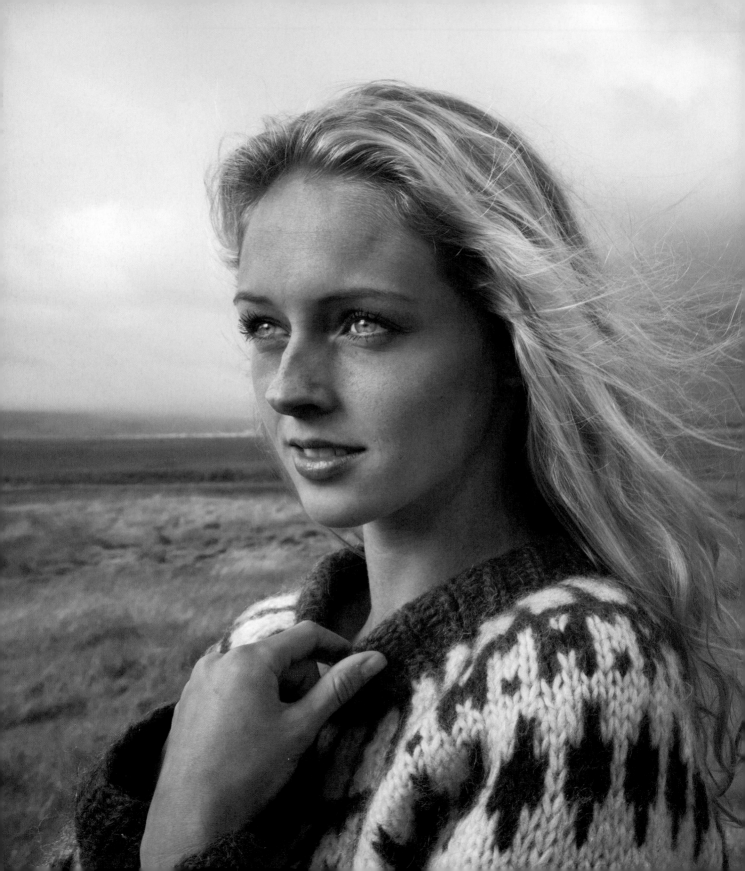

But Then,
I Just Couldn't
Take It
Anymore...

A WHOLE WEEK WITH ONE LIGHT. I was proud of myself. But then, I backslid. I approached Drew, keeper of the keys to the flash chest. I was twitching, looking away, kind of rambling, beating around the bush, saying stuff like, "You know...I been really good, man...I was just wondering, you know...you got some more flashes in that bag, yeah, man...so...you know...I could really use another flash, man...."

I was a feverish case of strobe-seeking behavior, but not without reason. And, in fact, the multiple flash solutions I had in mind were destined to have the feel, effect, and direction of just one light. But if you need power and you are a resolute small flash user, or you are out there with small flash and encounter a mountain of an exposure to climb, multiple lights can be a way to go. And, the good news is, there are a variety of devices out there now that can handle a gaggle of Speedlights, all mounted coherently and firing in the same direction. No more "flash tree of woe," as I've described in the past.

I helped Lastolite design a current version of their TriFlash, which is basically a three-cold-shoe rig with an umbrella sleeve in the middle. I had the suggestion of making those cold shoes ratchet 360 degrees, thus enabling the light sensor panels of a gaggle of SB-900s point in a coherent direction. It's a useful adaptation of the older style, in which the cold shoes were fixed and the sensors were then locked into being at right angles to each other. Firing a commander pulse at this older-style arrangement would often not trigger all of them.

With the picture of the ballerina in the field (in the previous chapter), as you recall I had to take the diffuser off the strip light to gain some flash punch. Logically, then, trying to achieve a similar feel with similar depth for Sara, our wonderful Nordic goddess, out there on that same field, in the same light conditions, would be rough with just one small flash. Time for the TriFlash, albeit a pre-production model.

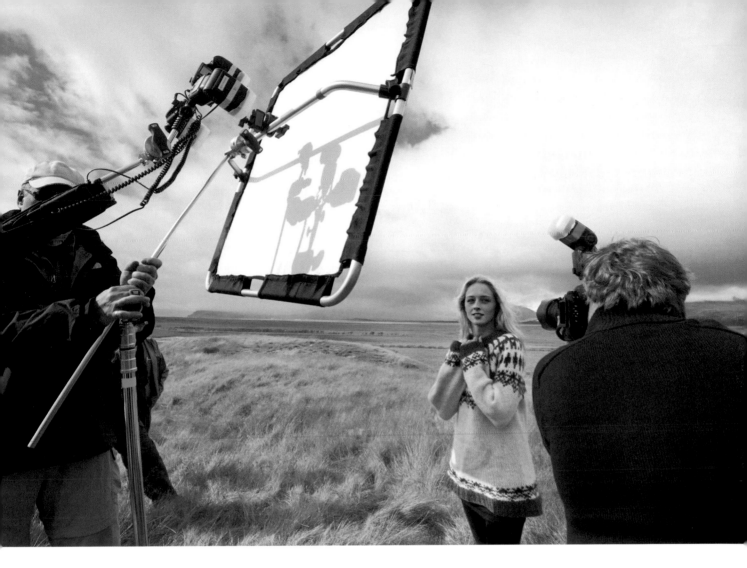

Tripling up the light gave me f/13, at 1/200th, at ISO 200. The lens was set to 32mm. The camera was set to auto white balance, in manual mode. With the firepower of the threesome, I was able to keep their dome diffusers on, and then re-diffuse them with a 3x3' panel. The result is a really pretty light, for a really pretty face. It was a simple, beautiful combination of light, subject, and setting, done TTL. As you can see, my commander flash is tipped towards the lighting rig, and the flashes up there are swiveled to maximize the reception of the signal. The result was very solid—all three fired, all the time. By the way, the TTL signal I'm sending them was, in fact, a directive for manual. No sense in even playing the plus one, plus two, plus three TTL game here. I needed the pedal to the metal out of all three units to get my f-stop up where I wanted. Full blast, into domes, into diffusion, and then softly, gracefully, to Sara.

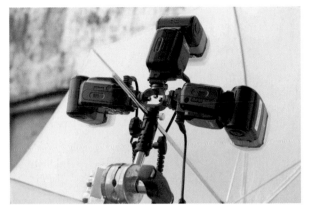

And then there was the farmer and his daughter. One of my favorite pictures of the last couple of years. It shows affection and devotion, in the simplest of settings—an old, battered barn that, predictably, smelled of manure. My light had to look like it had been there all along, just like the barn.

First thing I did was cover the smallish window near the camera with a 3x3', one-stop diffuser panel. That did two things: it gave me a layer of diffusion, and it sealed the window off from any errant sunlight that might bounce toward it. The only light coming through there now was going to be created and directed by me. Outside, I put up a TriFlash, cranked all the sensors so that they faced the window, and put on a simple 34" one-stop diffuser umbrella, which I used in shoot-through mode. I kept the dome diffusers on the lights.

The three layers of diffusion speak to the need for three SB units, which I can command, believe it or not, from my commander flash, inside the building. I've found that, within reasonable distances, the commander pulse travels easily through diffusers.

But hey, wait a minute. Three flashes, all at $500 a pop! Surely there's a better way! Well, there are different ways, to be sure. Who's to tell a photographer which is the best way to light? Or to shoot? Let's tick some other approaches off, as I did last chapter when discussing high-speed sync.

Big flash. Of course. Anything from a Quadra, to a Ranger, to a Pro-foto 7B works. There was electrical supply out there in the barnyard, so if you had a long extension cord, you could rock along with a studio pack and head. It would be one light with a big pop. The most elegant trigger for this setup would be a radio. But, honestly, the window is close to camera, and out of frame, so you could easily take a trek back in time and run a hard wire out there, right from the PC port on the camera. Quaint but highly effective, not to mention dependable.

You could then drive the small flash fill, inside, next to camera, off that big pop of the main light. An SB unit has a built-in slave eye, but just about any small flash will liaise with a cheap, simple slave eye, such as ones made by Wein, for instance. This style of building an exposure is, of course, done manually. Test a bit. Get the value of the main light, and then—and only then—dial in increments of fill, just a little at a time.

Don't try to measure or meter multiple lights from multiple directions all at once. It will get confusing. Get the main light nicely done. Then, just like turning a faucet, slowly let in some fill. Doing this with a big flash approach might indeed call for the application of a piece of standard equipment that, for me—and for many shooters—has fallen into disuse: a handheld light meter would be handy here. Meter the strong side of the light, facing the window, and then click your way around your subject's face. I used to call this a wraparound. Imagine a face looking at the camera as a 180-degree half circle. When you take exposure readings at various degree points around that half circle, you establish a good sense of where the light starts to fall into shadow, and how abruptly.

Then, I would shut off the main and just meter the fill. If my main gave me, say, f/8, my fill for something like this should pull in about f/4,

"I don't use a handheld light meter. I just gut it out with the LCD and the blinkies, and even, occasionally, with the dreaded histogram. I feel so dirty."

or even f/2.8 and a half or so. Fill needs to be just...there. If the fill gets too close to the value of the main, it draws attention, and that runs counter to the mission here. The light and the scene all have to be of a piece, presented in seamless fashion.

(Now, I don't use a handheld light meter. I just gut it out with the LCD and the blinkies, and even, occasionally, with the dreaded histogram. I feel so dirty.)

In the Speedlight realm, could you use just one out there instead of three? My answer would be a qualified yes. You would have to make adjustments, most likely in ISO, and perhaps peel back at least one of the diffuser barriers, which would then sharpen the feel of the light just a touch. One flash out there would most likely work, but would give you fewer options and leeway. Also, even if you could leave the dome, the umbrella, and the diffuser panel right where they are and squeak out an exposure, the light would not be quite as rich and soft. One of the beauties of the TriFlash is that the three heads, acting in concert with and close proximity to each other, give the source a good-sized volume, just the way a bigger light would. Small on their own, the three heads combine effectively into one bigger source that sort of smushes the light all over the umbrella before translating through it. ("Smushes" is a technical term.)

Via the three-Speedlight approach, you are dividing the workload— not driving one lone flash to the brink of self-immolation, but using three to create efficiency, recycle speed, additional power, and, very importantly, a big-flash-sized volume. And, via the commander, you control the output of the lights without having to walk outside. Presto! Flash that looks like window light, and it's controllable right from the camera. The thing about creating window light like this, however, is that while it is beautiful and soft, it is also very directional. Given my choice of frame and direction of the action, my subjects are very, very side-lit.

"Not a good idea. Not only would the calf not take direction well, its presence forced me to start filling the scene to the point of it getting flat and character-less."

For the farmer, all on his own as a single subject, that light can almost work all by itself. If you maneuver him and the camera angle carefully, and keep him essentially turned into that main window light, you are good to go. A bit of drama, to be sure, but you can skate around having to fill from inside the barn when you have just one face to deal with. Plus, as you can see, if you are just going for a hint of character, and he is just part of the scene, then the side-lit view—where the shadow essentially splits his face—as I say, comes close to working.

But put two faces together out there? Forget it. You *have* to fill it in, just a touch. With just the one directional main light, his daughter will get swallowed up in his shadow. And, with their body language being so effortless and wonderful, I was loathe to corkscrew them around physically, just to fit my one-window-light approach. Plus, their body language made the photo quintessentially about them. It gave me an obvious path. When I first started to set this picture up, a calf wandered in, and it got me to thinking (wrongly) that maybe I should try to incorporate the actual denizens of the barn into the shot.

Not a good idea. Not only would the calf not take direction well, its presence forced me to start filling the scene to the point of it getting flat and character-less. As you can see from one misguided frame (page 82), the whole darn place is looking way bright, and the emphasis and direction of the light is gone. This self-inflicted wound is done with shutter speed. The specs on this shot are 1/30th at f/5.6. The final select, with the framer and his daughter, is 1/200th at f/5. Big difference, right? As I often describe, shutter speed is like a curtain you pull back. The more open (slow) the shutter, the more light pours in. That can

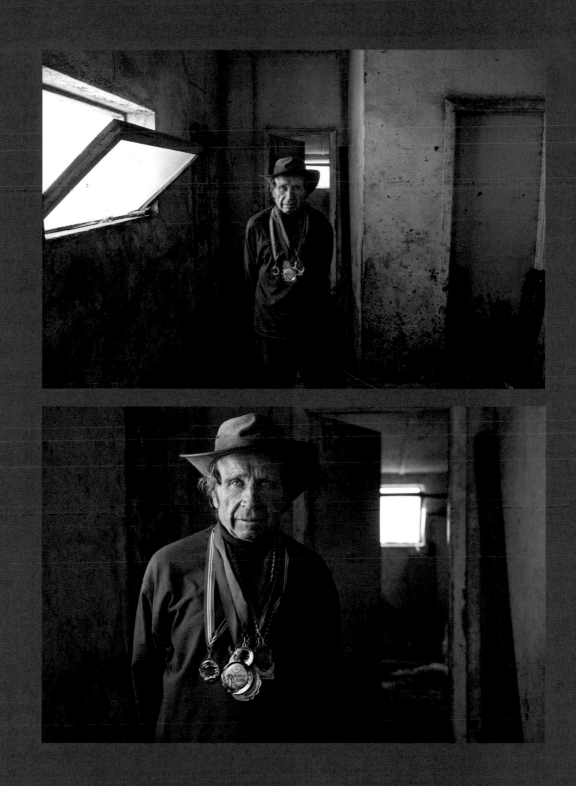

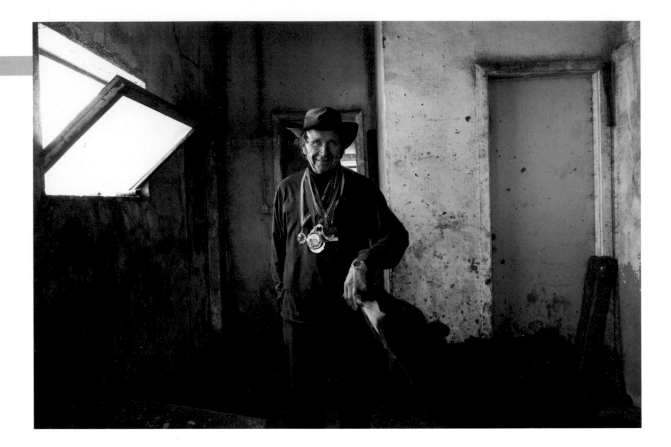

be a good thing, but not here, where I wanted to retain control and essentially recreate "natural" light via controllable flash that was going to light just the areas I wanted lit. The slow shutter approach globally lights the room. Keeping the shutter faster dims the room, and the areas lit by flash take center stage.

Also, at 1/30th, the farmer gets way hot, standing near the window. The ambient pouring through there now overtakes my flash input and swallows it. Now I got a big, hot light source on my farmer. That's the price for universally adjusting the feel of the light via the shutter.

At 1/200th I am controlling the room and keeping the whole place muted. But, then, the price I pay for that control is introducing another light for fill. To do

this, I simply turned my on-camera commander into an exposure-making flash. Now it's doing double duty. It's the mechanism I used to adjust that directional light outside, and now it's also a light to fill the scene. Having turned it into a light, though, I decided to pull it off the hot shoe, and connect it to the camera via an SC-29 cord. That does several small, but beneficial things.

It gives me the leeway to move the light around. If it's locked onto the hot shoe, it will almost certainly splash a little hard light on them—given they are quite close to camera—and lessen the natural feel of the light. The camera is slightly below their eye line, and that could make that little splash look truly unnatural and quite perceptible, not to mention introduce a bull's-eye catchlight in their eyes.

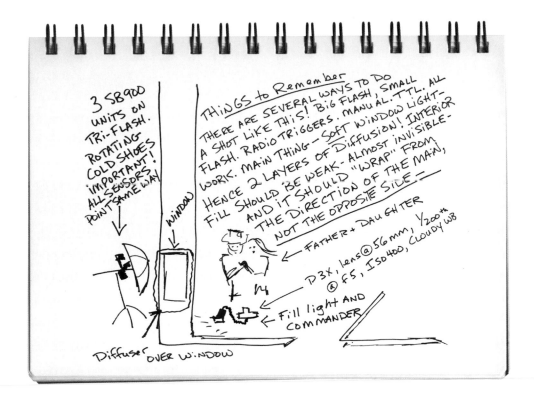

3 SB900 UNITS ON TRI-FLASH. ROTATING COLD SHOES IMPORTANT! ALL SENSORS POINT SAME WAY

WINDOW

THINGS to Remember
THERE ARE SEVERAL WAYS TO DO A SHOT LIKE THIS! BIG FLASH, SMALL FLASH. RADIO TRIGGERS. MANUAL. TTL. ALL WORK. MAIN THING — SOFT WINDOW LIGHT — HENCE 2 LAYERS OF DIFFUSION! INTERIOR FILL SHOULD BE WEAK — ALMOST INVISIBLE — AND iT SHOULD "WRAP" FROM THE DIRECTION OF THE MAIN, NOT THE OPPOSITE SIDE —

← FATHER + DAUGHTER

D3X, LENS @ 56mm, 1/200th @ f5, ISO400, CLOUDY WB

← Fill light AND COMMANDER

Diffuser OVER WINDOW

(Remember, the mission here is to make the photo look like I said, "Hey, just stand by the window," and went click. The flash is invisible. Wave your hand. Hit the shutter. A Speedlight Jedi mind trick.)

So, I set the flash free from the hot shoe. Moved it up and directed it into the filthy, disheveled corner of the barn's ceiling, just over my left shoulder at camera. Given the minimum pop I needed out of that light, it doesn't need an 8' tall, antiseptic, super-white ceiling to bounce into. Just a surface, plain and simple. If that surface has a color, it will most likely be the color of the barn, and the light will look, again, like it belongs. Popping it up in there has the advantage of continuing, or wrapping, the fill around from the main. In other words, I'm not trying to open up the shadows by bringing the fill light from the shadow side. That, again, will become a red flag, and even, if egregiously

mishandled, create crossing shadows. This fill is almost invisible because it comes from the same side as the big window light. It just tweaks, and almost imperceptibly opens up the feel of that wonderful main source. Most of the time, that's where you want your fill to be. You only notice it if you turn it off.

I almost made it through a whole week using just one light! But here's something to perhaps notice, or ponder. The couple of shots discussed here, which used multiple lights, actually look just as simple as the ones done with just one light. It's not about how many you use, just how you use them.

I like this set of pictures. Almost makes me want to go back to Iceland. Almost. □

One Light, One Window, One Room

SEE THAT LONELY FLASH out there on the stick on the sidewalk (following page)? That's the setup. The whole deal. End of story.

I love frosted glass. Love it. I see a window made of frosted glass in a room like this locker room, and my job is done. It's so helpful, and I'm so grateful, I actually tremble sometimes. I love it so much that occasionally, I just walk over and, you know, touch it.

That little lonely light on a stick was the source for this whole series of pictures. All I did was move the angle of approach, here and there. And change out a gel once in a while. The window of the locker room is my light shaper. It's a softbox built into the building. I'm sure the architects didn't design the thing with photogs in mind, but they were unknowingly helpful.

The light is about 10 to 15 feet from the window, which gives it room to disperse like daylight would. Generally, the farther away you can move the light in

situations like this, the better off you are. But with small, battery-operated flash, this was about the furthest I could place the light and still have a workable amount of f-stop inside the room.

The triggering mechanism was line-of-sight TTL. You can see in the production picture how it was done. By linking three SC-29 cords together, you can still achieve TTL messaging while also giving yourself a long leash to move around the room. I positioned the commander flash on a Justin clamp on the bench and zoomed the signal to 200mm (to achieve good power and punch for the TTL pre-flash signal to get through the window), and I had touch-tone control of the light on the sidewalk, via the flash in the room with me.

When you light like this, what you're doing, really, is illuminating the room with different qualities and quantities of light. Some areas will be lit harder than others. Some of the lockers will take on a sheen, other parts will fall naturally into shadow. My advice is, once you set up a light like this, shoot around without any subjects. Just pop a few frames here and there. That will give you the weather report for the exposure zones of the room. It also may contain a few surprises that will lead you to try pictures you might not have thought of right away. Lighting like this is like setting up a buffet. You can wander, browse, pick and choose.

You should also try a frame or two without flash, to find out what the ambient level of the room actually is, and thus have an idea of how much flash it's going to take to overpower the light that's already there. My first snap (page 88), on Aperture Priority, pulled in a "normal" room exposure of 1/100th at f/4, ISO 200. Wide lens view, at 14mm. Given this info, I did two things right away: I shut down the fluorescence, and I went off Aperture Priority to manual. I'm seeking control here, so instead of playing the game of exposure compensation at the camera versus exposure compensation at the flash, I just eliminated a variable and took the camera into manual exposure mode. The room needs to be darker than this to feel the drama and effect of the flash. (As soon as I shut down the overhead lights, the room got quite a bit darker, right away. With no fluorescent blazing away in there, I immediately had much more control of the look and feel of the place.)

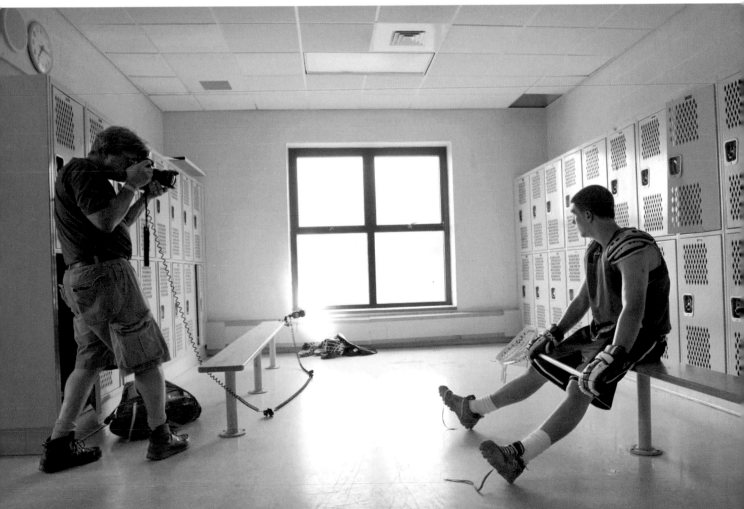

> "Don't get satisfied with one view, and one good-looking frame! Shoot and move, shoot and move."

Time for subjects. I placed Andrew, an appropriately sweaty lacrosse player, in the path of the flashed window light, being careful to stay out of the way and not cast my own shadow somewhere. Sure enough, the frosted window gives out a quality of light that has character and edge. The shape of the window defines the background, and his shadow is thrown backwards toward the lockers. Good frame, easily done. Finals on this are 1/250th at f/3.5, ISO 200, D3S. 24mm lens. There is a half cut of CTO gel on the light, providing warmth. White balance is auto. Because I am trying to define edge and shadows, I am sending the remote light a signal to go manual, 1/1—max power. Off to a good start.

Don't get satisfied with one view, and one good-looking frame! Shoot and move, shoot and move.

The lockers are metallic, so I moved the light to come straight through the window, beam on to the back of the room. No angles or shadows here. I was really blessed with having an array of wonderful student athletes to pose for me that day, so I asked Courtney to just go stand in the highlight caused by the newly frontal angle of the flash. I got low (in order to get out of the light path), and shot this at 1/250th at f/2.8, ISO 400, D3S, with a 70–200mm lens zoomed at 70mm. I had to open up and jack up my ISO in response to this scene being really deep in the locker room. That little light is cranking! It's traveling a long ways, but doing so effectively.

Having looked straight away from the light source, I then tried looking right into it. I moved the light stand, just slightly, into the camera left quadrant of the glass. For this frame (page 90), which speaks to late, late light, I put a full cut, or full conversion, to tungsten gel on the Speedlight. Shot the scene with a 24–70mm lens zoomed to 29mm, at 1/250th at f/4. I dimmed the power of the flash by half, going to ½ on the manual setting—again, sending it a TTL signal to adjust its power.

But, if you notice, there's no commander clamped to the bench this time. In this frame, you see the whole room and the whole window. No hiding the gear! But, again, the flexibility of the multiple–SC-29-cord approach saved the day. Just to camera left, there is a door to another room with a window out to the sidewalk light. I just snaked the cords in there, and fired my commander from the other room.

Onward! There are still more possibilities I can wring out of this tired little Speedlight.

I moved Courtney close to the windows. She has such a wonderful, youthful face, I decided to ease up on the drama and shadows. The frosted glass is to her immediate right, about three feet away. If I shot with just the diffusion of the window, she would have been split lit—one half of her face in shadow, one in the light. Not the appropriate approach, I thought, for a beautiful high school female. So, I introduced the only other light shaper (besides the window) that I used during my whole locker room stint—a large Lastolite one-stop diffuser TriGrip. That is very, very close to her face, hence my framing is to put her camera right and let the rest of the locker just play out in the background to the left. The result of this tactic is double

diffusion, which produces some of the softest, most easygoing light you can imagine. The light is coming entirely from the side, but it is so soft at this point that it simply wraps around her whole face, fills her eyes, and then fades off. Because of the extra diffuser, I went back up to full power here, and shot it at 1/250th at f/2.8, with my 70–200mm zoomed to 110mm. I also took all the gels off the light. I felt that her blonde features spoke to keeping the light clean and neutral, not sunset warm.

There's more! That Speedlight is out there screaming, "Leave me alone!" (And in fact, if you work an SB-900 this hard, it is best to either give it a break here and there, or switch it out for a spare if you have one. Drive 'em too hard, and they will melt on you. At the very least, have another set of batteries at the ready.)

Back to the profile view of the lockers, with Dan, another lacrosse player, seated on the bench. For this, again I adjusted the position of the light, moving it slightly toward the right side of the window. That way, the light sweeps the whole set of lockers and creates some shadowing, but nothing fades to black as it did with the first lacrosse portrait. The moves I'm making with the light on the sidewalk are crude guesses, by the way. I just look at the light and how it will travel, and guess at the shadow play. There's no science to it. Just move it a couple feet, and test.

"The beauty of this approach is that the result doesn't look lit. There's nuance, soft shading, and a couple of harder slashes of shadow, the likes of which would never have been created by an umbrella in the room with you."

Here, because the light is covering the whole side of the room, I can work tight or wide as I see fit. The thing to be cautious about is to make sure your subject stays in the brighter, sweeter part of the light splash. Remember the window has framework running through it, and that will cast a shadow, dimming that sliver of the picture. Make sure your subject's face doesn't end up in that sliver.

Then, just work. These two views are both shot at 1/250th at f/2.8, but with different lenses, which see different areas and tonalities of the light. The beauty of this approach is that the result doesn't look lit. There's nuance, soft shading, and a couple of harder slashes of shadow, the likes of which would never have been created by an umbrella in the room with you. In fact, from this angle, lighting him with an in-room source would have been a nightmare, as the lockers would have reflected back just about anything you might have put up. The wide view is 17mm, and the tighter view is 28mm, and I'm playing with the density of the warm gel to vary the warmth of the scene.

Okay, I see that the light playing along the lockers is nice, so it's time to take advantage of that and do a quick portrait that has an edge. Here, I go back to a minimum-depth-of-field approach, using a 50mm f/1.4 for the portrait of Jabrill (following page). (I also pumped the ISO to 500.) With a camera like the D3S, the fear of a higher ISO is gone. This shot was done at 1/250th at f/2. The quality of light has serious drama and punch. It's there, lurking along that locker room wall. You don't have to do anything except find it, then put your subject there.

That wall of repetitive shapes lends itself to graphics, of course, so I tried a shot of Courtney with the same minimum-DOF approach, except I went back to my 200mm f/2, at f/2, and jammed myself up against the lockers. Man, will an art director love you for a shot like this (page 95). Yards and yards of simple, one-toned, out-of-focus texture to drop tons of type all over. They'll be ecstatic. (And, an art director who's excited about you is a good thing. The phone may ring again.)

At the end of the day, could this series have been done another way? Of course. A big, raw flash from an even greater distance might work, but it also might flood the room with light, making it very even-toned. Here, the smallness of the source—the Speedlight—which is something I generally try to enlarge and improve, actually works for me in terms of creating falloff and shadowing. Could I have used a radio trigger? Absolutely. You can trigger just about any light source with the radio technology we have now, so that approach is viable. But with either big flash or an SB-900 on a radio, you lock yourself into manually adjusting that light out

there. That means walking through the locker room and outside to initiate every increment of change in power. Not a big deal, but the beauty of the TTL signaling system is that I can stick with the camera, make on-the-fly adjustments, and stay in the room.

What about PocketWizard Flex/Minis, you ask? Yeah, definitely possible. There are still a lot of both possibilities and problems with that technology, though. I talk about it much more thoroughly in another section of this book (see page 232).

One room. One window. One light. Lots of pictures. First frame to last? One hour, twenty-one minutes. ☐

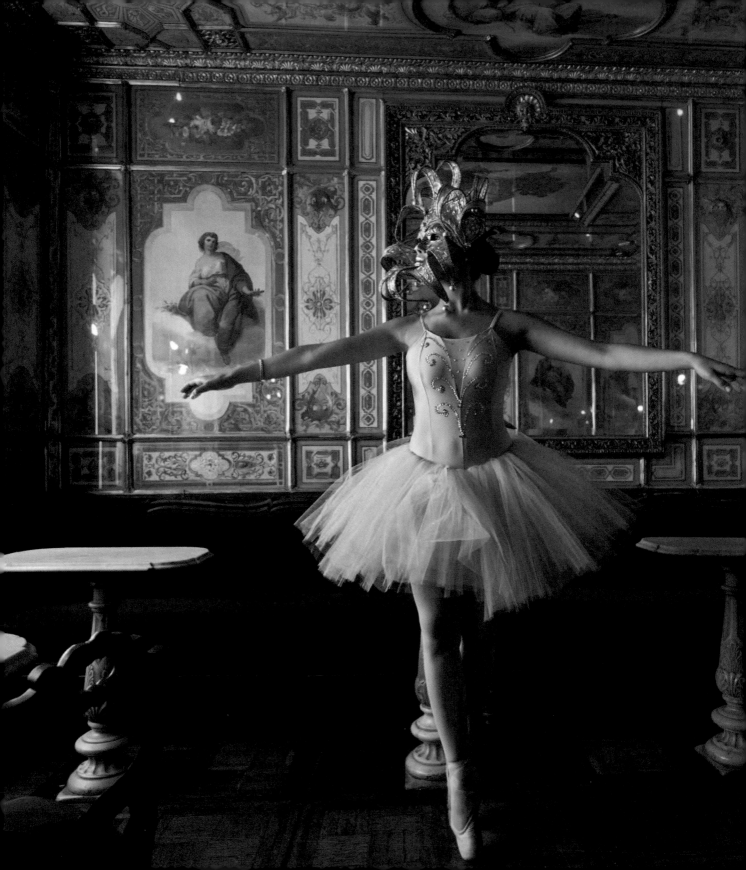

Of Frosted Glass and Dirty Windows

I JUST SHOWED A ROOM I worked via a really nice, frosted glass window. But, you know, it doesn't have to be frosted, or nice.

A bed sheet will do. That generally produces a beautiful, softly directional light that will often just fill a room. Move your subject close to the sheet, and the light gets soft. Put them further away, it develops a bit more of an edge. If it's a big window, or a set of windows, use more bed sheets. They don't have to be 800-thread-count Egyptian cotton from the tombs of the Pharaohs. Sheets from Walmart do fine.

In Venice, I was able to light the entire Café Florian with a couple of bed sheets and three small flashes. And while throwing a bed sheet into a window with A clamps (or tape) and putting flashes outside on the walkway might sound a touch complicated and over the top, it's actually easier than working one umbrella on a stick. In this environment, if my light were inside with the ballerina, I'd have all sorts of potential umbrella reflections and hits in the mirrored surfaces of the room. As my subject moved, I'd have to get up from the camera and move the light with her. Frankly, it'd be a pain in the ass. Here, with the windows covered and control of those lights outside, I'm done. She can move anywhere in the room, and she's lit. I can just stay at camera and concentrate on gesture. The finals on this pic were D3, manual exposure of 1/20th at f/4 on a 14–24mm lens, zoomed to 18mm, ISO 200. The flashes were manual, 1/2 power, and triggered via an SU-800 commander off camera and directed out the doorway via SC-29 cords.

Another thing to look for is old factory wire glass. It's almost always pebbly and has some degree of frosting on it. And, given the industrial nature of settings with this kind of glass, it's probably filthy. Put one light outside, and fire it through one of these grimy light shapers. Shoot some frames all over the room, just to scout and see what this light does. If you find an area of the interior where you like the light this produces, put your subject there. The picture of the lovely Brittanie (opposite page) was done with one Ranger on a radio control, with a bit of warming gel on it. It's on a light stand about 20' away from the window,

Frank Keller

at a steep angle to it. I liked the hard light pattern it created in the corner of this decrepit room, so I put her on a table over there, and she collected herself into a pose.

The shadows are created by the fact that the light has no modifier on it. It's blasting, just like the late afternoon sun, through the glass. If you want to soften the effect, just put a shoot-through umbrella on the light. Or tape a piece of diffusion right on the reflector pan, close to the flash tube

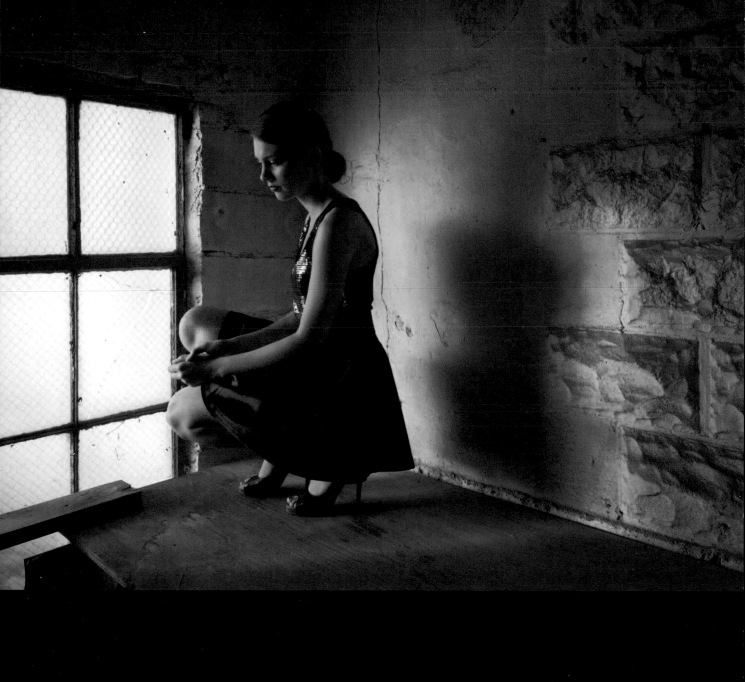

> "No need for warming gels. This window
> was an 81A filter all on its own."

itself. Or do both. Take a knife and punch a small hole in that diffuser, and then slide the umbrella sleeve through it. Double diffusion! That's the beauty of working a bigger light and power pack. You've got watt-seconds to burn, so slapping on some diffusion doesn't squash the light.

Failing frosting, find a really dirty window. Those aren't in short supply at Eaves Ranch, the old movie lot in Santa Fe. I put one Ranger flash outside on the walkway, and just popped it on very low power through about 30 years of dirt and yellowed curtains. No need for warming gels. This window was an 81A filter all on its own.

1/250th gave me control of the room, i.e., it gave me darkness. The small splash of strobe from the street gave me f/2. With a 200mm lens, I am living dangerously in terms of DOF. I turned the lovely Madeleine—transformed via wardrobe into a young lady from the 1800s—into the camera, nearly frontal. There's just the tiniest angle to her face as she regards the camera. With this very slight turn, she picks up light from the window well, across her face, and I'm able, just barely, to keep both her eyes sharp at f/2.

Three quick one-light solutions. (The café shot is three flashes, but they collect into one source.) Nothing fancy—just flash heads on sticks, and some funky windows as light mods. Why not? That's where light comes from anyway. And the dirtier the window, the more interesting the light. □

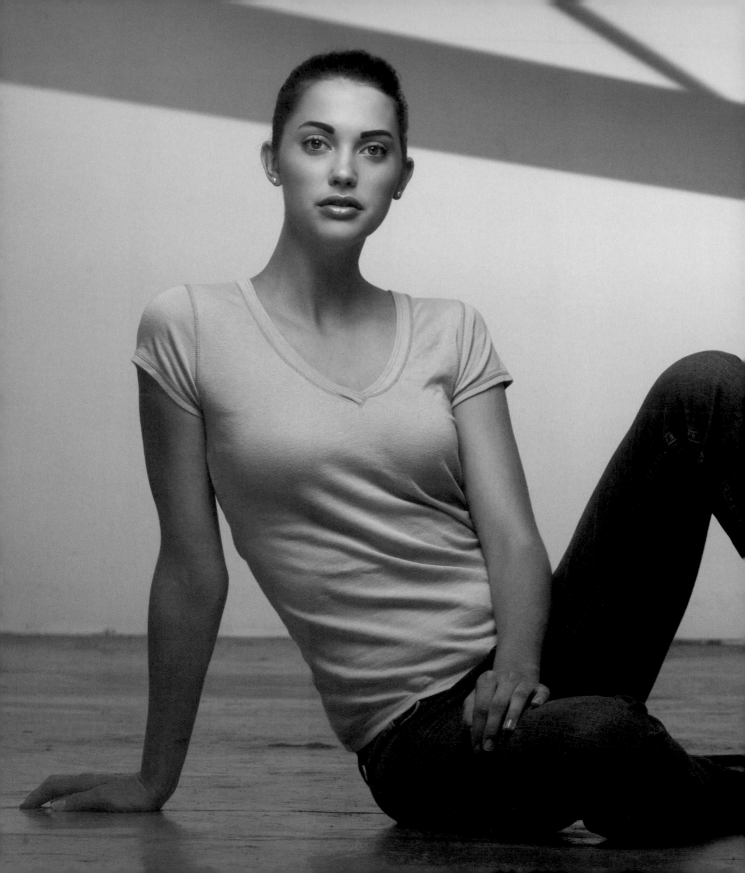

The ABCs

IN THIS SET OF PICTURES,
I practice what I preach, almost
to the letter. These frames came
together calmly and in orderly
fashion, which is a rarity, of
course. It was like a school lesson,
and I followed the syllabus to the
letter. I'll keep it quick and simple,
like the pictures.

I got my angle. In this instance, it was a 200mm point of view (POV) into a blank wall in a warehouse. In a situation like this, with a great deal of control and a static subject, once your POV is established, it can be advisable to lock the camera down on a tripod. Then, there's a continuously definitive point of reference that you go back to in between frames. In doing this, you eliminate a very big variable—you. I firmly believe one of the frustrations people feel about TTL inconsistency is that they get unraveled at the camera. They're uncertain of the frame from the get-go, so they try a snap, and it's bad, so they try going wide, and of course that's bad too—and even more frustrating, the flash result is different than their original starting point. Now they've got two problems: a framing they're unhappy with, and a poor flash exposure. They're trying to do too many things at once. Photographically, it's like chewing gum, reading the newspaper, making a cell phone call, and drinking coffee, all while you're driving. Something's gonna suffer, sometimes disastrously.

Remember this about TTL: The flash and the camera work in concert to determine exposure, depending on what the camera sees through the lens. At 200mm, you will most likely have a very different flash result than you will at 14mm. The camera gets different information from different framing, and relays that to the flash. Keeping to the classroom analogy we've got going here, the camera/flash tandem, both being machines, are book smart. They crunch hard, fast numbers and zones of exposure pretty well. But they're not interpretive. They don't know you're in trouble at the controls and offer you helpful opinions on how to solve it. They just stoically report back on what they see. Camera info is a clinically worded book report, not a stirring, inspirational novel.

So just walk and chew gum. Keep it simple. Get the angle. Breathe. Make an available light exposure. Breathe. When I "scout" like this, I use Aperture Priority mode on the camera with matrix metering. I want the camera's brain, which is pretty darn smart, to assess the situation and tell me what it thinks. In this case, with 0.0 exposure value compensation, I got an overall scene reading of 1/100th at f/5.6 at ISO 200. The camera's brain is almost certainly reacting to that swatch of white wall and underexposing the whole megillah just a tad, and that actually works out quite well for my purposes. (If that were a black wall, the camera would have gone the other way, right? Reacting to the black value, it would have overexposed the whole scene.) But, the white backdrop is influencing the meter to make the frame a touch darker than a truly "normal" reading would have it look. I have detail front to back in the pic, but it's muted. It won't compete with what I'm about to do.

Which is, locate the model in the frame. There's a bank of windows to camera left, and those portals are providing a good deal of available light for the room. I don't want to take the chance on putting her in the path of those windows. The clouds could lift, and hard sunlight could pose a control problem for me. So I locate her in a wide swatch of shadow created by a large section of windowless support wall. So, the scene is in the light, and she's in the shadow. That's a good strategy, because I'm about to provide my own light for her.

I do this with one light, in Group A. For the sake of order and organization, I try to match up my groups of flashes with their respective responsibilities in the photo. There are three zones in every picture—foreground, middle ground, and background. My lights go into three groups—A, B, C. Logically, then, my main light is always Group A. My Group B is the fill, kickers, hair lights—the middle ground lights, if you will. And my background lights are always in Group C.

I put that Group A light into a 24" Ezybox Hotshoe softbox, off to camera left and slightly higher than her eye line. Reason to place it on the left? That's where the soft daylight is already coming from. Go with the flow. At camera, where I have no EV

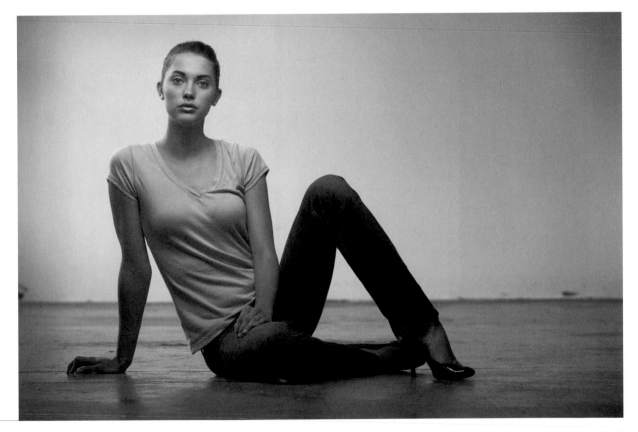

"Drama, low glow, beauty light, footlights: All are variations on the same theme of filling the face from below the eye line to create a spark—a theatrical, fashion-like type of look."

compensation dialed in, I start with the flash, also at 0.0 compensation. I'm talking to that remote light with an SB-900 hot shoed on the camera, in commander mode. My first exposure was bang on. The camera's doing its job. Actually, it's doing my job, as well. When TTL is on the case like this, and it's working, it does a lot of heavy lifting for you. It allows you to stay at the camera, and move fast through a set of photos.

And the results are nice. She's lit well, and her face is quite naturally the brightest thing in the photo, which is good. There's a soft, simple gradation from highlight to slight shadow across the frame from left to right—again, a good thing. The camera and flash are blending exposure so seamlessly that there's even a small, pleasing highlight on her right temple that's coming from the soft window light. That's the key word, by the way—"blend." The flash here looks like it belongs. It's not garish, or out of character with the rest of the frame.

Never one to leave well enough alone, I added a Group B fill light, just under the main light. It's skipping off a silver reflector and up into her face. The first one-light treatment had simplicity, shadow, and character. This approach has a bit of glam to it, as a low light often has the tendency to create. Drama, low glow, beauty light, footlights: All are variations on the same theme of filling the face from below the eye line to create a spark—a theatrical, fashion-like type of look.

Now I'm managing three lights—two flashes and the ambient level. Still in Aperture Priority, I went to −1 at the camera EV control. My f-stop stayed at f/5.6, so that programmed underexposure automatically slid my shutter speed a full stop faster, to 1/200th of a second. The flashes listen to that command, so to keep my Group A softbox light

influencing the scene with the same relative power, I direct it, via the commander, to go +1 EV. I want the fill skip to be subtle, so I sent that a message to go −1. Coupled with the underexposure message at the camera, that low light is now effectively running at two stops under, thus ensuring it remains in the category of "fill." Play with this light! Dial it up and down. You may like the serious pop of glamour that a more powerful under light gives out. Or underexpose it even further so it's barely discernible in the overall feel of the scene. The choice is yours, and yours alone.

Okay. Enough listening to the camera! Real men shoot manual! I killed the fill light, dialed out all the plus and minus EV nonsense I had previously dialed into the camera, and did this the old-fashioned way! Almost.

In Aperture Priority, to get rid of all the ambient light in the room, I would have had to dial in serious underexposure at the camera. Like, −3 or even −4. Once the numbers get big like that, I tend to shuttle over into manual control and take over both the f-stops and the shutter speeds myself. Remember, the flash EV compensation in TTL mode is only three stops up and down. I was afraid I would get beyond this range, so I just zeroed everything and pushed the camera to 1/250th at f/11, which gave me what I wanted—a dark background. Essentially, I started all over again in manual mode, both with the camera and the flashes at a 0.0 starting point.

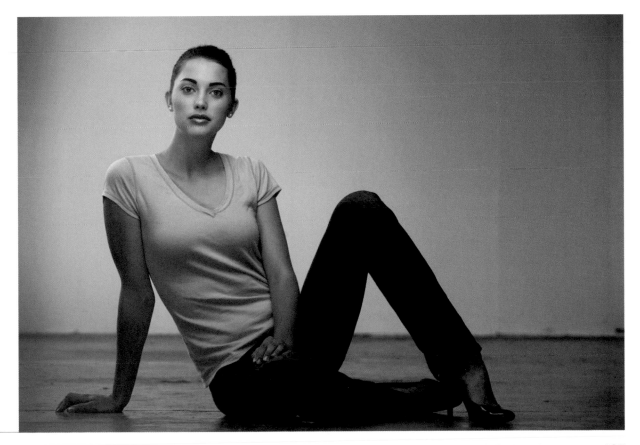

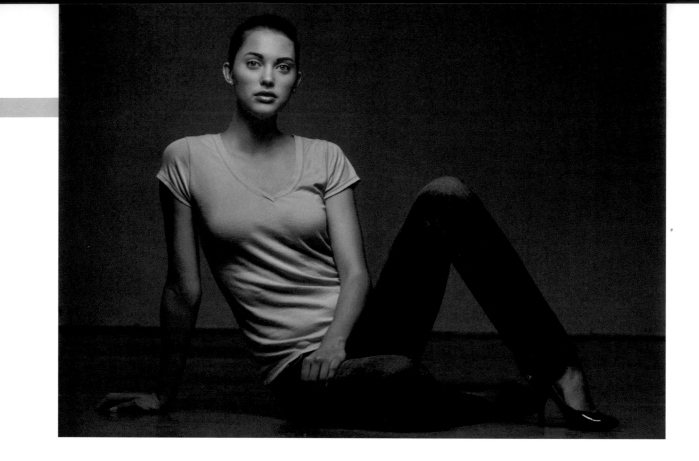

With the softbox on the extension arm of a
C-stand, I was able to move the light more over-
head of the model. See how the shadows now
are more centered on her face? The catchlight in
her eyes is a good indicator. It's just about directly
above her.

1/250th at f/11 is a fairly steep exposure hill to
climb for a small flash, especially one with a dome
diffuser and a softbox strapped to it, but this is the
beauty of working your lights right to the edge
of the frame, as close as you can get them to the
subject. The flash is very close, so even f/11 doesn't
overtax it. If I had the light fitted into a reflected
umbrella 10 or 12 feet away, it would have suffered,
and it might not have had enough juice to get this
done. But, if you position small Speedlights wisely
and carefully, they can really stick with you, even in

situations where you think their power capabilities
might be suspect.

I dialed in a good level of power here, some-
where between +1 and +2 on the flash EV. She
is popped now, and the quality of light is more
contrast-y. There's no longer the softening influ-
ence of blended ambient light. This is all flash, all
the way. No available light allowed.

Reason I did this was to grab complete control
of the background. Darkness rules back there now,
which means instead of letting the windows pour
soft light on it naturally, I have the option of creat-
ing my own look for that wall. Which I did via a third
Speedlight, in Group C.

That light is well off to camera right, low to the
ground, and firing through a random piece of scaf-
fold that was hanging around the warehouse. It

has no dome diffuser, and is zoomed all the way to 200mm, thus creating a hard look and feel for the shadows. Up front, I reintroduced the low skip (Group B) to soften the feel of that overhead main flash.

All three lights see the impulse from my commander flash at the camera. I can push-button in various values as I see fit, without ever getting out from behind the tripod. Because the shadow-maker light for the background is pretty far off the set, and I'm still at f/11, I sent it a signal to go manual 1/1, or full power. It gets the job done, throwing a hard shadow of the scaffold up on the wall. And here's a quick tip about controlling that third light. Even though it is zoomed to 200mm—and thus produces a fairly narrow beam—there's a chance it could spill stray light on the model. Just a chance. You can

forestall this with a couple pieces of gaffer tape on the side of the light nearest the camera. This can be called a flag, cutter, or gobo. Or it could be called a couple pieces of black gaffer tape. No matter. It cuts any spray of light that might wander toward your subject. If you want to get fancy with this, you can buy a Honl Speed Gobo, and attach that with Velcro.

A, B, C. All at my command from the camera. All work, either in concert or individually, to create a look for the light. No one frame is necessarily better than the other. They're all just different, and that difference was created by control of flash.

There'll be a quiz in the morning. ☐

Build a
Wall of Light

SOUNDS LIKE A PROJECT. Lengthy and time-consuming, involving contractors, blueprints, and a crew who promises they'll get it done by, you know, next Tuesday. If not all that, then, at the very least, figure on a few assistants and some heavy lifting.

Not so. Building a wall of light is one of the simplest and most straightforward ways to light somebody. All you need is a white wall (or reasonably white wall), or a sheet of seamless paper, or a couple of sizable bits of foam core. Or, you can just use a portable light reflector, like a big TriGrip, depending on how loosely you define "wall."

The thing about a wall is that the light that reflects off of it bears the same characteristics of the wall itself—big and smooth. And flat. If you're looking for snap and shadows, wall light is probably not the way to go. But, if you want to drop a

blanket of even-toned, wonderfully wrapping light on somebody, give it a try.

It's also a dead-bang easy way to take your flashes—be they small or big—and make them much, much bigger in a very low-tech, inexpensive way. Just turn the flash around, facing it away from your subject and into the wall that is just a few feet behind your back at the camera position. Bingo, you just made the cheapest indirect softbox anybody could imagine.

The varieties of light management you can produce off a wall are pretty endless. Small flash or big

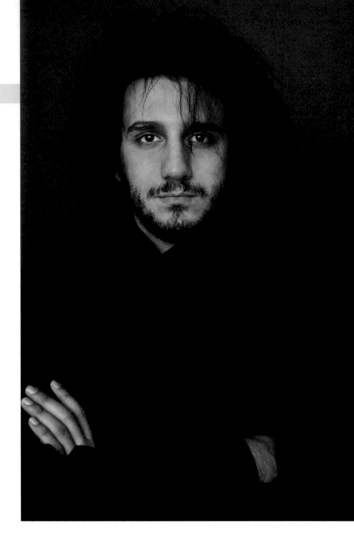

flash works. One or two light sources, or a whole bunch. Bracket the height of the lights—put some high and some low. Weight the upper lights with more power, dial the lower lights down so they act more as a fill. Sweep the floor coming out from the wall with white seamless paper (again, cheap) and roll it out to your subject's position. Now you have an uninterrupted stretch of continuously similar reflectance. Drive the lights with a radio remote, or shoot in TTL Speedlight mode. Use a small flash hot shoed to the camera, angled back at the wall, which makes it a reflected light for your subject, but also a trigger for the other flashes, be they other Speedlights or power pack lights. If they have slave eyes, or are wired into one, they'll all trip off that hot shoe trigger light.

Here are some examples, from the very simple use of an existing wall to the improvisation of wall-like light from free-standing sources.

Puglia, a talented shooter and Vancouver-based man of mystery (he's been known to stand in front of green-gelled flashes, ax in hand, with his shadow playing ominously off an alleyway wall—or so I hear), simply stood about 12' from a white wall and regarded the camera. A dark, portable background got placed behind him. Two lights were used. One is slightly high, and camera left. The other, about the same height, hovers almost directly behind the camera lens. Both are equally powered. (Glad I got the right exposure on this frame, 'cause it's the only one I shot.)

You can do this with big flashes—Rangers for instance—running on low power, triggered via radio. Or, you could go the TTL Speedlight route.

The only concession that using Speedlights might force you into making could be in the realm of power. My exposure here is f/10 at 1/125th of a second. Small flash might pull you up short of that very healthy f-stop. 24–70mm lens, zoomed to 55mm. Auto white balance. As I said, one frame. A truly exhausting shoot.

But that's the ease of this type of light. It rushes forward off the wall and embraces the subject, just as surely as if you dropped the camera and went over there and gave them a hug. You can get fancy with this style of light, as well, and ramp it

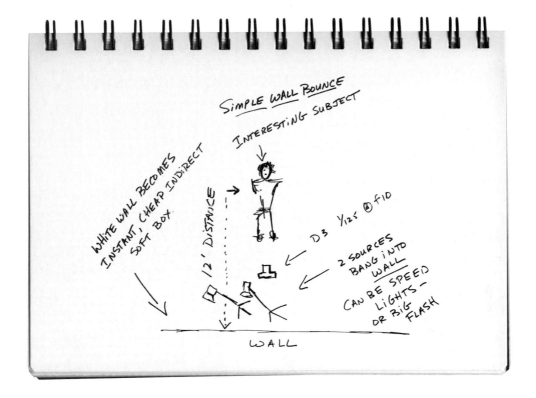

Simple Wall Bounce

Interesting Subject

White wall becomes instant, cheap indirect soft box

12' distance

D3 1/125 @ f10

2 sources bang into wall

can be speed lights - or big flash

WALL

up a bit by inserting another set of walls. V-flats, in other words.

V-flats are just that—two flats taped together in a V shape. Cheap and easy, they are, to me, essential studio tools. Take two 4x8' foam core boards, all white on one side, all black on the other, and gaffer tape them together along the long side. Some folks use boards that are 1" thick, which makes them quite sturdy, but I have skated with boards that are ½" thick. (Makes them more bendy and therefore easier to stuff into the back of a Suburban.)

If you take two of these and stand them vertically, in a V shape, and you put the camera in between them, you can alter the feel of the wall light considerably. Take your lights, whatever they may be, and bang them into the V. No light goes forward to your subject; it's all trapped by the V-flats, and then sent backward toward the wall.

These two sizable waves of light then combine at the wall and rush back over you at camera towards your subject in a towering, gentle tidal wave of soft light. It's so soft and wrapping that you, standing at camera, cast no shadows. You're just enveloped in the light pattern you've created, which is so sizable that you disappear, like a shore rock in a rising tide. The only place you're visible, honestly, is in the pupils of your subject. Right there, smack dab in the middle of a big-ass catchlight. Wave!

My lovely subject, Martina, gets caught up in this V-flat wave (page 115). It drapes on her, allows her to express freely, and look up, down, or away. As is typical with soft, soft light, colors really glow in a saturated way.

Puglia and Martina share one thing—a fondness for a black wardrobe. For some shooters, the fact that this type of light drops on a subject, light as a

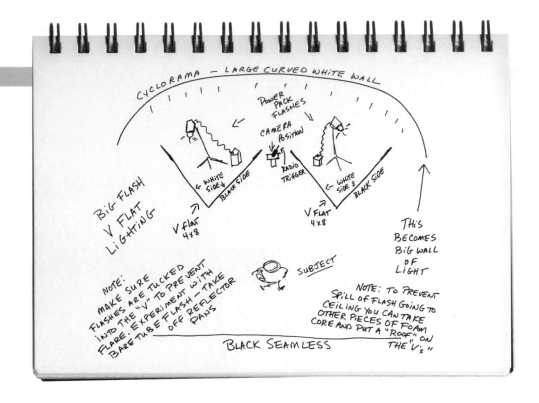

CYCLORAMA — LARGE CURVED WHITE WALL

POWER PACK FLASHES

CAMERA POSITION

RADIO TRIGGER

BIG FLASH V FLAT LIGHTING

← WHITE SIDE →
BLACK SIDE

V FLAT 4×8

← WHITE SIDE →
BLACK SIDE

V FLAT 4×8

THIS BECOMES BIG WALL OF LIGHT

NOTE: MAKE SURE FLASHES ARE TUCKED INTO THE "V" TO PREVENT FLARE. EXPERIMENT WITH BARE TUBE FLASH — TAKE OFF REFLECTOR PANS

SUBJECT

NOTE: TO PREVENT SPILL OF FLASH GOING TO CEILING YOU CAN TAKE OTHER PIECES OF FOAM CORE AND PUT A "ROOF" ON THE "V's"

BLACK SEAMLESS

feather, and (some would say) flat as a pancake, is a problem. No separation! The blackness of their hair fades into the blackness of the background. To each their own, but for me, it's not a problem. If I really wanted to separate them, I would change the backdrop to a gray instead of changing the quality or tenor of the light. Another way to go would be to put very subtle rim lights on either side of them, in the background. Play them light and easy, and it could be a way to pull them out of the black in fairly easy fashion, without destroying the overall feel that the frontal wash creates.

Both of these pix were shot with a wall being the main source. Puglia's face is hit with a one-shot bounce. I pointed the lights backwards and flew them off the wall. Martina has another level of richness that reflects the fact that I played ping pong with the light, banging them first into the broad surfaces of the V-flats, and then back into the even broader source of the wall. This tactic amps up the size and spread of the light source, making it in fact a source as big as the wall you're standing in front of.

So what if you don't have a wall? I did mention that using a wall type of light in this fashion was basically creating, ad hoc, a really big, indirect softbox. Well, a quick (and expensive) way to create very soft, big, fuzzy-blanket type of light is to just go get a big, indirect softbox. The classic of these guys, as I've said, is the Elinchrom 74" Octa. It's built to collapse and travel well, and is so popular that it's been modified to fit non-Elinchrom strobe heads. Use it as one source, up close, and the results are predictably beautiful, as you can see in Maggie's portrait (page 116). One source, the big Octa, camera right, about three feet from her face. Add wind machine. Start calling fashion magazines and telling them you're the next big thing.

How about a rich, creamy, white-wall quality of light from a distance? That time-honored maxim of size of source and closeness to subject starts to work against you when you widen your frame for full-length work. De facto, you've got to back up your light source, and its size and wrapping power naturally diminish over the distance it needs to cover. One way to retain the up-close glow of a big light as it retreats is to extend its size, and there are lots of ways to do this. You don't have to buy another Octa and double them up, or even—yikes— take out a second mortgage and purchase a parabolic, one of those silvery, multi-thousand-dollar satellite dishes of a light shaper, the ones that look like you swiped it from the Very Large Array.

A combo I often employ when I've got the big-guy Octa at a distance from my subject is to just throw something white on the floor directly below it, and bounce another head right down into it. A floor skip, in other words, but a sizable one, and one that approaches the subject from the exact same angle as the main softbox. Think of it as extending the reach of the Octa all the way down to the floor. The beauty of this is that you not only enlarge the source, but you do so with another flash head, one that can be powered up or down independently of the main. This way, you can easily create full-length light for a full-length subject. It retains its creamy, rich feel as it travels towards my beautifully sinuous subject, Jasmine (page 118). She's wearing white on a white background, which is another reason to be as easy with the light as she is on the eyes.

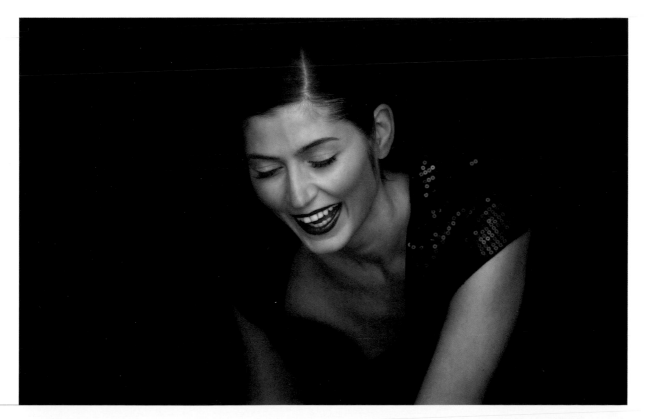

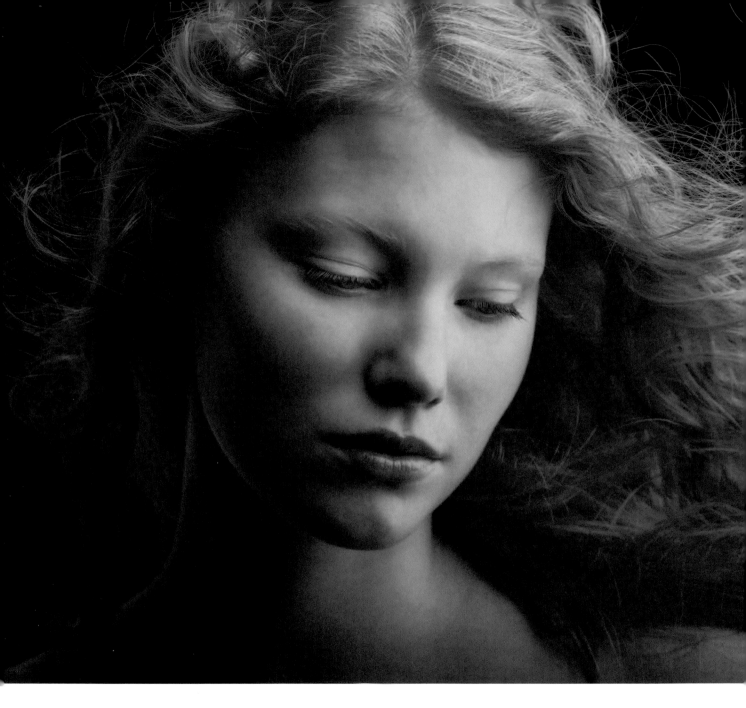

"One source, the big Octa, camera right, about three feet from her face. Add wind machine. Start calling fashion magazines and telling them you're the next big thing."

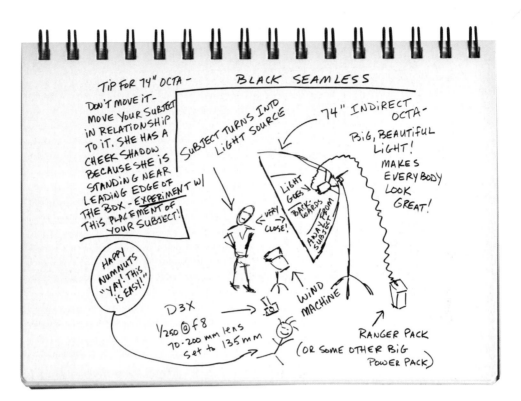

I'm assisted in all this creaminess, albeit passively, by the white wall that is just off camera right. It catches the big softball of light I've sent Jasmine's way and bounces it gently back onto the set, keeping the white seamless not too white, but not too dark, either.

Easy, as I say. Two light sources that act as one. 1/200th at f/8. 70–200mm lens at nearly 200mm.

What if you want to create a wall of light, and you have no wall, and you only have small flash? Won't a big expanse of wall or some humongous light shaper just swallow up a Speedlight?

Not necessarily.

One of the reasons I consistently use Lastolite Skylite panels is that, used properly—i.e., closely—they come close to big-strobe, big-light-shaper quality. The 3x6' panel is probably my favorite, being very versatile. You can stuff it in a window to diffuse sunlight, suspend it horizontally over and in front of a fairly sizable group of subjects and light them all, or, used vertically, I found it's a really nice source for really big feathers.

When confronted with a Murut warrior—historically a head-hunting tribe on the island of Borneo—you are confronted with a truly majestic, colorful presence. And a lighting problem. One of the signatures of their traditional costuming is a feather headdress, the plumage of which can extend at least two or three feet above the warrior's head. So, you

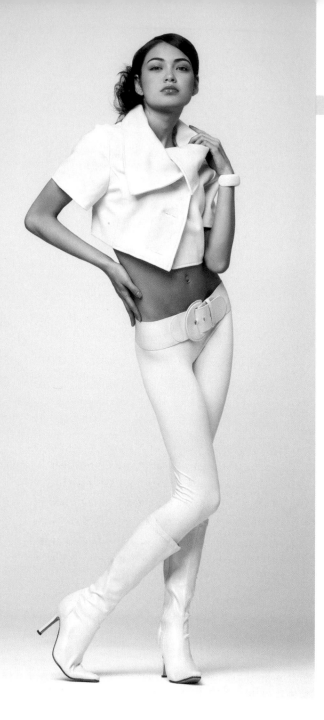

are not just lighting a face. You are a power-ful symbol of their history. Just shooting a headshot with an umbrella ain't gonna cut it.

There's another story in this book called "The Shape of Light" (page 244), in which I advocate you try to match your light shaper with the shape of the subject you're approaching. Here, I practice what I preach, spinning the 3x6' vertically, lining it up with the vertical nature of the costume (page 120).

There are two SB-900 units firing into the panel, as you can see in the production pic. Logical—one high, one low. That main light, even though it is one source, is lighting two things—the face and the feathers—both of which have distinctly different colors and tonalities.

So, here's a beautiful thing about Speedlights. You can take two lights firing into the same light shaper, like this panel, and put them in different groups. That way, I can program different power levels into each of them, effectively creating different zones of intensity within the 3x6' diffuser. Here, I have Groups A and B into the panel, and A is at −1 EV, and B at −2. Group B is lighting the feathers, and is logically pulling less power, given the fact that the feathers are brighter tones and physically closer to the surface of the light. Group C, running at −2 EV, fires through the handheld TriGrip diffuser, putting a mild highlight on the back of the warrior's head and costume.

"I don't get concerned about strange math or numbers. I get concerned about the feel of the light."

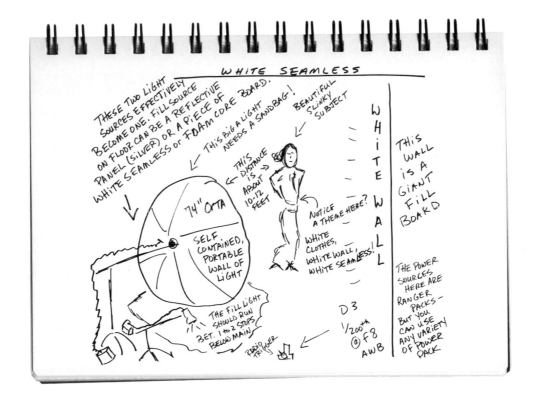

All done. The lights receive their exposure commands from the hot shoed master flash at camera. Manual exposure mode, 1/250th at f/11, ISO 100, D3X, auto white balance. No gels involved. The only customized adjustment I made was to strap a couple of the Honl Speed Gobos on the background side of the lights so that no light strayed back there and made the seamless less than a true black.

And lastly, what if you have a big wall, but just small flash? Can you get a great, big, V-flat feel out of just Speedlights? Sure. I've done V-flat light with either two or four Speedlights popping into the flats. Obviously, four makes it easier, and creates a bigger volume of light, with a touch richer quality and certainly faster recycle. But, especially with fast glass, you can get by with just a couple remotes.

For the picture of Frank (page 121), I went for broke, and put four SB-900 units into Group A and angled them to fire, two each, into V-flats right next to the camera, right and left. They all have their dome diffusers on, as I am reaching here for as much spread and "bare bulb" feeling as I can possibly get my hands on. The master flash is also doubling as a flash here, reversed at camera to bang back into the wall, assisting with the exposure and easily triggering the Group A lights.

Not stopping there, I added a little low fill to the light pattern by taking a handheld Group B light and bouncing it downwards, right below the lens, into a silver bounce card.

Yowza, three groups—master, A, and B. And, here's a weird piece of metadata—they're all programmed to −3. Reason being, I don't need much power, as I shot a 200mm lens flat out at f/2. Low power, fast recycle, rapid falloff in DOF and a wonderfully rich, full quality of light on Frank's face.

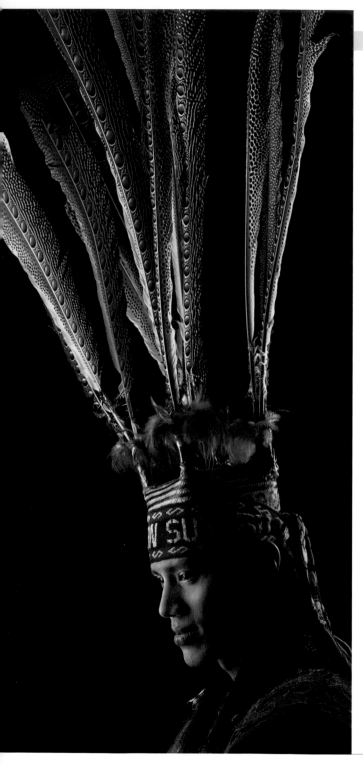

WARRIOR LIGHT!
MINUS 2 EV
B GROUP

BLACK
BACKGROUND

C GROUP
-2.0
FLASH
COMPENSATION

A GROUP - MINUS
ONE EV

LARGE
TRI-GRIP
DIFFUSER

3×6 DIFFUSE
PANEL

VAL

HIGH LIGHT (GROUP B)
LIGHTS FEATHERS - RUNS
AT LOWER POWER BECAUSE
FEATHERS ARE LIGHTER IN
TONE AND CLOSER TO LIGHT

MURUT
WARRIOR

LOWLIGHT (GROUP A)
AT HIGHER POWER - RUNS
LIGHT THE
FACE

D3X - ISO 100 - AWB
1/250th @ f11
COMMANDER FLASH
DRIVES ALL 3
GROUPS

Louis Pang

I took caution with the big lens at f/2, making sure the focus cursor was bang on his eye.

Was I surprised by −3 for all three groups? Yes and no, and I guess, at the end of the day, mostly no. Light is a continuously surprising event, and TTL can make it even more, uh, surprising. So I go with the flow at virtually every turn. I begin, always, with one group as a main director of the lighting event. Then, I add to taste—a pinch here, a dollop there. I don't get concerned about strange math or numbers. I get concerned about the feel of the light. I know tomorrow, the sun will come out and the numbers will be different, as will my results. It's okay. Just another page in the picture adventure book. Serenely, resolutely, I continue to have faith in the chaos of location photography. I'm actually

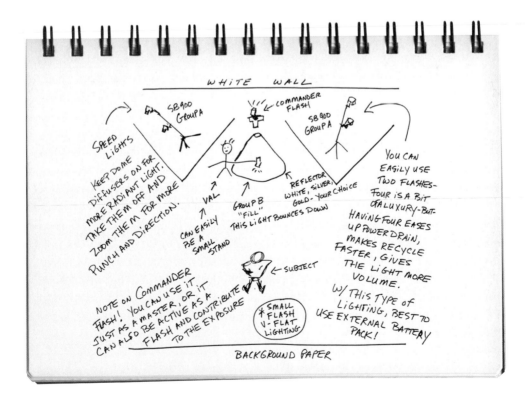

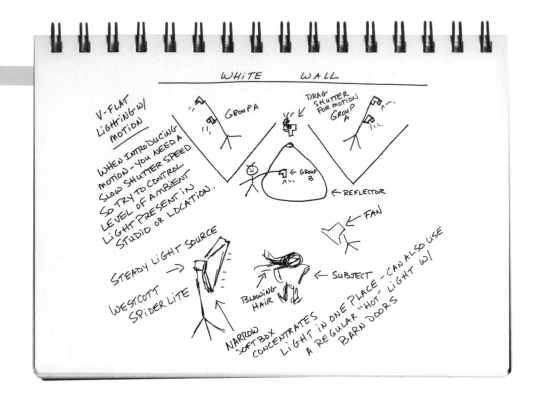

WHITE WALL

V-FLAT LIGHTING W/ MOTION

WHEN INTRODUCING MOTION - YOU NEED A SLOW SHUTTER SPEED SO TRY TO CONTROL LEVEL OF AMBIENT LIGHT PRESENT IN STUDIO OR LOCATION.

GROUP A

DRAG SHUTTER FOR MOTION GROUP A

← GROUP B

← REFLECTOR

← FAN

STEADY LIGHT SOURCE →

WESTCOTT SPIDER LITE

BLOWING HAIR

← SUBJECT

NARROW SOFTBOX CONCENTRATES LIGHT IN ONE PLACE - CAN ALSO USE A REGULAR "HOT" LIGHT W/ BARN DOORS

happy to not be able to consistently produce the same numbers and f-stops time and again. Where's the fun in that?

And, in fact, chaos struck almost immediately. Here's a different subject (opposite page, bottom), shot with exactly the same flash grid. The three groups adjust upwards in power, with all of them now running at just −1 rather than −3. Reason for the change? Several things:

- Different lens. Now shooting a 70-200mm lens wide open at f/2.8.
- Different skin tones for my subject.
- Very different shutter speed—1/20th of a second.

Why the change to shutter speed? Having read a fair number of Irish novels, I guess I was intrigued by a subject with flaming red hair that could blow around like the wild grasses on the sea cliffs of county Donegal. So I brought over a fan, and a

daylight-balanced Westcott Spiderlite fitted with a mid-sized softbox. I placed the light in the background of the photo, off to camera right, and positioned it so it would mostly light the area off her left shoulder. Then, I just blew her hair into the light.

What we get is a TTL-flashed foreground with a steady light for just a piece of the background. That Spiderlite has to stay off the background. Don't want any light going back there! It has to collect on her blowing hair and go nowhere else. Best to do this in a darkish studio environment, by the way. With a dark environment all around, you have no worries about other, unwanted light bleeding into your exposure as you lower your shutter speed. I didn't have that luxury on this set, and I was fighting the window light a bit, putting up blockers and flags, trying to shield my subject from any light I wasn't supplying her with.

As a result, there is an open, blended quality to the hair light because it's mixing with the daylight bleeding into my exposure, and the Spiderlite itself is daylight-balanced. If you look at the ballerina picture (right), you'll see the effect of a hot light—a tungsten, steady source used in a similar fashion, but in more of a blacked-out studio. It's more localized, defined, and intense. And because it's tungsten in nature, there's a warmth to it.

The results of mixing flash with constant light sources? The subjects stay sharp in the areas dominated by flash light, but things like hair and scarves blow around in the breeze that you create and control. The wind from a fan in the studio is not as romantic and dreamy as the sea breezes off the Atlantic on the cliffs of Donegal, but it does the job. □

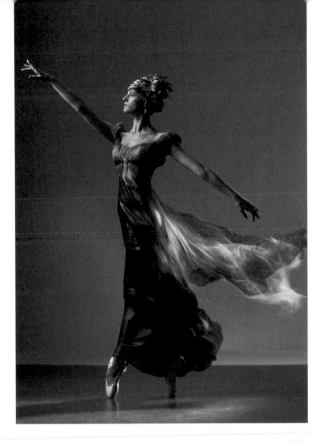

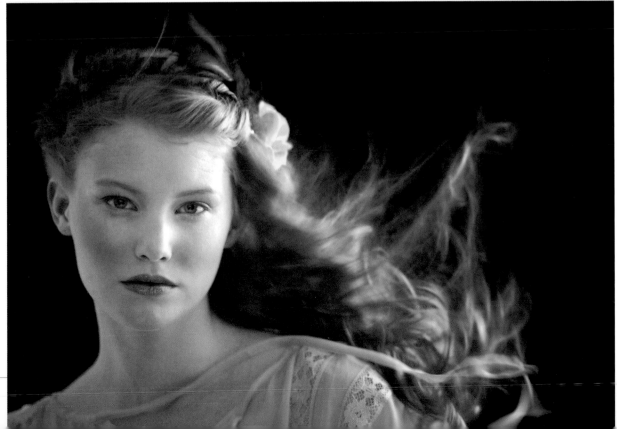

Make the Light Jump...and Other Lessons

AS THE PHOTOGRAPHER ON THE SET, you drive everything. You direct the light, relate to the talent, manage the personalities, listen to the art director, and, at all times, try to please the client. Photographer as ringmaster! Except you are often running far more than three rings simultaneously. These kinds of photographic juggling acts are exhausting, not to mention difficult to survive. Photographic nirvana is achieved on those truly rare jobs when the client yields the road to you, with the only mandate being to make great, gorgeous photos, and you are the art director, the lighting director, the casting agent, and the cameraman. Those are yippy skippy days, to be sure, but they come with a burden, as well. If the shots don't soar, all fingers, including your own, have no place to point but at you.

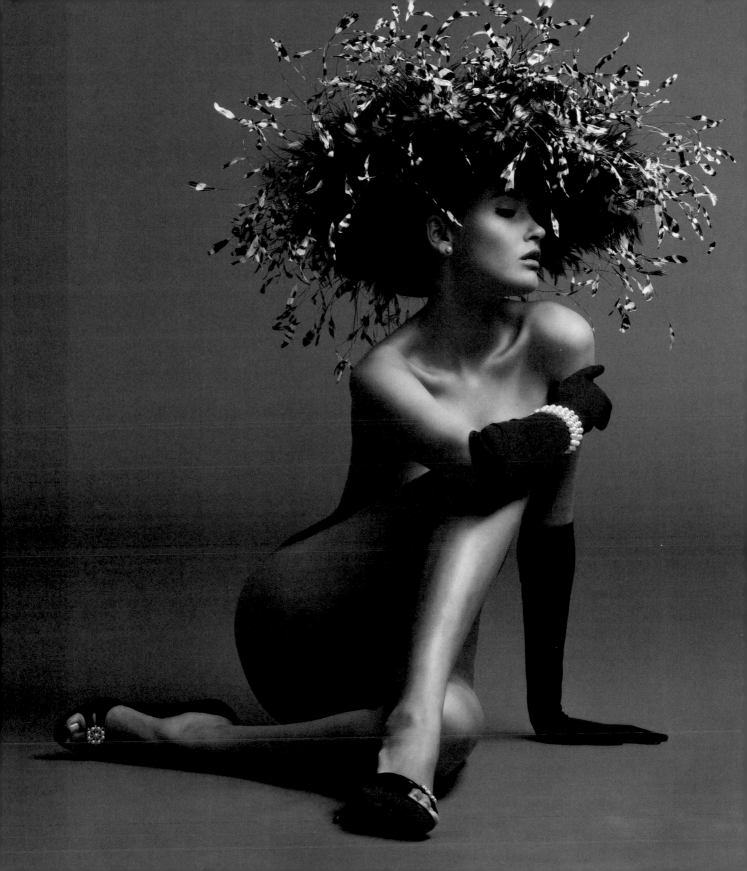

Because on these lovely days when you are essentially photographing your own imagination, it falls to you to articulate same. That can be easy if the photo notion has relatively "normal," rational architecture. It can get more difficult if the idea is fanciful, not readily apparent, or downright strange.

And let's be honest, everybody gets strange (at least a little) when they have a camera in their hands. If you don't, ever, then that's potentially a bigger problem than if your visual imagination has permanently checked into Hotel LaChapelle. The camera is supposed to be the magic carpet that your thought process transports on, the machine that makes your ideas lighter than air. If your pictures are continuously earthbound, rooted firmly and forever in logic—the photographic equivalent of the State Department—well, maybe, you know, there's always carpentry.

But I doubt that condition really exists. When anybody, even the most practical of souls, takes a camera in hand, they yearn for adventures to record. The pixel-driven pursuit of light and shadow often takes you over the hill and far from the Shire. I'm not saying every click is a wild and woolly action flick, but at least some should be. And we know that adventures have all sorts of endings.

And then, when your ideas get strange—and naked—well, there's some explaining to do, yeah? This is where the above-described role of "relating to the talent" comes into play big time. This is where you have to summon up your best and most persuasive instincts and describe this wonderful picture that's about to happen...but will only be truly wonderful if your subject is bare-ass naked. In the fashion world, this is a fairly easy hurdle to jump, actually. Models are often called upon, depending on the rate and the job, to display some or even all their wares. Working it is par for the course. Not a big deal. Athletes are often the same way. Proud of their bodies and willing to show them, in a picture frame, as a work of art.

Certainly Maryam, the marvelously confident model in this picture, made it easy for me. I had the notion of the wild hat, a pair of killer

shoes and gloves, and nothing else. She looked at me and said, "So I will be nude, yes?" as only a nearly six-foot-tall Uzbeki killer goddess can say. With a half smile she sauntered into hair and makeup, not that she needed any.

Here's the thing. When you want somebody to do something sensitive, or risqué, or rip the protective band-aid off their emotional core and bleed a little for the camera, I find the absolute best thing you can and need to do as a shooter is to be as plain and blunt about it as you can be. Tap dancing gets you nowhere, and can actually slide you into the "shifty" category if you do it badly. Your request has to be as naked and unvarnished as you intend them to be in the photo. Being straight-up is best. If they say no, they will say no immediately. Also best to get all this done before getting behind the camera. The "Oh, by the way, can you take your blouse off?" approach in mid-shoot is more apt to get your block knocked off than render a fantastic photo. What it might appear to have in devil-may-care artistic spontaneity it sorely lacks in sophistication, common courtesy, and chance of success.

So be straight, and work it out beforehand. Then, when you have this amazing, sensuous creature adorned in nothing but a hat right out of an Audrey Hepburn movie, try not to blow the lighting.

I have to admit, I didn't even think about small flash here. (I was, after all, shooting this as a catalog photo for Elinchrom.) But even without the client's needs to demo their products, I still would have used the same light source, in this way. The light shaper here is the Elinchrom 74" indirect Octa softbox. I have said this many times: When you use this Octa, you might as well start playing "Your Cheatin' Heart" on the studio jukebox. It just isn't fair. This light makes everything and everybody look good. It's like your subject is in one of those commercials for 1-800-MATTRESS, and they get to fall, slo-mo, into a giant bed in such a luxuriant fashion that it appears they are being swallowed by the mattress instead of just sleeping on it. That's what this light does, too. It swallows your subject in a sea of feathery photons, which grace every curve and fall slowly and easily into shadow.

What's the big problem here? Getting light under that hat, as ornately lovely as it is. Okay, that's not a problem, you say. Just move the whole source low, down there with her, which is what I did. But as always, if you make a move with a light to solve a problem,

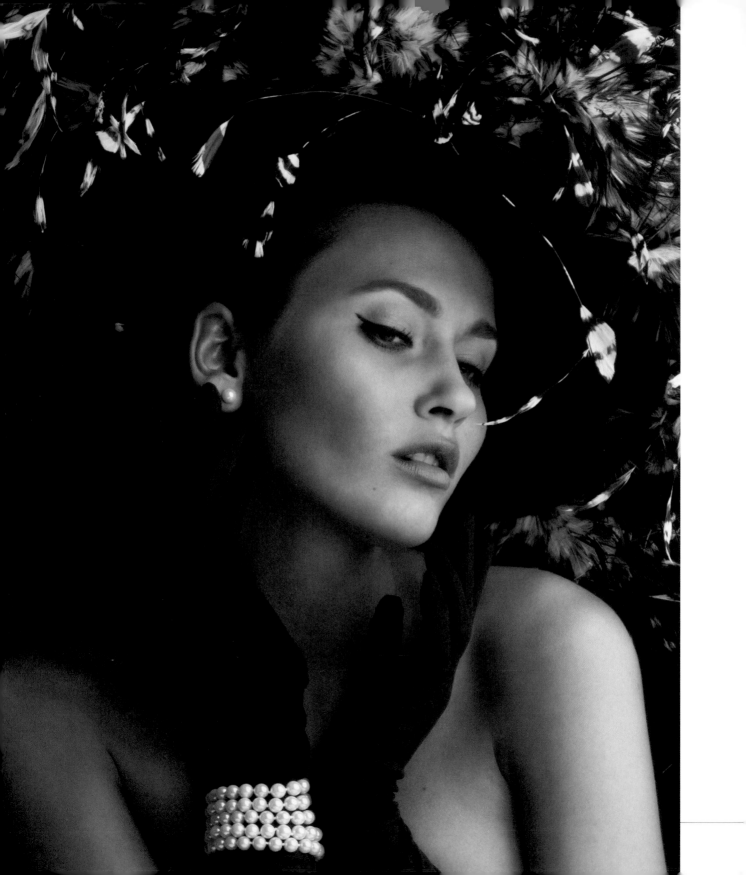

"Physiology is physiology, and we just can't help it; bright areas are a siren call to everybody's retinas."

you'll create three others. In this case, only one: heating up the floor, exposure-wise. This big a swatch of light covers everything—the model, the hat, her sumptuous pose...and the floor.

Everyone who engages in photography knows that the human eye is drawn to light areas, so if you're not careful with a big light source, you can light up stuff you don't want or mean to. The model is sitting on stone gray seamless, but if too much light pours onto it, it's gonna go dead bang white and scream for attention. Now, you could say someone would be crazy to gape at the floor when there are far more interesting areas of the photo available for perusal, but physiology is physiology, and we just can't help it; bright areas are a siren call to everybody's retinas.

But, this big soft light is the key to the photo, so I didn't abandon it. Apart from its size, the other truly key thing is the nature of its construction. As I note elsewhere in the book, it's an indirect softbox, built with the light source facing away from the subject, instead of the more traditional type of direct box. With "normal" softboxes, the light source (strobe head) radiates straight at the subject, in the same direction the light shaper is pointed. The light flies through baffles, or diffusers, to be sure, but its path to the subject is beam on. The light can still be quite soft, but that directness makes for slightly more pronounced shadows. Incremental and subtle, but definitely more shaped, with perhaps a touch more contrast.

The indirect style of softbox refers to the kind of light shaper—generally a fairly sizable one—in which the actual strobe head or flash is aimed exactly *away* from the subject. It fires into the interior of the box, and then bounces back through layers of diffusion. The result is very even and very smooth light, not screamin' hard or defined. Light as a feather, to coin a phrase.

If you want screaming hard light, take a look at Maryam (right), lit with one hard flash through a window about 40 feet away. Edges, shadows, and drama rule, which works for this frame. It wouldn't work

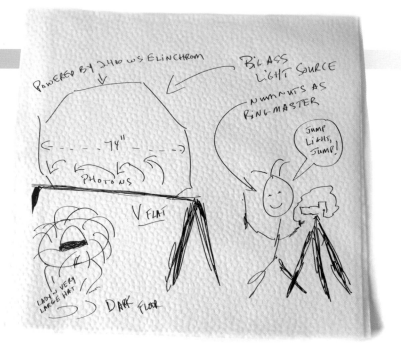

for the hat shot! In light like this, the shadows under that brim will be the equivalent of a coal mine. Black, impenetrable—even with the best post-production fill tools—and defined by hard, slashing lines between lights and darks. The light needs to match the mission. For the hat, go big, soft, and indirect.

Those three qualities will produce the soft, wrapping light that will migrate under the hat, light her face and eyes, and still render that amazing head gear with appropriate detail. It will also spill right to the floor, and wreak some exposure havoc. How to avoid this?

Make the light jump!

Doing this is a simple fix, and demonstrates why one of the very first pieces of gear, if you can call it that, I look around for in a rental studio is a V-flat. In "Build a Wall of Light," I talked about V-flats as light shapers, but here, it's a flag that cuts the light from the big Octa away from hitting the floor. Laid on its side, the V-flat becomes a blocker that is uniform, and covers the entire wide stretch of Octa. Even and linear, it creates a barrier that cuts the low part of the softbox out of the exposure equation, and forces the flashed light to literally jump over this opaque hurdle, much the same as a horse in a steeplechase. It is passive and simple. With one absurdly easy maneuver, you get the exposure on the floor back in control without losing the beautiful quality of light you need for the rest of the frame.

It's a simple move, with one of the most inexpensive photo tools out there. DIY and cheap. Do two for your home studio. You will not regret it. V-flats are quintessentially versatile and can be used as light shapers, light blockers, cutters, gobos, flags,

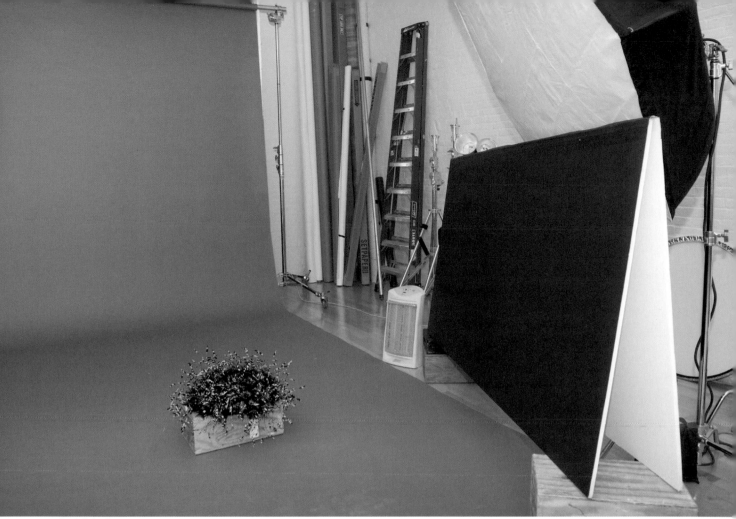

Scott Holstein

backgrounds, walls for an impromptu dressing room, background gradient lights, blackouts for the windows, you name it.

Another nice thing about V-flats is their size and symmetry. You can gobo a small light with just a tiny piece of their 4x8' square footage or, just as easily, you can flag down the giant Octa. And the results are even, not jagged. We've all been out there, without these benign monsters, trying to opaque a window with an assemblage of winter jackets and hefty bags, or feather down an area of exposure by placing a sofa in front of the offending area of light. Effective, to a degree. Symmetrical and practical? Hardly.

Simple and easy. No moving parts. Leapin' light! □

Big Flash, Small Flash, Far Away

WHO SAYS WHEN YOU MOVE the light far away it's got to be big? Like all things photographic, the answer is a definitive "Sometimes...."

This picture of the wildly beautiful, leaping Bleu, one of our favorite people to work with at my studio, is a sun/flash combo shot. Lots of sun, hence, lots of flash.

The sun is blazing, just getting a touch warm, but not yet near the horizon. Blasting, in other words. How do you tweak, shape, or even mildly redirect this freight train of light power?

One way is to open up a big can o' whoop-ass flash power. An AC-powered 2400 watt-seconds unit. No small flash, no battery packs. These are studio units, and run off of electrical power. When

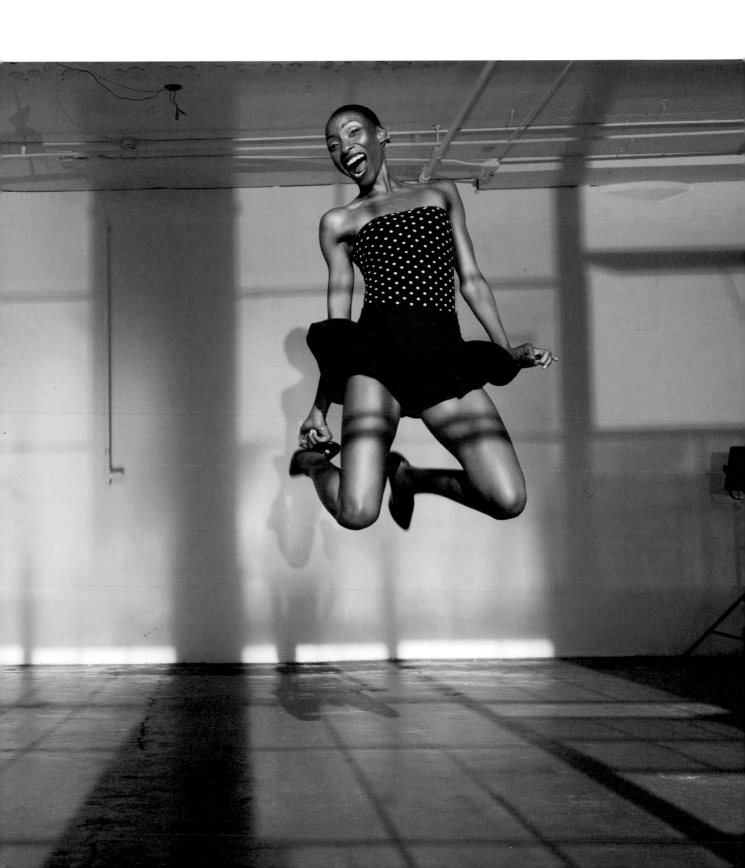

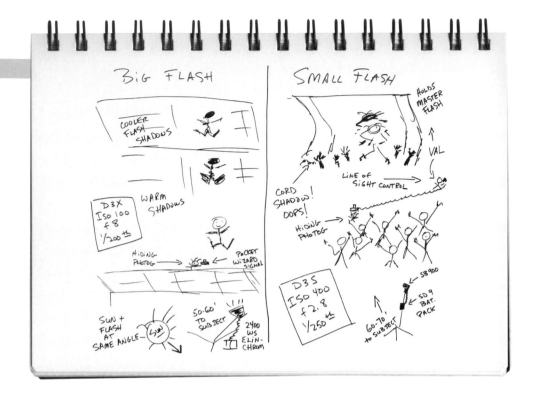

you bring them outside, as this one is, it's time for the extension cords! Run 'em out the window and power up this big, heavy box of photons. (Make sure the electrical outlet supplying this puppy is a clean circuit that can support 20 amps. If you try to power a pack like this on a 10- or 15-amp line with the blender, your clock radio, and the 120-inch surround-sound flat panel, you'll blow the whole mess.) Hook up a flash tube to it, turn the dial up to the "Nuke the Bastards" setting, and stand back. When you use a 2400 pack at full power, you can always tell, because the flash tube pumps out blinding light with a definitively audible "pop" that you can pretty much hear down the hall and around the block.

That's the method here. This light is outside the windows, near a set of train tracks. It is an Elinchrom 2400 Ws pack, a big dog of a light source.

Power was needed to match the sun, so this pack is ramped up to the max. All 2400 watt-seconds are dialed in. To simulate the hardness of raw daylight, there are no light shapers on this flash head. Just a reflector. No umbrellas and the like. No-frills flash!

Even this light is not going to overpower the sun when it's full-tilt boogie, but it does extend its reach a bit. To make that happen, as always, it must be right on the same axis as the sun relative to the subject. That way, the shadows will line up and appear to be all made from the same single source. There are a couple giveaways in this pic, though. The shadow patterns line up nicely, to be sure, but there's a color shift. The warmer tones on the floor are produced by the sun, just starting its trek towards the horizon. You can see where the sun—and the shadows it's producing—end. The cooler light-and-shadow play on the wall is

produced by the flash, which has a decidedly more neutral tonality.

The sun is higher than I could get the flash, so, while the angle is accurate, the height is not. Which is actually a good thing. The flash is pretty much at her eye level. (We are in the second story of a building, so the flash head is on what is called a high roller, a huge stand with a max reach of 25'.) Reason it's a good thing is that the eyeball-to-eyeball approach of that light extends the shadows all the way to the back wall. If you look closely, the angle of the sun produces a shadow that ends right at the

seam of the wall and the floor. I wanted the shadow pattern up the wall, and that's what the 2400 Ws punch did for me. Bleu supplied the excitement, I just set the stage with the light. She is lit because the flash source of light is lower than the angle of the sun. (Hey, even a high roller only goes so high.) So, while the sun does a nice job lighting the floor, when she leaps, she is leaping out of the sunlight— and into flash light. If there was no flash, there would be no Bleu.

The other thing to watch for when you have a hard light essentially coming right over your back

is—your own shadow. I hunkered down underneath the windows; otherwise my fat head would be outlined right against the wall.

Now, flash from far away may seem like the province of big lights, but I've gotten away with using hot shoe flash from a great distance as well (though not in intense sunlight, as the example we just discussed). With digital ISOs being what they are, there is much greater experimental leeway one can take with small lights, and still get really good quality.

The lessons of light are with us always: big source, close to the subject, nice wrap and diffusion; small source (and what we're talking about now is a really small source) far away, the shadow is as hard and declarative as the drop of a guillotine.

In this game of shadows, it doesn't have to be just the subject playing. Clean white backgrounds are nice, but what about a little context? In other words, something populating that dead whiteness surrounding the subject? Easy enough to do. Just throw some other stuff in front of the light, and watch the shadows play.

In the shot on the previous page, the model Hope is on white seamless, doing her best Lady Gaga, with all her fans in the audience raising their hands to greet her. Again, an SB-900 is the only light source, far away, at the back of an auditorium. That old truism that shadows get harder and sharper when the light is further from the subject is, well, true. Witness the shadow of Hope on the background. Clean and sharp as a scalpel. She is the full distance from the light right smack against the white paper. In between, though, you have that sea of hands and arms, and their shadows are a touch fuzzier. At least part of that is due to their being not so close to the background and not so far from the light.

The specs on this shot are 1/250th of a second shutter speed at f/2.8, at ISO 400. The flash is zoomed to 200mm, which is the maximum concentration/minimum spread. A tight bundle of light, thrown at the subject from a fair distance. Think baseball. When a fastball pitcher rears back and throws the heat, what sound do you hear in the catcher's glove? Smack! Same thing with this type of light.

"The other thing to watch for when you have a hard light essentially coming right over your back is—your own shadow. I hunkered down underneath the windows; otherwise my fat head would be outlined right against the wall."

Helpful hint: In the menu of the SB-900, there is a "light distribution" option. You can program right at the source for Even, Standard, and Center-weighted dispersion of the light. For this style of light, you want it to be as concentrated as possible, so it might be a good idea to take a few seconds and go into the menu to program it to Center-weighted, as opposed to Standard or Even. Small move, but then again, any sliver of an advantage you can create for yourself out there is a good thing.

Also, with this approach, from this distance, TTL goes out the window, as far as I'm concerned. No real need or sense letting the unit decide anything for itself. If you move fast, you might be zooming around with your lens, and taking in lots of white background, or maybe not so much, frame to frame. The amount of white the lens sees can conceivably skew the flash/camera conversation, and produce some ups and downs of exposure. You don't want gray; you want full-blast, full-blown white. So say goodbye to the up-and-down nature of TTL flash and just immediately take the unit into manual land. Send it a signal to go manual, 1/1, the absolute full power one of these pups can give you.

That way, you know you've got the max. That little flash back there is basically donating you its kidneys, heart, liver, and lungs. All power is going to the pop, and none is being diverted to the beep-beep, flash-flash, wink-wink conversation that occurs prior to an exposure in TTL flash mode. This is it—105% percent on the reactor, captain!

Which is not, in most circumstances, advisable. Here's a cautionary note—don't run an SB-900 on max power for very long, and don't try to shoot fast. You run the risk of turning the unit into a glowing, radioactive isotope. Pick your moments, get the shot, but be selective. If you push it, you'll fry either the batteries or the flash.

So, before we move on, let's do a quickie punch list about these two iterations of flash—what you get with each, and what you give away.

Big flash, far away:
- **Good:** Hard shadows, lots of power, big f-stop, fights the sun real well.
- **Bad:** Need to connect to electric, heavy power pack, a lot to manage. Sometimes too much light. Big stand, maybe sandbags.

Small flash, far away:
- **Good:** Small, versatile, easy to work without assistant, small stand. Line-of-sight control.
- **Bad:** Small, lacks power, small f-stop, won't get it done in bright sunlight from a distance. Line-of-sight control can be iffy.

Photography: the good, the bad, and the potentially ugly—if you don't light it right!

Oh, and remember what I said about getting my fat head out of the way, and ducking below a wall to shoot leaping Bleu? Well, in the picture of Hope, I am safely out of the way, but guess what isn't? See the little coil cord shape in the lower left? That's the SC-29 cable connecting my camera to the trigger flash that is blessedly not a shadow shape in the picture. Yep, I'm successfully tucked away at the edge of the frame, but doing so rendered it impossible to signal the remote flash from the master while it was hot shoed to the camera. SC-29 (actually three of them, linked together) to the rescue. The commander flash is off to camera left a considerable distance, thanks to the linkage of the cords. But there's its little curlicue shadow, right up there on stage with Hope. Ha! Let the shadow games begin! □

News Flash

USING A FLASH CAN KILL YOUR PICTURE. Corollary to that: A good picture can survive bad flash. Addendum A, sub paragraph D, pertaining to the above: The biggest softbox in the world can't save a poorly conceived photo.

As a shooter, ever feel like you've just plummeted into this, well, situation, and you're supposed to sort it out and make a coherent, vibrant, storytelling set of pictures out of it? And you're supposed to do so, kind of like, immediately? Your mission is to explain the world unfolding in front of you to someone who's not there seeing what you're seeing, and do this via crystalline, explanatory, incandescent imagery that has logic, power, and a coherent story line. And you haven't a clue as to how to do that?

Life is going around you like a three-ring circus, and you don't even know where to point the camera. You not only can't figure out where to begin, you don't even know what lens to put on. (The only thing you might be certain of at moments like these is that the lens you currently have on is the wrong one.) And your interior desperation meter is spiking, because the life you're there to report on is charging along without you, and you're missing stuff. People are laughing, babies are being hoisted, old men are playing cards, school children are playing interesting games. And you haven't shot a frame.

You stand there—the interloper, the object of the occasional suspicious glance—without a clue about what to do, worried about the quality of the light. Trust me, it's a worry that's exclusive to you.

You see things happening that you'd like to shoot, and you take a few stumbling steps towards it, tentatively putting your camera to your eye, but what just drew your eye is over before you can say, "I should have gone minus one." You're on the outside looking in, feeling awkward and lacking confidence. In desperation, you feel like pulling a bullhorn from your bag and shouting into it, "Alright, all you colorfully dressed indigenous peoples! You quirky, offbeat locals! Please stop doing all these spontaneous and wonderfully natural activities while I set up my lights! I will then ask you to recreate these activities under strobe-lit conditions, and my direction, so it looks as if you are really doing them."

Sounds like I'm joking, but I'm not. I don't know of any shooter who hasn't experienced the feeling of being lost and overwhelmed, of having events and environment overtake logic, thought, and ability. I think it's most likely because we're supposed to capture and preserve moments, and moments don't take a number, stand in line, and wait. As a photog, you can feel like Lucy at the chocolate factory. Life keeps coming at you, just like all those bon bons on the conveyer belt that she was desperately trying to pick up and wrap, all nice and pretty. A precious few of them will make it into the box, but most you will miss, and they go splat on the floor. And inevitably, somebody, just like Lucy's supervisor, shouts, "Speed it up!" Then it gets seriously messy.

Sometimes it's best to leave the lights alone and crank some ISO into the camera, and just shoot. Spontaneous gesture trumps good light any day of the week. And, given the perennial beast of misfortune lurking in the shadows of any shooter's life, just when you decide to go back to the car to get your flash and grip out of the trunk, the townies will have all stripped naked, rubbed oil on their bodies, and fornicated publicly en masse, in the village square, to celebrate springtime and the rising of the sap, and then gone home. By the time you get back with all your stuff, it'll all be over, and there will be just a couple of drunks there, laying on picnic tables, slurping warm hooch and slobbering the words, "Geez, you shoulda been here just a little while ago. There were hundreds of interesting people doing fascinating things. Oh, well, they'll do it again next year."

So it goes. At least some of the time, we have a natural tendency to want to control things—set it up, light it nicely, expose with complete accuracy and confidence, and then take this bundle of well-ordered pixels and put it into our stock files, like a beautiful bird in a cage. It's ours now. We shot it, and now we got it. It's trapped. Preserved forever to show the neighbors. Things that are out of our grasp, unanticipated chaos—i.e., life—are harder to grapple with, photographically. Life doesn't stay on the seamless. It runs out of the studio and down the hall. Keeping up with a camera requires a different set of skills, and some luck.

I went on the road with country music star Travis Tritt. He had a massive stage show, with lots of special effects. One of the most special was the laser vortex that the man with the black hat faded into at the end of each show. People would go crazy. I saw this and thought, wow! Set up some lights, get them to turn on the laser, and do a spectacular portrait. I was also less than confident about shooting it in real time during a show, so setting it up made me feel better. If I could stage it and control it, I'd know I'd have a picture.

He agreed to pose for it before a show. We smoked up the arena, powered the laser, and I put one simple softbox on stage with him, camera right, and shot it on medium format film. The mechanics of this are irrelevant. I tested the laser exposure on Polaroid, metered the flash power, and matched them up in the darkness of the arena. What does soar, though, is exactly how cheeseball these pictures truly are.

Lifeless, overwrought, and staged. I captured the image alright. And in doing so I killed it, right then and there. It might as well be a stuffed moose head, hanging on a wall. My Travis-with-the-laser trophy that I wanted so badly.

It wasn't his fault. He's out there trying, fairly dripping in rock star appeal. The fail is utterly mine, at camera. I stopped life to catch up to it with a camera. Instead of trying to capture the full-throated roar of a rock and roll stage extravaganza as it happened, I told it to pipe down, behave, and get in front of my lens. The results speak for themselves.

I did get one frame of the laser exit as it actually happened. It was a dicey, manual focus, 300mm lens shot from the back of the house during a show. Didn't give it a prayer as I rattled off a motor-driven series of frames. One turned out to be sharp, and had a vibration and energy to it, plus the silhouette of the hat. It, of course, ran as the lead double truck (and runs here on page 138). After three weeks on the road, shooting all manner of stuff, posed and otherwise, the opening pic came down to a lucky, out of control, unplanned piece of pushed Ektachrome. And a softbox was not involved.

As an aside, I did like being on the road with Travis. His lyrics and song titles were such that I thought he was singing about shooters.

For instance, in honor of those photogs whose standard conversational patter goes something like, "But hey, that's enough about me, let's talk about what you think of my work!":

Here's a quarter, call someone who cares...

For those days when things have gone really well, and you can do no wrong with a camera:

When I'm ten feet tall and bulletproof...

The life of a shooter:

Hard times and misery...

It goes like that in the field. You key on something, invest a bunch of hard work and hope in it, and the picture just sits there, limp as a doll on a shelf. Other stuff that you don't even think about—throwaway stuff, even stuff you know you've shot badly—ends up looming large. Days in the field are almost always a patchwork quilt of success and failure, stitched together with good and bad luck.

Stuff happens, and despite the old maxim of "be ready for it," you rarely, truly are. There are always compromises. Sometimes you know you're sacrificing technique but the spontaneity of the shot is worth the cringing feeling of shooting it poorly. Covering the Masters Golf Tournament a few years back, I was out with the commentating tandem of Dave Feherty and Verne Lundquist. They were

tootling around the course, trying to get a feel for the greens to better inform their on-air chatter. Feherty's a puckish Irishman who's a hoot to be around. I made some stuff of him putting and such, and also some fan pix, as they were constantly being stopped by folks for autographs. Stopped, in fact, so often that it grew a bit tiresome for David.

A fan, big in every sense of the word, stopped their cart. Lundquist was giving out hale and hearties, and all of a sudden, Feherty just looked at me, as I was scooting over to them from another cart. I charged, and hit the shutter. Straight flash on camera. Technique? Horrible. Expression? Priceless.

I took a second to adjust the flash into bounce position, and made a series of frames in better, softer light. More diffuse, and more gently scattered. This bounce position I'm referring to points the flash up at 45 degrees. There's nothing to "bounce" off of, but the subjects remain in range of the 360-degree dispersal of light from the dome diffuser. Some photographers, especially wedding shooters, take it a step further and rotate the head of the flash in bounce position to actually fire most of the light away from the subject. That can require powering up the flash (or the ISO), but it does mean, again, that the subject matter is being lit by light scatter, not full-bore straight flash. It's the difference between a summer rain shower and a heavy, nasty thunderstorm.

But, by the time I got my flash to behave better, the expression was gone. That moment flew by me like a line on a news ticker. I'll never get points for slick flash work here, but anybody who looks at this kind of odd photo gets a chuckle, which means I did my job. It's like winning ugly. You might not be proud of your performance, but it's still a W. □

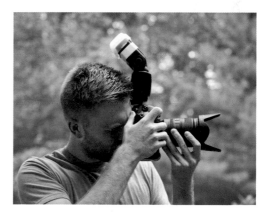

Here's Sunshine
Up Your Skirt!

EVERY ONCE IN A WHILE, you try something on a wing and a prayer, and you get a picture that works. You gave it just about zero chance of success when you put the light out there, and then it's so absurdly first-frame simple, you have one of those "coulda had a V8" moments back at the LCD. Which, of course, you then try to cover up by assuming a knew-it-all-along look, a confident nod, and a quiet, murmured, "Think I'll just shoot a few more of these."

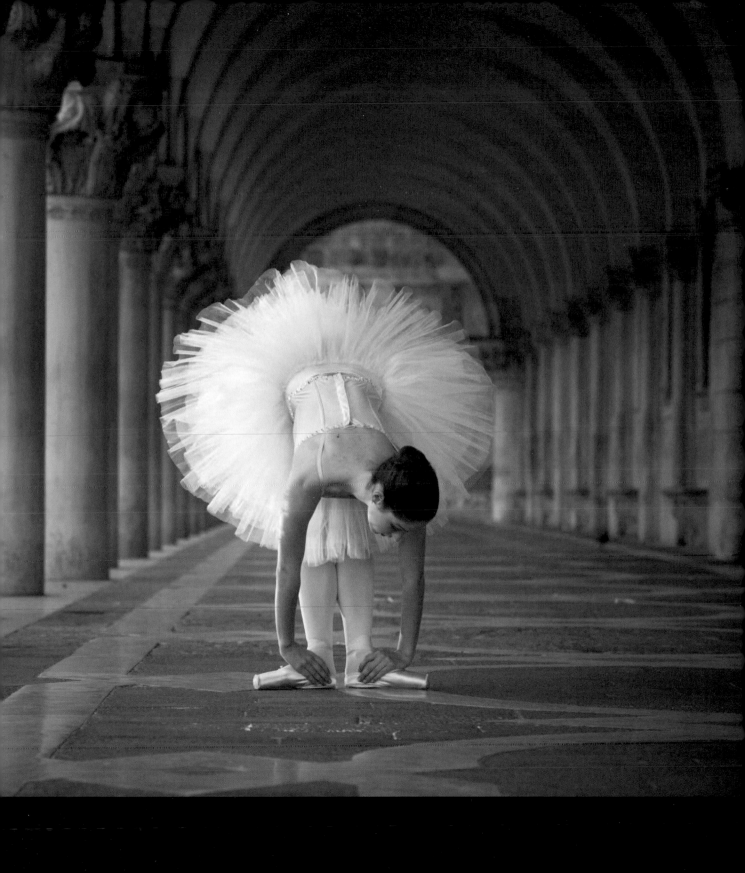

I was on the main plaza in pre-dawn Venice, which is the only time of day that beautiful, historic place is not a sea of backpacks and a jumble of accents and languages. The sun was up and light was bounding out on the waterways, but I was struck by the cool, beautiful nature of the ancient arches, where open shade still ruled.

When trying to work simply and influence a scene with just one small flash, open shade can be your best friend. You don't have to stress the light by fighting the high, hard sun, and the muted tones introduce the possibility of effectively influencing the color palette of the scene without bringing in movie grip trucks.

This setup was, as I indicated above, crazy simple. I used the little plastic floor stand that comes with the SB-900, put a full CTO warming gel on the light, took off the dome diffuser, and zoomed the flash head to 200mm so the light spread would remain pretty tight, and placed it out there on the ancient stones of the plaza. The zoom feature helps in directing the light right to the dancer, and also keeping floor spill to a minimum. As worn as they are, the tiles on the plaza will pick up light and reflect it pretty well, so if your light is zoomed wide and splashes everywhere, you got a problem. Zooming the light tight sends it where it needs to go—to the dancer—and minimizes the telltale photon path on the floor. A hint of light works fine. A big, blown highlight is not okay. Nuking the floor is always a concern, obviously, when you actually place the light down there. I didn't need to employ this tactic here, but a couple of simple swatches of gaffer tape on the floor side of the flash head, serving as cutters or flags, works really well, as shown here.

I just happened to have a ballerina with me. I'd suggested dancers to the group I was shooting with, and it was a notion they embraced vigorously. Bringing a dancer onto the Plaza Venezia in dawn light is definitely stacking the deck in your favor, kinda like flying in a sure thing, but it's a good thought when seeking subjects for flash portraits. It's certainly better than wandering the streets hoping an ancient drunk with an interesting hat stumbles into a beautiful highlight. (Unless, of course, you're street shooting and looking for happenstance. Different mission altogether.)

"Zooming the light tight sends it where it needs to go—
to the dancer—and minimizes the telltale photon path
on the floor."

Repetitive columns and telephoto lenses are made for each other. The lens perspective stacks up the gray pillars nicely, making for a seemingly endless graphic pattern, into which you drop the tutu-clad dancer. The light is off to camera left, outside the columns. One would think that line-of-sight TTL goes out the window. Time for PocketWizards and manual control!

Certainly that would be a valid and doable approach, one with almost certain return, unless the radio fails. But they never do that, do they? (Knowing smiles here.) But I didn't have a radio with me. So that option went away. What I did was rely on TTL, line-of-sight technology. I strung together three SC-29 cords, thus linking my commander SU-800 with the hot shoe of the camera. A hard wire, in other words. Given the coiled nature of these cords, you can really stretch that commander flash out there a considerable distance from the camera's POV. I asked one of our group to do me a favor and walk that commander straight out to the left of camera until it saw the main light, sitting on the deck about 50 or 60 feet from the master flash. No trigger troubles at that distance and in that quality of muted ambient light.

So, two units, but only one flash for the exposure. Commander SU-800, handheld, 20 feet to camera left, and one remote SB-900, sitting on the ground, to the left of the subject, firing in between the stone columns. No light mods, no stands. That's it; that's the basic physical setup. As I said, simple.

But the key to the photo really wasn't so much the placement of the light, or the color (as important as they were). It was all about maintaining a richness of exposure, and making sure the beautiful scene was a stage for the ballerina—just like in the theater, with the SB-900 as her spotlight.

When most digital cameras, as sophisticated as they are, look at a vista like this, they basically overreact by trying to expose for everything out there; they reach into shadows to bring forth pixels you don't necessarily want to see. They're not making a mistake or doing anything wrong. They're just expressing the souls of the engineers who made 'em. They're industrious, these genius cameras of today. They'll work like the devil to render detail in the whole frame if you allow them to. They are not acquainted with the old expression, "Let a sleeping shadow lie." They don't know from mood, or subtlety. If it's there, they go after it and try to snap it to attention, exposure-wise.

The scene, though, doesn't need to be exposed, really. It just needs to be there. The result you wish for here is just as faded and worn as the old rocks themselves. They are quiet—background music if you will—while the vibrant youngster of a dancer, dressed in shocking pink, is the crescendo.

Hence the mechanics of this image read out to be −2 EV using Aperture Priority mode on the camera. Those two stops of underexposure give me the right tonality. For me. Not the camera. The camera don't know. I have to give it direction

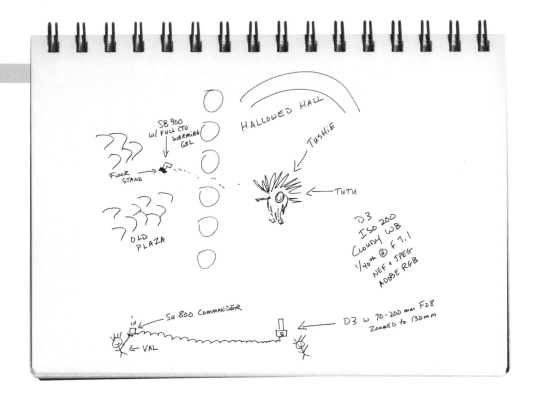

Hand-drawn sketch labels:

SB 900 w/ FULL CTO WARMING GEL

HALLOWED HALL

TUSHIE

FLOOR STAND

OLD PLAZA

TUTU

D3
ISO 200
CLOUDY WB
1/40th @ F 7.1
NEF + JPEG
ADOBE RGB

SU 800 COMMANDER

← VAL

D3 w 70-200 mm F2.8 ZOOMED to 130mm

here, and drive it to a place where, if it could talk, it would probably start debating me. "Are you sure you wanna do this?" Yes. I wanted the scene to be muted. By doing this I'm following that time-honored principle of getting the available light right, then mucking about with the flash.

And, in this instance, via the mechanism of line-of-sight TTL, I'm able to muck about with the flash pretty easily, just by viewing the results at camera, and asking the VAL holding the commander unit to adjust accordingly. This particular flash exposure worked out in relatively even fashion, with 0.0 compensation at the flash, given the fact that it was already subdued by the −2 EV at camera. The nice thing about working this way is not having to constantly walk to the light to adjust it. With wireless technology, you can effectively signal the light from the camera to do your bidding. It doesn't always

work, but when it does, yowza! Makes your life easier as a shooter, which is something I'm all for.

The 70–200mm lens is set at 130mm, and I am handholding an exposure of f/7.1 at 1/40th of a second. It seemed a reasonable combination to produce a bit of depth of field, and enable me to handhold the lens effectively. There is no magic to those numbers, by the way. I never go into a situation thinking f/7.1. An f-stop like this is still an alien setting to me. It's basically what was once referred to as a strong 5.6 or a weak 8. When working Aperture Priority, I let the camera speak, then I do the hair-splitting with pieces of f-stops and in-between shutter speeds. My main concerns were getting the image sharp and keeping a bit of depth. The only reason these numbers are special is because they worked at this particular time, for this particular scene.

As always, I wish I had shot some more, but I was happy enough with the final result. As you can see, genius here didn't start out thinking about lighting her backside. We started with a couple fairly classical dance poses and, compositionally, I wasn't happy with her placement relative to the columns. It was working alright, but I was almost at the point of hoofing it down there to direct her a bit better and re-position the light, when I thought of having her stretch and adjust her pointe shoes.

To me, this move is always touchingly, awkwardly beautiful. When a ballerina wearing a classic, sharp tutu does this, she looks a bit like a duck doing a surface dive. The back end of the tutu snaps upward like a fan and, depending on the material, it often takes light quite well. Here, the shape mimics the overall shape of the archway, which works.

And, if I told you I planned this, I would be a liar. On location, with a camera in your hands and just a few frames to shoot, some things, like f/7.1, just happen. □

Set the Table
with Light

OCCASIONALLY, as we're positioning a light, I'll say to the crew, "Okay, let's tabletop the main light." Depending on who's on the set, this will sometimes produce a quizzical head tilt, as in, "Whazzat? Tabletop the light?"

TABLE TOP LIGHT

EXTREME TABLE TOP POSITION — ALMOST 180° TO FLOOR — THIS POSITION PRODUCES VERY DRAMATIC LOOK

BEAUTY DISH

C-STAND W/ EXTENSION ARM

SUBJECT MUST KEEP FACE UP INTO LIGHT

LESS EXTREME ANGLE — LIGHT IS SLIGHTLY IN FRONT OF SUBJECT

BEAUTY DISH

C-STAND

THIS WILL PRODUCE MORE OF A FULL LIGHT ON HIS FACE

This refers to the positioning of the surface of the light source relative to the subject. A tabletop is a flat 180 degrees in relationship to the floor. Same thing with this type of light, only it's usually at a slightly less absolute angle than a table surface, most of the time. In other words, the angle is steep, overhead of the subject, but not absolutely flat. You wouldn't want to put a plate on the angle you're creating for this surface, for instance. Take a look at the sketch for a rough idea of the angle of this light.

Think of a face as the side of a cliff. It has prominent bits—like the forehead, nose, cheekbones and chin. Other areas—most notably the eyes—recede. If the sun were directly, absolutely overhead of this cliff wall, the only surfaces of it that would be clipped with light would be those promontories, the pieces of the rock face that protrude or extend. All else is in shadow. Very dramatic. There are highlights and there are shadows, and not much middle ground between the two.

Same thing with an overhead flash source. A completely tabletop position would produce extremes of light and shadow. But what happens when you tip the angle of that source off of an absolute 180 degrees to, maybe, 140 degrees? Pull it slightly forward of the plane of the subject's cliff wall of a face, and then you start to get a bit of light into those declivities and recesses, i.e., the eyes. Then you get drama, but not completely unforgiving drama.

I have referred to this style of overhead light as "goodfellas" light—it's tough-guy, "You talkin' to me?" light. It can take someone who might be pleasant as the day is long and turn them into somebody who looks like a leg breaker for the mob or a middle linebacker who leads the league in tackles. Or, just a face with serious theatrical possibilities.

This is just me talking, but my instantaneous, go-to light source from this position is often a

PILOT SHOT

RANGER HEAD + PACK TRIGGERED VIA RADIO LOTS OF POWER GIVES F11 EVEN THRU ② DIFFUSER LAYERS

FADING SUNSET LIGHT

BEAUTY DISH w/ SOCK DIFFUSER

3x3 LASTOLITE PANEL

←— DISTANCE HERE VERY CLOSE!

EXTENSION ARM

C STAND

RANGER PACK

VAL

19mm ZOOM 1/125 @ F11

PILOT - LOOKS INTO LIGHT SOURCE
CLOUDY WB - HELPS WARM GLOW OF SUNSET

WET TARMAC (VERY HELPFUL!)

beauty dish. It has a short, sharp profile, and it produces a snappy quality of light that emphasizes facial structure; it hits what it hits with a highly directional quality of light, followed by a fast fade to black. Given its name, it's unsurprisingly a popular source for the fashion crowd. Using this source naked gives you an uncompromising, edgy light. But, of course, you can mitigate the degree of contrast that this light shaper produces by diffusing it. A lot of the bigger types of dishes—like the Elinchrom 27" and others—have features and accessories that can make small but significant changes in the quality of light produced.

Most beauty dishes have some sort of deflector or light blocker either built into them or supplied with them as a drop-in, attachable item. The Elinchrom type offers access to different densities and colors of blockers—silver, gold, white (frost), and translucent. You can also get a stretchy "sock"

that is essentially a one-stop diffuser with an elastic band that whips around the edge of the dish. You can also get a dish with a silver interior or a white interior. The construction of most beauty dishes is designed to produce a pop of light that has a fair amount of zip to it, so for me, the white interior works well. The silver might be perfect for your needs, too—if, for instance, you're Halle Berry's personal photog. In my view, though, most folks out there in the world can only take so much contrast.

There are additional, external steps you can take, as well. If the beauty dish, even baffled with a sock, is still just too zingy, slide another diffuser between it and the subject, such as a 3x3' Lastolite panel. An effective way of using this combo is to place the beauty dish at a reasonable distance above the subject, then slide the panel between the source and the face, and slowly drop that panel ever closer to the boundaries of the frame until it is right at the

edge of clearance for your field of view at the camera. That way, there's separation between the flash and the panel, giving the dish light a chance to radiate and spread a touch before it is re-diffused when it hits that scrim. The result is a light that screams, but softly.

Take a look at the shot of the pilot. This is exactly the combination of elements I describe above, except off to camera left and not overhead. (It's not in the photo bylaws that this combo has to be overhead.) There's a richness to the light and an easygoing drama to the way the shadows fall off. The limitation is that he has to look off camera, into the source. If he looks at the camera, the angle of approach of the light is too steep, and only half his face is lit.

For a straight-on look with eye contact, overhead placement is most likely the way to go. For Bernard, a dancer who starkly, gracefully regards the lens, it's a well placed, appropriate light source. There is detail, and there is drama. There is just enough facial architecture, and there is light for his eyes. This overhead placement is modified and refined even further by a bounce card just below his face and chest. You can see it as a glimmer of

a low catchlight in his eyes. This softens the blow of the extreme light overhead, tweaking it, massaging it, and bending it to favor this face. It can be passive—as in, just a simple fill card that reflects the active overhead light—or it can be another source. In this type of scenario, I often blend a big light into the beauty dish with a Speedlight fill, running at extremely low power.

My fill board of choice is the TriFlip. You can handhold them very easily, just out of frame, or you can just throw them on the floor. The kit comes with different colors and intensities of reflective sheaths, giving you another lever of incremental control over the amount and color of the bounce. With an SB-900 serving as fill, it fires off the main, bigger light via optical slave mode (SU-4 mode). Play with this light in terms of position and volume. It has third-stop increments of power, so fine-tuning is eminently possible. Which is a good thing, as the amount of fill will vary from face to face. As I mention elsewhere, a good starting point is between one and two stops under the rating of the main light. But there is no magic bullet, no always-and-forever formula to adhere to. This is the playground of light. You have to run around and have fun, and find what works for you, your eye, your taste, and your subject.

I got all this in place, and really it's not much, right? One light, diffused and placed on a stand, and a handheld fill board. That's it. But I got it ready, tested the exposure, and got a pretty nice picture, in which my subject simply and serenely regards the camera. At that point, I stepped forward with a spritzer bottle and got him wet.

A good skin prep for doing this is a bit of baby oil or body sheen. There are lots of different kinds out there. (All the makeup artists seem to have their own favorite, and they always have a supply somewhere in their kit.) When this type of substance is applied to the skin, a spray of water will bead up just like self-generated sweat. (Be kind to your subject! Make it warm water!)

We were doing this to our patient model—sheening and spritzing—and someone on the set, observing all the fussing, asked, "Why are you making him wet?" I recall the question being asked in somewhat strident, judgmental tones, as if they really wanted to ask, "Why are you bothering with all this? It seems stupid and unnecessary."

I don't think I said much. I simply returned to the camera and made a frame, which then popped up on the monitor for all to see. I turned to the group and said, "This is why we made him wet."

Sometimes people just look cooler when they're wet.

And, some people look really cool, and mysterious, when you only see a little bit of them. For this effect, the tabletop placement of a beauty dish is pretty perfect. For a shot like the one of Aimiende (above, right), I used the beauty dish with the diffuser sock, but no other external diffuser was applied. And the angle of the light source is really almost classic, full-blown, radical tabletop—in other words, almost flat over her.

To make an extreme placement like this work, get your subject to crank their chin and shoulders slightly up, just a bit, into the straight-down nature of the flash. Imagine this: The light fall is just like a waterfall, a sheen of fast-moving, gravity-pulled water. The subject's face approaches it, tentatively, gently pushing into the cascade. It doesn't have to push in too far to be splashed with light.

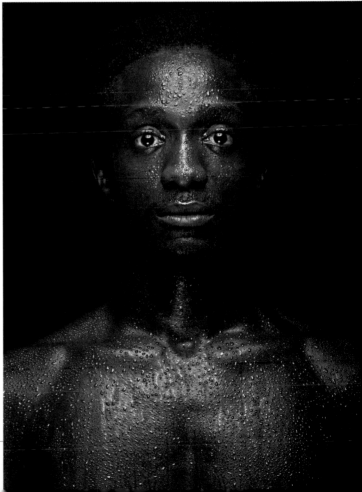

BUT THIS IS JUST THE BEGINNING...OF THE ATHLETIC, RIM-LIT PORTRAIT

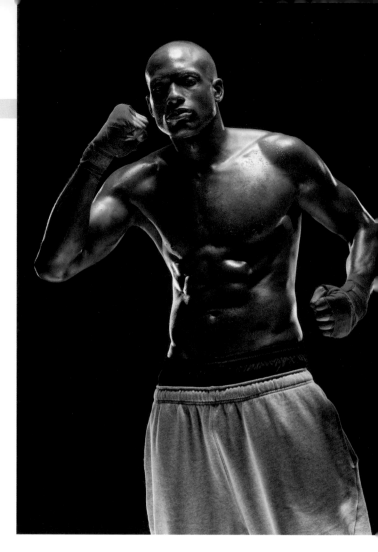

This extreme overhead placement is just a one-light beginning for an extremely popular style of tough-guy, athletic portraiture that has been popularized by *ESPN* magazine covers and all sorts of super-dramatic athletic posters. You've seen them—athlete up front, all sweat and muscle, daring somebody to score on them, with hot, almost nuclear rim lighting.

Speaking of this style of pic, why, here's one now! Aaron poses as a boxer, which he is. Overhead beauty dish, extreme placement, hardly any detail in the eyes. Again, that's the starting point. For this, I added two rim lights (both small flash) and had him stand on a big silvery reflector sheet. There are two more Speedlights bouncing straight down into that, and washing up his body. Put some oil on his torso, have him strike a pose, and bing, you're done. That snappy beauty dish drives everything.

The overhead light placement we've been discussing is the cornerstone, or beginning, of this light grid. Let's talk about it, piece by piece.

As wonderful a light source as the beauty dish is, I rarely travel with it at this point. It's just too painful. For a while, we had it stashed in a drum case, but the drum case proved awkward and bulky. We tried stuffing it into a duffel bag, surrounded by soft stuff, and it still got dinged up pretty badly. So, I found a cool, much more transportable source—the 24" Ezybox Hotshoe softbox, fitted with the most narrow and defined of the package of three creative

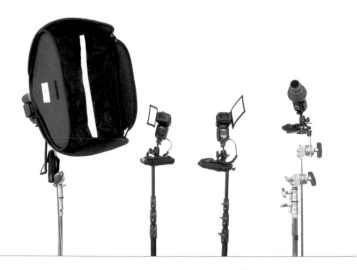

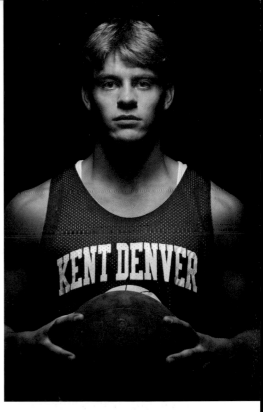

"This light zooms down the middle of the face, creating definitive cheekbone shadows and tremendous falloff toward the shoulders and arms."

diffusers Lastolite makes. Again, the savings here is on gaffer tape. I used to religiously tape strips of gaffer tape across light shapers to narrow their beam, or confine their coverage. Now, there are a lot of store-bought, factory-made options to do this. These attachments just Velcro right into the face of the box.

The softbox approach is not as contrast-y as the beauty dish, but by confining it to a narrow channel of disperson, via the creative diffuser, you do get serious drama. I use this narrow strip for the boomed, overhead light box, and I arrange it vertically, in line with the nose of my subject and about two feet above their head. Basically, it's a stripe of light that is overhead, steeply angled, and slightly forward of the subject's face, in line with the camera angle. The line of light is in line with the lens. Like a skinny highway, this light zooms down the middle of the face, creating definitive cheekbone shadows and tremendous falloff toward the shoulders and arms.

Face it, if you light some folks like this, they're not going to look good. But, if your subject is a terrific athlete, with muscles to burn and a competitor's face, it could be just the ticket. Again, it's important to have your subject angle their head just slightly up and into the path of the flash. Nothing dramatic. Just a couple degrees. For sure, don't have them look down. Then you're as sunken as their eyeballs are going to look.

The snooted grid to the rescue. Place it low, just below the bottom edge of the frame, in line with the lens and the top light. Sight it and pop it into your subject's face. If you use this at full exposure, and no other light, your subject's face will be a detached, ominous-looking cranium floating in a sea of blackness. But, moderated as a fill, and playing in concert with the overhead strip, it can ease up the shadow drama just a touch, while providing its own contribution to the tough-guy feel.

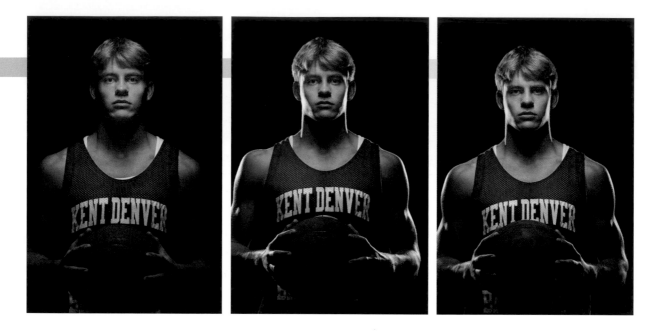

(Quick hint: This is all small flash territory, and let's face it, the attempts to equip Speedlights with a working model lamp are lame. What I do to sight this little pop of light out of the snooted grid is to use the test fire button. Pop it a few times. You can locate the center of the flash right on the subject's face. Lock it down on the stand. Tell your subject to remain in that position.)

Any light below the face and eyes can be construed to be slightly—or overtly—ominous, depending on how forcibly it represents itself in the light solution. Here, with Richard, it is severely underexposed, opening the face so slightly as to be almost unnoticeable. But it's there. Classic fill light. You don't notice it unless you outright take it away. The readout on that Group B fill light confirms this, by the way. It is programmed to manual, 1/128th power, the lowest it can go.

Having filled the face ever so slightly, you've still got the problem of dimensionality. All this frontal drama doesn't do much to alleviate the fact that he is basically pasted onto a black surface. Time for a

little depth and dimension, via rim light.

Two (or four) Speedlights, placed camera left and right, at roughly 45 degrees to the subject, maybe 10 feet away, just off the edges of the frame, should do the trick. (For the even-up placement of these units, I often stand right at my subject's backside, looking back at those lights, right and left, eyeballing their distance and placement. If you make a judgment call from the camera, there is no way you'll get them placed in symmetrical fashion. If there are two flashes—one on each side—I generally put them about eye height. If I've got the luxury of four, then they go high and low, one set up by the head, the other set taking care of the torso.) Orient the Speedlight heads vertically. The human face and body is a vertical thing, right? Play your light accordingly.

Give those lights a test pop. Check out their symmetry and the way they hit the subject. If you've been careful in their placement, the first frame could easily be right on, although it may—I repeat, *may*...this is TTL after all—be on the hot side. Also,

play with the zooms on the lights. My first instinct with lights in this position is to zoom them tight, right away, to 200mm, the max for the SB-900. But, you might find this gets too spotty and hard, so be prepared to play with the spread of these lights.

I don't worry about the heat those lights generate. First, I have touch-tone control of their power right at the camera, so I can tell them to do whatever I want via the commander flash. Second, I'm going to put a gel on them, introducing some color. That will affect the way the picture looks and feels, obviously. Do the gel thing, make another test snap, and factor from there. More power washes the color of the gel out, less power makes the color richer and more saturated. For myself, if I'm going to take the time to select a gel and tape it to the lights, I'm going to want to see it, so generally, as a rule, I will power these lights down. That will take blue from pastel to royal, red from pink to fire engine, and green from pale, icky, off-color fluorescent to outright swamp thing.

Done!

Uh, no. See the basketball? (Opposite page, right.) "Just barely," you reply. (Snark, snark.) I agree. It's not well lit; it's just a darkish orb in his hands. It needs an under light to bring it to life and make it look like a basketball. How to do this? You've got three groups and they're all out there in the field, working hard for you. That's all there is and there ain't no more. The current light readout for the (nearly) finished frame is: Group A, 0.0 compensation; Group B, manual 1/128th power; and Group C, −1 EV. Those groups are doing what they need to do, but they're not in a position to light the ball.

Do you just put out another light and hope that will fit into one of the group's already existing power ratings? That's a lot to hope for, and as location photogs, we all know we are generally bereft of hope. Or chuck the TTL baloney and go manual via radio triggers? Viable option, to be sure, but it would seem a waste to have done all this techy TTL hoop jumping and then be forced at the last minute to concede the future and revert to manual, hand-to-hand combat. Even worse, we could go optical slave mode (SU-4) and trigger the whole shebang with a very lightweight pop at camera, a blip of flash so light as to not implicate itself into the exposure and change the feel of the photo, but heavy enough to trigger the remotes. All viable, all valid.

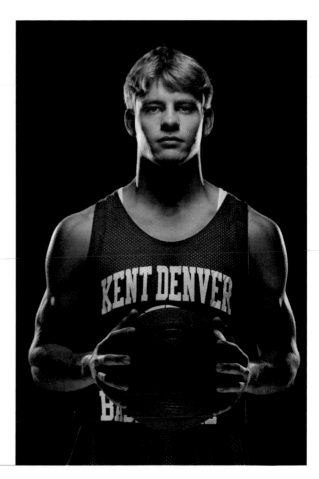

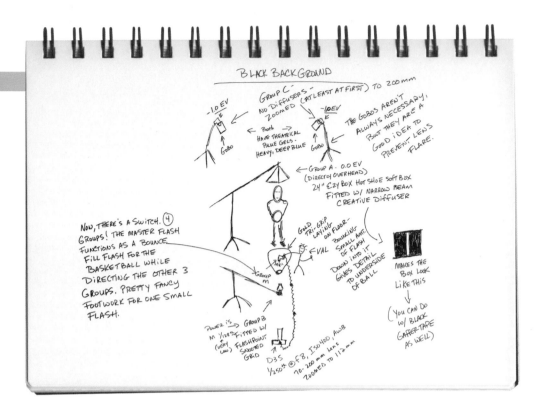

BLACK BACKGROUND

-1.0 EV
Gobo

GROUP C.
NO DIFFUSERS -
ZOOMED (ATLEAST AT FIRST) TO 200mm

← Both →
HAVE THEATRICAL
BLUE GELS.
HEAVY, DEEP BLUE

-1.0EV
Gobo

THE GOBOS AREN'T
ALWAYS NECESSARY,
BUT THEY ARE A
GOOD IDEA TO
PREVENT LENS
FLARE.

← GROUP A - 0.0 EV
(DIRECTLY OVERHEAD)
24" EZY BOX HOT SHOE SOFT BOX
FITTED W/ NARROW BEAM
CREATIVE DIFFUSER

NOW, THERE'S A SWITCH. ④
GROUPS! THE MASTER FLASH
FUNCTIONS AS A BOUNCE
FILL FLASH FOR THE
BASKETBALL WHILE
DIRECTING THE OTHER 3
GROUPS. PRETTY FANCY
FOOTWORK FOR ONE SMALL
FLASH.

GOLD TRI-GRIP
LAYING
ON FLOOR.
BOUNCING
SMALL AMT.
OF FLASH
DOWN INTO IT
GIVES DETAIL
TO UNDERSIDE
OF BALL

EVAL

GROUP
M

MAKES THE
BOX LOOK
LIKE THIS

↓

(YOU CAN DO
W/ BLACK
GAFFER TAPE
AS WELL)

POWER IS → GROUP B
M 1/128 FITTED W/
(VERY FLASHPOINT
LOW) SHOOTED
GRID

D3S
1/250 @ f8, ISO 400, AWB
70-200 mm LENS
ZOOMED TO 112 mm

But, you do have a fourth group—the master flash can be both a flash and a commander. And, via an SC-29 cord (or two), you can get it off the hot shoe and bounce it down into a gold or sunfire reflective TriFlip laying on the floor in front of the stalwartly patient ballplayer. This strategy will light the underneath of the ball, just lightly, and at the same time trigger all the other groups. Dicey, but definitely possible.

Now the readout is this:

Master flash at manual, 1/8th power; Group A at 0.0; Group B at manual, 1/128th; and Group C at −1 EV. Four groups, all listening to you at camera and talking to each other, via the master flash, which is doing double duty as an exposure-making light and a traffic cop for the remotes. Cool!

And mildly complicated. Four zones of light, all at different power levels, all responsible for different, specific areas of the photo. It can bend your brain, just a little. Here's a Speedlight strategy I adhere to, just to make things a bit simpler for Mongo. (That would be me.)

There are three zones to a photo—foreground, middle ground, and background. This is not exactly news. But, I do try to dovetail my lights with these zones, so when I am back at camera dissolving in a sweaty puddle of anxiety and my beleaguered noodle is juggling f-stops, the subject's moods, and the art director's nervous tic, I know all the time what area my lights are in and what they're supposed to do. The main light is always Group A. The middle ground lights—fill lights, sidelights, hair lights, kicker lights—are all always Group B. And the background is always Group C. Always. It keeps things simple. And I cling to those simple things in life.

So much for the sleek, athletic, rim-lit, don't-mess-with-me-'cause-I'll-take-you-to-the-rim,-Jim portrait.

IF YOU JUST WANT CRAZY...

Remember I said a light that's placed low and below the face, looking up, can, depending on how it's played, look ominous, dangerous, even creepy? Well, if you play it virtually alone, and hard, as a main light...well, it's just a hop, skip, and a jump to flat-out wacko.

Young Michael Cali, who works with us at our studio, is a great guy and a very talented, burgeoning wedding shooter. And a Justin Bieber doppelganger. Seriously. I've been with him and women have called out, "Hey Justin!" to him, spontaneously. Then in a moment of what can only be described as youthful exuberance, they fling their brassieres at him and make all sorts of intriguing promises that sound quite athletic and exhausting.

I digress. He's a terrific photo subject with a wide array of expressions, this one among them (below). Truth be told, I asked him to scream at the camera. He obliged. The guys at the studio, unbeknownst to me, and him, fixed up the rim lights with a pink gel. Nice. (He was, after all, the new guy.)

Let's work this picture back to front, okay? Pink is nice. Downright sweet and soft. Not exactly a color you want to play hardball with. If you notice, the rim-light quality on Cali is very smooth and even-toned. That's because the rims here are being generated by strip light softboxes. Long, tall, indirect boxes of light, in the back of the set, just off the seamless, aiming back towards the sides of his face.

The rim light for the basketball player was harsh and slashing because it was generated by Speedlights, which are small and spectral. The light from the strips is obviously much, much smoother. The strips have the added advantage of being long and skinny, which automatically conforms to the shape of a subject standing in front of your lens.

We're discussing this picture back to front, which is essentially how I worked it on the set, as well. The strip lights are powered by Ranger packs and heads, triggered via radio. They pop, and in turn pop the little snooted grid light that functions as the dominant main, or frontal light. He does have a softbox, also triggered via SU-4 mode, suspended over him, but it is powered very weakly. The frontal combo here is running a reverse of the light I used for the athlete. In that frame, the dominant light was the overhead, and the pop from the low snoot was just that—a pop. Here, the snoot takes over, and the feel of the picture changes dramatically. Varying the power of the lights alters their ratio, and how they play together. Think of the lights out there as an orchestra, and you are the conductor. Sometimes certain sections play strong, and others are just a whisper, barely audible but still significant. At other times, all the pieces jam together in a full-throated crescendo.

Cali has beautifully smooth, pastel highlights from big rim strobes, and an edgy, hard combo of light from small flashes for his face and eyes. ISO 200, 1/200th at f/8, on a D3X. I advised him not to show this to women he might be in a position to meet. At least not right away. □

The Two-Speedlight Character Portrait

I'M GOING TO TRY TO EXPLAIN THIS as quickly as I shot it. Here we go:

1. Put your subject in a chair, and back off with your lens. You don't have to put them in a chair if you don't want to. I just find it handy while I'm framing up a shot. It means they don't wander around, and I have a constant point of reference. They're also at least somewhat comfortable while I do all my plus and minus shenanigans. I can always lose the chair once I'm set.

2. Put two lights on sticks: one to camera left for the subject's face, and the other to camera right and slightly behind him for rim-light purposes. Take off the dome diffusers and zoom them to 200mm. Strap a Honl Speed Gobo to the camera side of that rim light so it doesn't flare into your lens. Fire a test. The back light will be close to being okay, most likely, because you want to

start with a bit of a hot rim and then back it off, power-wise, as the shot progresses. The main light will be too hot. With TTL, the first frame in a sidelight situation is almost always about a stop too hot. The camera's not getting a lot of reflectance piped back into the lens and is looking into blackness. Without good information being fed to its little brain, the command to that unit will invariably be to power up 'cause baby, it's dark out there. You will almost always need to dial this light down. This frame above is 1/250th at f/5.6 with Group A, the main light, at −1.3 (told ya!) and the rim light at even-up 0.0.

3. Put a blue gel on the rim light. It must be blue—always blue. (Just kidding! It can be any color you want it to be.) Test again. Same read as before, but the intensity of that back light comes down a touch, seemingly, with the blue gel on it. Tough to know exactly why. Who cares? It looks okay for now (opposite, top). Keep moving.

4. Zoom the 70−200mm lens from 92mm to 140mm to see if you like the feel of a tighter portrait. These zoom values are the only ones that work. Amazingly, the TTL power levels hold steady at −1.3 and 0.0. Pinch me, I'm dreaming.

5. The main light is nice, but a little severely off to the side, so have your subject look off camera in that direction. Soulfully. Meditatively. Interrupt the flow of that hard light by having someone hold a large TriGrip one-stop diffuser between the light and the subject, with that panel as close to the subject's face as possible. Test again with the same values (below). Whoops.

6. Given the diffuser, gotta get more power into the main light. Power it back up by 1.3 stops, to 0.0 power. Back light hangs in there at 0.0. Subject

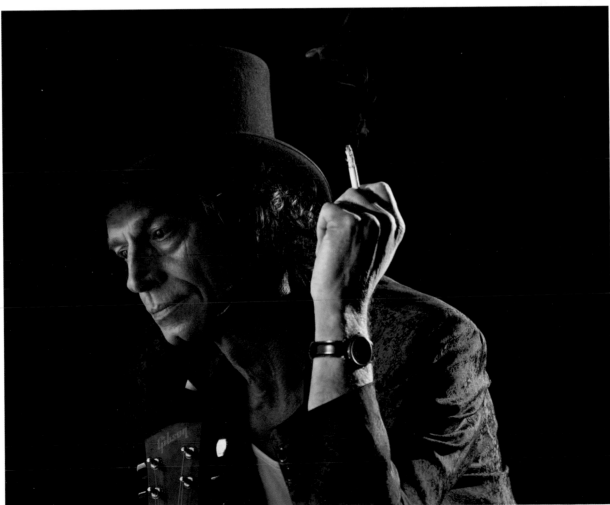

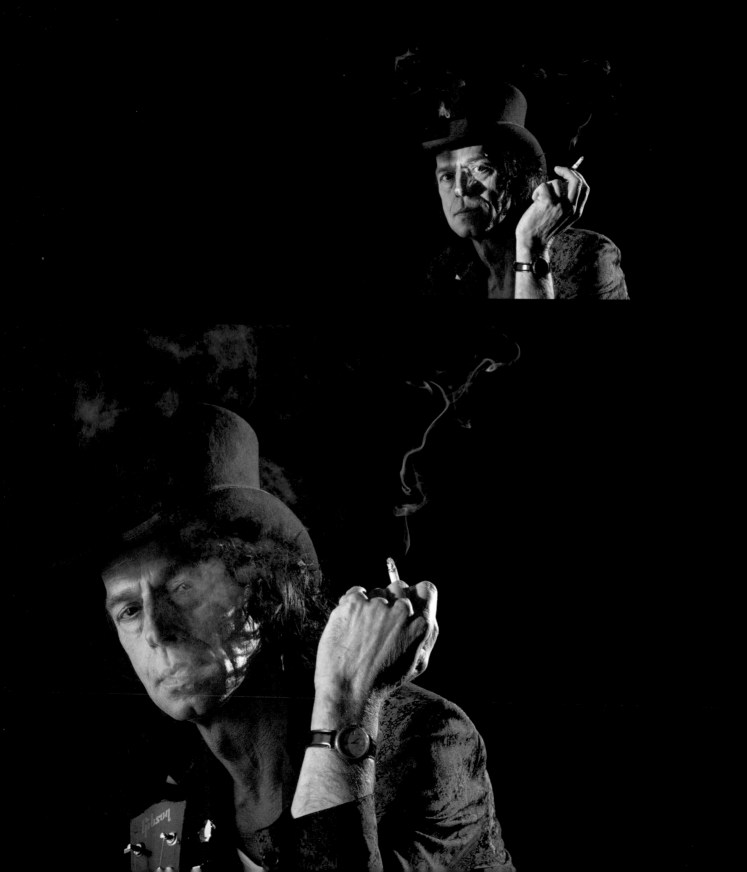

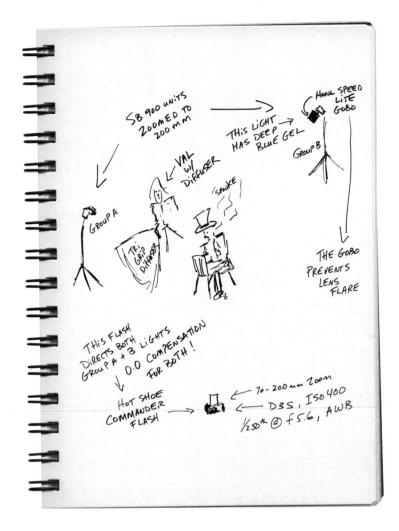

takes drag on cigarette. Looks at camera. You start to get happy (opposite, bottom).

7. If your VAL's attention wanders, and the diffuser drifts a bit off the subject's face, this image is what results (opposite, top). Soft light on part of the face, hard light on the rest. Not good. But you can't get mad about it, 'cause you're a photographer most likely doing this job with minimum funding and your VAL could very likely be doing other things right now. They're doing you a favor, so just calmly ask them to adjust the panel. If you yell at them, they'll just leave.

8. Subject takes a big drag, and exhales in a world-weary way. Smoke drifts into blue highlights. His face is appropriately lit, with character and dimension. The finals on the shot (page 165) remain 1/250th at f/5.6, auto white balance, ISO 400. There is 0.0 compensation (which means none) for both of the lights. The focus point is on the near eye. First test frame in chair: 5:27:26. Last frame—the one shown at the beginning of this story: 5:36:49. Less than 10 minutes, start to finish.

9. Make sure your subject wears a top hat, looks like Keith Richards, and smokes like a chimney. □

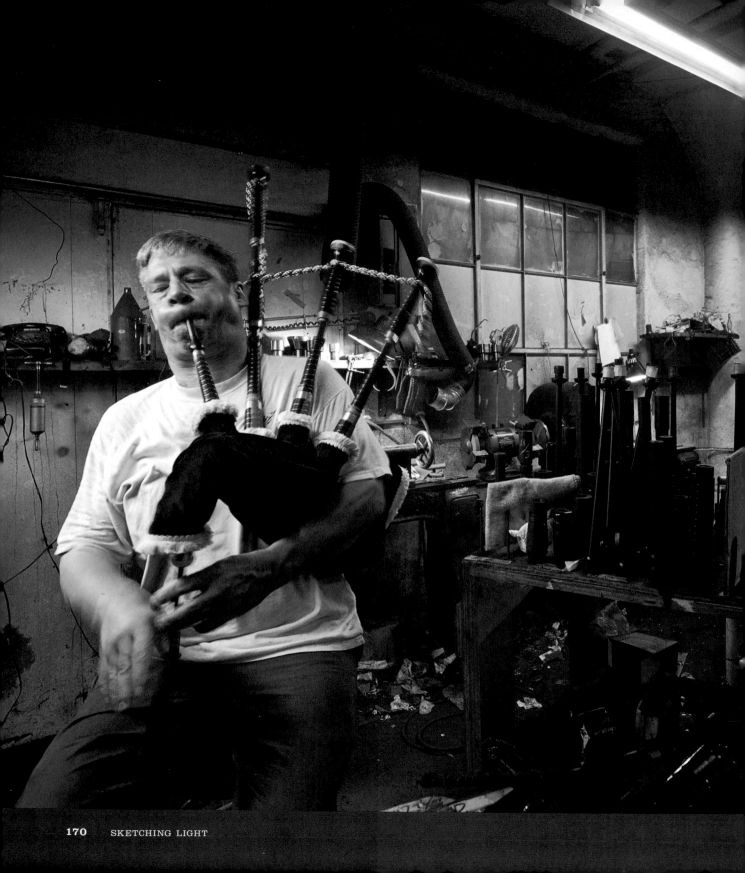

Industrial
Light

WALKING INTO CHARLIE'S SHOP was like tripping over something and falling headlong into someone's very rumpled, overstuffed, disorganized closet. There were machines, cans, papers, paint, tools, and, of course, bits and pieces of bagpipes. That's what Charlie does. He builds and repairs bagpipes.

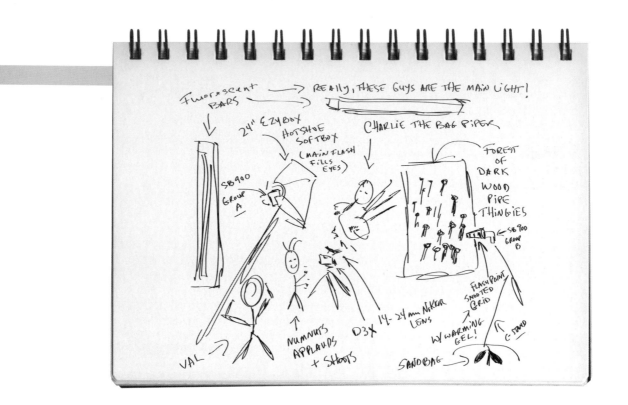

All of this glorious disarray was illuminated by a few filthy, hanging, fluorescent tubes. No window light to speak of. No glorious beams shafting through well-placed slats. The existing light was a greenish, horrible mess.

When I think craftsman, especially an old-world-type guy like Charlie with the improbable mission of keeping the pipes humming, I naturally conjure something out of the movies. Some chap with white hair and a handlebar mustache, carefully scraping away at wonderfully detailed bits and pieces of stuff at a weathered worktable, beautifully drenched in soft window light. Picture perfect, in other words.

Not so with Charlie. His shop was halfway between a grease monkey's garage and a mad inventor's hideaway. It was fascinating and rich, but hardly pretty. So what do you do? Drag in the 74" Octa as a stand-in for a big window light? Clean the place up? Prop it out like it's an ad for the Scottish tourist board? Or do you just go with the flow? Stick with small flash and just tweak the light that exists? Remember, it's a portrait, so anything goes. As the photog, you control the direction and the gesture of the photo, and if you want to make it look a certain way, the door is open to you.

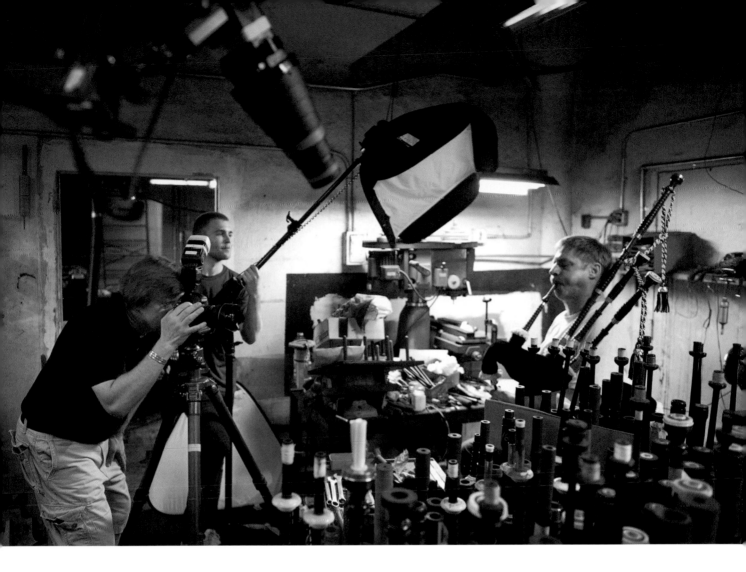

I stuck with reality. Charlie's a character, and looking at his shop, I felt like I was looking at his personality. So I went with it, in all of its disheveled glory. (He actually apologized to me, rather sheepishly, saying, "Sorry, this place is usually more organized." I was like, uh, sure, Charlie. And that would have been during the Truman administration?)

I chose wide glass and framed horizontally. It's a fine line, right? You want to show as much of the environment as possible, but still make Charlie the star of the show. In this case, 19mm on a 14–24mm zoom got me close enough, but also wide enough. I left the white balance on auto, which cleaned up the color, but not overmuch. The place was still warm, and a touch green. It felt right. I wasn't, after all, shooting for *House Beautiful*.

"The two flashes—as minimally as they are
applied—extend, bend, tweak, and shape
the unusable existing light into something that
speaks to Charlie, and who he is."

The main light in the picture was basically the overhead fluorescents, really. The shot was done in Aperture Priority mode, at −2 EV, which gave the scene some richness and depth of exposure. If I had exposed "normally"—at zero compensation—the camera's brain would have tried to seize on at least some of the shadows in the place and bring them to exposure life, as best as possible. Thus the tubes in the picture and the back wall behind Charlie would have gone nuclear, creating such a bright draw for the eye that my bagpipe-playing subject, in the shadowy foreground, would have gone unnoticed. By controlling the exposure, I wrangled the ambient light, getting it to the point of actually working for me pretty well—lighting up the background and rendering small, multiple highlights on Charlie's hair and face.

Then two SB-900 units simply partnered with the fluorescence, matching it and, most importantly, redirecting it. The ambient was all up above, lighting the top of my subject's head, but not his face and eyes. I had to push some exposure into Charlie from the side and front, popping his eyes and his instrument. Taking my cue from a fluorescent tube up high on camera left, I moved a 24" Ezybox Hotshoe softbox in as far as the frame would let me, and just underneath the fluorescent. This became Charlie's key light. It sparked his eyes and gave me enough flash pop to make him sharp, while his hand moving on the instrument at 1/10th of a second is blurred.

The other SB flash is running through a Flashpoint-snooted grid. Shaped like an ice cream cone, this cool little attachment spits out a very controllable dollop of light, just about anywhere you need it.

In this case, I needed it on the dark rack of pipes to camera right. Without exposure detail in these, some of the magic of the shop, and most importantly, some of the editorial details—Charlie's story, in other words—would be lost.

There is nothing fancy about this little spot light, running in Group B (the main is Group A). It just clips those wood shafts with a bit of highlight intensity, allowing them to become part of the information of the picture, and not just a mass of dark area sitting there next to Charlie. The only modification I made to that light, aside from spotting it down, was to gel it warm. The overall color palette of the shop is on the warm side, and if I introduced a splash of neutral, clean, white light into the mix, it would draw attention to itself, i.e., the light, not the pipes.

Lighting this way is like throwing a rock in the pond and causing no ripples. The artificial, or supplied, light is submerged into the existing light pattern. There are no telltale footprints of flash. While it is invisible, especially to the untutored viewer, it is still powerful. The two flashes—as minimally as they are applied—extend, bend, tweak, and shape the unusable existing light into something that speaks to Charlie, and who he is.

I sorted out the values for this frame right on the LCD, which of course is a textbook no-no. But in this instance, moving fast, camera on a tripod, Hoodman loupe at the ready, blinking highlights turned on, and the histogram also available, I had plenty of info to make the call. Then I just shot, and listened as Charlie's beautiful music filled that messy, wonderful shop.

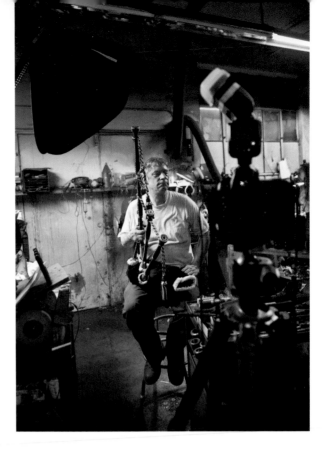

Which is now gone, by the way. Charlie moved out to a much smaller, more sterile place. The encrusted patina of his old digs, derived from years of sweat, sawdust, grease, and grime is no more. Glad I got this snap before it vanished. Pictures, just like Charlie's mournful notes on the pipes, echo. ☐

Finding Faces

A WHILE BACK, I was contacted to teach some lighting at a photo organization. Really great bunch of folks, and they pulled together a terrific weekend event. Per usual, they had arranged models to shoot. These models were very young, wonderful people, eager to get pictures made, and easy to work with. Their lineless faces ranged from downright pretty to open and friendly. They also knew how to vamp it up and project the notion of sexy into the lens. Which was great for everyone involved in this particular educational scenario.

Given the popularity of the photo workshop scene and the flash movement out there, young ladies such as I'm describing are pretty ubiquitous. Has anybody out there cruised through the website known as Model Mayhem? Yikes. Seems like a rite of passage now, really. Everybody's out there, working it. "Do pouty...that's it, do sexy, yeah, now work it, work it...."(Really not being sexist here, I don't think. I know there are men being photographed, as well. But at the end of the day, most of the people in front of the lens are women, and most of the people behind the lens are men.)

And there's some really good work out there, with many talented folks creating it. But there are also yards and yards of stuff that are facsimiles; they are poorly done reproductions of a look that is supposed to be au courant, or hollow replicas of something seen in a magazine. In other words, it's posing that is about something I think I'm supposed to look like, and if I wear very little and move around a lot and my boobs are stuffed into a corset that makes them look like missile launchers...man, is that hot or what?

Well, to turn a time-honored phrase around a bit, *pretty* or *hot* or *sexy* is nice, but it sure isn't interesting. Or different. Or fun to shoot, necessarily. It might be all steamy and sweaty, and the gyrating photo subject/gymnast out there on the seamless might indeed be working it, but after a few dozen of these you start to realize it's really more about exercise than thoughtful photography. And trust me, I'm as guilty as anyone in this regard. Photographing an attractive person is better than a poke in the eye with a sharp stick, right? You could do worse than shooting a hot, young, ripped, cut, bouncing, full-lipped, sloe-eyed, brassiere-bursting package of youthful hormones stuffed into skin that has seen a lot of loofah time.

Sometimes, though, when confronted with this type of energetic scenario—and maybe I'm just getting old—I actually want the person to stop. Please, just stop and look at me, and consequently, the camera. Do *thoughtful*. Look away. Remember something important. Look at me like you know something I don't, and these pictures are a series of questions you answer, a little at a time, giving me dollops of knowledge about you and your life, but not all at once. Like an investigative reporter, the camera seeks, and it is quite content with snippets that can be put together later. Let's just take this a pixel at a time, shall we?

When I photographed Michelle Pfeiffer wearing the National Gem Collection of the United States, I was, of course, nervous. Would I be up to the task? I knew we would get along, as we had already met, but could my camera keep up with her? Were my ideas any good at all? Would she look at me like I was crazy? Or an idiot?

We did fine together. Smooth. I had done my homework. The various scenes and sessions went great. She was a great beauty, adorned with an array of brilliant, legendary gems. At moments, she was cerebral and studied; at others, she was aloof, ethereal. She could radically alter her mood and expression simply by moving an eyebrow. She rarely smiled, and when she did, it was in a quiet, knowing way—not a toothy Gap ad of a grin that screams, "This fall it's RED!" (Though of course there's a place for that, too.)

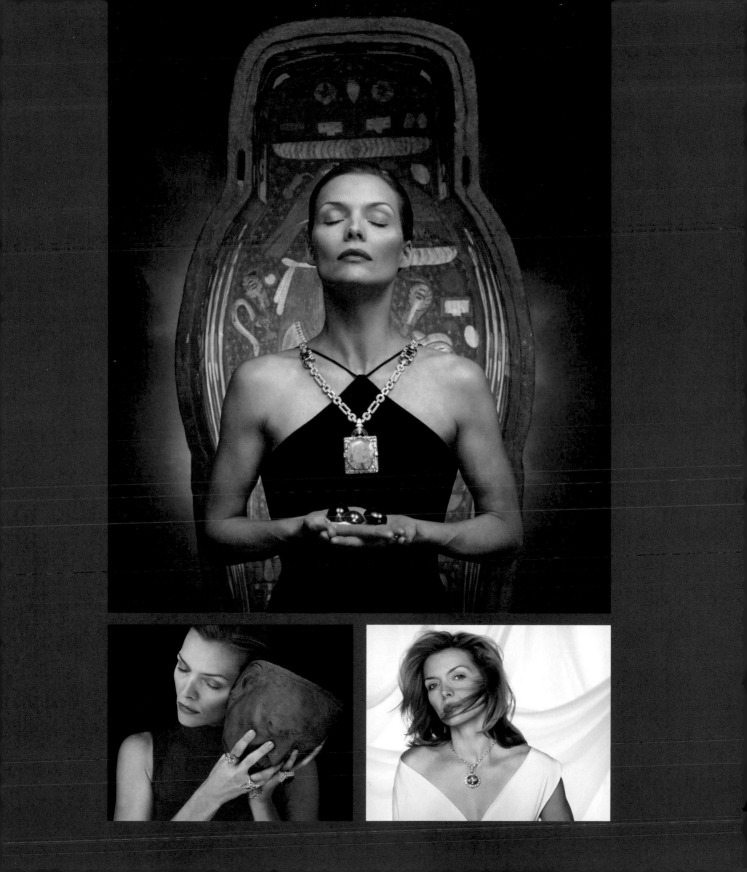

But she looked at the camera as if it was a co-conspirator; the two of them were in on something, and the rest of us, if we were patient, would eventually catch up. She spun a web around the set, and all were caught up in it. When that happens, as a shooter, you have to step forward, realize what's happening is special, and be protective of it, even if it means being a bit of a curmudgeon. At one point, the director of the Smithsonian (which housed the gem collection) came down with an entourage to offer a gift to Michelle, which she accepted graciously, while we were in the middle of a take. He and the museum gang then settled in behind my camera, thinking they were now at the movies. I shot two more frames and I turned around and invited everybody to leave. I did it nicely, but I was firm, and Michelle was very grateful. While what you're creating as a shooter is a very public art form, sometimes the creation of that art needs to be private. Connection with the subject is everything, and it can get lost in the noise of a busy or populous set.

A truly effective session with a camera is like courting. You're sending notes and flowers, and definitely making some intimate late night phone calls. It's called getting to know you. A set of pictures that leads somewhere is like a series of dates that gets progressively more interesting and committed. The camera plays the role of an ardent, earnest, proper suitor. This process could be termed a seduction, but it's a delicate, hesitant, and respectful one. Like any relationship worth a damn, the whole thing has to be handled delicately, like a treasured Christmas ornament. Many of the pix out there on the internet are such a no-frills, in-your-face slam dunk of plastic sexiness that the creator with his camera seems not to be an inquisitive, interested gentleman, but more like a drunk at a bar sidling up to a hot chick and blurting out, "Wanna boff?" Charming, eh?

I digress, but what I am saying here is that I am a seeker of faces. Faces drive me. I stare at people, quite frankly. I'm lucky at this point in my life that somebody hasn't just come up and clocked me, confusing my interested, head-tilt gaze—with the resultant daydream about the light source and angle—to be an outright leer. It's especially awkward, of course, when my object of interest is female. But, to be honest, when it comes to choosing and sizing up photo subjects, I am literally an equal opportunity leer-er.

"While what you're creating as a shooter is a very public art form, sometimes the creation of that art needs to be private."

So it goes at workshops. I'm always scanning for faces to put in front of the camera. The workshop I mentioned at the start of this ramble was no different. I did due diligence to the young ladies assembled for the gig—the paid talent, if you will—but I was also in scan mode. Seeking, seeking, all the time, for the face, the person who would simply confront the camera in an interesting way. Way at the back of the room, I found a gentleman named Eric, not young, not old, but definitely sporting a visage that announced he had lived life. He was quintessentially comfortable in his own skin, which you could tell from his easygoing demeanor. He was surprised but not at all ruffled by my offer to stand in front of a couple hundred folks to be photographed.

We were together photographically for all of about 10 minutes, and if I had my druthers I'd have fine-tuned the backlights, feathered things here and there, all that finesse stuff you do as a shooter

"Presence in front of the lens. How do you measure it? How do you know when someone's got it? It's a hard call."

pursuing a portrait. But at that moment the point wasn't the light, really. It was connection. His personality, his confidence, his look—it all added up to that ineffable quality we all seek for our cameras: presence. I actually think the best picture of Eric would have come at a different time and setting—maybe at a coffee shop with window light, with the click of a camera punctuating a conversation.

Presence in front of the lens. How do you measure it? How do you know when someone's got it? It's a hard call. Some of it's cheap physical, of course. Looks. Very important. But looks that have defined themselves. I'm not down on youthful models, but you have to accept the simple fact that their personality is not yet formed, so what you're shooting is the surface. Which is okay, 'cause there is no underneath. Just like car photography, it's all chrome, highlights, and color.

But it goes beyond looks. There may be a quietude to someone's behavior, a steadiness of gaze that you pick up on. The next day at this workshop, doing a field demo, a young lady came along who was a friend of the makeup artist. From the moment I saw her, I simply had to shoot her. I did my class lessons with the workshop models. All very nice, and instructive. But then, I set up in the intense Florida sun to make a picture of Antoinette.

Having spent a good deal of time in Africa, I could tell from her look and the inflection in her voice that she was from that amazing continent. Born in Nigeria, studying in Florida. In this instance, I was determined to finesse and finish the light, and complete the portrait. At the same time, I tried to incorporate a lesson for the workshop about the mechanics of shooting in high-noon, tropical sun.

The beaming sun on days like this is intensely bright, and small. A far-away spectral light source, creating knife-like highlights and

shadows. No forgiveness out there in the baking heat. First thing to do when it's like this is, of course, run for cover. Find open shade. That blessedly cool darkness gives you back control of the light, makes your subject less of an egg in a frying pan, lets them look at you with full eyes and not squinting slits, and enables you to actually see what you have just shot on the LCD. (By the way, bright sun equals Hoodman loupe. On days like this, gotta have one, or your camera LCD is just about useless.)

Classic open shade is generally created by opaque objects, such as leaves on trees or the sides of office towers. Another strategy is to stay in the sun, and simply baffle it with a diffuser very close to your subject. You are putting them in a condition I'll refer to as bright open shade—not traditional open shade, the like of which you'll find on the north side of buildings. The hard sun is not hitting a solid item, it is hitting a translucent one, and that creates a very bright, vibrant quality of shade. You are channeling and modifying the power of the sun here, taking that small, violently specular highlight in the sky and turning it into a lustrous, hugely beautiful light source very close to your subject.

But, even though your subject is now bathed in very shootable light, what have you done? Cut the level of that light by at least a couple of f-stops. Fine for the subject and the immediate area around them, but what of the background? If it is still dominated by the unfettered sun, whatever you are shooting at back there will gather exposure power and either blow out completely (relative to the foreground) or at the very least go to highlight heaven.

If you are looking for that type of airy feel in the way back of the shot, shoot away. You are done. But if you want to subdue the background, you need to replace the light you lost by using a diffuser on your front matter. In other words, re-supply some of the power of the sun, but do so nicely, on your terms. Given the relatively new magic of high-speed sync, you can face down the sun (in a local, limited fashion) with a couple hot shoe flashes that run on AA batteries, which we will do here. That seems like a mismatch, of course—a couple of small flashes squaring off against the power of the heavens—but a combo of flash placed close to the subject, along with extremely high sync speeds, can do it.

We thoroughly discuss the mechanics of high-speed flash in another part of this book, so we won't dive too deep into the f-stops

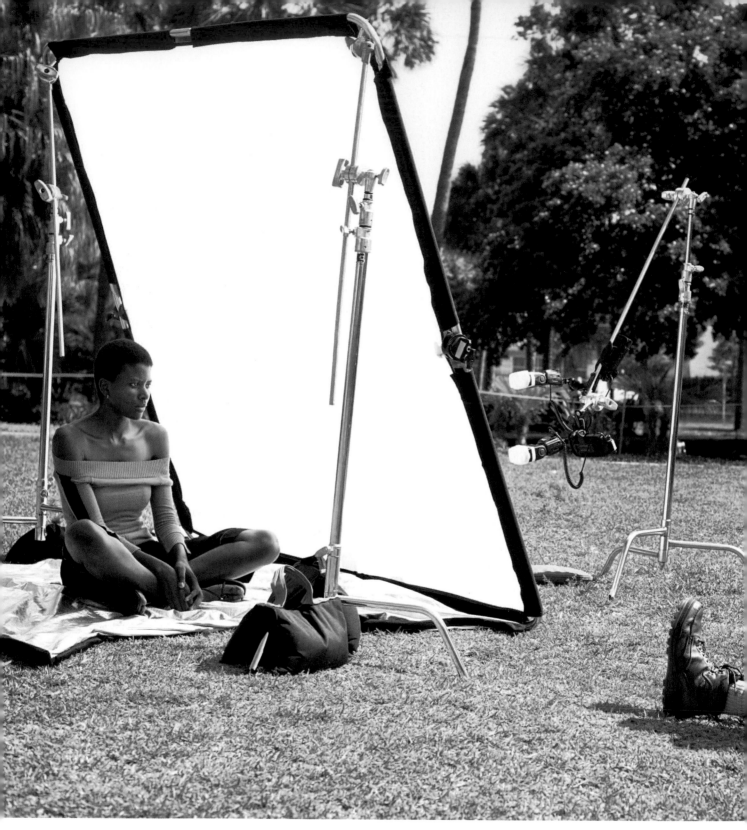

and shutter speeds right here. Instead, let's talk about more important, aesthetically crucial matters, such as how to shoot it. I purposely placed Antoinette in an area where, when I framed her up with a long lens, the camera would see only trees. Witness the stunning photo I made of just the background (page 183). On blazingly bright days like these, trees make for good backgrounds because that greenery will go dark fairly quickly without any real reflectance or highlight problems. Also, when a stand of trees gets thrown out of focus, it is often very mottled and pleasing. Just textures and shadows. You don't have to wrestle it to the ground, photographically.

That leaves me to concentrate on my subject. If you notice, she is sitting on a reflective silver blanket. Why? As I just indicated, green absorbs light pretty well, so the grass won't give me great lift and bounce, but whatever does report back into the lens has a very high likelihood of being tinged with green. (Light picks up the color of what it hits, right?) So I nix the greenish bounce of the grass, but still amp up the bounce factor itself with the silver blanket. It is 6x6', same size as the silk. That's the nice thing about the Lastolite kits—they come with diffusers, and options for reflectors, all the same size. You might pick up on the fact that I am wearing shorts, too. My legs are rated as a +2 EV highlight on most light meters, and by moving them around strategically I can introduce subtle fill and highlights to the scene.

Antoinette is also, you might notice, sitting *very* close to the main light source, which is a 6x6' one-stop diffuser, supported by two C-stands. You don't

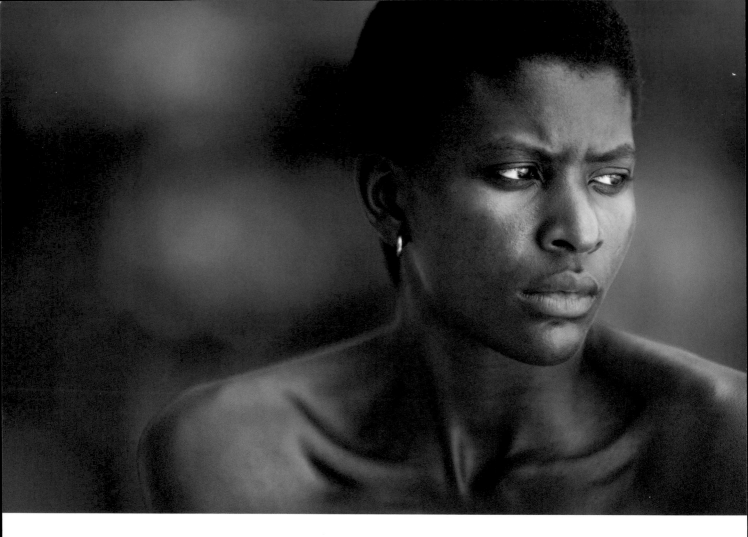

have to do this with two Cs. You could get away with one, or use regu-
lar stands. The crucial item is not the stands; it's the sandbags at the
bottom of the stands. If you want this much material to be stable, you
gotta weigh it down. It's a sail, basically, and even a smallish breeze
can take you and your lighting rig to parts unknown. The light stand
with the hot shoe flashes is not bagged. It's creating little to no wind
resistance.

Some folks I know actually take bigger silks to a seamstress or
tailor, who in turn will slice open vents in them, and then stitch around
them so they don't continue to rip. This can lessen the wind pressure
and, interestingly, create a port you can stick a camera through. If I
were very close to my subject, using this silk frontally to her instead of
off to the side, a vent would be very handy. Without venting, I would

basically have to back the silk off a touch and jam my head up against the material to get the clearance I need to shoot the photo.

Enough on the support system and wind patterns. The truly important factor is how close she is to all that material. I'm working a tight frame with the long lens, shooting right through the fairly narrow channel created between the surface of the silk and the vertical pipe of the stand. Which is cool. I don't need a lot of room with the 200mm. Forget about a wide lens in this configuration, though. If I wanted wide, I'd support the 6x6' with C-stands from the back, using the extension arms to clamp onto the silk frame, and leaning it forward into position. The angled position is important. Intuitively, I feel the light source should tip towards the subject, instead of being flat and even in relationship to them. By leaning the light source, there is an ever-so-slight increase in brightness up where you need it (the face) which then (again, ever so slightly) tapers as it goes down the body.

The two SB-900 units have dome diffusers on them, splashing their light on the piece of silk closest to Antoinette. They both are running SD-9 external battery packs, which won't up their overall power but will increase their overall efficiency by cutting recycle time. Also, in intense sun like this, I occasionally shroud the SB-900 (which will overheat with heavy use) with aluminum foil. The flashes are made of black plastic, which will serve as a magnet for hot sun, thus making the units hot before you've even popped a frame. So, while I didn't do it on this shot—being unprepared as ever (no foil!) and keeping the light stand in the shade till the last minute—if I were to attempt to use the units in the shade-less desert all day, I would wrap them in foil.

This is not a piece of scientific advice, by the way. I have not gone out to the Mojave with SB units, foil, and a thermometer. I just hark back to the days when I have been stuck on a camera stand in hot sun all day waiting for a news event to happen, with six feet of black telephoto lens attached to my camera. In those instances, you might as well put your whole rig on a spit and start turning it like a roast, 'cause that's what you're doing to the lens—roasting it. Most shooters in this situation used to cover their lenses with foil to reflect back the heat. So, at least occasionally, I have employed this time-honored tactic with my flash units.

The finals on this frame were 1/6400th of a second at f/2. Minimum depth of field. Crucial focus dropped on the eye nearest the camera. Background hugely out of focus, and saturated. My regal subject turns into the light, and her solemn gaze belies her youth. There is history there, behind those eyes. Stories to be told. The simplicity of her architecture, and the wonderful lines of her face and shoulders all speak to having a quiet, commanding presence that holds the camera's attention.

Lots of lessons here. A lot of camera and lighting principles at play, all operating in concert. There are the physical aspects of the shot—big source, supporting it, angling it. Small-flash strategies at work. Background choices and solutions. Lens and f-stop choice. All worthy of discussion, analysis, and debate.

What's the biggest lesson by far? Find the face that owns the lens. □

How Do You Get Fired from LIFE?

IT'S AN ODD AND IRONICAL BUSINESS, RIGHT? This art, craft, and business of making pictures. We photographers are celebrated, told ridiculously flattering, untrue things, patted on the back and the head. Shows are staged, award dinners thrown, and parties linger into the night. All in rapturous celebration of pictures and those who make them. We stand at podiums and receive brass blocks, glass ingots, checks for modest sums, and accolades extolling that particularly exquisite higher level of understanding that propelled our lenses to look just this way at just this instant.

Some of the hoo-hah is deserved. This is not an easy thing to do, and there are photographers out there who deserve every scrap of recognition that comes their way. Their lives are a testament to tenacity, relentless curiosity, a steadfast sympathy for the human condition, and bull-headed resilience. The best shooters are, at their core, good storytellers. They see the best and the worst of us, and their visual dispatches enrich, inform, move, tweak, nettle, provoke, or outright discomfit the rest of us.

They refuse, ultimately, to be corralled behind the velvet rope and record the sanitized view of the world that the spinmeisters roll out for viewing. So many out there would push and pull us for their own purposes! Or outright squash us.

BALLET'S
MOST
FAMOUS
COMPANY
SEEKS TO
REKINDLE
THE
MAGIC.

BOLSHOI
OFF
BALANCE

ONCE UPON A TIME, not very long ago, Moscow's legendary Bolshoi Ballet was making plans for a 1997 tour of the United States. Indeed, the company wanted to be here . . . oh, right about now. Well, it ain't comin', even if it could use the money. Rather than visit Lincoln Center or even Lincoln, Nebr., the Bolshoi has chosen to keep its leaps and lunges, pirouettes and arabesques in Moscow, where it will help the city celebrate its 850th anniversary in September.

For a taste of what you're missing, enjoy them here as they twirl through the streets and neighborhoods of their exotic, ever-changing hometown.

Photography by **Joe McNally** Text by **Charles Hirshberg**

Nadezhda Gracheva, is the Swan Princess, en pointe—and on high—in Moscow

64

Surrounded by busts from the museum's collection of ethnic sculptures, Pfeiffer shows off the **VICTORIA-TRANS-VAAL DIAMOND**, one of the most elegant jewels in the Smithsonian treasury of more than 10,000 pieces. Cut in the shape of a pear, this 67.89-carat gem glows in a circlet of 108 matching diamonds like champagne in sunlight. Today the Victoria is worth at least $3 million, but in the 1950s the De Beers diamond cartel paid a miner in South Africa a bonus equivalent to $75 for finding the raw, 240-carat mother stone from which the jewel was cut.

Here is a feast for the eyes, America's national jewels, a galaxy of gems more magnificent than the British royal family's. The sinister Hope Diamond, the stunning Hooker Emerald, the colossal Logan Sapphire—they are all kept in the Smithsonian Museum of Natural History, their safety assured but their splendor dimmed by shatterproof glass. Now for one brilliant moment, removed from their cases while the Gem and Mineral Hall is under renovation, the collection's masterpieces glitter for the camera. They are displayed for the very first time as jewels are always best displayed—worn by a beautiful woman: Michelle Pfeiffer.

Photography by **Joe McNally**
Text by **Brad Darrach**

ROMANCING THE STONES

When the Shooting Stops

We refuse to go along. As a group, we're like a big Nerf ball. Step on us here, we'll squish out over there. Shut the front door, we'll climb the fence and knock on the back. Ragtag and persistent, we collectively refuse to let well enough alone, and just slip away quietly, or stand in a corner, mute and inactive. We run when others walk. We work when others play. Our lives are often a passionate mess, with the only moments of clarity achieved during those crucial moments when our eye is in the lens, and the world is seen through that familiar rectangle. The click of the shutter when that occasional good or even important frame is made is absolution, redemption, and validation, all rolled into a sliver of a second.

Given the degree of difficulty, the occasional attaboy is much appreciated, to be sure. But be careful! Reading your own positive reviews is prelude to actually believing them, and once you sink into the myth of yourself, the pictures get a little out of focus. To me, the cult of ego that surrounds certain shooters engaged in this most fragile of endeavors is unexplainable.

We are not the thing. The story is the thing. The viewer is the thing. We are just a vessel, a conduit. It's important that we do our job well, but then equally important that we step out of the way and let the pictures do the rest. Like having children, you have to let those pictures go, and they will do what they do.

We live to tell stories, to experience, and then to communicate that experience. I have always loved

What is the cost of war? For millions uprooted by the decade's armed conflicts—and for one photographer who traveled the world to capture these panoramas of devastation—it is too high. PHOTOGRAPHY BY **JOE McNALLY**

AFGHANISTAN
One of every 129 Afghans is, like these patients at a Kabul clinic, an amputee; most were maimed by land mines. Some 110 million of the devices are planted around the world.

the example of sportswriter-turned-novelist Paul Gallico. He was a writer, but he didn't phone in his stuff. Just like a photog, he got into the middle of things, which once meant he got into the ring with Jack Dempsey, the Manassa Mauler, to see what it was like to go toe to toe with the heavyweight champ of the world.

He got knocked out. Then he wrote about it. And his description vibrates with reality, much more than if he described someone else getting his lights punched out from a perch up in the press box. For Gallico, the story was indeed the thing. I have always loved what he once told *New York* magazine: "I'm a rotten novelist. I'm not even literary. I just like to tell stories and all my books tell stories.... If I had lived 2,000 years ago I'd be going around

to caves, and I'd say, 'Can I come in? I'm hungry. I'd like some supper. In exchange, I'll tell you a story. Once upon a time there were two apes....' And I'd tell them a story about two cavemen."

We tell stories with pictures. All the other stuff, including the awards and the every-so-often recognition of the work, is crap.

I am the last staff photographer, ever, in the history of *Life* magazine. You would think that would be a pretty big deal, right? Kind of, you know, a career-insuring, ongoing, no-more-worries kind of job. It sort of was, for about three years. A quick parable, if I may.

I was asked to join the staff of *Life* magazine in the middle '90s, and thus became the first staffer there in over 23 years. The original staff had been disbanded with the demise of the weekly *Life*, and the reborn monthly edition got along on freelance work. Putting the words "Staff Photographer" up on the masthead of *Life* after all that time was considered by some to be mildly newsworthy, but only briefly.

The job lasted three years. During that time, I worked for three different managing editors. (In magazine parlance, the managing editor is the boss. It's his or her vision that is the ultimate arbiter of what gets published and what doesn't.)

Let's describe my time as a *Life* staffer as fun while it lasted. Kind of a roller coaster ride—lots of swerves and tilts at high speed, and quite brief. One of the last major stories I was allowed to do was called "The Panorama of War." As the title suggests, I dragged a couple 617 pano cameras with me to some fairly dicey places to shoot the aftermath of conflict, and the tough conditions some of these unfortunate nooks and crannies of the earth cope with on a day-to-day basis.

The story was hard to do, and well received. So much so, it won the first Alfred Eisenstaedt Award for Journalistic Impact. Geez, who'd'a thunk it. Won an Eisie!

On the awards night, the joint was filled with swells, and there was a lot of good food and wine. It was quite well attended. (Free food and booze always brings out journalists.)

My name was called, and I went to the podium and got my chunk of glass—a sculpted interpretation of the human eye—and a check for $1,500. Cool. Said some nice things. Smiled at everybody, even Norm Pearlstine, then Editor-in-Chief of the whole company, who was sitting in the front row looking for all the world like he was in the dentist chair. (He was a former editor of the *Wall Street Journal*, so a night celebrating pictures was not exactly his cup of tea.)

Through my smiles and nods, there was one thing I knew—and only a couple others in the room knew—right at that moment of one of the biggest attaboys I had ever gotten. The previous week, I had been fired by *Life* magazine.

You see, the latest edition of the boss who arrived at the mag was brought on specifically to fire a bunch of folks, myself among them. On the day that *Life* as we knew it ended, she wore white, and literally flew down the hallways, doling out pink slips every fifteen minutes or so. My appointment, as I recall, was for 1:15. I made a Post-it noting the time, drew a little happy face on it, and stuck it on my computer screen. Cheeky bugger!

I knew what was coming and was determined to have fun with it. First line from her: "Joe, as you might imagine, we are not going forward with the position of a staff photographer." My reply:

"Sure, why would a picture magazine have a staff photographer?"

So, my staff job was no more. I was back on the streets, in my later forties, with really nothing going for me except having a few very used cameras and, of course, my sculpted Eisie eye. It was a situation remarkably similar to when I first showed up in NYC, albeit some 20 years previous. I had no job back then, either. Just some ideas, hopes, and a couple battered cameras. Lots of clicks under the bridge, and there I was, with the big job gone, and back on my own pins. *Life*, too, was almost gone. (The magazine limped along for a brief stint under the new boss's stewardship, and then it folded. A cool thing about having been a staffer? I got my kid on the cover!)

I had to dig in, redirect, and find work.

Point of this parable? No matter who you work for—*Life*, *Time*, the *East Bramblebrook Daily Astonisher*, your own blog about your own life, or just your Facebook page—you are working for yourself. You cannot take a camera in your hands and hope somebody just pulls you along. You can never feel safe, or self-satisfied. If you predicate your sense of self-worth or self-esteem or fulfillment as a shooter on what somebody else does to and for you and your pictures, you will be miserable, 'cause no one—certainly no publication—will treat your stuff the same way you would. If you hit a patch of easy street where some editor thinks you are the world's greatest picture maker and lavishes praise, high-paying gigs, and first class air tickets upon you, know that the editor in question will be fired.

Whatever good thing you have going as a shooter, understand this: It will evaporate, deteriorate, get worse, or just shrivel up and blow away.

Fun, huh?

The life of a shooter is driven by passion, not reason. This is not a reasonable thing to do. A colleague I know offers this advice: "If you want to do this, you have to make uncertainty your friend." Indeed, you do. In this life of uncertainty, it is, however, absolutely certain that some bad stuff's gonna happen to you.

What follows are some notions on coping.

If the angels sit on your shoulders on a particular day or job, and you knock it out of the park, feel good—giddy, even—but get over it. Tomorrow's job will be on you like a junkyard dog, and will tear the ass outta your good mood in a New York minute.

If you win a contest, appreciate it, be gracious, and give thanks to everybody involved, especially your editor and the magazine, even if they had nothing to do with it and actually did their level

best to obstruct you at every turn. Contest wins give a warm fuzzy feeling inside, but shrug it off 'cause tomorrow it'll still cost you $2.25 to get on the subway.

Understand that the money monitors who show up at these photo fetes and breathlessly exclaim, "Love your work!" while shaking one of your hands with both of theirs are simultaneously eyeballing you and wondering why you cost so much money and there's lots of pictures out there for free nowa-days and why aren't we using them? Smile back, and be thankful to them that for a brief interlude, they lost their sense of fiscal responsibility, and somehow you got a bit of budget to do something that, originally, was terribly important only to you, but because you executed it with such passion and clarity, it has now become important to lots of people, given the impact of your photos.

Know whole bunches of folks will try to take credit for everything you just did. It's okay.

Understand that in the world of content-desper-ate big publications, and the multi-nationals that own them, that next year's contract will be worse than this year's. And if the contract is real, real bad,

they might actually hire somebody to come in and explain why it's "good for you" in so many ways. Know that the phrase "good for you" is interchange-able with "you're screwed."

Know there will be days out there that feel like you're trying to walk in heavy clothes through a raging surf. The waves knock you about like a tenpin, you have the agility of the Michelin Man, and you take five steps just to make the progress of one. The muck you are walking in feels like con-crete about to set. Even the cameras feel heavier than normal as you lift them to your (on this day) unseeing eyes.

There will be these days. You must get past them with equanimity and not allow them to destroy your love of doing this. Know on these days you are not making great art, and that every frame you shoot is not a shouted message of truth that will forever echo down the corridors of time. You are out there with a camera, trying to survive, and shoot some stuff—however workmanlike or even outright mediocre—that will enable you to a) get paid, and b) live to fight another day.

There will be times when you cannot pay the bills. You look at your camera and desperately wish

STRONG WOMEN

Xena. Buffy the Vampire Slayer. Ripley. In a year of cartoon women warriors, we found six of the genuine thing.

PHOTOGRAPHY BY **JOE MCNALLY**
TEXT BY **JEN M.R. DOMAN**

Fiona Apple
She grew up on the West Side of Manhattan, a true daughter of the Big Apple. Her lyrics are as moody as the city's streets after dark, her voice full of urban pain. Since the success of *Tidal*, her first CD, Apple, 20, can afford to take limousines, but she'd rather ride the subway—even if she has to wear armor.

"I WILL ALWAYS HAVE THE COURAGE TO SAY WHAT I WANT."

WHILE CONGRESS DEBATES THE WISDOM OF CONTINUING OUR PARTNERSHIP WITH RUSSIA'S SPACE PROGRAM, THE ASTRONAUTS STATIONED OUTSIDE MOSCOW IN STAR CITY GIVE COOPERATION A THUMBS-UP.

High-flying cosmos and astros from left: Yuri Gidzenko, Jim Voss, David Wolf and Sergei Krikalev

STRANGERS in a STRANGE LAND

Photography by **Joe McNally** Reporting by **Lisa Sonne**

THINGS I THINK I KNOW. HOW DO YOU GET FIRED FROM LIFE? **195**

LIFE

Babies are SMARTER than you Think

They can **Add** before they can **Count**. They can **Understand** a hundred words before they can **Speak**. And, at three months, their powers of **Memory** are far greater than we ever imagined.

JULY 1993/$2.95
07

it was an ATM or the stock portfolio of a far more sensible person. Have faith. Return your phone calls. Keep shooting, if only for yourself. Actually, *especially* for yourself. Use this work to send out reminders that you are around and alive. Stay the course.

Love this fiercely, every day. Things change, and generally for the lonely photog, they don't change for the better. What you are complaining about today, after the next few curves in the road you'll recall with fond reverie. "Remember those jobs we used to get from the Evil Media Empire wire service? The ones where they paid us 50 bucks, owned all our rights, and we had to pay mileage and parking and let them use our gear for free? Remember those sumbitches? God, those were the days, huh?"

Remember we are blessed, despite the degree of difficulty. We are in the world, breathe unfiltered air, and don't have to stare at numbers or reports trudging endlessly across a computer screen. Most businesses or business-like endeavors thrive on a certain degree of predictability, sameness, and the reproducibility of results. They kind of like to know what the market's gonna do. By contrast, we are on a tightrope, living for wildly unlikely split-second successes, and actually hoping those magic convergences of luck, timing, and observation will never, ever be reproduced again.

We don't know what's gonna happen, and most of the time, when it does, we miss it. Or what we think we're waiting for actually never happens. It's anxiety-producing, and laced with forehead-slapping frustration. If we were a stock or a bond, we would undoubtedly get a junk rating. Not a smart pick, no, not at all.

But what a beautifully two-edged sword this is! What shreds your hopes one day cuts back, just sometimes, and offers up something to your lens that's the equivalent of paddles to the chest. Clear! You're alive again, and the bad stuff and horrible frames fall away like dead leaves in an autumn rain.

At those moments, the camera is no longer this heavy box filled with mysterious numbers, dials, and options. It's an extension of your head and your heart, and works in concert with them. Whereas many times you look through the lens and see only doubt, at these times you see with clarity, precision, and absolute purpose.

Know these moments occur only occasionally. Treasure them. They make all the bad stuff worth it. They make this the best thing to do, ever. □

LIFE

Naked
POWER
Amazing
GRACE

A Photographic
Celebration
of the Olympic
Body
by Joe McNally

A Meditation
on Athletic
Beauty
by Lisa Grunwald

JULY 1996/$3.95

DIVER
RUSS BERTRAM

LIFE

Naked
POWER
Amazing
GRACE

A Photographic
Celebration
of the Olympic
Body
by Joe McNally

A Meditation
on Athletic
Beauty
by Lisa Grunwald

HEPTATHLETE
JACKIE
JOYNER-KERSEE

JULY 1996/$3.95

LIFE

A Photographic
Celebration
of the Olympic
Body
by Joe McNally

A Meditation
on Athletic
Beauty
by Lisa Grunwald

Naked
POWER
Amazing
GRACE

THE
U.S.
WATER
POLO
TEAM

JULY 1996/$3.95

LIFE

A Photographic
Celebration
of the Olympic
Body
by Joe McNally

A Meditation
on Athletic
Beauty
by Lisa Grunwald

Naked
POWER
Amazing
GRACE

JULY 1996/$3.95

SPRINTER
GWEN TORRENCE

Big Light, Small Flash

WE ARE IN AN ERA of intense interest in small, portable flash photography. Speedlights, so named for their versatility, ease of use, and thus, presumably, speed of use, are rocking the house. Small, light, and fast! Get in and out! One-man-band stuff.

Which is cool. Bigger lights still have a sense of belonging to the studio world, high-budget jobs, assistants, heavy stands, and multiple cases of stuff. Properly so.

And, of course, what tends to go along with the above sensibilities is an understandable corollary reasoning that bigger lights drive through bigger sources, like whale-sized Octas. The small Speedlights are matched up with light shapers that are collapsible, stuffable, cheap, easy to carry, quick to set up, and thus not very big. Big enough to get good light out of, for sure, but not with the size or sophistication of sources you might match up with a 2400 Ws, big-box unit.

But technology forges ahead and continues to open doors—and possibilities—for small flash shooters to get good, big light, even though they are using Speedlights. (Note the plural.) And the techy aspects of those little flashes can actually trump their big brothers, depending on the situation. Here's an example.

For this picture, I used an 84" reflected umbrella. Nothing fancy, nothing sophisticated. It costs $100. Umbrella light is basic light, right? It is often the first way station on that winding country road of flash photography. You might expect, quite naturally, that for coverage purposes this type of broad-based light source would require a studio type of flash head: one big head plus one big umbrella equals good, big light. Cool.

And, truth be told, I would hesitate to put just one lonely small flash into this ocean-sized light shaper. It could easily drown in there. But three? Hmmm. A TriFlash bracket can comfortably hold three small flashes on three separate cold shoes that surround an umbrella sleeve. And those shoes now ratchet, so the sensors can be arranged in a uniform direction. In the old style of TriFlash, the cold shoes were fixed, and thus the sensors were permanently at right angles to each other.

So, why this big umbrella and not just an Ezybox Hotshoe softbox, or a smaller, "regular"-sized umbrella?

My subject here is Claudette, a Caribbean musician whose personality is one part whimsy and two parts mysticism. I wanted to show her in a dense sweep of St. Lucian jungle, which meant stepping back from her with a wide lens. Which meant pulling my light back a distance from her. Which meant that, if it were a smaller, softbox type of light, it could get hard and shadowy, really fast. Not what I wanted.

Size of light source and the distance of that source to the subject dramatically affects the quality of the light, right? Small source, far away? Hard light. Big source, up close? Softer light. (I say that

a few times in this book, you might notice.) The use of a wide lens to show lots of environment for a portrait forces you to push your lights back and away, with resultant loss of the diffusion and grace of the light. One way to counteract this is simply to chuck the small light shaper and go big. (And, by the way, here's a helpful field tip: always test your lights out! Even if that means using yourself as a stand-in for the subject [right].)

And go big with small flash. Again, referring to the current intense interest in all things lighting, it is not uncommon now for shooters to have two, three, or more Speedlights in their kit. Place those into a large source like this umbrella, and you can defy traditional wisdom by getting big-light quality out there in the woods, with the added benefit of push-button, TTL control right at the camera.

And...you also get...drum roll...the access, technology-wise, to high-speed sync. If you want to limit your depth of field and control the focus of the greenery in the background of a photo like this, small flash gives you that gift, via the mechanism of high-speed sync. You have virtually no restrictions

on your shutter speed, as long as your two or three Speedlights can muster the power to throw enough light. That was certainly the case here, as I immediately went to f/1.4 on my f-stop ring, which pushed my shutter speed up to around 1/500th. (I discuss high-speed sync in depth in the next chapter.)

Try getting a big flash down to f/1.4. You'll find yourself running it out of the B or C port of the pack—the one that gives you the least power rating—and programming the absolute minimum of juice into it. And then, quite possibly, layering a

bunch of neutral density filters onto the light itself. (Neutral density filters are gels that don't really alter the color of the light, but they knock the stuffing out of its power. They're smoky gray in color and generally come in one-stop increments.)

But then, if you got the big pack to squeak down to f/1.4, it'd be tough to get your shutter speed up fast enough to where it would give you a proper exposure at that super-wide-open f-stop. There's a lot of experimentation right now with high-speed syncing of bigger power packs (sometimes called hyper-sync), but the traditional limit to normal sync with studio units is generally 1/250th of a second, or sometimes even just 1/200th. For this scene, 1/200th at f/1.4 would've been blow-out city, blinkie heaven. The ambient light level, combined with an enforced, "normal sync" shutter speed, would have forced me to use a more closed-down f-stop. Smaller f-stop means more depth of field, and more clarity to the jungle. Which could have been okay, but it just wasn't what I wanted here. I was going for minimum depth of field.

(I was about to go all au courant and say I really wanted all that beautiful, gorgeous bokeh, but instead I threw up in my mouth.)

This setup is dead-bang simple. One big umbrella, camera right. The pieces of it are a stand, the TriFlash, and the reflective style of brolly. Three Speedlights. Camera, with fast prime glass. Commander flash on the hot shoe. All the lights are in one group (A) because, effectively, they are one source. There was only one adjustment I made when I changed subjects from Claudette, the time-less minstrel, to Alana, the ingénue bride. For the

latter, I simply brought in a silver TriGrip as a little bit of a beauty reflector. That's it. Positioned right under the umbrella, it's flat, like a tabletop, and catches a bit of the low spill from the main light and flicks it back up into her face. In one move—and without adding another light—the feel of the flash solution transforms from a softly directional char-acter light into a big beauty light.

There are folks who occasionally quibble with the practice of using multiple Speedlights to do a job that one bigger flash could do quite well. They are absolutely right. A Ranger unit or a Profoto 7B can easily supply a ton of portable light power with-out the headaches of AA-battery lights, iffy line-of-sight triggering, and even iffier TTL weirdness. But here, I think, the substitution of multiple little lights for one big one makes technological sense, and isn't a case of just using Speedlights for the sake of using Speedlights. I don't know anybody who would do that. That's just plain, I don't know, stupid.

So big flash, right? Uh, no. Small flash! Nope, not really. Whaddaya call this? Big small flash? Small flash done big? Dunno. But it works in terms of control. You get the beauty of a big, expansive light source, and the touch-tone control of small, dedi-cated Speedlights.

Either way you go will have a price tag, to be sure. As I have mentioned a couple times, your workflow and style of shooting will direct whether you dump coin on small lights or big lights. You alone have to choose your own brand of relatively expensive poison. The gear, no matter what brand or type, costs, to be sure.

But, then, nice light in the jungle? Priceless. □

The Aesthetics of High-Speed Flash

SOUNDS FANCY! And boring! Bear with me.

High-speed flash has been discussed ad nauseam in any manner of photo flash guides, in addition to the riveting, emotional descriptions of this technique that you'll find in the manual.

It's been around for a while, and is now a fully disclosed, hashed-over, knowable camera function, as opposed to back when it was first introduced as a cool new techno wrinkle in camera work. At that point in time, getting a flash sync speed up to $1/8000^{th}$ of a second was so unheard of that it sounded like some sort of photo black magic—a ritual-based menu option in which the blood of chickens needed to be spilled onto the camera sensor. Auto FP high-speed sync! Strange juju!

For Canons, the switch is on the flash. For Nikon users, it's on the camera. Activating it does nothing to the normal operation of the flash in concert with the camera. And by "normal," I mean flash pictures up to and including $1/250^{th}$ of a second, as a general rule. By activating the high-speed option, though, you open the door to the possibility of syncing your flash at super-high shutter speeds that are decidedly not normal. This feature is handy for bright sun conditions and, of course, for stopping motion.

This function, I think, is cursed by its multi-syllabic, clinical-sounding name, and the fact that any discussion of how it works involves the Speedlight pulsing, the shutter blades traveling at super

speed, and a power loss factor that grows exponentially as you climb the shutter speed scale. Whew! The manual makes it sound like you're attempting fusion, not a simple frame of photography. Easy to turn the page on this, right? You think, "I'll never use that! Sounds too technical!" But high-speed sync has its uses—even if you are not trying to freeze-frame a bullet going though an apple.

Like...it's very handy and simple to use if you want to make a background disappear or go really, really out of focus. The curse of the power loss it creates can become a commensurate blessing, if you are able to accommodate that power loss by a radical widening of your f-stop.

(Why the power loss? Once again...here we go. At very fast shutter speeds, you don't get all the light, just pulses of it—slivers, really— through the traveling blades of the focal plane shutter. An awful lot of the light produced by the flash gets trapped on the backside of those blades and never gets to the subject. Just pieces of it. Hence, to counteract this loss, you employ certain basic strategies, like moving the flash really close to the subject, using it at full power, opening your f-stop, and stripping off any diffusers, which soak up even more power.)

"It's very handy and simple to use if you want to make a background disappear or go really, really out of focus."

Let's say you're out there in bright, bright sun, which is a ready-made situation that high-speed sync can help you work out really well. At a reasonable digital ISO of 200 in raw sunlight, harking back to the sunny-sixteen rule—in bright, open-sun conditions, your ISO becomes your shutter speed at f/16—a likely meter reading will be about $1/250^{th}$ at f/16. Follow the bouncing ball: 250 at 16 is 500 at 11 is 1000 at 8 is 2000 at 5.6 is 4000 at 4 is 8000 at 2.8.

Most of the time, I'd prefer to shoot a street portrait or a bride at f/2.8 rather than f/16. And, provided you can work your Speedlight in to an effective working distance from the subject, this flash response to those intensely sunny days is eminently doable. And logical. Big sun equals high-speed sync.

But, you can painlessly use this feature even on those days when the atmospheric conditions don't absolutely demand a high-speed response. Take a look at the available light picture of Rebecca in the alley (opposite page, left). Charming, huh? Nice job, Joe. ISO 200, $1/80^{th}$ at f/11. Bright sun in the background, open shade up front. I think the no parking signs and the dumpster are nice touches, don't you?

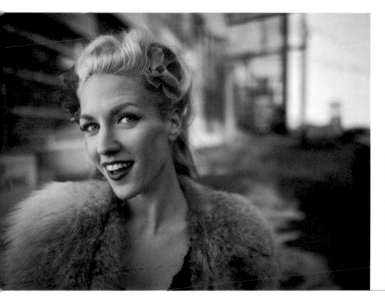 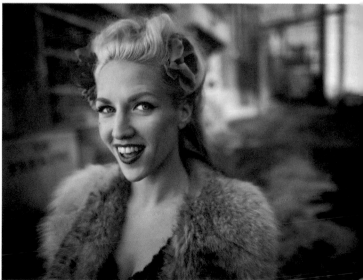

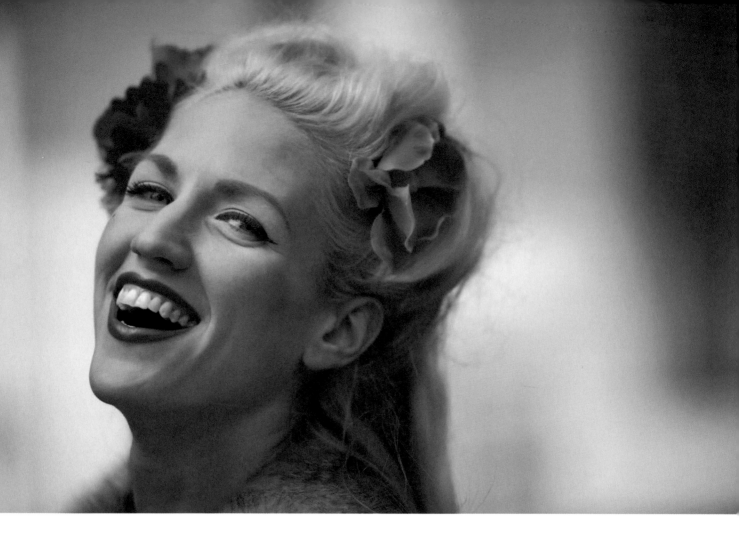

Okay, pull out a flash—in this instance, a single SB-900 into a 30" Ezybox Hotshoe soft-box. This one's not my best effort, either (page 206, right). There's no light in the eyes, and the flash is underpowered, relative to the scene. It's shot at 1/160th at f/11, which is within a normal range of sync speeds. Smooth, huh? Now, I still have a badly rendered, busy background and a poorly lit foreground. I'm doing well with this.

The changeover to a prettier picture came by opening up the lens radically, to f/1.4. I don't know whether it's been pressure from pros, or the realization on the part of camera manufacturers that variable f-stop zooms have limited appeal, but there now exists on the market a new breed of ultra-fast prime lenses. After an intense concentration on zoom lens technology for many years, focus (forgive me!) has returned to fast, sharp, fixed-focal-length glass. The pictures in question here were made with a 24mm f/1.4 (previous page).

Okay. I opened up to f/1.4 and moved the flash as close as I could, and a touch lower. This lady's got deep-set eyes! I set my shutter speed to 1/8000th. Presto. The background

Marc Koegel

settles nicely into out-of-focus texture and she pops, not just because of the light but also because she's the only sharp thing in the picture. Even the filthy water in this alley has a certain charm at f/1.4.

Understand that for every shutter speed you climb above 1/250th—the line of demarcation between normal and high-speed operation—you lose just about half your flash power. So, even though the flash is real close here, remember I am firing it through a dome diffuser, through an interior baffle, and through the exterior diffuser layer of the softbox—at 1/8000th of a second. That's a lot to ask of that one flash, so I sent it a TTL signal to go +2 EV. That ramp-up in power gave me a good exposure.

Sticking with this approach, I changed up lenses to a 70–200mm, zoomed all the way to 200mm. I downshifted to 1/4000th at f/2.8, and shot some tighter headshots. With the telephoto at f/2.8, the

background goes bye-bye. I know that 1/8000th at f/1.4 is not exactly equivalent to 1/4000th at f/2.8. It's a stop darker, really. To shoot at this combo, I needed even more power out of the flash. I bypassed TTL, and sent it a wireless signal to go manual, 1/1, the most powerful setting the unit's got. It was just enough.

But here's the beauty of working like this: It ain't in the numbers. It's in the control of those numbers and how they, in turn, affect the aesthetics of the picture. At one point, I framed my subject vertically and, because I liked the girders and poles in the distance, down that Vancouver alley, I switched

back to normal flash operation and shot at 1/160th at f/11 in Aperture Priority mode. Going back down the f-stop scale to f/11, a pretty closed-down setting, I picked up a ton of depth of field, and thus the graphics of all that background stuff now reads. I was also able to mute the tonalities of the background a bit by dialing in –1 EV at the camera—a global input that affects both the ambient light for the scene and the local light of my flash. Correspondingly, I sent the flash a TTL message to go +1 stop, and I brought in a silver fill board just under

the model's face. Done. According to the metadata, this entire set of pictures took 20 minutes to shoot.

I maintained the same fast pace on a pedestrian bridge in Hong Kong. There was nothing pedestrian about our model, so I wanted at least two different looks. Gotta move fast when you have a supermodel on your hands, so again, playing with the numbers, I was able to knock these out in a matter of minutes.

We were in open shade, so I didn't need high-speed sync to rescue me from harsh sun, nor did I

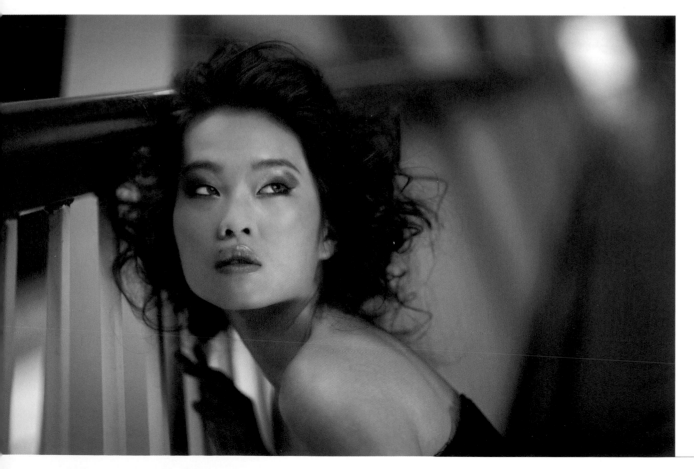

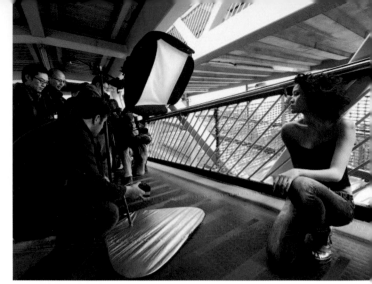

Louis Pang

need it to stop fast motion. I simply used it to play with the graphics of the bridge.

First situation: fast glass to the rescue! I shot with an 85mm f/1.4, and placed the lovely Evon by the railing. I wanted all that metal to fade, focus-wise, so using manual exposure mode, I went wide open to f/1.4 and pushed my shutter into high-speed territory, at 1/2000th of a second. That combo gave me a decent, workable saturation for the scene. (Remember to get the scene exposure first! The available-light frames you make to establish this are just as important as the flash pictures!) I pushed a 24" Ezybox Hotshoe softbox in close and just above her. As you can see, there's a gold TriFlip laying on the ground, and Drew is handholding a Group B fill light bouncing down into it. The main light is running at +0.7 (i.e., +2/3) and the low light is straight-up 0.0—no compensation at all. The gold reflector accounts for the slightly warm tonalities of the low light.

The flashes are not being overtaxed here—mostly, I suspect, because the 1/2000th shutter is not too awfully radical. Remember you lose power in increments as you ascend all the way to 1/8000th. At 1/2000th and with the lights in close, there are generally no power problems. I will advise, though, that anytime you go to high-speed sync, you use an external battery pack. You are still pushing the system, especially when using just one main light. The extra batteries give you more leeway to push the edges and have good recycle time.

I then moved Evon over to the middle of the bridge (following page). Here, I figured I'd just change up and go for depth, and a different kind of graphics. I headed back down to normal flash territory, which is, of course, accomplished just by shifting the shutter speed, f-stop, and flash power. No heavy lifting, just some button pushing.

Here are the changes I made to get this look.

Changed lenses to 14–24mm, set at 16mm.

Changed white balance to incandescent, B4. (Super cool.)

Put a full conversion CTO gel on the flash. This brings the look of the flash back to a "normal" skin tone, even though the camera is set for tungsten balance. Depending on how you want the model to look, you often need to play with additional warming gels—layering a $1/8$, $1/4$, or $1/2$ CTO gel on top of that one, full conversion gel. That main gel gives you an even-up trade-off between the daylight temperature of the flash and the tungsten balance programmed into the camera. (The gel essentially turns that daylight Speedlight into a tungsten balance flash, with roughly the same color temperature as the incandescent bulb in the reading lamp by your bed.)

But there are variables, such as how much of the ambient light level of the scene might bleed into your foreground, flashed exposure for the subject. That light seepage, if it occurs, will be a cool color, and it might drag skin tones toward the blue side of things. Likewise, you might program in slight variations of white balance at the camera. I went to incandescent as my overall space to work in,

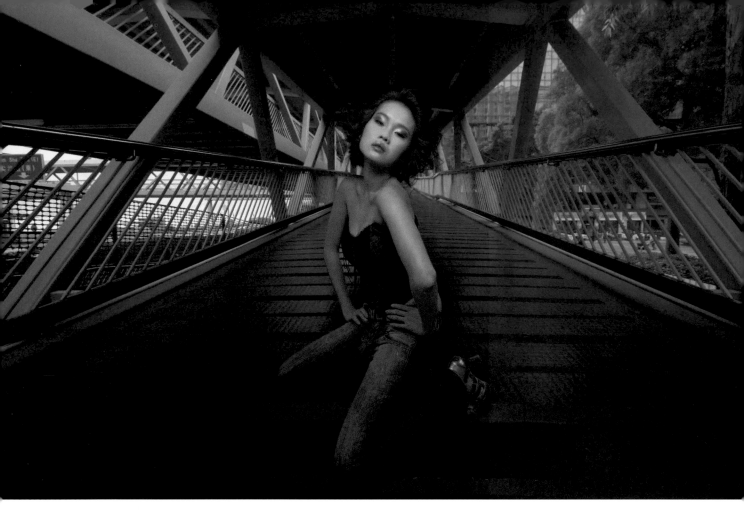

but then I pushed it just a touch cooler via small incremental sub-commands. (This type of white balance customization is available on most higher-end digital cameras. Check your manual.) You have to make these small but crucial decisions ad hoc, at the camera, on location, depending on the way you want things to look.

Closed down my f-stop to f/8 to give me a great deal of depth with the wide glass.

In Aperture Priority mode, I programmed −1 EV into the camera, which gave me a shutter speed of 1/80th. The underexposure makes the blue tones of the background get richer and more saturated.

I used only one flash. No fill. That SB-900 is pro-grammed at +0.7 via a wireless TTL command from my commander flash at the camera.

All done.

Are you noticing a trend here? In the famil-iar confines of normal flash sync, I tend to live in Aperture Priority mode, and I comfortably play the very easy game of ratios between camera EV and flash EV adjustments. It's an ever-shifting game, of course, and on location you might find yourself starting with one command at camera and a cor-responding command at the flash, and ending the shoot with different values programmed on both

> "Things slip and slide out there, and it gets messy. You have to make constant judgment calls, largely from your gut."

fronts. As I keep saying, there's really no right or wrong here, and absolute precision is virtually impossible a great deal of the time. A −2 global EV adjustment at camera will not always dictate a +2 adjustment at the flash. Things slip and slide out there, and it gets messy. You have to make constant judgment calls, largely from your gut. Location strategies are often ad hoc, and they depend on a wide range of unpredictables—changes in weather, clouds, and light; the subject's skin tone, and whether they went to the tanning salon yesterday; what they're wearing (what part of "Don't wear a white shirt" did you not understand, sir?); the framing you use, which affects how close your flashes can be placed to your subject...and so forth.

But, once you get used to the numbers and establish conversancy and control of them, even the fire swamp of location work holds no more fear. I actually enjoy the math of camera work—and trust me, math was not my strong point in school.

So, it's easy to shake, rattle, and roll a bit when working "normally." Within those parameters, you have lots of options to mix and match settings as you see fit. But high-speed sync is not normal operation. When you get seriously into fast flash, you are de facto operating at the limits of the flashes and the extremes of f-stop and shutter speed combinations, and your range of options gets a bit tighter. In this realm, I tend to take over the camera, abandoning Aperture Priority to drive the train myself. No more plus or minus stuff. If I want it darker, in manual mode I just make the shift accordingly via f-stop

or shutter speed. That will then dictate the move I need to make at the Speedlight. For the flashes, if I am close in to my subject, I can stay in TTL mode and dial in power settings as I see fit. Often, though, in the rarefied air of 1/4000th and 1/8000th territory, I just send the flash a signal to go manual—and usually that manual setting is 1/1, or, in other words, all the power you've got, Scotty.

Okay, let's shift inside. Inside? Why would you use high-speed sync indoors? Well, the windows might be very bright. And you might want to soften them up and make them sort of, you know, go away.

Tavish (page 215, top) has got a face made for a short, sharp light. He's got movie-star good looks and a set of cheekbones that I'm sure turns heads wherever he goes. Uh, that's probably why he's, you know, a fashion model.

The gear for this was crazy simple: one SB-900 flash with an SD-9 battery pack, and a LumiQuest III handheld softbox. The reason it's a handheld light is that Tavish is a mover in front of the lens. He gives you all that good stuff you want from a model—constant mobility of body position and facial expression. It's cool, and your job at camera is to keep up with it.

The sun is fading in the west, but it's still pretty bright. I put on a 50mm f/1.4 and positioned Tavish about 20 feet in front of a big set of windows. The final numbers on this shot are 1/800th of a second right at f/1.4, and ISO 100. At that aperture, the window shapes just become soft graphics and the late sun a gleaming, warmish highlight.

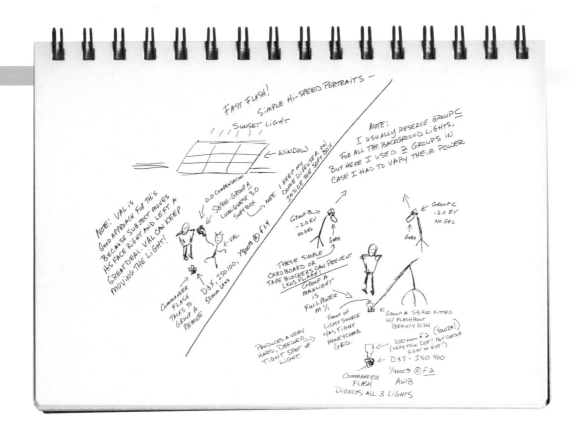

The challenge? Keeping critical sharpness at f/1.4. Tavish is moving, and I am at camera constantly adjusting the position of my focus cursor to stay right on his eye. I don't want to miss expressions and the ongoing nuances of his face—it's my job not to miss them. But it's fast-paced and dicey, because there's no forgiveness at that f-stop.

Okay, so there's a use for it indoors. But a nearly blacked-out room? Huh?

Here's the thing. Sometimes I just want to see what I can do with various settings and techniques. It's not driven by need; it's driven by curiosity. Sometimes I'm showing some folks the possibilities, and hopefully being explanatory in word and deed. Other times, I just see a face, and it speaks to me, and to a certain way to approach it. Elex (opposite page, bottom) has one those faces.

He has a determined look and an angular, intense quality, both in his visage and in the way he regards the camera. He also has temples and a facial structure that is simply made for rim light. Even in a room without environment, I wanted to come up with something, some fillip of difference in the way I approached this portrait. I didn't want to just toss this off with an average try for a picture. It's not an average face.

Here's where camera work rules. You have no environment—no chipped, painted walls; no rusted boiler room; no large spinning ventilator fans with smoky light shafting through them, the type that Hollywood movies always seem to able to find to put in the background. I have no background, only foreground. His face. So I went with long glass, super wide open—200mm at f/2. Drop the cursor

right on the eye. With this combo of length of lens and aperture, your DOF is razor thin.

The light source for this is the tiny little Flashpoint beauty dish that I mention and demonstrate elsewhere in this book (see pages 15 and 65). It's super tight spill of light, and hard, clean, directed light are perfect for a face with architecture and hard edges like Elex's. But with just a simple, frontal, one-light solution, he will float in the blackness, and this image will have no depth or dimension.

Time for rim light. You can manage two lights, three lights or 20 lights in high-speed sync mode. The number of flashes is irrelevant. The same issues persist—chief amongst them is management of power. For the two rim lights—given their angle-of-incidence/angle-of-reflection look back at the camera—power is not an issue at all. They literally skip off my subject's temples, producing a highlight gleam that easily reads.

The finals here are ISO 400, 200mm lens at f/2, 1/4000th for a shutter speed. The main light is up there at the ceiling of its power, 1/1, manual mode. The two skip lights, though, stay in TTL, both running at −2 EV. See the disparity there in terms of power? That main light is running through a light shaper, which in turn has a spot grid over it to tighten up the spill and sharpen the focus of the flash. It's doing the bulk of the exposure work for the whole picture, and the high shutter speed and the honeycomb grid are chewing up a lot of power. I make sure I move that light as close to his face as the frame allows.

By contrast, the skip lights have no light shapers or diffusion. They are zoomed to 200mm, so they really zero in on their mission of edging out Elex's face very efficiently. Plus, all I need from that carom of light is an edge, a glimmer. □

Up Against the Wall

STRAIGHT FLASH BE UGLY, RIGHT? You can take someone who has a wisp of a chance of being attractive, and easily turn them into Quasimodo via the transformational wonders of bad light.

But sometimes it's the only game in town. Sometimes, you have to use it. And sometimes, maybe, it's not so bad. Given my well-announced criticisms of straight flash on the camera, I thought I'd take a look at it and see what happens when you're locked in to one light, perched on the camera, on axis with the lens.

It might be my overactive imagination, but when I'm looking at someone through the lens with a flash on the camera, I always have the sense that I am a U-boat commander at the periscope, peering at the hapless human on the seamless as more of a target than a potential portrait. "Range: Five meters and holding! Plot firing solution! Fire!" Then there's this almost viscerally felt whoosh at the camera, followed by the blinding impact of harshly flung photons at this unsuspecting, defenseless merchant ship of a subject. I continue to peer through

the optics as he or she, grievously wounded by my ineptitude, slowly slides below the waves.

I digress. Back to the business at hand, which is nuking the entire scene with a full-blown, straight-flash light treatment. When you pop the dome diffuser on most flashes on the market nowadays, they automatically zoom to their widest possible dispersion, tracked in millimeters. There are various possible numbers associated with different makes of flashes, but a wide play of light from the camera generally pulls in anywhere around 14 to 20 mil-limeters, more or less. Hence, if the zoom feature on your flash reads out at 14mm, it will theoretically cover the field of view of a 14mm lens. Again, in theory, the coverage is complete, and edge to edge, with no falloff of the light. Also, many flashes have an "auto zoom" mode where, when programmed properly, the flash tracks with the lens. In other words, when you zoom the lens, the flash zooms with you. It will go right through a bunch of mil-limeter lengths, keeping pace with your lens until said lens gets "too zoomed," i.e., too long. Most flashes have an upper end of about 200mm for their zoom function.

I rarely go into full-blown clinical test mode, but I decided to try this out against a white wall. I put a very attractive subject, Ashley, out there, swiveled my peaked cap around backwards, and went into submarine captain mode.

First shot I tried was with a 24–70mm f/2.8 Nikkor lens, zoomed at fifty mil. Dome diffuser on. Wide dispersion of light, amply covering the "normal" field of view of the lens. Presto! Instant coverage. Edge to edge, full light, lots of detail,

zero subtlety. Very predictable, and in this instance, given Ashley's attitude out there, it almost gets a passing grade. Mildly comparable, really, to an awful lot of stuff out there on the newsstands, where hip is often confused with good. On the wall, plain as graffiti, is the absolute, anticipated characteristic of a light firing just over the lens. Its origin point is slightly higher than the lens, thus the shadow it throws from the subject is just slightly downwards. This light is definitely a straight line, right? No bending, curving, or softening. It hits her like a Mariano Rivera fastball, coming from just over her eye line to the camera, and her form is pinned to the wall, verbatim, albeit a touch lower than her actual form. Hence, her ears repeat on the wall, well, prominently. This sort of does her a disservice, as she has attractive ears. The size of those ear shadows would seem to go along with a trunk and a set of tusks.

So, I proved to myself that the camera manufacturers aren't lying, at least in this instance. The flash, with the dome on, does in fact cover the waterfront. But shooting like this is kind of like hitting the Record switch on a tape deck. The camera, robot-like, gives you what it sees, quite faithfully. It's almost like you, as the shooter, take yourself out of the equation, especially given the TTL metering conversation that the camera is having with the flash. It makes you kind of an interloper, hovering at the edge of the cocktail party, but not hip enough to be truly included.

Given this rather blunt tool of a light hot shoed to the camera, what can you do? How to influence the scene in any way at all? Keeping the flash right where it was, I pulled the dome diffuser off, which gave me back control of the flash zoom. That means I can zoom the lens and flash independently

of each other, and they don't track together. I kept the lens at fifty and cranked the flash zoom function on the SB-900 out to 200mm.

As you can see on the previous page, that produces a hot core of light around the model, with considerable falloff at the edges. Wow. After years of railing about the nastiness of straight flash, I almost liked the result. The hard, centrally located pop of light keeps you with the subject, that's for sure, and the rest of the frame at least achieves a gradation. It becomes more interpretive, more like a spotlight on a stage, and, perhaps as a result of this, I encouraged Ashley to get more theatrical in her gesture.

Dunno. You be the judge. Given the generation gap at my studio, the younger guys on the set were all over this, thinking it was pretty nice, and something to file away and try sometime. I think they were actually shocked the geezer came up with something that might run in the pages of *Spin*, or *Eat It Raw*, one of those downtown-type magazines that specializes in showcasing pictures the young people like.

Then, I kept to the course of the light being bang-on axis, but pumped the SB-900 into a Ray Flash Adapter, a popular brand of ring light for small flash. Ah, the ring flash! It's aptly named, 'cause it's an alarm clock of a light. Usually only seen in an orthodontist's office, the ring-a-ding is a specialty light. It's a flash that literally circles the lens, ensuring that the light is hitting the subject at the same

angle that the lens is seeing the subject. The ring flash is sometimes referred to as a shadow-less light, but that is a bit of a misnomer. There is a powerful shadow created, but it falls directly behind the subject and thus, if the angle of approach is beam on, you don't see the shadow, or at least very much of it.

So how did this happen? How did this weird diagnostic tool of a light migrate into popular use? I could see how it would be popular at the ortho office. It illuminates everything in somebody's pie-hole—every glitch, crack, stain, or slant. This, coupled with the sneaky notion I have that most orthodontists slyly get real close with a slightly wide lens, and you can see why those guys are rolling in dough—a wide lens used that close will turn a mild overbite into outright horse teeth, and freaked parents immediately start pitching money at the magic mouth man, desperately hoping this "before" picture becomes an "after" picture.

I think the ring light and its au courant popularity stems from the fact that photographers are continual tinkerers, especially when it comes to using light. The ring has a definitive look when it's used "properly." (Is there a proper way to use a light?) It is, or can be, very cool and expressive. When used carelessly, it's godawful. And, as opposed to an umbrella, which, if misplaced, will just look kind of blah, when you go off the reservation with a ring light, your subject suffers. Time for emergency Photoshop!

It sounds ridiculous to offer a sort of "rules of the road" for a ring light. (Anybody out there old enough to remember *Butch Cassidy and the Sundance Kid*? When Butch is challenged for control of the gang by Harvey, and they're about to have a knife fight, and Butch tells him to hold off, wait a minute, 'cause they first gotta get the rules set. Harvey's exasperated response: "Rules! In a knife fight?")

Yeah, I guess. Here's one. Call it advice. Use it straight onto someone. If you tip it around like crazy, and perhaps use it low, looking up at someone's face, you better be paying them to pose, 'cause if it's a commission, you won't get called back. Generally speaking, people don't want their nose hairs lit.

With Ashley, I did use it straight on, and bingo, that mildly discomfiting shadow mostly goes away, hiding directly behind her, leaving only a faint, telltale line of darkness around her, which is characteristic of ring use. What can I say? The ring encourages risk-taking, pushing the lens in close,

and letting her get her posing ya-ya's out. Coupled with some funky makeup, it pops. Whether it pops pleasantly or jarringly is left to the judgment of the viewer. When you put that ring flash on as the main light, you know you just bought a ticket to the flash funhouse. Let it rip, and see where it takes you.

The Ray Flash works fine on TTL, by the way, when using it alone. Which means, of course, that you are subjected to the vagaries of potential exposure changes, as you would with any TTL flash approach. Manual mode works well, too. Choose your method. Be aware that if, for instance, you wish to use the Ray Flash ring as a tandem main light/commander (for example, let's say you have another TTL light as an off-axis fill or backlight), you may have trouble getting that Group A, B, or C light to pick up the TTL commands. The ring is obviously a very directed light, without a lot of spread, so using it in any commander capacity can be dicey. If your remotes are skewed to the side in even a slightly radical way, their light sensors can easily miss the pre-flash set of commands.

There are a couple popular ring flash models on the market right now. The Ray Flash and the Orbis. Check them out, and see which fits your needs. Note to self on the Ray model: when you put it on the flash head (at least, I have found this to be true with the SB-900), bring gaffer tape. The locking mechanism doesn't really work. Best to lock it, and gaff it.

Ring flash time is a time for experiments in exposure, tonality, and posing. This isn't Rembrandt lighting, and it certainly doesn't produce a three-to-one, classic portrait ratio. It's not a light most photogs will trot out every day, and it could be construed to be so exotic that a shooter might not bother owning it outright, and just renting one occasionally to experiment.

I've already shown the feel of the ring for a subject in a relatively sedate, clinical fashion. But given that there's a get-yer-ya-ya's-out feel to this light source, here are some notions and examples.

SHOOT HIGH KEY

It's a personal preference, but I like the exposure expression of the ring to be more in the high key realm. Hot, straight, and bright seems to be a good way to go. Vanessa's always been one of my favorite models, and out against that white wall, in hot pink, with the outlandish head gear and the "Who, me?" kind of expression, the ring style of light is definitely working. She has the feel of a diminutive, innocent waif. By contrast, the light's got the trapping power of a police cruiser searchlight in an alleyway.

GET GOOFY!

Ring light time is party time. A perfectly outrageous light for the outrageous face. Bang! Hello! A good light to use for grunge bands, a portfolio of WWE headliners, or, perhaps, a roller derby star who goes by the approachable, pleasant moniker of Pistol Whip.

WORK IT!

Bleu is an amazingly beautiful lady—cool, and elegant to a fault. She's also so limber, and unabashed in front of the lens, that she can take on an otherworldly persona and become a female version of Mr. Fantastic. Here, the combination of outrageous makeup and in-your-face physicality morphs her into an X-Lady, fully deserving of one of those cool, evil, comic book nicknames. I'm not going to light this with an umbrella.

DAMN THE REFLECTIONS! FULL RING AHEAD!

School's out with the ring flash—so, all the care we usually take to hide our flashes and all evidence of their hits and reflections is out the window, too. Go for it! I find some of the best iterations of a ring can occur when it's used bang on to something highly reflective. The wash of the ring around the subject almost creates a halo, or aura, of reflected light which, again, is not a feel they teach in the basic textbooks of lighting, but it can be fun and effective. Put somebody up against something that will bounce the light right back at you and try it. And make sure they're wearing a hat.

Hard light from the camera. Who knew straight flash could be this much fun? □

THINGS **I THINK** I KNOW

I Thought the Lights Would Be On

DO YOUR RESEARCH. Check it out. Read everything you can. About any job. Especially one where you block off half of 5th Avenue in NYC with a 120-foot boom crane.

I was assigned by *National Geographic Traveler* magazine to shoot the great museums of New York in panorama camera format. Great job. It forced me to think differently. I had to take fairly bulky, 120 format cameras into some dimly lit environments and shoot very wide perspective photos. I had to use my eyes differently, i.e., very horizontally. Definitely a tripod job. Not to mention a job that needed planning and scouting, seeing as I was working for editors based in

Washington, D.C., some of whom apparently had no idea how long a city block was in New York.

There's this thing on 5th Avenue called Museum Mile, and it stretches from 82nd Street to 104th Street. It's home to at least eight of the great museums of the city, and in certain cases, of the world. To an out-of-town, deskbound editor, this sounds dreamy, right? Hey, maybe the photographer can get all these museums in one photo!

This was really suggested. I mean, I couldn't make this up, right? "Can you get all of these museums in one photo?" Real question, from home base.

"Uh, sure, I'll just rent one of those satellite cameras." Seems appropriate, 'cause this request was definitely from outer space.

I politely explained that, for instance, the two truly prominent institutions up there, the Met and the Guggenheim, are separated by at least six blocks and, oh my, are on opposite sides of 5th Avenue. This is what you call a real-world, real-time problem.

The editors came around to being reasonable after a bit, and sent me off to do the story. And then, shaking my head at the utter imbecility of those foolish folks in D.C., I went off and wrote my own page in the Stupid Book by not thoroughly researching a big, expensive picture.

The idea I had to replace their notion of a multi-museum lead photo was to get up high, over the tree line on 5th Ave., and shoot the distinctive, famously round shape of the Guggenheim in 617 format. The camera, pointing south down the avenue, would frame the museum on the left, and the panoramic nature of it would sweep out over Central Park, and in the distance would be the skyline of Central Park South, the Empire State Building, and all things New York.

I got a little feverish about the prospects of this photo, to be honest. I had never rented a crane to block off a major city street before! This was exciting! Photography rules! I got the permits and the permissions, and rented the truck. Never even talked to the museum. Why bother? I'm on public property, shooting public stuff. There really aren't even any people in the picture, so no worries there.

Luckily, I had a beautiful day to work. Glorious sun, clear skies. Got there early to position the truck. Went up and got the height and angle I needed. Then I waited. I was looking to shoot this right about sunset time, when there would hopefully be little scallops of detail on the edges of the trees in the park, and the city lights would be coming on, along with the exterior lights of the Guggenheim.

Fortunately, during my wait for this momentous iteration of golden hour, I made a few frames, which proved to be handsome enough. Sunset light in the distance, great light on the museum. But it wasn't what I was after. I was going for dusk—deep, rich sunset, the city aglow, maybe tracers of traffic down the avenue!

So I'm up in the crane, watching the sun head west, and passing the time with some clicks of the camera. It was, as I say, a nice scene, and this was a vantage point I was never gonna have again. Instincts ruled, and I shot some stuff. But I discounted it at the same time, because I was up there waiting for *the* picture, the one I had in my head.

The city was growing dim, and beginning its nightly ritual of self-illumination—but not the Gug, which was gradually receding into darkness. I began to get nervous. Ever get those icy tentacles clawing at you inside? Whispers in your head that grow to shouts, and eventually screams? For me, it's sorta like that plant from the *Little Shop of Horrors* starts growing inside my stomach, fed by leaping anxiety, and it begins to devour all confidence and logic.

It was just me and my stupidity up there in the crane bucket in the accelerating gloom. Not to mention my insecurities, along with the absolute confidence that I had just made the mistake that would finally do me in, ruin my reputation, cause my career to crash and burn, and make me an un-hireable, bankrupt, homeless ward of the state who would spend the rest of his days rocking back and forth on a steam grate on 42nd Street, snarling incoherent obscenities at the swells whisking past to jobs that they continue to have because they weren't a has-been loser of a freelance photographer. There were some

other equally morose thoughts and feelings up there with me, as well. It was actually kind of crowded in that tiny bucket.

I grabbed the two-way radio and shouted to Gabe, my assistant on the ground, to run into the Guggenheim and ask when they were going to turn the lights on. He came back presently and tried to explain on the radio that they had some sort of display of historically important Russian lithographs or something up on the walls, and for the duration they weren't lighting the outside of the building. The curators feared the long overnight whammy of noxious mercury vapor light would fry the artwork. So, sadly, the building would remain dark.

I summoned what was left of my shredded self-importance, puffed my chest out, ego as fully erect as the crane, and screamed into the

mic to go back inside and tell them to turn the damn lights on, because there was "a *National Geographic* photographer out there on 5th Avenue shooting pictures!" Mercifully, Gabe didn't press the transmit button with his response, but dutifully went back in to plead my case to the powers that be. In between gales of laughter at the presumptuous nature of my demand, Gabe heard the word "no" quite forcibly, several times.

He reported back. There was nothing left to do but hit the descend button. The crane truck rumbled and my platform sank, along with my hopes. All that was left to do was process what I had shot, and hope the magazine might be happy with what they saw, which they were. About the only wise move I made during the entire debacle was not tell the editors about the notion of a dusk shot. I just told them it would be "a different, exciting angle."

Lessons here:

Research. Find out what's going on with the people, what's happening inside the building, whatever. You never know what will impact your chances of success.

Shoot! Don't put all your eggs in the sunset basket. Or any individual basket. Cover the job! Make those pixels sing! You can always throw them away later, when you get the prize pic. But, those "other" pictures—the ones you don't think much of at the time—can later on be your lifeboat. As a shooter, I have been so guilty so many times thinking the shot I'm about to get is better than the one I just took. Your fevered hopes are wonderful. Pre-visualization of that amazing shot is great. But don't let that breathless anticipation become a visual straightjacket. Shoot like crazy. Especially if you've just spent a few thousand bucks on a crane in the middle of New York.

Undersell! Don't blather on to anyone about how great this idea is and what a shot it's going to be. Then, you raise expectations, and if you don't meet them, it's a screw-up. And trust me, screw-ups stay with you, whether it was of your own making (your bad) or something you couldn't control, like crappy weather (still your bad). You see, many editors out there are like hothouse plants. They never experience real-world storms. For them, life is good. It's always warm, some sort of sun is always shining, and they get fed on time.

They never understand that sometimes the lights don't come on. □

Radio
TTL

AS PHOTOGS, we are definitely—along with much of the rest of the world—caught up in what's coming next. The future is wanted badly, and now. More megapixels! More speed! We seek software programs that seamlessly correct our sins, turn summertime trees the color they only have in October, and make skin smooth as pudding. And we're never content with stuff just coming off the shelf, cool as it might be. A piece of gear comes out that appears to be all the rage, and within 48 hours some photo-engineer has blogged about a mod he or she made where what had been designed to simply diffuse light now transmits files and downloads music.

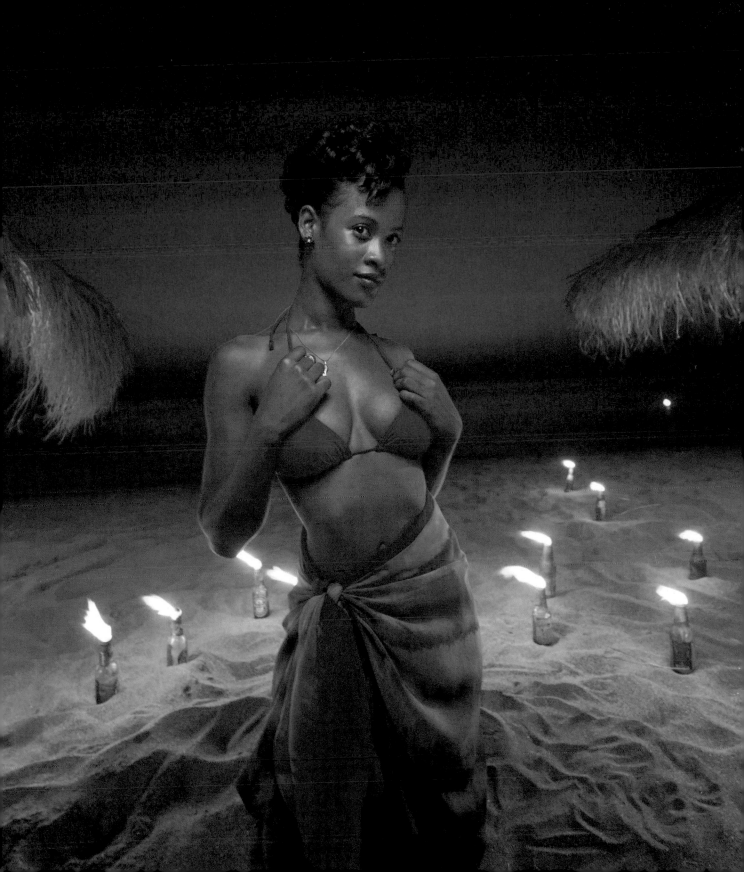

It's natural, then, that the news that TTL control for both Canon and Nikon flashes—so far the province of line-of-sight infrared and optical pulses—could be extended by radio wave transmission would be seriously applauded, anticipated, and fairly drooled over. Quite frankly, I would count myself as a drooler.

What nirvana! The idea of putting one or more small but powerful flashes out in the field, hidden from sight and perhaps hundreds of feet away, yet controlled at the camera by the flick of a switch, boggles the noodle, plain and simple. That, in my opinion, doesn't just enlarge the envelope. It shreds that envelope faster than a sixteen-year-old who thinks they just got their driver's license in the mail.

It stopped short of the frenzy caused by, say, a new iPhone, but when these puppies were announced for the respective big-boy systems on the block—Canon's version was out considerably ahead of the Nikon model—needless to say, the joint was jumping. TTL radio! The voice of the future talking to us, right now!

And it's great. When it works. Let's just say there's been some static, and it's ongoing. I have tried mightily to achieve success with these units, even extending the deadline of this book a bit to see where the next firmware leads, but now, as I write, what I can report is great promise amid intermittent reception, with some fine-tuning to be done.

Which is to be expected. This isn't a garage door opener you've got mounted to your camera. It's a highly sophisticated liaison to your already mind-numbingly complex camera. The two systems do a very intricate dance step every time you press the shutter. They will stumble, as all technology occasionally does. I remember having problems with a unit in the early going, calling in for help, and being told to shut down the vibration reduction function on my lens, as that minutely affects the timing on the chain of events constituting an exposure. When you have things parsed out in milliseconds, even the slightest of hitches throws the whole deal off. Making these radio units work is not a surface fix. These guys are drilling deep into the bedrock of the camera's system.

The whole deal is delicate, in other words. Lots of potential, and I greedily want them to work reliably, right now, but in my limited experience, I'm still waiting for the other foot to fall with a much more reliable thud.

Here's the good news: We have made them work.

The beach shot is tailor-made for these units. It's a low-light shot at dusk, as you can see, and illuminated by a great number of flambos, which is evidently what they call a Molotov cocktail in St. Lucia. The scene was set, the fires lit, and the sun was fading nicely to a deep, deep blue. Underneath

"When your subject is silhouetted like this in extreme light conditions, I often go to manual focus and use an iPhone flashlight type of app to light up the eyes and pull my focus."

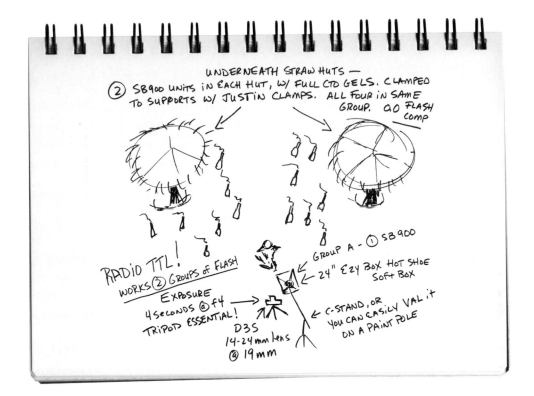

UNDERNEATH STRAW HUTS —

② SB900 UNITS IN EACH HUT, W/ FULL CTO GELS. CLAMPED TO SUPPORTS W/ JUSTIN CLAMPS. ALL FOUR IN SAME GROUP. 0,0 FLASH COMP

RADIO TTL!
WORKS ② GROUPS OF FLASH
EXPOSURE
4 SECONDS @ f4
TRIPOD ESSENTIAL!

GROUP A - ① SB 900
→ 24" Ezy BOX HOT SHOE SOFT BOX

← C-STAND, OR YOU CAN EASILY VAL IT ON A PAINT POLE

D3S
14-24 mm LENS
@ 19mm

both straw huts, distinctly out of line of sight, were SB-900 units—two per hut, and Justin-clamped to the wood struts. I gelled them to the color of fire (full CTO).

To do this with line-of-sight TTL from my camera angle would have required taking the master flash off the hot shoe via an SC-29 cord, and most likely bouncing it downwards off a reflective board on the sand in hopes that the TTL signal would skip off that source and ping pong up under the straw roofs to ignite those flashes and give me control of them at camera. Working line-of-sight, as I am generally used to, this would have been my approach, and it most likely would have worked.

But with radio TTL, it's a no-brainer. At least after some fussing and sorting out. The only Nikon we have worked with the PocketWizard Flex/Mini system is the D3S. We started on the beach with a D3X,

but either the camera or the radio system wasn't having it. We switched up to the D3S, fussed again with all the on/off sequencing for the Flex/Minis at the flashes and at the camera, and voila! Radio TTL transmission occurred.

Overhead the model was a boomed 24" Ezybox Hotshoe softbox. It's placed just at the upper edge of my frame, straight onto her. On the sand down at her knees was a reflective TriGrip, but honestly I don't think it's doing much, and we may have even removed it during the shoot. There's no low catch-light in her eyes, which is a good indicator that the overhead light is doing the heavy lifting. She just has to keep her face up into a bit. If she looks down, the picture disappears, along with her eyes.

Two TTL groups, driven by radio! Very cool. The lights underneath the huts needed no tweaking, power-wise, and ended up running at

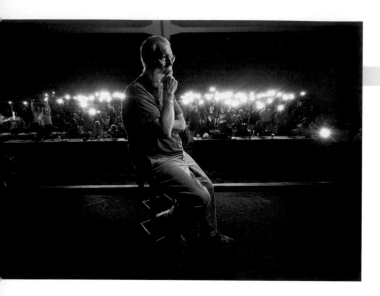

0.0 compensation. Same for the boomed main flash. Finals on this were D3S, ISO 400, 4" (that's four seconds), at f/4. She stays in darkness and holds relatively still for the long shutter. Notice the burning bottles are by and large behind her. If I swung those around to the foreground and they starting incrementally lighting her face up, I would have had a sharpness problem with a four-second shutter drag. But as long as she's in relative darkness, she's controlled by the fast duration of flash. (When your subject is silhouetted like this in extreme light conditions, I often go to manual focus and use an iPhone flashlight type of app to light up the eyes and pull my focus. Here, because she's wrapped in the firelight glow, surprisingly the camera did okay with auto focus.)

So, the future is upon us, and it looks bright, indeed. Naturally, me being me, when it comes to light, I try to push the future, or at least the limits. When Nikon says you can put several flashes into one group, I wonder, you know, how many? (So far, in my personal experience, the answer is 128, from our Flashbus stop in Atlanta, GA [see pic above].)

I just tried a bit of a complex setup with the radios recently, just prior to the closing deadline on this book, and...I ended up going with a line-of-sight solution. I'm unsure if proximity of the Flex transceivers to each other was the issue, or whether it was radio weirdness relative to a big concrete wall, or the fact that I tried to change up cameras in mid-stream, or what else the glitch might have been. We started off okay, taking one gingerly step after another, but then we fell through the ice. At the end of this story, there's a look at that shoot. Lots of lessons learned, and the biggest one might be: Have plans B, C, and D already in your head.

At this point I'm completely tantalized by radio TTL. I'm excited about the possibilities of hyper-sync. I'm thrilled that the new generation of Pocket-Wizards are backwards-compatible with all the PW stuff I already have. And, I'm anxious for the day more stuff gets sorted out.

The gang at PocketWizard are literally a bunch of geniuses. This mission they've embarked on definitely means they're not in Kansas anymore and are on an uncertain road, filled with pitfalls. Just for ordinary flashes, radio transmission on location can be an iffy proposition, because radio waves are radio waves. Lots of situational, unpredictable stuff can interfere with their performance. Now, the simple radio transmission is interlaced with exposure information from the camera, which opens a whole Pandora's box of Canon/Nikon proprietary information, which, as you can well imagine, they are grudging in the dissemination of. In short, much of the language that PWs are using had to be gleaned in a reverse-engineering fashion. Here's my

ongoing strategy for use of PW TTL, for the Nikon system:

- Keep it simple.
- Make sure you observe protocols. Turn your lens VR off. Make sure the SB-900 Speedlights are set to Standard mode for light dispersion, not Even or Center-weighted mode.
- Use the "top down" turn-on sequence religiously Flash, Flex, Mini, camera. FFMC. (Is that a new rap group?)
- Keep it simple.

These guys will get caught up. They solve problems almost daily, and shout out firmware updates on a regular basis. Being a TTL shooter, I salivate over the coming dependability of these devices. This radio station could really be the voice of the future.

So, I looked over at this abandoned, messy corner of a factory building and thought, "Wouldn't it be cool if there were a life-sized doll just kind of laying over there?" I don't know why. Certain very colorful events from the early '70s might still be reverberating in my head.

The crusty beauty of the corner was enhanced by a pair of nearby windows. Flash through a window! That's where the light comes from, anyway, so I set about creating daylight that I could direct and control. "Direct" and "control" are the operative words here. If you see the splash of sunlight on the floor, camera left, you'll understand the sunlight is behind her, and the window on camera right—the main light, if you will—had very soft, indirect light that was just too soft to use.

I did want soft light through that portal, so I put up a big, big umbrella on a very large stand (this scene is on the second floor; go figure). I tell you, the availability of big, cheap umbrella sources is

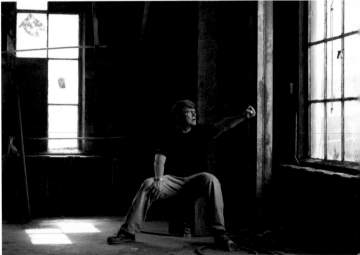

pulling me back from softboxes to liking a simple umbrella style of light. The big size did two things: it made the light soft; and it essentially flagged or blocked other indiscriminate daylight from coming through there. That blocking ability added to my control of the scene.

One little flash into that giant swatch of umbrella wasn't going to cut it, so I mounted a TriFlash out there to fire three SB-900s fitted with external battery packs through it. It was just outside the panes of glass, and Martina is looking right at it.

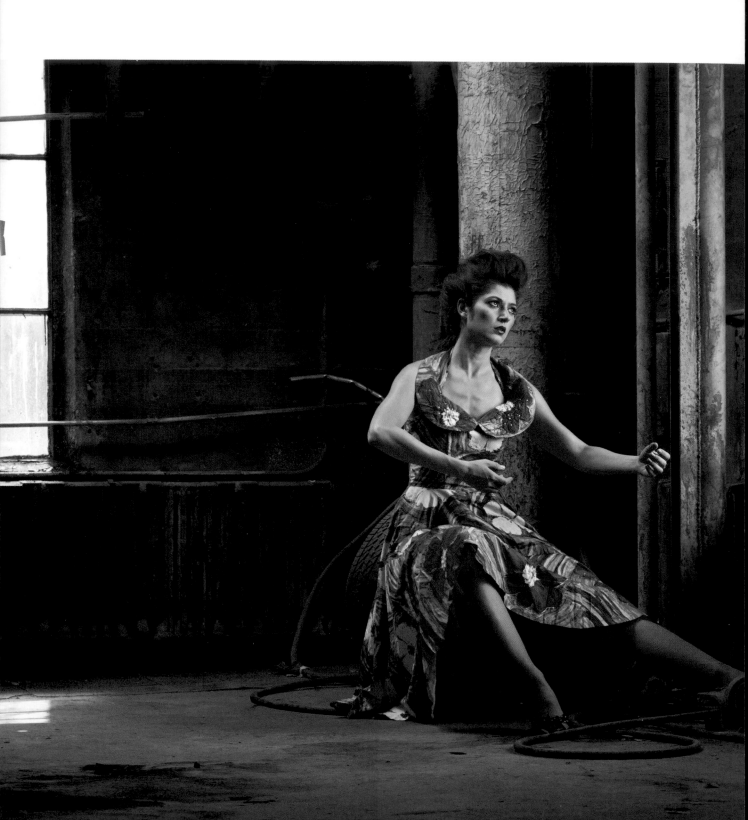

I couldn't stop there, though. Big as the umbrella was, it basically hit her and died. Almost no detail got into that, uh, lovely corner back there. I had to use a fast shutter speed to control the windows or they would have blown out, highlight-wise. But doing that (using 1/125th of a second) ensured the immediate background for her would go completely dark. The shot you see of me directing the placement of the light (page 237) is shot at the exact same value as the shot of Martina the beautiful doll, 1/125th at f/5.6.

Light had to come from inside, and the answer was more flash. I know, I know, with me it's always more flash, right? Not necessarily. If I could have skated on this with just the one source, I would have. (In fact, 80% of this book is about using one main source of light.) But, again, the need for control reared its ugly head. It really comes down to the camera, and its inherent, well-established inability—fancy as it is—to deal with radically different zones of exposure. Expose for detail in the corner? Blow the windows. Push the exposure down to get the windows under control? Sure. Lose the corner. Why did I choose this location? The shabby feel of that corner. What was part of the appeal of the corner? The nearby windows. Sheesh....

I put up two gelled flashes inside, on a tall stand and a boom arm, firing into the filthy ceiling. In this type of setting, any naturally occurring interior light might well have been tungsten-based, so my Speedlights both sport half cuts of CTO. (Didn't go to full—I just wanted a hint of warmth in the interior details, and I didn't want too much yellow light to spill onto her.) The combo of the gel and banging them upwards into a surface that had not seen a dust mop in a hundred years robbed them of

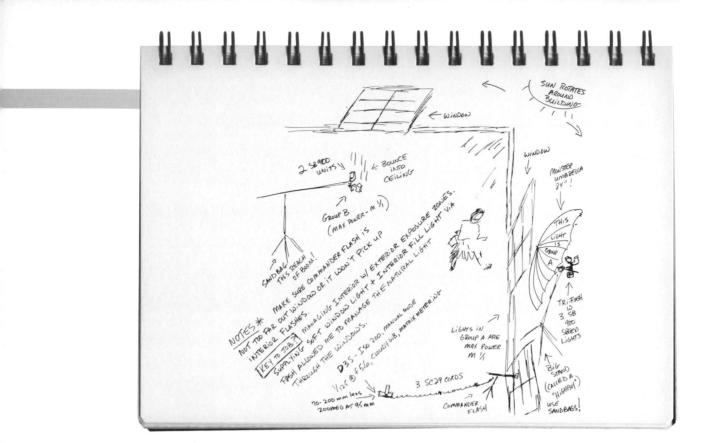

SUN ROTATES
AROUND
BUILDING

← WINDOW

WINDOW

2 SB900 UNITS → ← BOUNCE INTO CEILING

GROUP B
(MAX POWER - M 1/1)

MONSTER
UMBRELLA
84"!

THIS
LIGHT
IS
GROUP
A

SANDBAG THIS REACH OF BOOM!

NOTES ✳ MAKE SURE COMMANDER FLASH IS
NOT TOO FAR OUT WINDOW OR IT WON'T PICK UP
INTERIOR FLASHES.

KEY TO JOB? MANAGING INTERIOR W/ EXTERIOR EXPOSURE ZONES.
SUPPLYING SOFT WINDOW LIGHT + INTERIOR FILL LIGHT VIA
FLASH ALLOWED ME TO MANAGE THE NATURAL LIGHT
THROUGH THE WINDOWS.

TRI-FLASH W/
3 SB
900
SPEED
LIGHTS

LIGHTS IN
GROUP A ARE
MAX POWER
M 1/1

D3S - ISO 200, MANUAL MODE
1/125" @ f 5.6, CLOUDY WB, MATRIX METERING

3 SC29 CORDS

70-200 mm lens
ZOOMED AT 95 mm

COMMANDER
FLASH

BIG
STAND
(CALLED A
"HIGHBOY")
USE SANDBAGS!

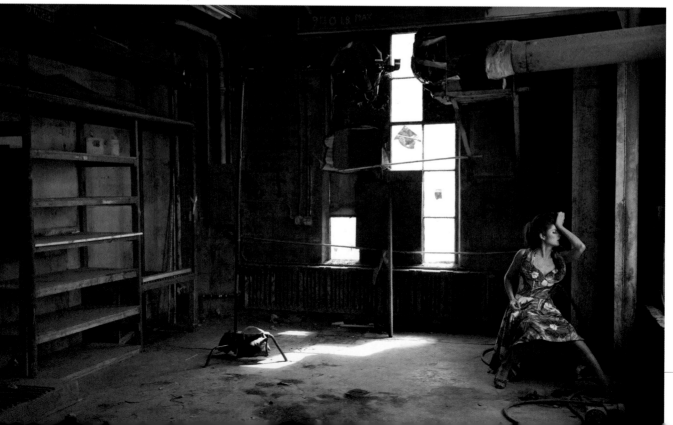

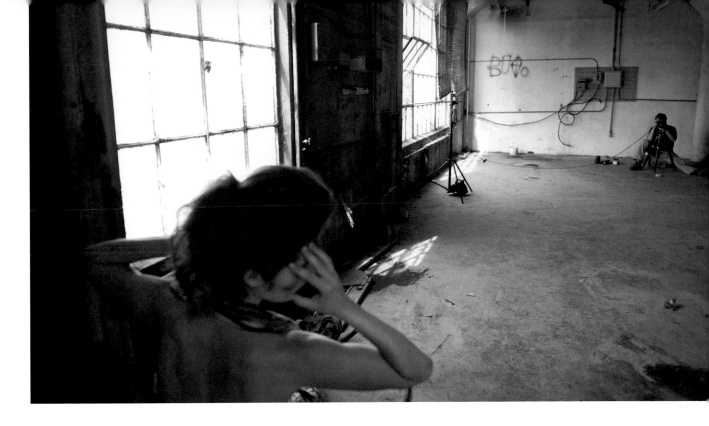

their power and efficiency, to be sure, but it makes sure that the feel and direction of that light source would appear natural. It wasn't an overt light, in other words. It wasn't a directed softbox that put a studio-like highlight on her hair and shoulder. It simply elevated the ambient level of the room. But instead of relying on the real existing light, which was coming from the wrong direction, I was able

to take my small bounce flashes and use them to literally push a bunch of light back into the corner. It was about as ceremonious as shoving all the clothes you have on the floor into the closet when unexpected company rings the doorbell.

The scene worked. For the model, I had a strong key light that looked like window light, and just enough detail in the corner to make that wonderful shabbiness part of the picture. I got the windows under my control via the combination of f-stop and shutter speed that the flashes enabled me to access. The conundrum here, of course, was that I've got lights outside and inside the building, which I thought would stress the radio TTL system nicely.

And, it worked with the D3S for the first 12 frames. Then I tried it with a D3X. No go. And, in fact, for whatever reason, that camera switch (which is me just never leaving well enough alone) proved fatal. We never got the PWs working again, and went eventually to line-of-sight triggering,

which worked well—even given the disparate locations of the flashes. We placed the commander flash in the window, but just a bit in the window. There was enough of it radiating outside and inside to pick up both groups of flashes. Finals on flash power were real simple—full up, manual 1/1 on all units.

Ups and downs are to be expected during the first flirtations with a system. It happens, and it's okay. We ended up staying with the D3X and line-of-sight for the rest of the day. It was working.

Here's the thing about glitches on location. They can be catastrophic and ruin the shoot. Or they can be a bump in the road. What matters is how you smooth that bump—no matter the size—and how quickly and decisively. When time is flying, and the sun is creeping around towards the other side of

the building, and the model's starting to sag a bit (we were blessed with Martina, she's a trouper—many subjects are not), you have to readily deviate from the original path, pull out the machete, and start bushwhacking a new one. That's what we did here. Next stop would have been to go traditional PW radio trigger to all units, and go into manual adjust mode. But with an umbrella the size of a city block on a stand heavy and high enough to be used as a cell phone tower, you don't really want to be running it up and down, up and down. The line-of-sight triggering gave us TTL control, right there on the second floor.

And here's the beautiful thing about a big light source, dependable transmission, and TTL technology: You can work it. Martina changed outfits and went into decidedly non-doll mode. I moved to a 200mm f/2 and shot a headshot at f/2, dropping the power on Group A (umbrella) to manual ¼, and completely nixing the interior lights, all with a couple button pushes on the commander. For the full-length swirl of the skirt, I stayed at ¼ power out the window, and she got some bounce fill from the sun off the floor. I shot a 70–200mm lens at f/3.5, ISO 100, still at 1/250th. I put the interior lights back in play, and those two, coming off the ceiling and thus being drastically weakened, stayed resolutely at full power for the whole deal.

There have always been lots of ways to do a shot like this, and pretty simple ones. The dawning of radio TTL promises to make it even simpler. □

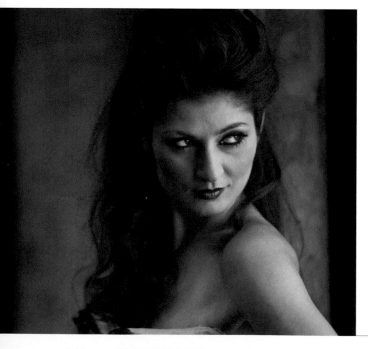

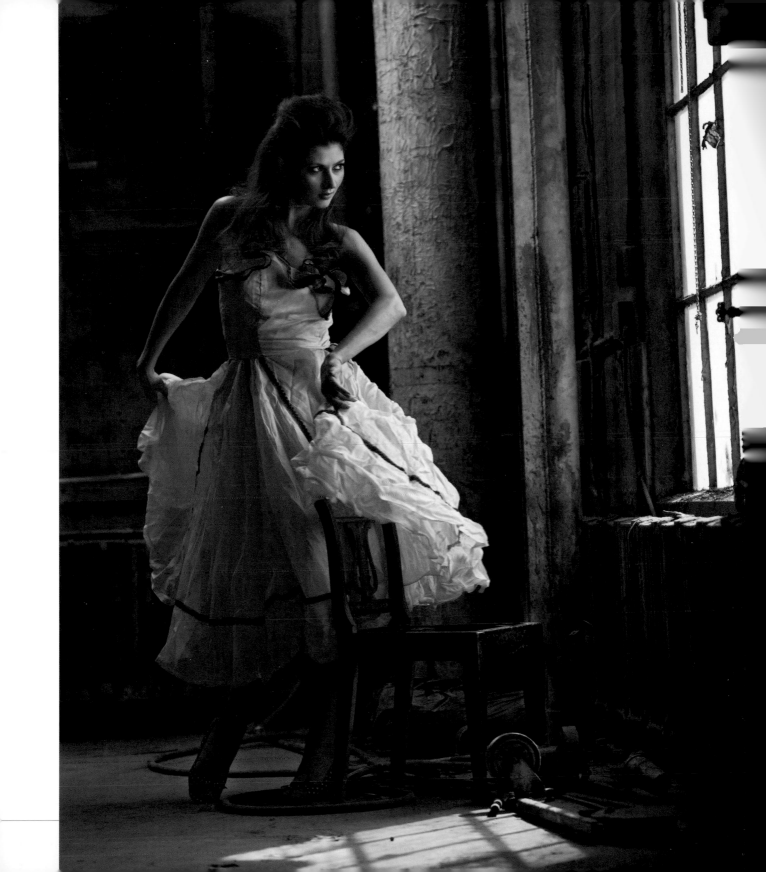

The Shape of Light

TOO OFTEN I'VE PUT UP A LIGHT and just used all of it, because that's what I do. I'm a knuckle-dragging photographer, so most of the time I start by putting up a light. Then it spills and splashes all over the place, hitting areas of the scene I don't want lit, or drawing attention to that lovely tie with the stains from yesterday's plate of chili, or the t-shirt that's so loaded with logos that my subject might as well be a Nascar. Duh...this ain't so good. What do I do now? The manual says put up an umbrella and everything will look nice.

Ashamedly, there have been times I've given up, and let the light do what it wants, not what I want. It's an umbrella, and it's supposed to be nice light, so there it is. I put up the umbrella. Can I have a prize now? I've been guilty of this more than I'd like to admit. Call it lazy. Call it resigned. Call it just not being able to think my way to an energetic solution on that particular day in the field. Call it thinking I can fix it later. Call it outright stupidity.

On other days, I've been (thankfully) more forceful, and literally done battle with the light or, more appropriately, done surgery on it. I've taped it, blocked it, flagged it, hung my winter coat on it, had somebody stand in front of it to kill some spill or spread, you name it. I've thrown anything I can get my hands on out there in the location world to try to bend a particular type of light to my will, and make it light in a directed, sculpted fashion—not just a splatter-fest of photons.

One of the ways you can avoid going to war with the light you just put up is to know why you're using that light. Direction and punch calls for perhaps small softboxes, or even a tight grid for real drama. Young children bouncing around in front of the camera might require a broad, smooth source with lots of coverage, so that Johnny jumping over here is lit with the same niceties as Suzy doing a back flip over there. That scene might need a real big, hazy,

soft white umbrella, or some broad bounces off of walls and ceilings. An intense, moody portrait of an angst-ridden young playwright whose dialogue is racked with pain might speak to a soft but dramatic source that's radically placed off to the side. Thus placed, one side of his face has richly beautiful light, but it falls off rapidly into shadow and darkness, just like his plays.

Another way to ease your location pain is to look at the shape of your subject, then look at the shape of your light shaper. They are called light shapers for a reason. At the very least, the light that comes screaming out of these things starts off mimicking its originating source. Much like a smoke ring, it dissipates and wanders quickly, but the source does enforce a character and quality to the light you make. Light from a small source starts off small, for instance, and has an urgency to it. Big light sources produce wrapping, blanket-like light that's soft and languid. What does your subject need?

Here, I am showing you two types of subject matter—one very horizontal, and one very vertical. One is very character-driven, and, well, bushy. The other is beautifully ethereal, set in a wonderland of a foggy forest. I could have used the same light for both if I had to—a standard-issue umbrella, perhaps—but I would then have had a bit of a tussle on my hands. For the horizontal fellas at the table,

"By dovetailing the shapes of the light with the shapes of my subjects, I avoided having to take out the chainsaw and rearrange a perfectly good umbrella."

LASTOLITE 3×6 PANEL — 1 STOP DIFFUSER — SMOOTH LIGHT!

AVAILABLE LIGHT

I'm under there somewhere

14-24mm WIDE LENS FILL FRAME!

MY CHECKLIST!

✓. GET STUPE! GET THEM SINGING! (THEY ARE, AFTER ALL, SINGERS.)

✓. BIG SOURCE — PUSH IN CLOSE TO MAKE IT SMOOTH + RICH, AND NOT MAKE BAD SHADOWS!

2 QUADRA 2 HEADS = EVEN LIGHT THRU PANEL

I most likely would have had some falloff at the edges, and not been hugely pleased with the overall softness and character of the light. Out in the woods, an umbrella would have surely lit up the plants around the dancer, and thus needed cutting and shaping. But by dovetailing the shapes of the light with the shapes of my subjects, I avoided having to take out the chainsaw and rearrange a perfectly good umbrella.

For the singing gentleman, I chose a 3x6' Lastolite Skylite one-stop diffuser panel. These guys are members of an all-male, a cappella singing group, over 40 strong, called Conspiracy of Beards. They sing nothing but Leonard Cohen songs, and are based in San Francisco. They're very talented and a hoot to work with. And, not surprisingly, they're characters. Porkpie hats, all scruff and beards, darkish, vintage clothing—if you light this wrong, you're in for a long day, and an even longer night monkeying with the Fill Light slider. Bring the light from the side and they shadow one another, and their tweedy attire disappears from view, which is bad news for the storytelling aspects of the photo, 'cause their garb is part of their look and persona. Also, shadowy side light will wreak havoc on their faces, which are wonderful but not the type you'll see anytime soon in an Abercrombie catalog.

Soft, frontal light, shaped for them, is the way to go. I put up the panel super close to them, basically right on top of my head at the camera angle. Then I put two sources into it—in this case, two Quadra heads, each with their own pack. There are diffusers on each head, so I'm trying for softness and spread right from the get-go. I'm smack in the middle of the guys and the light source, with the two heads on either side of me. A very chummy, tight-knit gaggle, to be sure.

But the result is a big, beautifully smooth light that covers this ad hoc Mt. Rushmore in the coffee shop quite nicely, and pokes photons into all

> "Strip lights are wonderful lights for the human body, long and narrow, especially if you want to do a rim of light, or a line of light along the edge of someone's frame or form."

the crevices and folds of their faces and garments. It's a rich, highly detailed light that softly lets their character come through. It's not a light that makes our eyes work hard for the reward. There is no squinting, "wish that was a little brighter" feel to the light here. A bucket of light, if you will, covering them completely. If it were a bucket of water, it would have been a big one, and they would be totally drenched. Same idea.

Now—two Quadras, eh, McNally? Sounds like a pricey, over-the-top solution. But it's not overkill, or just using every light in the bag 'cause I carried it along. Here's the method to the expensive madness. The Quadra is an asymmetrical unit, as most higher-end, controllable packs are nowadays. That means the A port delivers the full power of the rating programmed into the pack, and the other port—the B port—gives you roughly 30% of that rating. To do this with the two heads and only one pack, I would have uneven light. One head automatically gets much more power than the other. Not good.

I could fix that if I had to, by placing, say, a half-stop of neutral density gel on the more powerful head, the one coming out of the A port. That would even up the game enough to get by, albeit with perhaps some feathering of the heads. By "feathering the heads," I mean turning them at angles to the subjects by degrees, to cut the full force of the light. It's not to be confused with actually moving the light source. The stand or support for the light remains static, but the heads turn, sometimes radically, to put your subjects in the spill or edge of the light, not in the main path of it.

As often is the case in photography, fine-tuning and control can become the difference between a photo with problems to fix and/or a very tough day in the field. As it is, you're often fighting the odds going into the shoot. You don't want to be fighting your gear, as well. So, one universal rule in the world of power-pack lighting is that one pack per head gives you the most control. As soon as you have multiple heads running out of one source, you face compromises that have to be danced around.

Let's get into the woods, where one might think you'd find my grizzled, mountain-man subjects rather than an exquisitely delicate dancer. But a ballerina it is. I wanted her to

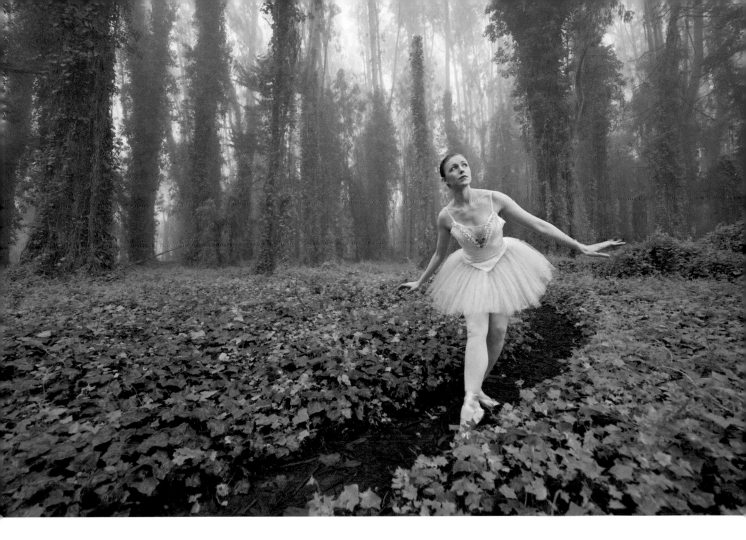

project a vulnerable, fawn-in-the-forest feeling, very similar to certain major roles in the world of ballet, where theatrical danger often lurks for the prima ballerina. Off to camera right is a strip light, so called because it is, as I've mentioned already, a long narrow strip of light.

Strip lights are wonderful lights for the human body, long and narrow, especially if you want to do a rim of light, or a line of light along the edge of someone's frame or form. In this instance, it is the main light. Or more properly, the main (only) flash. The forest is the main light. And the existing light is beautifully appropriate for the scene. But look at the difference between my subject and Drew, my first assistant, in the production pic (following page). She's got the spark of directional light. Drew becomes part of the forest. Actually, with his scruffy look and dark clothing, he becomes, well, kind of creepy.

With some light on her, she becomes the star, the point of attention. Notice the strip is up high and pitched towards her a bit, in an effort to keep it off the ground. The last thing you want to see is a flash highlight on the pachysandra. Dead giveaway that you're using a

flash, and it will lead the viewer's eye away from the subject.

One thing I would have liked, but did not have here, was a recessed strip light. If you notice, the front diffusion panel of the strip light comes flush—right to the edge of the black material on the sides of the softbox. An edge baffle surrounding that piece of diffusion would have made things easier for me. By "edge baffle," I mean somewhere around two inches of material projecting out around the edge of the softbox, which helps to contain, corral, and direct the light. My worry here with this style of box—without the edge baffle—is that, though the light produced will indeed head towards the subject, some of it will drop immediately to the floor as quickly as loose change through a hole in your pocket, creating the dreaded floor highlight. Most major league softboxes now come with this feature—the edge baffle, or hood. It dramatically controls spill and the tendency of light to blow everywhere as soon as it escapes the confines of the softbox.

Another very, very helpful tool in terms of controlling the light is often referred to as an egg crate. Briefly, it does, in fact, look like an egg crate. It attaches with Velcro and is a series of fabric cubes that columnate the flow of the light. The egg crate drops right over the diffuser surface and, combined with a hood, is a great way to make sure your softbox light goes right where you want it.

Makes sense, right? Your subjects have shape and form. So does light. Match 'em up well, and you won't fight the light. □

A Tale of One Face, Lit Two Ways

RICK'S GOT A FACE FOR THE AGES. It's a visage as blasted as the New Mexican desert he's lived in for many years, mixed with a touch of Johnny Cash and illuminated by a pair of weary eyes that have seen too much. At his core, he's a decent, affable guy who enjoys a laugh. I can only speculate, though, that if you crossed him...that would be bad. They would never find the pieces of you out in that vast desert.

And it's a beautiful face, too, though I suspect Rick doesn't hear himself accused of being beautiful too often. It's a well-worn topographic map of a life that's intersected with pain, laced and lined by confrontation with the dark side of the human spirit. Rick, you see, was a prison guard at the New Mexico State Penitentiary during the worst prison riot in the history of incarceration in the United States. He's been in the belly of the beast. When he smiles or laughs, as he often does, it's like daybreak through storm clouds.

How do you light this face? Well, the obvious answer, of course, is any way you want. There is no right or wrong here. There are a bazillion folks out and about with cameras, and each of them would have their own approach to making a portrait of Rick. I'm showing you two approaches here. Both are two-light scenarios—one done all with small flash, and one shot with "medium" flash. (I still hesitate to call the petite little Quadra a "big" flash. Park it next to a 2400 Ws Speedotron, and you'll see what I mean. When you toggle a 24 Speedo at full power, there's a definitive *POP!* that rattles the windows. It's like the full-throated bark of a German Shepherd guard dog. The Quadra, popped at full power, sounds like the yip of a shih tzu.)

Nevertheless, these two shots are done simply, with just two sources, of different types and with vastly different modifiers. Even given the difference in light mods, both have very definitive similarities in approach. Each is a confrontational, frontal portrait. Each employs the time-honored lighting mechanism of a main plus a fill, with the main being high and over the subject, and the fill being eye level or lower. In each case, the shutter speed is used as a louver for the background ambience. I control how brightly or dimly the back end of the picture plays by making my shutter slower or faster. Neither of these images is right nor wrong. Neither is better nor worse. Neither is necessarily more significant than anything that's been shot or will be shot of this legendary gentleman of the great southwest. They both even share a flaw that the composition police would issue me a summons about—bull's-eye framing. No rule of thirds. He's smack in the middle of both pictures.

"In each case, the shutter speed is used as a louver for the background ambience. I control how brightly or dimly the back end of the picture plays by making my shutter slower or faster."

What they represent, simply, is a choice of approach at the moment of the intersection of the light, the subject, and the shooter. All the elements of a photo are variables, subject to continuous change, on a job-to-job basis. Every day in the field, you react with your gut, your heart, and the equipment you happen to have on hand. What also sometimes mixes into the equation of a photograph are the demands of the assignment (if there is one), your mood, the subject's mood, the reach of your visual ambition that day, and perhaps the availability of some piece of gear you wish to try. (What also mixes in is how much time you have, what the weather is like, whether you ate Mexican food the previous night, if you just had to talk to your kid's math teacher about him or her failing the last three tests, and the fact that you're out on the road, trying to do this shot, and you're down to your last working credit card.) Accepting this type of location randomness (what works today doesn't tomorrow) of course flies in the face of the desperate wishes we all have for a photographic silver bullet—that thing you always do, a reliable comfort zone we can construct out there when we're shooting. It's also stressful for those who might feel that some universal tip—like, "Always use a tripod!"—will somehow be a perpetual open sesame to the good picture vault. Now, there's nothing wrong with following sound advice. It will make your pictures better. But the path to a good photo is never straight, comfortable, or assured, even if you carry that well-advised tripod faithfully, all along the way.

Sorry to be the rain on the parade. In a world that abounds with photo literature that fully discloses the numbers, the gear, the shape and size of everything used on the "set," there's still no certainty of result. The only thing left, at the close of the shutter, is whether the picture just made communicates or not, and that's as elusive and

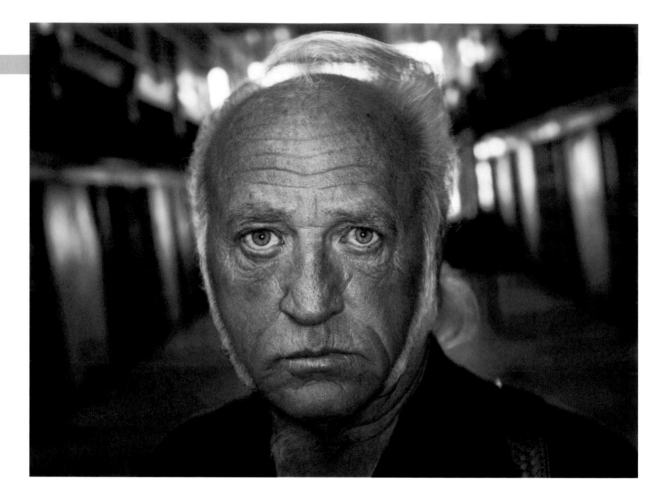

ineffable as ever it was. A picture that speaks, that has staying power, that trips emotions and imaginations, and does not simply take a place in the endless line of numbered, pleasantly presented, attractive failures that populate everyone's droning hard drives—including mine—is the grail we seek. And there is no treasure map. Yippee!

So take these two approaches as signposts in the wilderness of your choosing. They may point you to the top of the mountain, where the view is clear and the air is fresh. Or they could easily lead to the Cliffs of Insanity.

The shot above is small flash: Two SB-900 units, one overhead of Rick, above his eye line and very, very close to him, into a 24" Ezybox Hotshoe softbox. It's pitched forward towards him on an extension arm off a C-stand that is directly behind me. It's basically sitting on

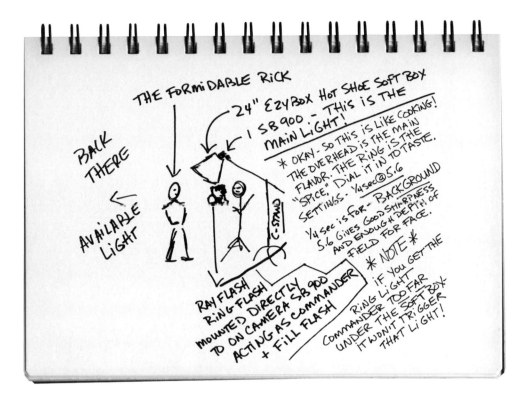

THE FORMIDABLE RICK

24" EZYBOX HOT SHOE SOFT BOX
1 SB900 - THIS IS THE MAIN LIGHT!

BACK THERE

AVAILABLE LIGHT

C-STAND

* OKAY - SO THIS IS LIKE COOKING! THE OVERHEAD IS THE MAIN FLAVOR. THE RING IS THE "SPICE." DIAL IT IN TO TASTE. SETTINGS - ¼sec @ 5.6

¼ sec is FOR - BACKGROUND
5.6 GIVES GOOD SHARPNESS AND ENOUGH DEPTH OF FIELD FOR FACE.

* NOTE *
IF YOU GET THE RING LIGHT COMMANDER TOO FAR UNDER THE SOFT BOX IT WON'T TRIGGER THAT LIGHT!

RAY FLASH
RING-FLASH
MOUNTED DIRECTLY TO ON CAMERA SB 900 ACTING AS COMMANDER + FILL FLASH

my head. Underneath it, I am beam onto him with a Ray Flash Ring Flash Adapter circling a 50mm f/1.4. The lens is pushed uncomfortably close to Rick, and the ring serves to pop out every line, ridge, and gully in a face desiccated by the harsh winds of time and life. It's not a comfortable light, either. It is unforgiving and raw. For this, I didn't ask Rick to smile or be the ever-gregarious storyteller he generally is. I just asked him to regard the lens and drag on an ever-present cigarette as he saw fit.

It's an uncompromising portrait, and, truth be told, a frame I'm fond of. The light is rough and unvarnished. Rick embraces it and stares back at the lens in an equivalently unvarnished way. The softbox does its job here, covering the waterfront with even light, providing me with a baseline. The ring is the spice in the gumbo, for sure. You could make the argument, quite logically, that the feel of the ring light is what dominates the picture, so it, de facto, should be listed as the main. That's okay by me. I simply prefer to think of my overhead as the covering light, the starting point, and thus refer to it as the main light, even though it really becomes, at first glance, pretty invisible in the photo equation.

My exposure is ¼ second at f/5.6. ISO 100, Auto white balance, with my focus cursor on that 50 mil dropped directly on Rick's eye. No messing around here with an auto area auto focus. The eyes have to be critically sharp, and at this closeness, there's not any room for error, even at the reasonable f-stop of 5.6. My exposure is, of course, the combo of the overhead box and the ring flash. What contributes what, or how much? This is where, once again, we are in the photo kitchen, preparing a spicy pixel soup. How much ring (spice)? How little? My suggestion is to get to the f-stop you need with your cover light. (And 5.6 is certainly a reasonable f-stop. It isn't necessarily *the* f-stop.) It should be well exposed, maybe just a touch under. Most likely, it will appear a bit flat, and dead in the eyes. Then, start dialing in the ring. Normal, plus one, plus two, etc. Stop where you like. Stop where it speaks to you, and thus explains Rick, even a little.

If you are shooting TTL and relying on the ring as a flash and a commander for the Group A light in the Ezybox, be careful how far you tuck yourself under the softbox. The ring is such a direct light that from that position, the commander signal it pops out there most likely will not find the light sensor panel on that softbox Speedlight. The bulk of the softbox itself can block effective transmission of the pre-flash, and thus communication between the two units can become dicey. There are a few ways to cure this. Pull your camera angle back so you are not directly underneath the box, which could then require you to grab a longer lens, such as an 85mm. This would put the ring/commander light in a position to more easily "see" the remote Speedlight.

"The real variable—hence, the 'difficult' thing—is the feel of the play between the two light sources. No one can tell you where or what that is. It's up to you, your taste, and how you want your picture to speak."

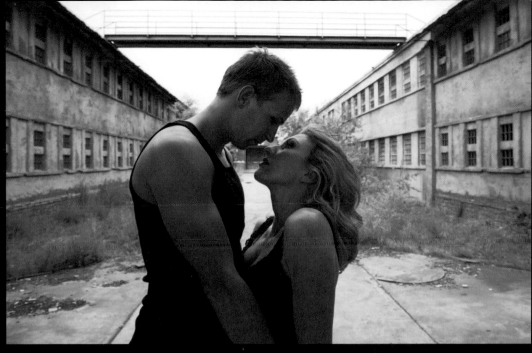
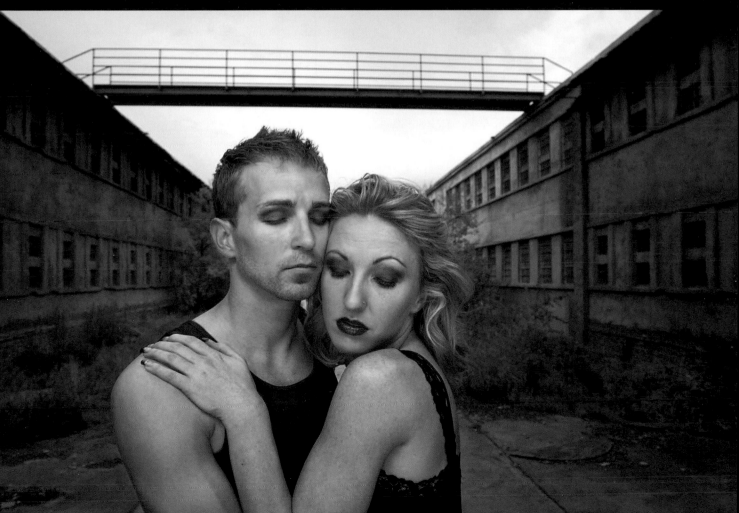

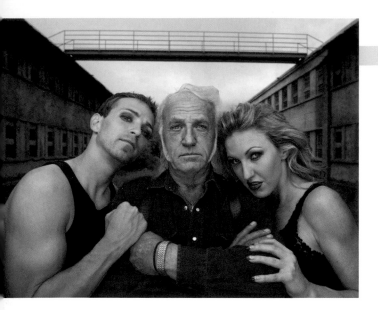

Or, put up a reflective board off to the side, near Rick but out of frame. That will most likely pick up spill from the ring and bounce it back up and into the softbox flash. Playing a little ping pong with your commander signal can get it to reach lights in places you wouldn't think you could ever trigger. Failing automated systems, a good option to have in your bag is a PocketWizard. You can fire the top light with the radio, and run the hot shoe ring flash in SU-4 mode, which is a manual slave trigger mode. Or, you could use the ring light as the trigger and take an independent slave eye and connect it to the overhead light via a cord running from the eye to the PC port on the Speedlight. You can let it dangle, if you want to live dangerously, but in this configuration, I would usually just take the slave eye and gaffer tape it right to the leading edge of the softbox, to maximize reception possibilities. Lots of ways to get the mechanics of transmission done, none of them particularly difficult, and some are automated, some manual.

The real variable—hence, the "difficult" thing—is the feel of the play between the two light sources. No one can tell you where or what that is. It's up to you, your taste, and how you want your picture to speak. But, any inflection you infuse that speech with comes from playing the ratio game—how strong one light is in relationship to the other. Test! Play!

Now for the medium flash shot—the one shown at the beginning of this piece. The vagaries of working fast on location led me to use two strip lights in a classic clamshell beauty combo for this portrait of Rick. He wasn't the original subject, truth be told. I was showing a class a couples' portrait light, using two young, beautiful people, all made up for drama. It's a nice enough shot. You can see the progression, from available light staging of the scene and framing the shot, to one light overhead, to that addition of a low beauty fill (and Rick), warmed with a bit of CTO gel.

Why two strips instead of two regular softboxes? Uh, the strips were set up and ready to go, and we were running out of time. I'd love to come up with a more nuanced, high-falutin' reason, but there you are. They did work out well, though, when I put Rick in the middle of the two young people, telling them they were a singing duo and Rick was their manager. The horizontal nature of the two sources was perfect for the trio.

But, you know, Rick is a black hole of such density, power, and interest, right in the middle of the photo, that I quickly excused the "models." They were wonderful, but Rick's bulk and flinty,

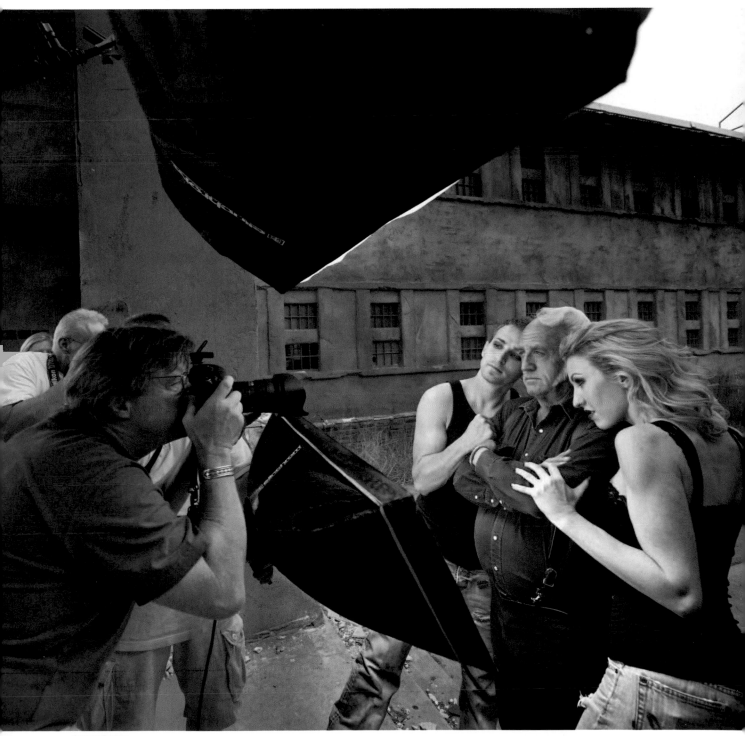

Garrett Garms

expressive exterior just became the boss of the visuals. Framed by the penitentiary cell blocks, he graphically occupied the middle of the picture, quite naturally.

He steps under the main light, the big strip. The small strip, the fill, has a half CTO on it for some warmth, which I probably did not need for him. If I could replay this, I would have gone for a neutral feel for both lights. Face it, Rick don't need adornments like filters and fancy moves in post. He is what he is, and I'm thankful for that, as he is one of the most amazing faces I've ever been lucky enough to have in front of my camera.

Thankfully, the warmth doesn't over-influence things because that low light is low power. See the production pic at right with the overhead main turned off? That small strip held just under camera is popping in a value that is about two stops of power under the main. The finals on this are 1/125th at f/8, ISO 100, D3X, 24mm lens. Cloudy white balance, mostly to keep a warm tonality for the buildings in the background. It's dusty out there, and a storm was coming up, so I wanted to complement the rich, earthy tones of the scene. I shot a total of seven frames. If I had my druthers, I'd have taken his watch off. Sigh. Do you ever shoot a picture that you wouldn't have done something different to?

Two setups, each with two lights. One small-flash style, the other with bigger lights and light shapers. Same graphics, really. One uses the inside of the cell blocks, and the other, the outside. Which do you like? Maybe neither. Myself, I like them both, but honestly, if I were to shoot Rick again, and I hope I do, I'll do it another way, and turn another page.

There are no real rights and wrongs here. No answers. Just the ongoing pull of finding the next good picture. ☐

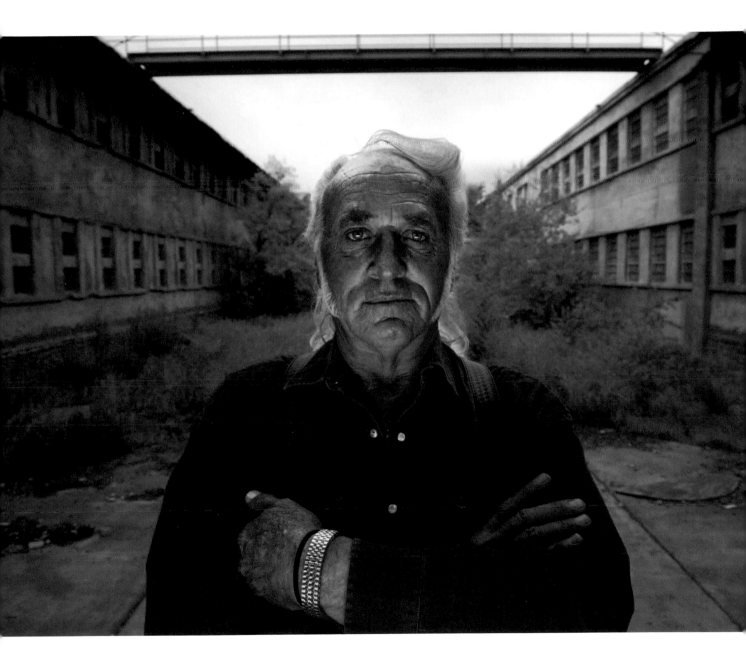

Mamie and Barbara, and a Lesson Learned

EVER HAVE ONE OF THOSE DAYS where you think your career is over before it's had a chance to even start?

I somehow managed to get this odd duck of a job years ago as a staff photographer for ABC television in New York City. I came to the network right off the streets—a complete black-and-white, pushed–Tri-X shooter for newspapers and wires—and got flopped clumsily onto the decks of the good ship Color Transparency like a gaffed tuna. My new boss looked at me and said, "We shoot Kodachrome most of the time." Gulp. "And we do a lot of lighting." Double gulp. I knew very little of either thing.

I went out and bought a set of Dynalites without even knowing how to plug them in. Ridiculous. I started experimenting. Thankfully, because stills were always the last consideration on location for a TV network, it was a job that expected failure, and I routinely delivered. Sometimes I failed because I couldn't get access. The star wasn't feeling well that day. Or the director didn't want to allow time for still shooting. Or there was only one good angle and the TV camera already had it, so I had to go to the side and shoot the talent at an off angle, and there would be stuff coming out of their heads in the background. Then they would see the pictures, and reject them. Sometimes, I failed just because I failed.

My week could start off with *Monday Night Football*, and careen from there to portraits of Susan Lucci on *All My Children*, to shooting a still life of an Emmy award in the studio, to zapping to Washington for pix of Ted Koppel. In between, there were campaigns, conventions, or shooting Hugh Downs on the set of *20/20*. (If you were assigned to shoot Geraldo, it was *Veinte/Veinte*.)

All done in color and black and white, horizontal and vertical, because the network would release the pictures everywhere, and there was a wide open field of potential uses for them. I felt like a mynah bird out there. "Color black and white, horizontal vertical! Photog wanna cracker!" At a breaking news event, I'd often have four cameras with me, all with different lenses and often with different ASAs (ISO). I'd be chasing a candidate and trying to simultaneously factor exposures for Tri-X at 800 and pushed indoor Ektachrome at 320. It was a juggling act of a job and I dropped the balls repeatedly, but I did

learn. I learned to combine what I knew from run-and-gun newspaper work with the principles of studio-like control of light. I also re-upped the ante in terms of being able to work fast. I got used to doing the 60-second portrait session. Color black and white! Horizontal vertical! Sixty seconds! Go!

Barbara Walters was about to interview Mamie Eisenhower at Mamie's home in Gettysburg, PA. Barbara yakking it up with a former First Lady was no small thing, so ABC dispatched me to PA to engage in what promised to be yet another of these luxuriously contemplative photo sessions I had grown accustomed to. Thing about this trip, though, was that I had to go with Barbara. In a four-seater Cessna out of Teterboro Airport, near NYC.

Barbara looked at the pilots before we got in. "Two pilots?" "Yes, ma'am." "Two engines?" "Yes, ma'am."

Okay. We got in. Barbara had a producer and a personal assistant with her, so that little plane was maxed out, people-wise. I crammed in next to her, knees bumping, and, being the lowly photog, was promptly dis-included in any conversation.

Which was fine by me, 'cause I had, that morning, woken up with a stomach flu, and had horked up any form of nourishment I tentatively tried to ingest. My stomach was rumbling almost as loudly as the props on the Cessna, and sweat was soaking through my shirt. Sardined into the seat next her, I managed a wan smile. I then turned my face to the glass and tried to figure out where to stash my next Technicolor yawn. There were bags, of course, but my experience from that morning was that my upchucks had been so forceful I feared I would

blow a hole right through the bag, and the material would shoot from the passenger area to the windshield of the plane.

"The pilots, blinded by the photographer's vomit, crashed yesterday while attempting an emergency landing. Television luminary Barbara Walters was among those killed. We can't remember the photographer's name, but it was definitely his fault."

Clenching my stomach like a fist, I made it all the way to Gettysburg without intestinal incident, surely saving my newly found staff job. I shot into the bathroom, made peace with my insides, downed a half a bottle of Pepto, and jumped into the limo to Mamie's. The crew was already there. Barbara always demanded (and got) the best crews. They knew what they were doing, and made the TV light nice, which it often is not.

Pleasantries were exchanged, and the interview rolled. I did my usual quiet pacing in the back, behind the cameras, ears on alert, waiting for the director to say, "Cut! Hey, you wanna shoot some stills?" When the moment came, I scampered onto the set, bobbing and weaving with my gear under the various sets of sticks and cameras populating the room. I arrived at Mamie's feet as if I were sliding into second base trying to break up a double play, and immediately jammed my camera to my eye and got my finger on the motor drive.

I was surprised when I looked up at her through the lens and found she was eyeballing me formidably, wagging a "No" at my camera lens with her forefinger. "Young man, you never shoot a picture of a lady from below her chin line."

Mortified, I mumbled, "Yes, Mrs. Eisenhower." Thus chastised, I composed myself, raised up off the floor, and began to shoot her conversing with Barbara from an ever so slightly elevated position. It's something I always remember, especially when shooting pictures of women of a certain age.

It's not everyday you almost kill your career by throwing up on a big TV star and then get a lesson in portraiture from a legendary former First Lady. A good, if painful, day in the field. □

Lessons from the
Acetate Era

ALLOW ME TO TAKE YOU down analog
memory lane for a bit, back to when nobody
knew what a pixel was, and picture-making
tools were just this side of what you might
find in a blacksmith's shop.

Drew Gurian

Imagine shooting a press conference back in, say, the seventies or eighties. It's a quickie, emergency press conference where the governor of whatever fair state will step to the microphone and admit to certain, well, discrepancies in his personal life. Hard to believe, right? I mean, this could never happen in real-time American political theater, but bear with me and indulge this fantasy. The gov is a married father of three and has championed family life, God, weekend barbecues, the flag, and church on Sundays, and he's campaigned on a pledge of cleaning up the streets to make things safe for good, decent folks. He's also a pretty forceful advocate for keeping our borders tighter than a nun's corset, as they say.

But, turns out this righteous paradigm of good clean living has been diddling the housekeeper for at least 10 years and launched a love child at the same time he was fathering children with his wife. Other women have stepped forward—some of them younger than his oldest daughter, and some of them even got paid for services that, Lordie me, can only be mentioned in those magazines behind the counter you have to specifically ask for, hopefully when there's no one standing in line behind you trying to buy a copy of *Knitting Monthly*.

This could never happen, right? But let's just say, back in the day, you have to cover this public confessional.

First things first. Get there early for positioning purposes, 'cause everybody from the networks to the lowliest weekly rag is gonna be there. Getting there early is a strategy that is certainly applicable here, in this dense and frenzied scenario, as well as virtually every other instance you might take a camera in hand. Even if you'll be out there all by your lonesome, shooting sunrise over an upstate lake, get there early. The morning you choose for that long anticipated sunrise shot, they'll have re-paved the highway to the lake overnight, and there will be crews out there diverting all comers off the main drag onto convoluted local roads that will no doubt add an hour to your travel time. You'll watch the sky catch fire while you're white-knuckling the steering wheel and screaming obscenities at the inside of your windshield.

Next, prepare the cameras, which at this point in time meant choosing your poison in terms of film, which also dictated the white balance. It's a press conference, made for TV, so the lights will be tungsten (incandescent) floods. Not flattering, but efficient. Generally a convocation like this would end up being shot on Kodak EPT slide film pushed one stop to ASA 320. (We said ASA back then. It means ISO.) If you were lucky, that would give you a shooting combo of about 1/125th of a second at f/2.8. If you hadda hadda, you

could push another tick in processing and squeeze ASA 400 out of the EPT, but let's face it: Indoor slide film balanced for 3200K sucked, so 400 was about as far as you could go before you started to produce grain you could drive a truck through.

Now that shutter/f-stop combo was available to you only if you had an f/2.8 lens, which, at that time, meant you would have to use a prime. None of the super sharp, fast glass zooms existed. So, most likely, I'd choose my favorite tele from back then: the 180mm f/2.8. For versatility, the Nikkor 80–200mm f/4 existed, and it wasn't a bad lens (manual focus, of course, with a single ring for both focus and zoom), but indoor color film at f/4 requires another ASA push, making it even rougher around the edges. Okay, decision made. Go with the prime and save what you can in the name of quality.

Depending on your position, the 180mm would produce a great headshot of the disgraced pol, which is something you had to have. But what about context? The telling shot had to be him and the stony-faced wife, looking like she had just inhaled a half a bottle of scotch, standing there in mute, stunned public support of her turd of a hubby. What if there was an exchange? Fireworks? A flinty, reproachful glance? Hadda be on that, too. So, maybe it would be safer to throw a 105mm f/2.5 on there and go horizontal, just in case. Without the happiness of a fast zoom, compromises were made. If she hauls off and slugs him, the 180 is too tight; and if action like that happens, it'll be over before you change lenses. And if action like that happens and you don't get it, kiss your job goodbye.

Gets complicated, don't it? If you had a second body, the 105 could be on that, and you would have a prayer of making a fast switch, as circumstance dictated. But remember you're shooting in a tungsten environment. Do you load that second body with indoor transparency stuff, ready to go, and balanced for the action at the podium? Or do you load that camera with daylight chrome, 24mm lens, and a Vivitar 283 flash hot shoed to the body? Why? As soon as the red-faced gov has eaten enough humble pie at the microphones, he's gonna bolt for the limo. You have to chase, most likely through dark halls into some sort of lobby and then out into the street into the oasis of his car.

You can't do that with indoor film in the camera, so that second body most likely has to be set up as a daylight, fill-flash camera. Now the flash on this camera is hardly reliable in terms of exposure. The little onboard sensor on the 283 might be a good gauge for broad-stroke work—much like the throwing of a hand grenade—but as a precise instrument to divine the exacting nature of transparency exposure, fuggedaboudit!

So, most likely you were going manual mode on the flash, which is a dubious proposition when the gov's security starts throwing bodies out of their way to clear the pol's

"Also, remember, during all this mayhem, you can't check the LCD, so you don't know at that moment how badly you've screwed up. You have to wait for them to tell you that back at the office."

path. You'd find yourself at five feet, ten feet, two feet, twenty feet from your target. On manual, that meant doing some long division in your head (guide number of flash over distance to subject gives you ballpark f-stop) as you chased your quarry through a circus-like atmosphere. Or just screw the math and rotate through a series of your best guesses based on the last time you were in an impossible situation on a photo assignment. Like, you know, yesterday.

Your rapidly, ever-changing distance to subject not only confounds your f-stop calculations relative to your flash exposure, it also bedevils your sharpness factor, right? No auto-focus back then, dear reader. You had to quickly eyeball the distance scale on your lens and set it at, well, something. It's gonna be a guess 'cause everything's moving so quickly that you won't be able to comfortably get your eye in the lens to compose and focus. Plus, you're stuck behind a video cameraman, and those guys are always, like, 6'5" and wide enough to show a movie on their back. So, while ideally you would like to see your subject, most likely your view of the event is the back of the video guy's t-shirt. Say, for the sake of argument, he's an L.A. Lakers fan. Instead of seeing the gov, you're actually staring at an artist's rendering of a Kareem Abdul Jabbar sky hook, and holding your camera over the video guy's head in classic "Hail Mary" mode, clicking off mostly useless, desperate frames.

This focus guesswork is why I suggested earlier that your second body with the flash—the one you're gonna run and gun with—would perhaps be set up with a 24mm lens, giving you half a prayer of sharpness. Not that it mattered all that much. At that point in time, you were probably shooting for a newspaper that had a dot screen so rough that your published pictures looked like impressionist paintings, so sharpness was overrated as a consideration.

Also, remember, during all this mayhem, you can't check the LCD, so you don't know at that moment how badly you've screwed up. You have to wait for them to tell you that back at the office. Jobs like these are the reason lots of older press shooters hit every bar on the way back to process their stuff at the paper.

Oh, and speaking of not checking your LCD, what about setting the exposure for the podium in the first place? After a while, experience dictates, but if you wanted to really know what the deal was up there at the microphones, you had to meter it. And forget about the in-camera meter. That sucked. Plus there was no one at the podium for the meter to chew on. Just empty space. What to do? Well, at that time the best way would be to give up your hard-won space in the scrum that is politely described as the "press gallery" and go to the podium, handheld incident meter at the ready. That way, you could actually, physically occupy the same space your eventual subject would occupy. Let all the TV lights hit that dome on your meter, and you could get a real good reading.

But, can you get to the podium spot? Most likely not. Security up there will pitch you off in a heartbeat. You ain't givin' the press conference, pal! Stay down!

Okay, officer. Could you hold this meter up there and just click this...no, okay, I understand, sir, you have a job to do and that job has nothing to do with metering f-stops and shutter speeds.... You would have to retreat to your spot, if you could get it back. From there, you would reach down and whip out a spot meter. That way you could get a read from a distance. But what to read? The dark wood of the podium? The silvery gray of the microphones? The gold velour background texture and lettering, where it says "Doral Midtown Hotel"? Yikes, you gotta make some decisions here, and those decisions are based on interpolation and educated guesses, rarely done deal fact. Only real hint here is to find something, anything, up there that might approximate a middle gray.

Also, be aware that all the sweat you're oozing trying to get an accurate meter reading on the podium is most likely for naught. Nine times out of ten, the cameraman from station KAZY—you know, the overweight dude who's always late—is gonna bull his way into the mix at the last minute, get right in front of da gov and blast him with the pepper light affixed to his video rig. Time for an exposure re-adjust!

Blunt tools, indeed. Compromises galore, and hardly pretty ones. Not surprising now to remember that some of the real old-line guys in the press corps—the ones with the Speed Graphics and the synchro-sun flash guns—basically had chiseled f/8 and 10 feet into their f-stop and focus rings and just left 'em set there. The flash made f/8 at ten feet, so they just hoped something significant would happen at that juncture of distance and exposure. They made life simple for themselves.

By the way, your problems would explode even higher and further if you only had one camera, which is why you've seen pix of the press gang from that era with three or four bodies draped on them. Different lenses, all prime, different films, dictating different

color spectrum. If you had just one body, you'd find yourself chasing and changing simultaneously. Chasing the subject while changing film—a recipe for disaster, either for the shooter or the job.

Given the very real parameters described above, does anybody out there actually want to step forward and complain about digital? Geez Louise, is this easy or what? The film-based solution to the press conference could easily have spoken to the need for three cameras. Now, one will suffice. Imagine being in the press conference at a middle distance from the podium. You are shooting, for instance, a D3S affixed with a super sharp 24–70mm f/2.8 zoom. The camera has notoriously excellent high ISO response, so in this situation, light levels no longer matter. In fact, you have the luxury of wonderful quality at ISO 1600, which affords you the ability to actually stop down a tad, giving you greater depth of field, so that wifey's withering gaze in the background is actually sharp enough to discern.

Shoot tungsten, by all means. You can even adjust your color temp incrementally to accommodate aging or weird bulbs, if you choose. In other words, tailor your camera to produce that which looks best. In days gone by, you pretty much had to be happy with what the camera gave you. And, of course, what the lab gave you. If the boys on the lab's morning shift came in to gin up the E-6 line after a hard night out at the bars, your Ektachrome could suffer from, quite literally, the blues. Or the greens and reds, depending on how the quality curve might be running on that particular day, and if anyone was paying attention.

Metering? No worries there. The in-camera meters are now amazing, and you can configure them in a split second to spot, center weighted, or matrix (evaluative) readings. And then you can double-check its estimation in the LCD. And the histogram. And the blinking highlights. You have a problem with this?

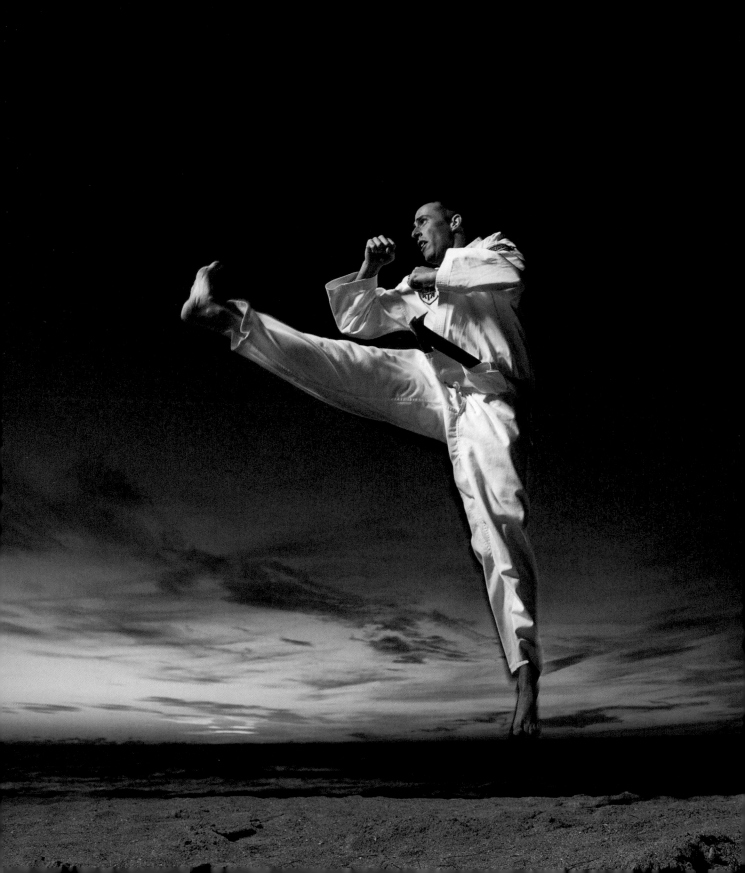

What you see is what you get, at least within the tolerance of the monitors you might use. Very reassuring. Very doable. Very in-camera. Highly automated. Lock solid, done deal, unless you really, really try to screw it up. Color balance adjusts at the flick of a switch. The very sophisticated in-camera meter hops back and forth between modes and areas of sensitivity, just as you designate. And your ISO, once a defined barrier, has been enlarged and enhanced. And it is effectively changeable at all times, seamlessly.

But, there are digital lessons to be learned that date back to that time of film—the Acetate Era— when photographers were just emerging from the primordial ooze and beginning to grow legs and opposable thumbs. There was a certitude about some techniques that even now have resonance and effectiveness.

Take color balance. As I indicated above, historically it was the function of whatever yellow or green cassette you slipped into the camera. Once you closed that gate, the color you received from that film was fixed. It had a defined response range. Place it in the wrong environment, it made you pay. If you wanted a different response, then you'd have to wind it up and play it again, albeit with a different type of film, presumably from a different pocket in your vest or pouch in your bag. (It was unwise to mix different types of film in the same place on your person on a job. Led to mistakes. Separating your types of film was a given, a ritual performed before every job. Kind of, you know, like the water and the wine at morning mass.)

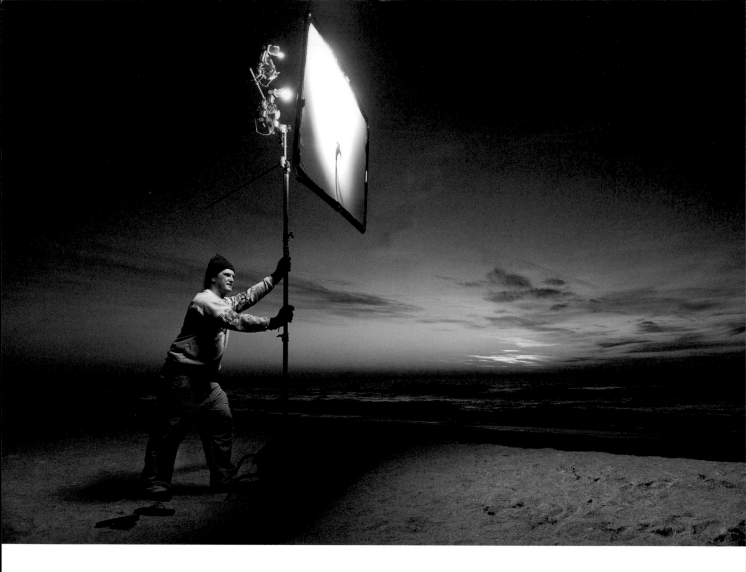

So now, digital cameras have an almost infinite range of possibilities, all inside the camera's computer noggin. Flick a switch, change a number, and your pictures look different. Not better. Different. You, and your personal preference, dictate that difference. You are no longer locked into 36 frames of the same look. If you are not liking the look, you can change it, mid-stream, frame to frame. Just like a painter, you can mix your color palette as you see fit.

Are there problems or worries with this? Yes, in my opinion. The cameras nowadays, especially the high-end ones, are super smart. No quibbles there. But to pull a phrase from a time-honored joke, "How do it know?" You still have to guide this machine. Your feel for color still has to supersede its mechanical estimations, and the safety net of the raw file.

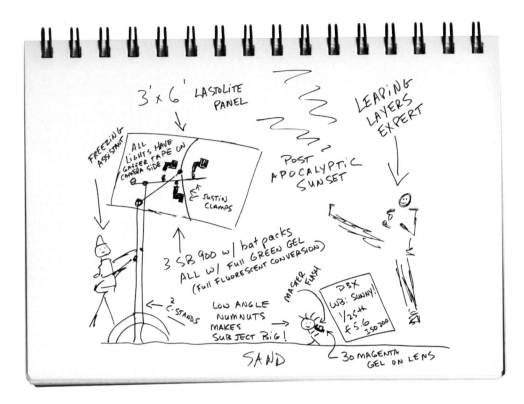

NEW PIXELS, OLD TRICKS

One area I have generally felt that even the smartest digital cameras tend to get fuzzy about is fluorescent white balance. (Now, this is in my experience. I have not used every camera out there. Some may produce perfect fluorescent assessments.) Personal preference here, but I just don't like the by-rote response the camera gives when popped into fluorescent mode. To me, it tends to be a bit warmish, and somewhat sickly looking, at least out of the gate. True enough, you can play the numbers, and come out with something reasonable. No worries or debate there. With higher-end models, there is now a white balance adjustment grid, where you can push or pull your pic towards hues that appeal to your eye as normal. Or not. Customize away! That's the beauty of digital.

Your camera literally has thousands of degrees of adjustments that are available to you at the flick of a button. Thing is, out there in the world, there are about a million billion color problems. Seat-of-the-pants, on-the-fly color correction is an inexact science at best. If the camera's rendering is off, or your judgment call misses the mark, neither the camera nor you are "at fault." There are so many wacked mixes of light out there that pure, controlled color rendition is something of a mirage. Even within the context of a defined space, there may be different light sources, different types of bulbs, various

"A simple, film-based solution, shorn of frills, expressed in pixels. No fuss, no interpolation. No guesswork. No post-production hype for the color. A time-honored formula from the past, when photographers first began to stand upright."

manufacturers, differences in the ages of the light sources. All of these will burn at different temperatures. Like an orchestra warming up, it is all dissonance and conflicting, unsynchronized noise. And, if you try to get it absolutely perfect, it can and will drive you mad. (Please note: I am talking about location work, pictures done out there in the world. If you shoot in the studio all the time with known parameters, this gets much simpler, very quickly.)

The hurly burly color you get dropped into as a location shooter is why I occasionally embrace the straightjacket of analog. Effectively, I turn my digital camera into a film camera, and lock the white balance down on daylight. Just like shooting slides. No auto adjusting, no letting the camera think on its own. I shut the noise off.

Uh, wanna explain that?

Hear me out. From many years of shooting film, I have a good, predictable sense of what daylight balance material will look like in certain situations, and how its simplicity (some would say its weakness) can be turned into a strength.

In the kick-boxing picture on the beach (page 276), the only light I have left is the light in the sky. If I expose for that sunset, then every element of the foreground goes black, which gives me absolute control over that area of the photo. The scene is daylight, and in the digital world, I could manipulate the camera's response to it. I could literally zoom it around the color wheel a bit, emphasizing the red of the clouds, for instance. Or, I could cool it down. All easily done with small adjustments in the camera's menus. And those adjustments affect only the sky, 'cause it's the only light left hitting the sensor. What is black, remains black. No detail, no color conflicts.

But, once I zoom around my digital white balance to points untested and unknown, what strategy do I employ with my white light flashes? The dark foreground area is where my subject will live, and I have to bring light there. Daylight-balanced Speedlights could

look really, really funky, depending on where I throw my dart at the digital color wheel. I have to find a filter mix to accommodate the color value I just dialed in. It could be a simple fix (one filter), or it could be a tad more complex and involve multiple filters. Definitely doable, but this approach could easily require some testing to find the right filter combo.

Instead, taking as my inspiration the drama-filled sky, I shut down the vagaries and potential of digital and keep it simple. The sky is daylight. So is the camera. To enhance the sky without digital maneuvering, I put a 30 magenta filter on my lens. All those points of pink take the heavens and turn them into end of day, post-nuclear attack. Fire in the sky!

But, again, my white light flashes will not like that. They're gonna go pink. Don't want to turn my subject—the kick-boxing Photoshop expert Matt Kloskowski—into jolly old St. Nick, so something has to be done.

What I do here is what I have done for years: affix a full fluorescent conversion gel onto my flashes. It goes by different names, depending on who you talk to. Some folks call it "window green," others refer to it as a "full cut" of fluorescent conversion. But it is simple and straightforward, and actually comes bundled together with some of the higher-end flashes when you purchase them.

So, one filter on the lens, one on the light(s). Magenta and green. Color-wise, a trade-off. They neutralize each other in the foreground area where the exposure is driven by the flash, rendering my subject normal-looking—not pink, and not green. Normal, daylight skin tones.

But what is not normal is any other area of the photo where light lurks. In this case, that would be the sky. That light has no green filtration, so it radiates, naked, right through 30 points of magenta and hits the sensor as a red-laced fireball. Normal tones up front, Martian sunset in the background.

(Quickie note for the technically minded: The three SB-900 units give me a fast recycle. They have dome diffusers on, but I try to control their spread, at least minimally, by affixing gaffer-tape gobos on the camera side and the low edge of the lights. That way, I cure potential flare at the lens and minimize spill on the sand. I want to see the foreground—to know what the surface actually is—but I don't want to overlight it. The gaffer tape helps in that regard. Collectively, the lights are one source so they are all in one group [Group A], and they easily respond to the line-of-sight commands from the master, which is hot shoed to the D3X I'm holding. I can maneuver their power easily, in response to Matt's distance from the light shaper and the dying sky. I'm in manual exposure mode, checking each frame for the sky and the relative intensity of the flash.)

A simple, film-based solution, shorn of frills, expressed in pixels. No fuss, no interpolation. No guesswork. No post-production hype for the color. A time-honored formula from the past, when photographers first began to stand upright. □

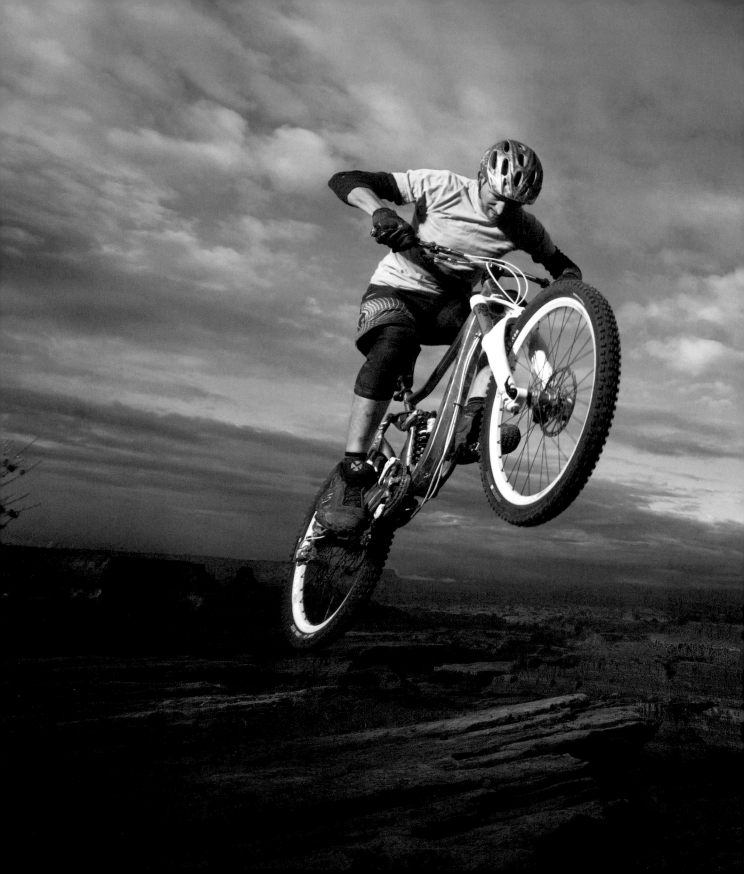

Finding a Picture on the Edge of the Canyon

I'M NOT MUCH OF A LANDSCAPE, national parks, hiking kind of guy. My idea of the wilderness is the New York City subway system. But, courtesy of hanging around with my friend and legendary wildlife shooter Moose Peterson, over the last few years I've had a chance to sample some truly beautiful areas of America.

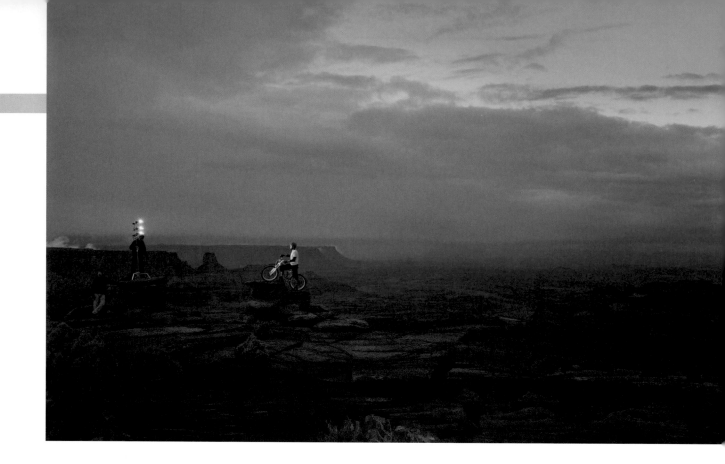

About four years ago, at sunrise at Horseshoe Canyon in Moab, UT, I saw an area that remained shaded by rocks, while the rest of the canyon got bathed in beautiful morning light. I filed it away.

It took me four years to get back there; thankfully, it being a national park, it was still there. (That's always the danger in urban areas. You see something you like, file it away in the "location futures" Rolodex section of your brain, and then you go back and they've built a Burger King right where you were going to put your tripod.)

I had been thinking about a shot there for quite some time, and mentioned it at the studio as we prepared for a return visit to Moab. In my tiny studio, we talk about potential shots and projects. It's pretty collaborative, which means the gang here has no qualms about telling me when my ideas,

or pictures, suck. But everybody was up for this one and thought it was a good idea, until I said the word—ballerina.

They begged me not to. I relented, and we settled on a mountain biker, which is a far more logical choice of subject, given the locale and the terrain. FYI, if you ever go to Moab, which is magnificent, and you need a good biker model, call the bike shop Poison Spider. They have top-notch competition bikers working behind the counter, and they really can advise you well, and get you good subjects.

We made arrangements for the shot and the timing, and went out. As I said, the spot was still there, shrouded in shadow, and with headlamps we got ready to shoot before the sun hit the horizon and started its daily, beautiful torching of all the red rocks and chasms out in the huge, sprawling canyon.

For four years, the shot that lived in my head was long lens, long lens, long lens. I was determined to test the range of line-of-sight, and compress the graphics of the canyon with a telephoto. We set up three small flashes on one C-stand, gelled them warm with full CTOs and positioned the biker. If you're melding multiple units into, effectively, one source, this is a good way to do it. We take the flashes and put them on Justin clamps, and then slide the Justins onto the extension arm of the C-stand. They all line up quite easily with the same pitch and angle.

I trekked back to a vantage point maybe 50–60 yards away with a 24–70mm and a 70–200mm, and started shooting. I did a few wasted clicks on Aperture Priority to get the ballpark exposure, and then went manual. It seemed simpler at that moment to manually control the exposure and make my own judgment calls as the sun rose. Also, because my subject was destined to live more at the edges of the frame, I went manual focus, as well. I used single servo AF, placing the cursor on my subject, pulled the focus, and shut the AF down. It wasn't like the biker, or I, were going anywhere. (I periodically checked it, of course. "Periodically"? Geez. I'll be honest. I'm so paranoid about focus and the aging of my eyes I probably checked it manically, not "periodically," just about every frame.)

The opening frames went pretty rapidly from $1/20^{th}$ to $1/40^{th}$ of a second at f/4, as the muted dawn light grew incrementally brighter. Line-of-sight transmission was seamless, and did not miss a beat. All three lights, because they are acting as one source, are in one group—A. Their initial power level was manual at ½. In other words, half the power of each individual unit. It's why I used three instead of one. One would have been seriously stressed, and I would have had to make concessions in either f-stop or ISO. Didn't want to do that, so I slung three of them out there. All three, by the way, have gobos (cutters or flags) Velcroed to the bottoms of the units, meaning the edges of the flashes closest to the ground. Purpose of this was to flag or cut any spill of light that might have heated up the ground, exposure-wise, and been a giveaway as to the position of my flash.

I had technical success going. Good exposures were occurring, and there were no flash woes. In fact, it was one of those rare shoots where I had exposure, sharpness, Speedlight control, and framing knocked, right from just about the very first frame.

Only problem, though, was that I didn't have a photograph. I was executing, but that hardly constitutes pictorial success. Just because the camera's working doesn't mean your brain is. I had an essential composition issue right from the very first second I looked through the lens: Get the biker big, lose the canyon; pull back for the canyon, and you turn the biker into something that looks like a Smurf

"I'll be honest. I'm so paranoid about focus and the aging of my eyes I probably checked it manically, not 'periodically,' just about every frame."

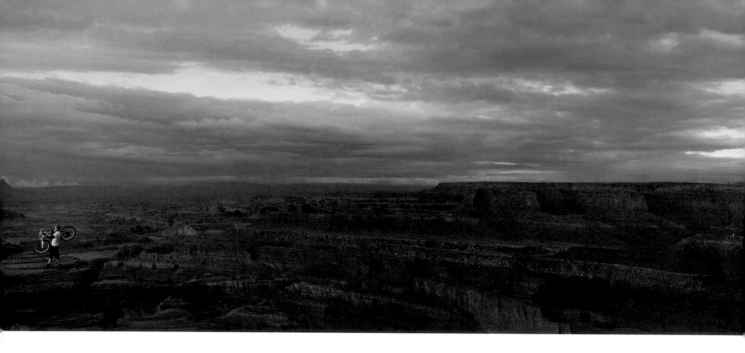

with a trike. Plus, the vantage point I stuck them on, while it looked cool, forced them to really, really pose. The picture was static. DOE—dead on exposure.

I convinced myself I could rescue the situation by shooting frames as a two-up, for composing later into a pano. But you know, that's just not me, generally speaking. If, in the field, I start to think that I have to ask the computer for an assist after the fact, I got a problem, and it's in the field, sitting right there in front of me. And that problem is called a bad, or at least ill-conceived, photo.

I'm not knocking post-production. It's a beautiful thing, and we use Photoshop in my studio. Post-production of one type or another is a given of digital shooting. I'm talking here about using the computer to mask bad photography, or a screw-up at the camera, in the field.

Which I was in the process of making. Not a career-ending error, mind you—Lord knows I've shot worse photographs. But it just wasn't pulling together the way I had envisioned it, in my mind's eye—for four years.

You'd think having a shot percolate for all that time would guarantee success, but location photography is a great teacher, and one of the chief lessons it imparts to all of us is how to turn on a dime, and improvise—fast.

I jumped off the rock I was on, approached my subject, got low, and put on a 14–24mm. This again is practicing what I preach. If you think it looks good with long glass, before you leave with all your eggs in that basket, throw a wide lens on and check it out. If you're up high, get low. If you're working with the sun, flip 180 degrees and try working against it. Do something, especially if you're not happy with what you're seeing from your first angle.

By the time I got the final picture—and had the biker, the gesture, the canyon, and the light all working—the sun had come up. My finals here were D3X, 14–24mm zoomed at 19mm, dynamic nine point AF, 1/250th at f/8, ISO 200. The lights stayed in the same configuration, still gelled, zoomed to 200mm, and now running at full power, manual 1/1. I had sky, canyon, and biker, in beautiful morning flash, uh, light.

Damn photography! I had thought about a shot at this location for a long time, and thought that I had a lock on it. And then I got back to the edge of the canyon, and I still had to try and find the picture. □

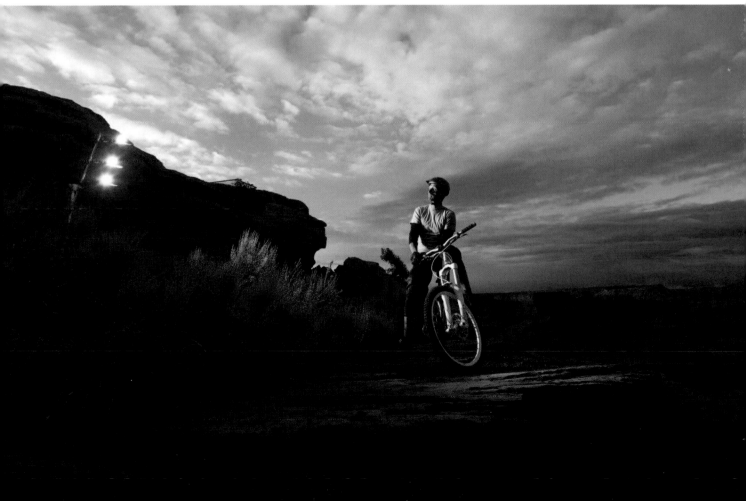

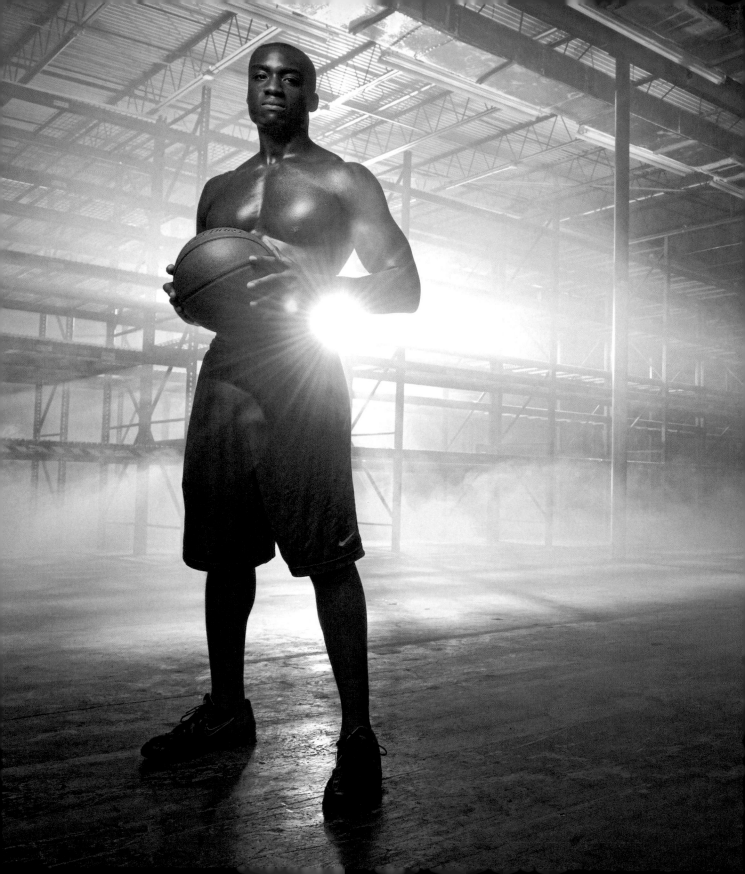

Sometimes, the Main Light Is in the Back

THIS SHOT IS BASICALLY TWO LIGHTS. One big, one small. There are other lights, real minor, kicker-type lights, and I mention them toward the end of the story, but really, this is a two-light photo. Now, conventional wisdom often dictates that the main light is the big light, and that's for the subject, or star, of the photo. The smaller light is the fill, or perhaps it's for the background.

Nothing wrong with conventional wisdom. It often works, and works well. Big light up front, little light here or there. But when you're dealing with yards and yards of cubic space, and your subject is just a piece of that space, you might want to re-think that time-honored equation.

This is a sports portrait, which is a style of portraiture that demands drama. If you've got an amazing-looking athlete in front of the lens, all sinews and attitude, are you just gonna bounce the flash and call it a day?

Let's make that a no. You have to push your light, the same way the athlete has pushed their body into this ready-for-prime-time condition. Pushing the sense of the light does not necessarily mean complications, with lots of lights and assistants. As long as whatever light you're using shapes and rims the human form and face with punch and impact, it doesn't matter if it's one light or 10.

The composition of this photo is pretty classic rule-of-thirds stuff. My subject is camera left a bit, leaving the warehouse space to create the rest of the frame, and hopefully complement him graphically. The warehouse, thankfully, was not empty. There were these rows and rows of empty racks—a grid, actually—and that called for some sort of light, and a lot of it.

For a space of this scale, small flash has challenges. I mean, you could put a bunch of them back there—maybe spot light walls and certain girders—open up your f-stop to accommodate the lack of power, and jump through a bunch of hot shoe flash hoops to make something work. Lord knows, I've tried that on many occasions, with varying degrees of success. But here, for definitive impact and direction—not to mention one coherent set of shadows—I really felt that one big light was the way to go. Put up a big fella of a strobe, step back, and see what happens. One-stop shopping.

Given the dominance of this light, the ground it had to cover, and its preeminent role in this photo, it really is the main light, even though it's 75 feet from the camera in the back of the frame. I've got my guy up front, but I'm not worried about him. I know I can light him. What concerned me was the overall level of drama in the pic,

"Light creates drama by casting highlights and shadows, but when it hits particulate matter in the air, be it dust or vapor, it can create unpredictable shapes and effects. It can also kinda sorta become its own light-shaping tool, like a big blanket of a diffuser."

which derives from that light out there in the hinterlands. It is a 1100 watt-second Ranger, running off a radio trigger. It is screaming right at the lens, assisted by a long-throw reflector pan. Those are really deep dish reflectors that channel the light and push it long and far in one direction. Most "regular" or stock reflector pans are about six to eight inches deep. These guys are 16 inches deep, and have a 29-degree spread of light. Inside the bowl of the reflector, it is highly polished silver. All of this adds up to a singular whap of light that's got serious legs.

I described this as an uncomplicated photo, and it is. I did, however, add to the atmosphere by introducing a smoke machine. Light creates drama by casting highlights and shadows, but when it hits particulate matter in the air, be it dust or vapor, it can create unpredictable shapes and effects. It can also kinda sorta become its own light-shaping tool, like a big blanket of a diffuser.

Given the prominence of Halloween and raves, smoke machines are pretty ubiquitous, and cheap. Just go into a somewhat sizable costume shop, and they got 'em. But be careful what you smoke up! Check with the building super, or the physical plant folks. Are there smoke alarms? Are they wired into central station? If there are windows, and smoke starts pouring out of them, will there be a neighborhood panic, complete with fire trucks, sirens, and stern-faced authority figures who—after an adrenaline-fueled rush to what they think is a major fire—actually confront...a photo shoot? This will not go well, unless you have checked it all out, maybe even gotten a permit, and let the local fire/police department know you are pumping four-alarm-blaze smoke through a local structure.

It will also not go well if you create smoke in a closed interior that has delicate surfaces, like perhaps vintage cars. Lots of smokers run on a mix often called fog juice, many types of which contain mineral oil. This fluid gets vaporized inside the heated chambers of the smoke machine and spews out in big dollops of heavy white cloud. All fine for a picture but, in an unventilated environment, it can leave a residue. If someone just spent their entire weekend waxing and detailing their classic car for the shoot, and you coat it with sticky vapor, you will not be invited back.

No problems with smoke here, though. Big empty space, with nothing noteworthy or delicate to speak of, and the vapor would quietly just melt away during a series of exposures. Which is generally what you do when you smoke something up—make a series of exposures. When you press the button on the smoker, you let loose a fairly uncontrollable item, as if you just dumped a box of cats onto your set. You just have to shoot your way through it. At the beginning, it might be too much, and at the end too little. But there will be a sweet spot as the smoke settles and your light graces it, just so.

Okay, on to the foreground, which is hugely important but relatively simple. Mic, the athlete, formidably regards the lens, basketball in hand. I told him to look at me and the camera as the only things between him and winning the slam dunk contest at the NBA All Star game. In other words, he would crush us if we got in his way. The light is a SB-900 into a 24" Ezybox Hotshoe softbox, placed off to his left on a handheld paint pole. It is running on manual slave-eye mode, again, what Nikon calls SU-4 mode. That means the light will react to the big flash in the back, and fire off that. The light is above him, so it really collects around his face, chest, and arms, then tapers down his body, which is what I was looking for it to do. You don't want his sneakers to be the same flash value as his face, unless, of course, you're shooting a campaign for Nike.

Two lights and done. Truth be told, way in the distance, on camera right, there's a yellow wall, also lit with flashes running at low power. I threw a bit of light on it at the last minute, just to subtly define the

reach of the warehouse. They, too, are slave-eyed, and running off the big light. That is really why the light in the back is the main light; it drives everything—the intensity, the backlighting, the smoke—and it triggers all the other illumination in the photo.

It also provides the additional drama of lens flare. Happy accident. I started the session by making sure my subject blocked the back-light, so that he would get rimmed by that flash but my lens would be shielded. But then, not really being able to see the position of that light shrouded in smoke, I drifted right a bit and picked up its blast in my lens. I liked it. One of those things that happens when you have a camera to your eye. Happenstance, accidents, of all kinds. It also relates to why I don't use a tripod unless I really have to. I move a bit, always looking, always shifting the camera POV in relation to my subject. Slight shifts can mean big differences, like seeing this light.

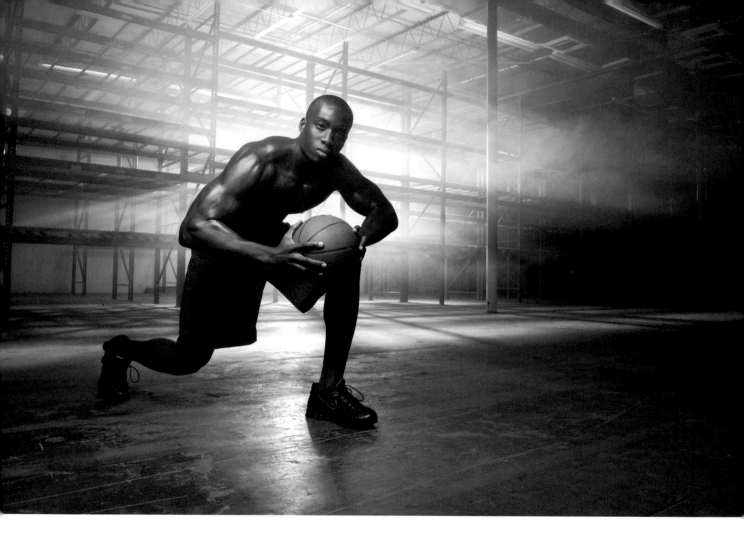

Could I have done it back there with small flash? Ah, the question haunts my dreams. Hmm…a qualified, not particularly forceful, yes. There have been many advances in small flash in recent years, and of course the various shapers and receptacles for them have followed suit. If I had put a TriFlash back there, with three Speedlights all firing in the same direction, I think that would have worked as well. To do it, I would have taken the dome diffusers off, zoomed the flashes to maximum tightness, and set them at full power. Manual settings, max power.

At camera, I would have taken my master flash off the hot shoe and run it up high on a stand, via SC-29 cords linked together. Again, dome diffuser comes off, and the flash head gets zoomed all the way to max out the range of the commander. That master unit would be angled so that it would pick up the Ezybox flash in the foreground and the three lights in the background. I definitely could not have left the master on the hot shoe at camera. It's a low-angle shot, and my subject would actually block a bunch of its signal.

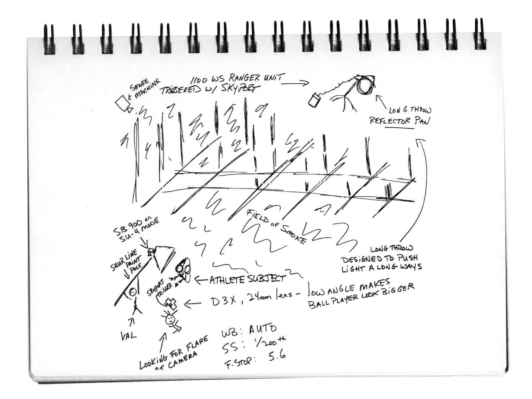

Cautiously doable. What are the drawbacks? Power. Probably have to give away an f-stop or two, either via ISO or actual f-stop. Not the worst thing, but then, if you're going to the trouble of lighting that background grid structure and blowing a bunch of smoke into it, you most likely want it to be relatively sharp. Unless, of course, you're a card-carrying member of the f/1.4 club, which has a lot of popularity right now.

Other potential problems? Line-of-sight triggering. The distance isn't that great, but you are blowing a bunch of smoke back there, so the triggering power of the master flash will degrade. You might get no transmission with the smoke at full bore, but then pick it up again when the smoke diminishes. If you don't want to put up with that iffy factor, then put those small background flashes on straight-up manual and drive 'em with a radio. Which is what I did with the big flash at first.

Hey, wait a minute. You mean there's a bunch of ways of doing this? Sure. Lots of options out there. Big flash, small flash. Or all big flash. Or, all small flash, with the caveat that you'll have to tap dance a bit, and probably lose more frames to transmission problems than you'd care to. It comes down to the gear you have with you, and your willingness to improvise, fail, stretch, and then work it out.

Just like your athlete subject, you gotta push it. □

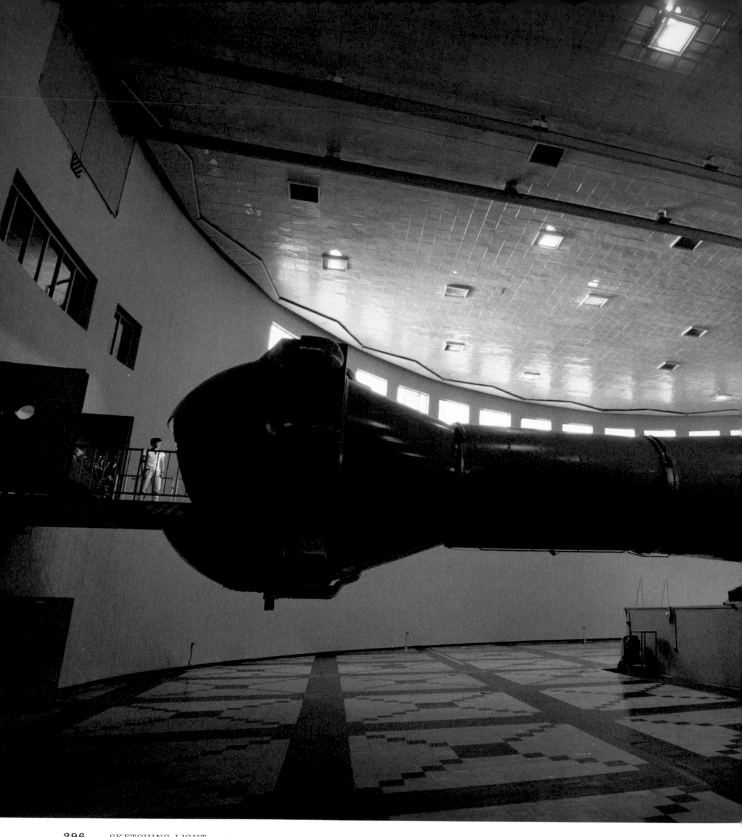

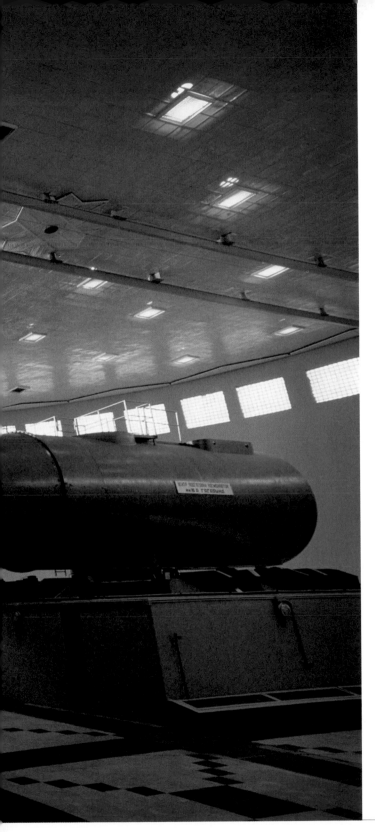

Don't Mess with the Photog

WE GET MESSED WITH all the time, right? We get told where to stand, when to shoot, what to shoot, who will sign a release, who won't, who is going to own the rights to what we just worked hard to create. If we want a credential to stand in a sweaty pit filled with gyrating bodies and flying elbows in order to make pictures up the flared nostrils of the hot new band Love Pump for approximately 150 seconds, we have to sign over the title of our car and clean the arena after the show.

But every once in a while, people who treat photogs carelessly or shamefully really should be careful.

When I went to Star City for *Life* magazine, I knew I was in for a dogfight. Star City is the home base of the former Soviet space program, and it was so classified that it didn't appear on any map, anywhere. Now its identity and location are public, and foreign astronauts—mostly Americans—live and train there for jaunts into space. All is done in the spirit of openness, cooperation, comradeship, and the desperate need the Russian space program has for cold, hard cash.

Journalism in the United States, at least most of the time, is not done on a cash-and-carry basis. In other words, the flow of information is generally free on both sides of the fence. The *New York Times* doesn't charge someone to put their story on the front page and, likewise, the subject of a story doesn't demand money to pose for a picture or sit for an interview. Most of the time, anyway.

There is no such distinction in Russia. "You wish to do story on Star City, comrade? Very nice, that will be ten thousand of your U.S. dollars." *Life* tried to assuage its conscience about acquiescing in this brutally commercial iteration of the otherwise holy practice of journalism by listing "services" in the contract for the payment. In other words, we were paying for interpreters, transport, and access to specific, high-profile buildings on the Star City campus. We weren't, God forbid, paying for the story! We don't do that!

Rationalization is a powerful thing, and thus, contract firmly in hand, I toddled off to the historic halls of the mighty former Soviet space program, the very halls that spawned Sputnik. Star City was the home base and prime mover behind "the heady days of Yuri Gagarin, when the world trembled at the sound of our rockets," as Sean Connery announced to the crew of the *Red October*. It's still a source of great national pride.

And it's a place where journalists are regarded with dismissive suspicion, and highly regulated. Also, it's evidently a place where contracts become, well, as weightless as a space walker. For instance, my contract specifically stated that I would be allowed to photograph in the building housing the underwater mockup of the legendary MIR space station. I had seen pictures of the place, and it looked cool. I was very excited. And, indeed, they brought me to the building. My guide's hand swept over the huge, deep pool where MIR lay. There was only one problem. The pool was empty. I pointed this out. Yes, I was told. We know it's empty. $30,000 will fill it!

I got pretty hot under the collar but, you know, as I look back, nothing in the contract said the damn pool had to be full. It just said I could shoot at that installation.

It went like that. Turns out I could only photograph the edges of the place, but if I wanted a real picture, deep inside the Russian space program, there would be more up-front, long green needed. It was vexing. Heated meetings ensued. Shouts even. I lost my cool at one point and actually went after my escort, and had my hands on him, so duplicitous was his activity. We were separated by American astronauts.

I left with a story, and what I could muster of my shredded dignity and patience. *Life* was definitely lighter in the wallet for the effort. But, I did get one comeback of a photo by adhering to Jay Maisel's time-honored teaching: "Always carry a camera, it's tough to shoot a picture without one."

In this instance, I carried my camera to the men's room, for whatever reason. Maybe I didn't trust leaving it behind at the meeting room where a bunch of people were cussing me in Russian. Lo and behold, just yards away from the main control rooms directing mighty Soyuz rockets into space was a bathroom offering only pages from *Pravda*, the national newspaper, as toilet paper.

Needless to say, this doesn't happen at Kennedy Space Center.

So I made a picture. *Life* ran it as a counterpoint to all the flag-waving, chest-thumping, hi-tech missile-man stuff going that constituted the message Star City wanted to promote. The program was hollow, desperate, and out of money. The picture

became overt evidence of that, and *Life* used it to drive that message home to the readership.

It's a funny, ironical life, being a shooter. You create images, and images are very, very important in today's world. But, as important as they might be, we're often not treated in commensurately important fashion. We're on assignment to shoot the CEO, but we come up the freight elevator with all the gear. We're told to shoot something in a matter of seconds, and then the resulting pictures are demanded immediately. And if they're not done in the exact, pristine, and expected way, we hear about it. And, even though the pictures we shoot are really the only thing that live beyond an event and have value after the fact, there are hordes of people scurrying about at those events whose main function seems to be to limit us, shut us in, shut us down, and tell us more about what we cannot shoot than what we can.

Sigh. Be it ever thus. Every once in a while, though, we get loose, like a cat out of the bag, and make a snap that, at the very least, gives us a chortle, or maybe a snort of satisfaction. A picture that gives evidence that, at least for a moment, we were beyond administrative control, and we got someplace we weren't supposed to be, and we have a picture to prove it. Those pictures are a photographic equivalent of the phrase, "Mess with me, will ya?"

In the game of control, which has been well lost for many years now, every once in a while a photog will score one for the home team. Like unseen snipers left behind in the bell towers while an en masse retreat is occurring, we'll just every once in a while make a picture that gets somebody's attention, tells the truth, afflicts the overly smug and comfortable, or vexes the powers that be.

They really should treat us better. □

Working
with D

MOST PHOTOGS THRIVE ON DIFFERENCE. I count myself among them. I get charged up by visiting a new country, seeing stuff I've never seen, and gaining access to things and places that are denied to the general public. Lots of folks like sameness, truth be told. Home. Going to the office. Working with the same people. Familiarity equals comfort, and I can understand that. But photogs yearn for the shock to the system, the town that ain't on the interstate, the revelation of encountering somebody, something, that embodies difference.

I've worked with Deidre Dean, a model and performance artist in Santa Fe, New Mexico, for about 10 years now. Time and again, when my imagination has started to ramble, I've called D. Which might seem odd. As I mentioned above, shooters share a common

ground in the ongoing yen for the new experience, the new face, the hot young thing, or the hippest of all the new clubs.

And D's is not a new face, at least to me. We've both been around the block and lived some life. You would think that working with someone once, twice, or a few times over the span of a few years would be enough, and you and your camera would then move on in search of different, newly stimulating inspiration. Which does happen, quite naturally and appropriately. It's an ongoing motif of every shooter's career.

But I like faces, and I see possibilities in them that need reexamining, time and again. Just look at the cover of this book. I've photographed Donald Blake for many years, and done it very well. (That's really not a pat on the back. You can't take a bad picture of Donald. He's a human version of a slot canyon. Ever see a bad picture of a slot canyon?)

I once described D as a one-woman Cirque du Soleil, which was a description she liked very much. She is one of the few people I have ever worked

with who can physicalize some of the odder bits of my imagination. She's a shape shifter nonpareil, like one of those beautifully mutant ladies from the *X Men* troupe who can eyeball someone across the room and instantly transport themselves into looking just like them. Here's the cool thing about D—she's able to do that with an idea. Like a super advanced computer form from the future, you speak to her, and she becomes it.

And she trusts me.

Put the pixels, the super-fast glass, and the fancy software aside for a moment. There is no greater thing, item, commodity, piece of gear—call it what you will—than trust on the set. She extends for me, and knows that, in return, I will do my best by her, and be the good shepherd of the pictures we make together.

That's not relegated to just Deidre, of course. It's a gift that's extended, or should be, to literally everyone you ask to get in front of your camera. I have said this before—in the flash of the lights and the click of the shutter, there is an unspoken agreement being made between you and the subject. They go to this vulnerable place, out there in front of millions of pixels, and you have to give them back a sense of knowing they can trust this visual transaction, and you.

And she calls me, too. Like when she gets her head shaved. "Hey, I shaved my head. Wanna shoot me?" Yes, of course. Likewise, I call her. "Hey, can I paint you blue and put you on a rock in the middle of the desert, in the freezing cold?" She'll be like, "You had to ask?"

It's a relationship, in a word, and I expect it will be ongoing.

It's also an investment in my eye, which is something I firmly believe in. I get antsy and irritable if I don't have something to shoot, and I manufacture assignments for myself all the time. We are in an era of photography—which I firmly believe is a good place to be—where photographers have largely been thrown back on their own pins and told to make their own fun. That's more than okay with me. Long ago, I accepted the fact that those relatively simple days—the time before the internet, before hyper-connectivity—are gone forever. (I remember getting my first pager. It was 1977. I brought it home, put it on the desk, and called the switchboard to test it out. Then I sat and stared at this little box, and, like magic, it went off, shrill and persistent. I recall thinking it was space age and kind of freaky.)

The business model for someone like myself used to be wait by the phone, and carry that pager. And the phone did ring, and the beeper beeped, literally dozens of times a week. Small jobs, half days, quickie portraits, an overnight here and there, mixed in with longer travel stints, as well. The deal was, go shoot this. Give us the film. We'll publish it and give you back the film. And if you do it well, we'll call again next week. Not much money was changing hands, so jobs dropped like leaves from trees.

It was all great, good fun. Because of the informality of the whole deal, you could actually badger, cajole, extort, or wheedle money out of editors fairly easily to go do something somewhat fanciful and extraneous to their mission. I remember a photog who was so persistent about going to South America that an exasperated *Newsweek* photo editor finally gave him a couple grand and told him to go. Down south of the border, the shooter got arrested, quite publicly, and it caused a bit of a flap. I was up at the photo department when that picture editor got called upstairs to fill the boss in on why a *Newsweek* photographer had just gotten arrested on an assignment the boss knew nothing about. I remember the hapless picture picker shrugging and wondering out loud how he was going to explain to the head honcho that he gave this photographer $2,000 just to get him out of his cubicle. "Here's some money, now go away" actually constituted a shooting contract back then. Magazines funded photographers' passions, which was, in a very erratic and non-quantifiable way, in their interest.

Then the accountants found out about it, and all that changed.

Fast forward to now, where blogging, Flickr-ing, self-publishing, tweeting, and websites are the order of the day. Magazines and other entities that at one point funded great numbers of assignments have waned, and they watch every penny, quite literally. Now, proposing to an editor the notion of funding a lark to somewhere there *might* be some pictures produces either a quizzical head tilt and a knitted brow ("Let me get this straight. You want us, to give you money, to go shoot some pictures?"), or outright gales of laughter. I also accept the fact that no one is going to call me, assign me, and pay me to paint someone blue and put them on a rock.

"I get antsy and irritable if I don't have something to shoot, and I manufacture assignments for myself all the time."

Handwritten annotations on the sketch:

3 SB900s ON SU-4 MODE (OPTICAL SLAVE MODE)

THESE LIGHTS ARE BRIGHT ENOUGH TO RADIATE THROUGH SKIRT.

THIS LIGHT GIVES MAIN FLASH EXPOSURE OF f8

BEAUTY DISH - THIS POP OF LIGHT TRIGGERS ALL THE OTHER LIGHTS ON SET
w/ DIFFUSER

QUADRA HEAD (MAIN LIGHT)

SB900 w/ TIGHT HONL GRID

THESE 2 FLASHES ARE VERY WEAK - JUST FILL

QUADRA PACK (INTERNAL SKYPORT RECEIVER)

SKYPORT TRANSMITTER

MAN-FROTTO MAGIC ARM

SB900 LumiQUEST 3.0 SOFTBOX

D3X ⅓ SEC. @ f8
ISO 200
24-70mm LENS
ZOOMED TO 36 mm
AUTO WB

THIS WHOLE SHOOT IS ABOUT SYMMETRY. THE LINES OF THE PRISON. SUBJECT IN MIDDLE. ALL LIGHTS ARE IN A LINE AS WELL - RIGHT UP THE MIDDLE OF SCENE + SUBJECT.

That's okay, too. The smaller jobs are gone, and we live now from big job to big job. Sometimes I feel like Tarzan, swinging from vine to vine. It's exhilarating, nerve-wracking, and a bit precarious, but what a thrill ride it is, being a shooter circa 2011. As soon as you let go of one job, your hand is outstretched, seeking the next, and those moments of freefall—that nervous, weightless time in between—can be outright scary, or the most productive time of your photographic life. Those empty spaces in my assignment schedule I now fill with my imagination.

Here's a thought. If you wait—with the cameras in the locker and your arms crossed—for somebody to give you money to go shoot a picture, this is a) not going to be much fun; and b) ultimately not going to work. You have to seek. You have to exercise your photo muscles. You have to evolve

and fund your imagination. It doesn't matter if it involves trying two Speedlights instead of one, or going into the woods to test the limits of a radio trigger, or stepping forward at the local bakery where you get coffee every morning and finally asking that wonderfully rotund, gregarious pastry chef you've always wanted to do a portrait of to actually sit for your camera.

You need to invest in your eye. I'd rather have a new photo than a new lens.

And that, to go full circle, is where relationships come in. I work time and again with people I love and trust, like Donald and Deidre, because they return that trust and work very hard to express my imagination and picture intent. I work with them on self-funded projects, and I try to include them in commercial projects, because that's the fair thing to do.

"If you shoot what you love well enough, somebody will eventually start paying you to just keep doing that which you gladly do for free."

Fairness is key. You have to pay the models, the assistants, the makeup folks, and the location. You have to share the pictures and take care of the people around you. It's a small business, ultimately, and what goes around comes around. It's the best investment you can make, really, because these self-assigned bits of your imagination extend your eye and your archive. I've shot dance for many years, unbidden and unfunded. Lo and behold, eventually I shot an ad campaign for the American Ballet Theater, and worked with some truly sublime dancers. Why? Because I expressed what I love to shoot, even though nobody was paying me for it. If you shoot what you love well enough, somebody will eventually start paying you to just keep doing that which you gladly do for free. As a photographer, that's a very good place to be.

Pursuant to that, I had a notion to work with some wonderful dancers out in a dry lake bed, and do something stripped down and elemental out there in the middle of the parched nowhere. I built, literally, a stage of light for them. Overheads, wing lights, and foot lights—all small flash. The overheads are Group A, the wings are Group B, and the foreground fills are Group C.

See my sagging overhead structure in the production pic? Just goes to show you how, even on a big shot, the details count. I asked the local assistant to make sure they rented 30 feet of rail pipe to go over the leaping dancers. She brought 20. We had to jury rig the bridge for the lights out of a cannibalized C-stand, which produced a swayback grip arrangement, and came darn close to torpedoing the lighting plan.

These self-motivated, self-financed gigs usually produce a pretty good picture, and some interesting information from the field, which can be used again at some point in the future. Call it ongoing education.

Don't wait for the phone to ring. It'll probably be a telemarketer anyway. Keep shooting. Keep going to school.

A QUICK TOUR OF SELF-ASSIGNMENTS THAT COME TO ME IN MY SLEEP

I'll be straight up. Nobody's going to pay me to do pictures like these. It would have to be one strange magazine, for sure. Even the gang in my studio—who long ago learned to have patience while I offered overheated descriptions of pictures to be had if we could only get an elephant and a crane out to a dry lake bed—have done head tilts at some of these.

But, I find I have to do these kinds of self-assignments, if only to clean out some of the debris in my head and see what actually might work as a picture. Self-assignments are the key to the whole deal, as far as I'm concerned, because they let the air out of the highly pressurized balloon of assignment work, where you often find yourself striving mightily to record someone else's vision. These pictures result from the simple urge to pick up a camera and have fun, no matter if there's money on the line or not.

And, alas, for poor Deidre, she has been the physical vehicle for a bunch of my nuttier ideas, even though it hasn't been a one-way street at all, which is the beauty of collaborating with creative people. It was her idea, for instance, to go to the burned-out forest areas of New Mexico. I just followed her with a camera. It was my idea (geez, I must have really liked *Avatar*) to turn her into a blue preying mantis. (Here's a quick and dirty field tip: See how red her lips are? Her tongue, as well. I gave her three or four cherry blow-pops on the way to the shoot.)

Lighting in most of these images is dead-bang simple—one or two sources, max. D's angular face looks good with an overhead beauty dish, filled slightly from below. That's the lighting motif in most of these shots. You can see the combo in the one production shot, where the beauty dish is positioned just over her eye line, and the fill is a small flash off a reflective surface on the floor. In most of those situations, the dish is a big flash like a Ranger or a Quadra, and the fill is a Speedlight, reacting to the main light via optical slave.

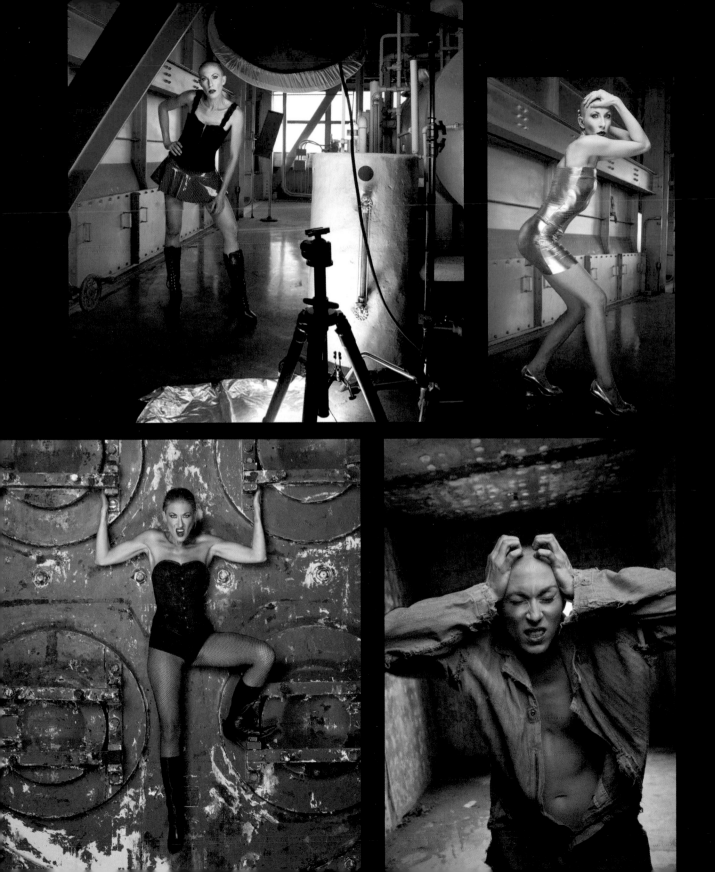

I've also used the combo of a dish and a ring light. The dish up above dominates the exposure, and the ring at the lens just wakes up the face and eyes. In most cases, the fill light is set to between one and two stops under the main light. I've also employed this same basic combo with small flash, using an Ezybox Hotshoe softbox as the main, and another Speedlight as a mild fill. I've found that if I provide this kind of lighting climate for the foreground, D's face thrives in it.

That is the case for the beauty shot between the pipes. There are big lights way in the background, firing off of radios. Three, to be precise. There's a Ranger providing the hot, white, uh, hair light directly behind Ms. Dean by about 40', and two other Rangers, gelled deep blue, off to each side, providing little glimmers and scallops of color.

The forest stuff was lit exactly as you see it, with a paint pole, a TriFlash holding three SB-900 units, all being held by a diminutive assistant. Reason for three flashes is not overkill, or abundance of f-stop. One 900 would have been okay, for a while. Then I would have burnt up the batteries or the unit, or both, by pushing it as hard as I needed on that shoot.

And the blue lady on the rock is saved by oddity and gesture, not by lighting. If I told you all that went wrong on that shoot, there would be another chapter in this book. Unexpected snow and freezing conditions, wind, faulty gear, you name it. I went with the tried and true—one Speedlight through a TriGrip diffuser; and it didn't really light the picture, it just eased up the shadows a bit. A good example of the interest level of the subject matter overriding the ineptitude of the photographer. ▢

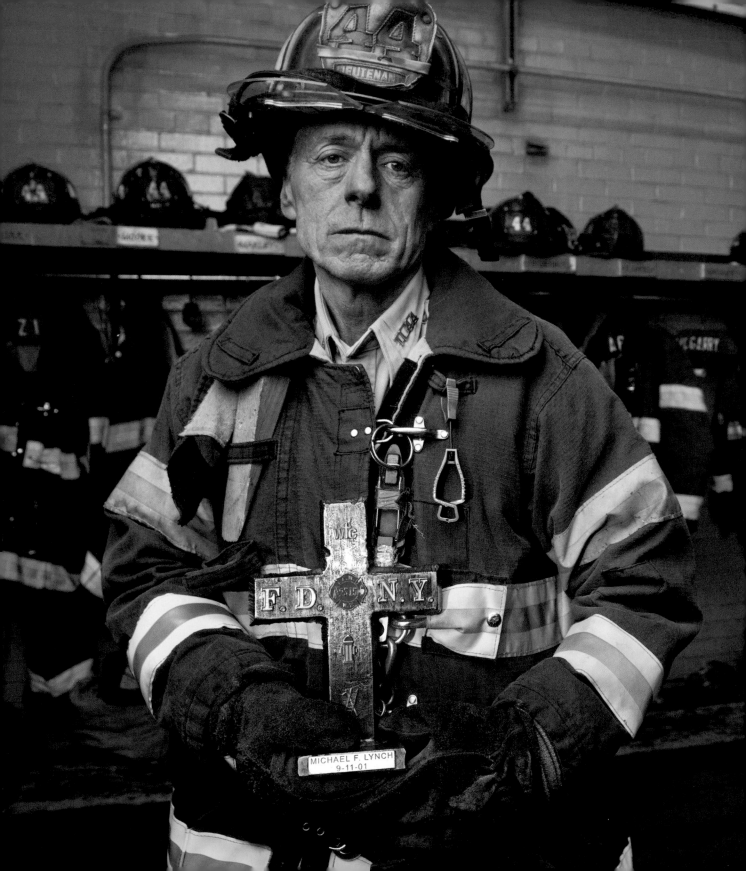

Light as an Exclamation Point

THE BIG LIGHTS FORM YOUR SENTENCES.

The little lights are the punctuation marks.

There's nothing special about any of this light. It's available to everyone. The placement and power is not radical or new. There's no wild and woolly Photoshop or intricate post-production slider play. If all three portraits remained as I lit them, in general terms, they would be pleasing portraits. But I wasn't assigned to do portraits for a brochure or headshots for a commission. I was there to tell a story about each subject. A story about love, and loss. To do this effectively, using the language of light, I couldn't simply speak in a monotone. I needed emotion. I needed to make a point, and raise my voice. I needed an exclamation point.

For Mike Morrissey, a lieutenant with FDNY in the Bronx, 9/11 remains a powerful, tough memory. He lost friends, and he watched his beloved department get battered and bloodied. He also lost his cousin, fellow firefighter Michael Lynch. I had to make a portrait that drew attention to this loss.

The cross honoring Michael is made from the steel girders of the World Trade Center. Mike showed it to me with reverence. He wanted a photo with it, and it was up to me, behind the lens, to honor that request, and to do so with compassion, to help him tell others about his cousin. If I stayed with just the one light—the overall Octa—I would have had a "nice" picture, a well-lit picture. But via a Speedlight into a snooted grid, with a touch of warm gel, I drew attention to what he was holding. And what he was holding, along with Mike's solemn, proud gaze at the camera, was the point of going to the firehouse with a camera that day.

It was the same with the Archbishop. He is holding a twisted, half-melted candelabra, the only artifact that survived from St. Nicholas Church in lower Manhattan, which was crushed by the collapse of the Twin Towers. Archbishop Demetrios, the spiritual leader of the Greek Orthodox Church of America, is not just holding a piece of metal. He is holding a powerful memory, a symbol, both painful and hopeful at the same time. All my nice light (and there's a bunch of it in this picture) is for naught if I don't, at camera, acknowledge the importance of that altar ornament, and consequently draw attention to it via what might seem to be just an inconsequential splash of flash. But that little piece of light helps tell the story. Small in scope and power, it speaks loudly in the photo.

With Katrina, I basically bathed the whole front of the house in flash, making it look the same way it would on a bright but cloudy day. But that "big" quality of light, nice and forgiving as it is, would gloss over what she is holding without paying it any special attention. And what she is holding needs to be seen.

Katrina's husband Kenny, a member of FDNY, was lost on 9/11. I got to know her immediately after the event, and we have stayed in touch over time. She is a remarkable, strong person and a wonderful mom. (She also bakes incredible stuff.) Ten years later, given the distance and healing power of time, she posed with the one thing she has of Kenny's, the frontispiece from his helmet. It's all that came back to her from the rubble of that awful day.

How could I go there and just let my light wash over the scene, and not acknowledge her courage and pride in what she is holding? I had to draw attention to it with a small but significant spot of

> "But via a Speedlight into a snooted grid, with a touch of warm gel, I drew attention to what he was holding."

light that gets inside the shadow box holding Kenny's helmet piece. There, in her hands, is the memory of her husband. The light finds it, and makes the viewer look, and remember.

The attachment I used in all three of these pictures is just a piece of plastic. Likewise, the cameras I shot are just a bunch of gears, glass, and wiring. Faithful as a dog, they record whatever I might point them at. But our job isn't simply taking dictation or being the visual equivalent of a court reporter. We don't recite and record. We don't paint by numbers. We seek what's important, and we tell that story in the language of light. And no story worth telling, no memory worth preserving, is told without strong, stirring words, and the occasional exclamation point.

THE WHY'S OF THESE THREE PICTURES

The Archbishop

Why f/11?
The formal altar setting is crucial to the picture, and it needed to be sharp. With a 24–70mm lens on the camera, f/11 gave me good DOF throughout the entire frame.

Why end up at 1/125th at f/11?
The ambient light was dim and virtually useless. I would have had to drag, drag, drag my shutter to really slow speeds to pull it into the exposure pattern at f/11. So, this combo just X'd out all the

ambient. It gave me a black room, an empty canvas over which I had control. I built the light from the ground up.

Why the medium Deep Octa?
It has great character and richness of tone, perfect for a distinguished face like the Archbishop's. This version of the softbox also has edge baffles, which I highly recommend. That extra material on the edges of the outer diffuser panel really helps contain the light and ensures that it is directed towards my subject and doesn't spill everywhere.

Okay, why camera left for the main light?
I don't know. It just felt right.

Why the big strip for the sidelight? Seems like overkill. Couldn't you have done it with a hard, small flash?
Yes, but it would have had a much more glaring and spectral feel. The long strip was the right tool for a couple of reasons. It's an indirect softbox, and thus produces a very soft light. Hence the highlight on the Archbishop's temple is not slashing and spotted. It's linear, and expresses as a soft glow. The length of the strip is helpful, too, as it provides a subtle highlight or edge right along the expanse of his black vestments.

Okay, how about a couple Speedlights through a panel?
Sure, this could work, and it could produce a reasonable facsimile of the strip. The problem with

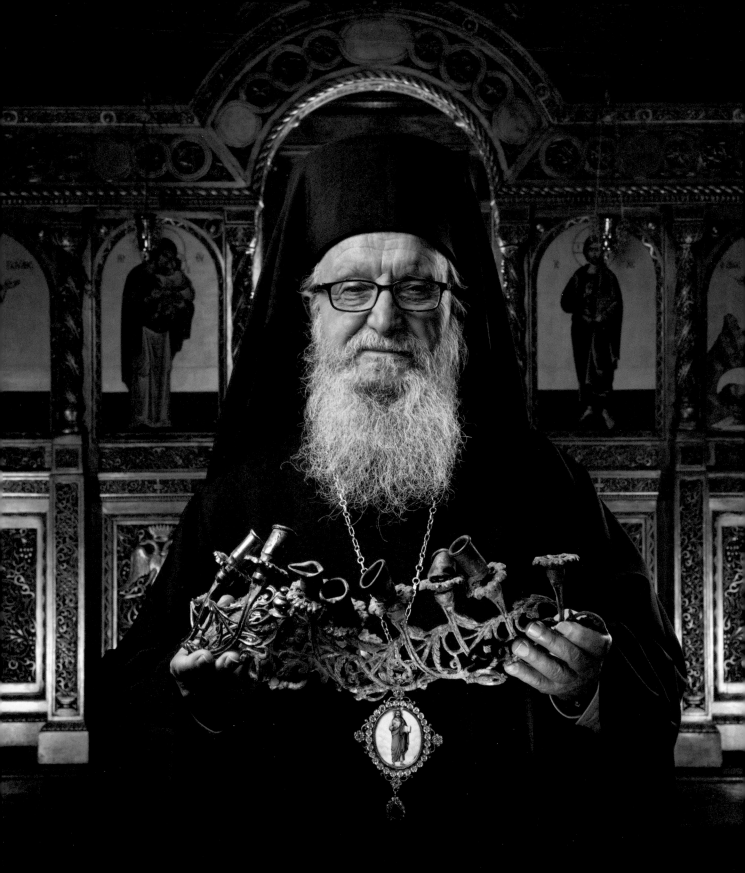

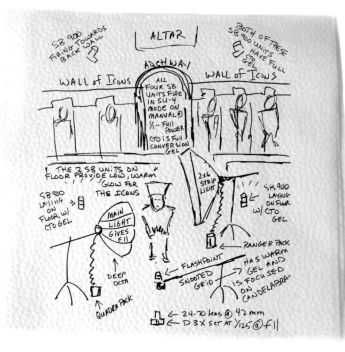

that solution is not the lighting result in the picture; it's quite literally the back end. When you light with small flash through panels, it's not contained light. In other words, the light flies through the diffuser panel towards your subject, and it also goes everywhere else. In the camera-right background of this photo, I couldn't have loose photons flying about. The icons back near the altar are highly reflective, and need to be lit with control. The picture is also about symmetry and balance. Putting up a couple unfettered lights would have weighted one side of the exposure with extra, unwanted flash. The way to go here was softbox—a contained, directional box of light that doesn't spill or leak out the backside of it.

How deep are the gels on the small Speedlights?
They are a full cut—a full conversion gel, called CTO—which alters their color balance from daylight to incandescent.

Why did you leave the dome diffusers on?
I wanted radiant light out of these units, similar to the glow of a candle.

Why are the two SB-900s behind the Archbishop lying on the floor?
I wanted low glow for the icons. We are in an altar environment, which usually has warm, low light—given the traditional presence of candles—and directed spotlights looking up at religious symbols, statues, and paintings. I wanted my lighting to mimic that feel.

They are beam onto the icons. Why not light those surfaces from 45 degrees, off to the side, like a copy?
As you can see, the icons are reflective, and set into muli-tiered frames and columns. All of this looks very impressive and ornate, but if you light them from the side, the very support structures for the

icon imagery will cast shadows onto the paintings themselves. I brought the light from the front, and placed it low. That way, there aren't crossing shadows from side light, and any spectral highlights my flashes are creating off the reflective paint are below my frame and out of the picture.

Why light all the way to the background?
I didn't want the way back of the photo to be all black. That area back there houses the actual altar, which is very significant to the Archbishop. Also, by lighting aggressively through the whole picture, I create a bit of depth for the viewer's eye, with the bonus of the archway over his head being rim lit. That was unforeseen, by the way. After I put my Speedlights back there, I picked up on the fact that they produced a cool-looking highlight on the underside of the arch which, again, helps define the space for my subject, and gives the photo some dimension.

How are all the SB units firing?
They're all on SU-4 mode, which is Nikon speak for manual slave operation. Once the big lights up front go, the whole room goes.

No problems triggering the lights?
No, the light sensor panel on the Speedlight is actually quite sensitive in SU-4 mode.

And all this amounts to not much of anything without that little splash of light that draws your attention to the melted candelabra he's holding?
Yep.

And that's a snooted grid. Any gel on it?
A small amount of warm gel. I honestly don't remember how much, maybe ¼ cut. The SB-900 firing into it is zoomed to 200mm, and has the dome diffuser off, obviously. It is on the end of a C-stand extension arm and is hovering, out of sight, just below the camera lens.

Power for that?
Not too heavy duty. It's about in the middle of the total output that the SB can produce. Just work it till it looks like it's just about right, which probably means it's a little too much. Get it there, and then back it off, maybe a third or two-thirds. I find lighting details like this brings me back to the days when we judged our lighting via shooting Polaroids. Film was always much more detailed than Polaroid, so if you got the Poly perfect, you knew you were probably a touch overlit. You'd back down your lighting power a tick or two for the final chrome. Same thing here. Subtle is best.

Do you think you'll have a higher place in heaven for having lit this altar scene so well?
No, but I hope it gets me some points back against all the stuff I've lit terribly over the years.

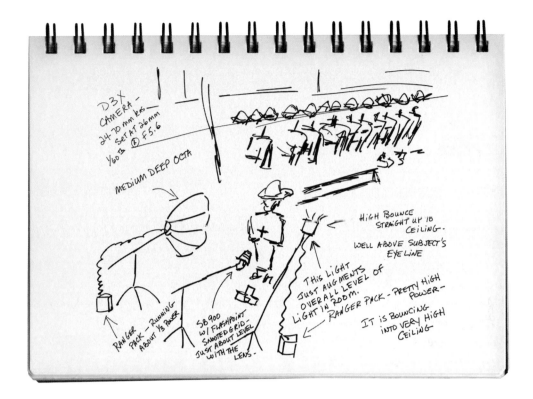

The Firefighter

Okay, 1/60th at f/5.6. Sounds kind of nondescript, middle of the road. Why there?
A multiplicity of factors. At ISO 200, that setting allowed me to use a bit of the ambient light to retain detail in the background of the photo. The firehouse is a big place, and I didn't want to have to light all of it. So I "bled" a little ambient light into the picture. The f-stop of 5.6—with the lens at 26mm—simply assured me that I'd have decent depth throughout the frame.

But you have a bounce light with a big power pack firing into the ceiling. In terms of overall light for the scene, didn't that take care of business? You still need a bit of the ambient light?
The big bounce helps, for sure, but it's just augmenting the existing light a touch, helping it along. If I really blasted that bounce, it would have pushed

a lot of light at my subject, and I didn't want him to be top-lit or really influenced too much by that bounce. I wanted to control the character of the light hitting his face. So the bounce is just a moderate pop of light, up and away, helping out the background. It mixes with the ambient levels, and helps me retain details in the background, like the hanging black bunker coats.

On the light for the cross he's holding, that's obviously warmed up a bit, yes?
One-half cut of CTO provides the warmth of that light source.

Why warm it up at all?
Good question. I wanted the cross to stand out not only in terms of an exclamation point of light, but also a slightly different tenor or color. His face is lit with a "normal" color balance of light, and it

does well in combination with his soulful expression. But the warm splash—that draws attention. It puts the viewer of the photo on notice that the cross is at the heart of the photo. It helps, of course, that the bunker gear is largely black. I didn't have to fight another vibrant color palette or anything busy, pattern-wise. The cross stands out against the uniform.

Speaking of color balance, did you have to figure out gels and a white balance setting here? You said you mixed in some ambient light. Doesn't that mean you have to filter for that type of light?
Sometimes that occurs, yes. In, say, a fluorescent environment or a totally tungsten scene, you would have to gel flashes to match what is already there. Here, I was able to skate around color issues by having the preponderance of the exposure remain in the realm of daylight flash. It really does overpower most of what exists in the firehouse. I tested frames on auto white balance, but that rendered a result that was too cool and neutral. Likewise, cloudy white balance was way too warm. I tried sunny, or daylight, balance, and liked it. So I went with that.

The main light: again, the medium Deep Octa. Why here, as well?
It's a strong light, for a strong face.

Again, it's on camera left. You got a port-side list when it comes to lighting?
I hope not. I don't think so. The firehouse graphics just set up this way. It was easy to locate him here, and I liked the composition. I find if I get the frame done first—get a composition I like—the lighting just sets itself up in a logical way around that. In a way, how you compose dictates, or strongly influences, how you light. I know on those days when I struggle with how to compose, I also struggle with how to light.

Katrina

The scene here looks very natural and simple. But the lighting diagram seems kind of complex. Seems like an awful lot of trouble to go to just to make something look like it's lit by natural light from the windows.
 Hmmm, that's actually a statement, not a question. Why don't you just push your ISO, and sit your subject down and shoot it? Why go to all this trouble?
Okay. I'll tell you. ISO addresses one thing, and one thing only—volume, or amount of light. Low light generally equals high ISO and so forth. But for a portrait, presumably you are in control of all the elements of a photo, and that means control

"How you compose dictates, or strongly influences, how you light. I know on those days when I struggle with how to compose, I also struggle with how to light."

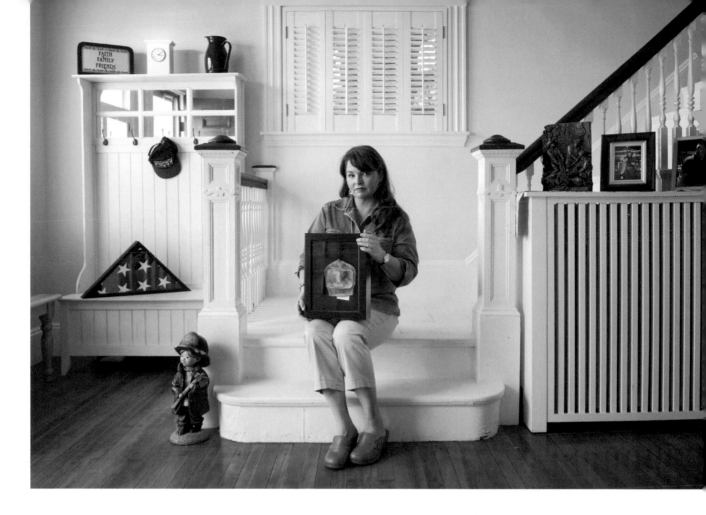

of the light. Not just the exposure for the light, or the amount of light, but the essence and expression of the light—quality, color, and direction. When you have command of those aspects of light, you are speaking with it and not just exposing for it. Jacking up your ISO is not an interpretative act on the part of the photog. More often, it's an act of desperation.

What you can't see in this photo is that it is pouring rain outside, and the clouds are very dark and ominous. It's not a nice day in the neighborhood, with soft, bright light washing through the windows. My flashes have become the sun, effectively, standing out there in a downpour, bagged in clear plastic.

Why the silk material over the door and windows? Could you have used a bed sheet?
I wanted diffused, simple light coming through those portals. Light that looked like soft, cloudy light coming in from outside. And yes, a couple of simple bed sheets would have done nicely.

You covered the door. Doesn't that making coming and going to adjust the power of the lights and to bring gear back and forth a pain?
Yes.

If you have this big wash of light coming in from outside, why the bounce light in the hallway? Wasn't the light from the windows enough?

RANGER PACKS + HEADS

IMPORTANT TO NOTE: THIS PACK FIRES THROUGH THE WINDOWS CLOSEST TO WALL IN BACKGROUND OF PHOTO. NEEDS TO BE FEATHERED OR POWERED DOWN A TOUCH OR THAT WALL WILL GET TOO BRIGHT.

THESE LIGHTS ARE 15' OR SO FROM WINDOWS

PORCH

12' SILK COVERS DOOR WINDOWS

12' SILK HANGS OVER DOOR + WINDOWS

GRADA. BOUNCE INTO CEILING SOFTENS FEEL OF ROOM

CAMERA SETTINGS 1/30 @ f 4.5

THIS LIGHT IS PLACED HIGH, WELL ABOVE CAMERA FRAME D3X 24-70mm (SET TO 27mm)

SB 900 INTO SNOOTED GRID ON SU-4 MODE MANUAL SETTING 1/4 POWER

RADIO TRIGGER POPS OUTSIDE LIGHTS

It was enough, just in terms of volume. But the inside bounce gives me control over the direction of the light hitting my subject. Again, that very powerful aspect of light—direction—comes into play. If Katrina were just illuminated from the windows and doorways on camera left, out of sight, she would be, naturally, side-lit. The interior bounce acts as a soft fill, and it drags or redirects the push of the exterior flash toward the camera angle to more softly, and frontally, wrap my subject. Without that light bouncing and filling the interior hallway, the side of her face furthest from the windows would have been too dark.

Okay, enough about the light. She's bull's-eyed in the frame. Isn't that a no-no?
Yes and no. There are classic rules of composition, such as the rule of thirds, which this frame obviously doesn't comply with. And there are legitimate concerns that placing your subject in the middle of the frame will make the picture static, and thus boring. But, as with all photographic rules, the rules of composition just sit there, waiting to be broken on a situational basis. The staircase, the foyer area, and the totems of Katrina's life with Kenny, which adorn the house, all added up to placing her right in the middle of things, especially when she holds the frontispiece of Kenny's helmet. The whole frame has a gravitational pull that Katrina and that shadow box are at the center of.

Would there be any other ways of composing this picture?
Yes, about the same number as there are photographers.

Are there things influencing the way you stage a picture that might not be readily apparent?

> "How hard you worked is only important and relevant to you and the other shooters you are telling tall tales to over beers. The viewer doesn't, and shouldn't, care."

Yes, of course. When doing a series of pictures that are going to be presented in a book or magazine story as a cohesive whole, you have to vary your sense of scale, composition, staging, lighting, etc., to provide graphic difference, frame to frame and page to page. If you approach each portrait from the same angle and approach, the viewer will get bored. As an example, Mike Morrissey, the firefighter, and Katrina Marino are both holding significant, emotional totems that reflect the time of 9/11. I couldn't shoot the two portraits the same way, with the same feel and color of light, or with the same lens-to-subject distance. I have to vary it. Publication-driven photography spins on a lot of very practical concerns. I have seen pages being laid out at *National Geographic* that simply demand a vertical photo. Hence, you potentially watch one of your favorite frames just disappear from contention because it's a horizontal, and what they need for the story, at that point, graphically, layout-wise, is a vertical. Done deal. Bye-bye, favorite picture.

As opposed to the firefighter portrait—where he's holding the cross—in this instance, the accent light you used for the framed helmet piece does not have a color to it. Why no gel here?
It would have been out of place. The entire scene is lit in very general fashion, mimicking daylight. A splash of gelled light in the middle of this very natural, window-lit photo would have looked and felt out of place.

Again, your f-stop/shutter speed combo is nothing extreme or radical.
True. 1/30th at f/4.5. Just enough depth for sharpness throughout the frame, with the lens zoomed to 27mm. Again, this modest combination, at ISO 200, allows some daylight to "fill" the feel of the flashes. It also allows daylight to bleed in through the shutters in the window behind her, which is a small thing, but crucial. If those window slats were black, there would have been a disconnect between the light I'm creating in the foreground and the look and quality of the daylight you see through that window.

The mirrors in the upper part of the furniture piece on camera left reflect bright highlights. Does that bother you?
Not at all. It's what would occur naturally if there were just daylight coming through the windows and doors.

So, all this work to make it look like you just walked in and went click, and did no lighting whatsoever?
Yep. No one should see your sweat in the photo. It should look and feel effortless. How hard you worked is only important and relevant to you and the other shooters you are telling tall tales to over beers. The viewer doesn't, and shouldn't, care. They should only care about how the picture makes them feel. □

One Light, One Shadow

THERE'S ONLY ONE LIGHT IN NATURE. It can appear in many different guises—hard, soft, warm, cold. It can hit objects and scatter, fragment, reflect, or disperse in wild and unpredictable directions, thus looking like more than just one light. But at the end of the day, when we fade to black, our world has been illuminated by one big, natural source of light—the sun.

Which, unless it has banged off of some irregular, reflective shapes—such as a metallic building with lots of angles—will produce one set of coherent, singular shadows. When the sun is hard and straight, the shadows it creates respond accordingly. They go in one direction, and have clean edges that are sharply shaped.

Hence, if we choose to mimic that behavior and create vivid, clean shadows, our job is simple—mimic the sun. Which means use one light.

It's very simple to do, but, as with all things photographic, there's stuff to keep in mind.

The farther the light is away from your subject, the cleaner and crisper the shadow pattern. In other words, if you're trying to make your flash behave like the sun, put it at a sun-like distance from your subject. There will be limits to this, of course—pending the power of your light source—but pushing that flash (big or small) as far away as exposure will allow is a good practice for making shadows.

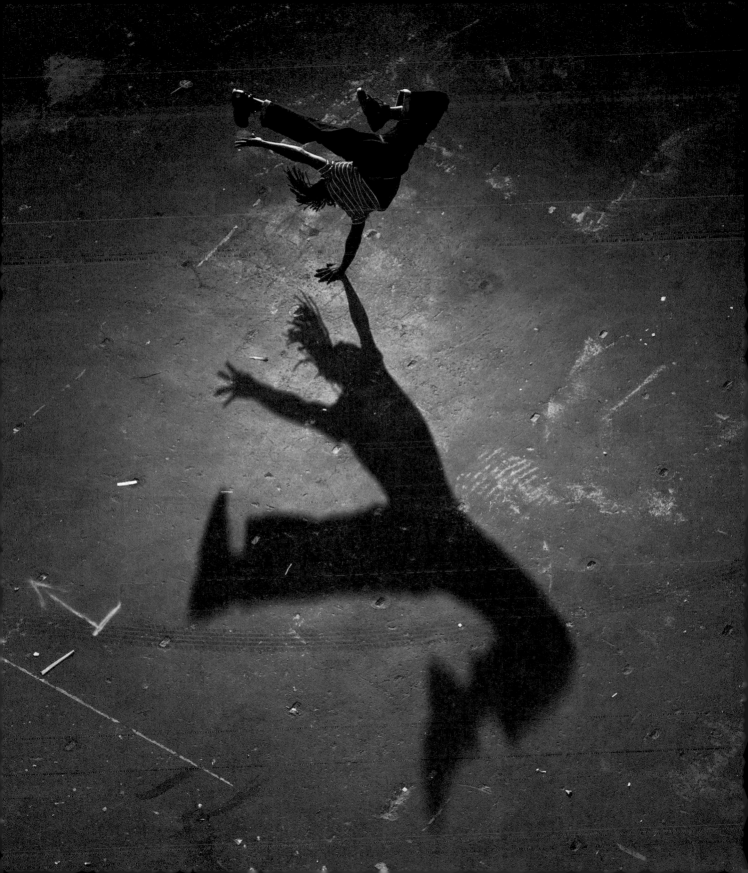

"The grid spot tightens the spill and channels the path
of the light, making it more directional and helping
to repeat the dancer's shape on the floor."

Control spill and direction. A flash will splash, right? Putting an unfettered, hard light source on a stand will produce hard directional light for your subject. That's a given. But it will also explode out of there like a hand grenade, throwing shards of light literally everywhere, pretty much 180 degrees from its point of origin.

If, for instance, that light is behind your camera position, you don't have to worry much about that errant, explosive light going every which way and heating up stuff, exposure-wise, in the photo. Most likely, all that scattery stuff is occurring behind you, while in your frame everything you see is being blasted with a roughly even quality of hard, hard light.

But, if you're shooting something like this break dancer, and you are looking down and into the scene as I am here, you have to be worried about spill—specifically, here, on the floor. Time for a grid spot!

In this instance, I put a grid spot over the Quadra head I was using as my one source of illumination. Without that honeycomb-shaped governor on the engine of that flash, the light will, as I mentioned, spill everywhere, heating up stuff, like the floor. I didn't want that floor to be overly hot, exposure-wise. That kind of telltale splash does two bad things: It creates a line of highlight that telegraphs your flash position to the viewer; and it creates a sheen on the floor that will draw the viewer's eye away from the main gesture of the photo, the acrobatic dancer.

The grid spot tightens the spill and channels the path of the light, making it more directional and helping to repeat the dancer's shape on the floor. Importantly, it introduces a core of light that is centered around his move, which keeps your attention on him and naturally

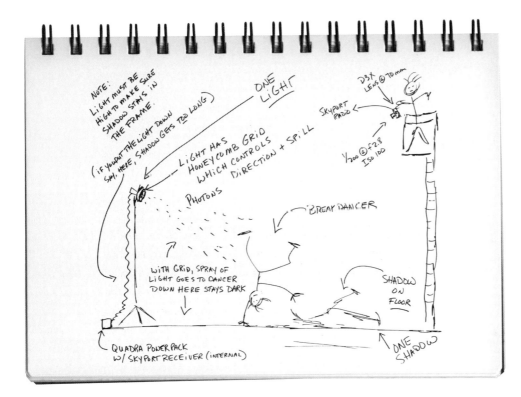

produces a vignette type of effect up near the light source. Without the grid, the light would flood the floor, creating attention-drawing highlights. I know there are moves you can easily make in post-production to darken the corners, but hey, why not do this right out of camera by controlling the light?

There are two lighting things left to adjust, control, and be aware of. The height of the light controls the length of the shadow. If it's too low, relative to your subject, the shadow will stretch, Gumby-like, right out of your frame. The second thing is that your flash has to overpower the ambient. If you let a lot of available light pour into the scene, it will soften the shadow game you're trying to play.

That requirement—to overpower existing light—is, by my lights (ouch!) the determining factor as to whether you can do this with small flash or not. In a relatively subdued light condition, small flash is good to go. If you've got to fight lots of other sources, it might be time for a bigger, power pack type of light. A big pop of light will make your shadow a slam dunk.

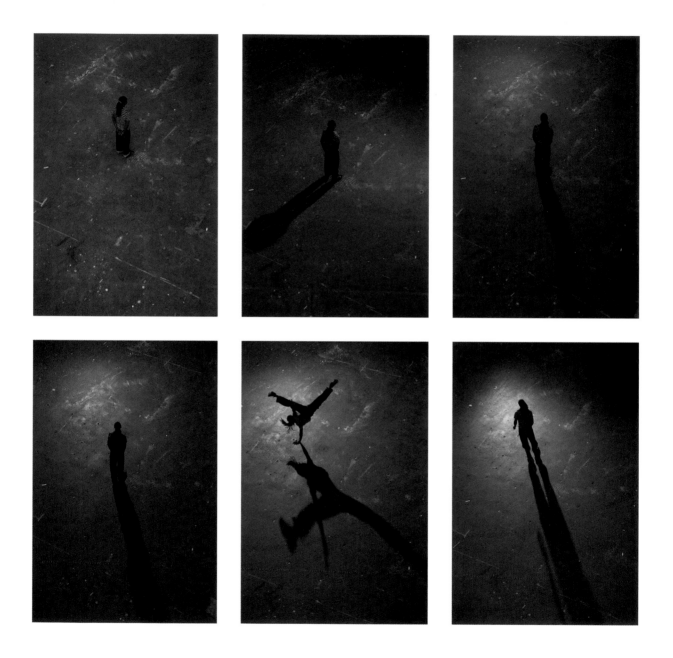

The last thing—and, of course, the most important—is the clarity, and definitive nature of the gesture. All dancers have moves in their repertoire; uniformly, they are beautiful physical expressions of the human form. Some will lend themselves to photography, while others, in my opinion, are best just left as a treat for the eye. What you need to do as a shooter is become a bit of a choreographer, working with the dancer to investigate what's possible.

That's the first question I ask of a dancer. What's possible? They are connected to the nature of what they're standing on in a way most mortals who just walk around are not. The floor, the stage, the surface—all are crucial for them. It will determine if they can leap and move with confidence. Here, with Daniel, an accomplished performer who has amazing physicality, it was especially important to consult and work out the move, because he was,

essentially, making it twice—his real form, and the shadow that form would create. The shadow dominates and is the point of the picture.

Thankfully, because the art form of his dancing is very urban, he was totally comfortable with the concrete surface. We decided on a move that would be athletic but also make a playful, almost impish shadow. Take a look at the grid of pictures to see the progression of the move. (And my mistakes!) He hits his mark every time, while I make adjustments to my light position, the color of the light (I decided to remove the warming gel), and the position of the shadow. I also worked with him to make sure his arms and legs—even his fingers—had separation from his torso and created their own shape. The camera needed to see all of him, and all of his shadow. We hit our select on the last frame. ☐

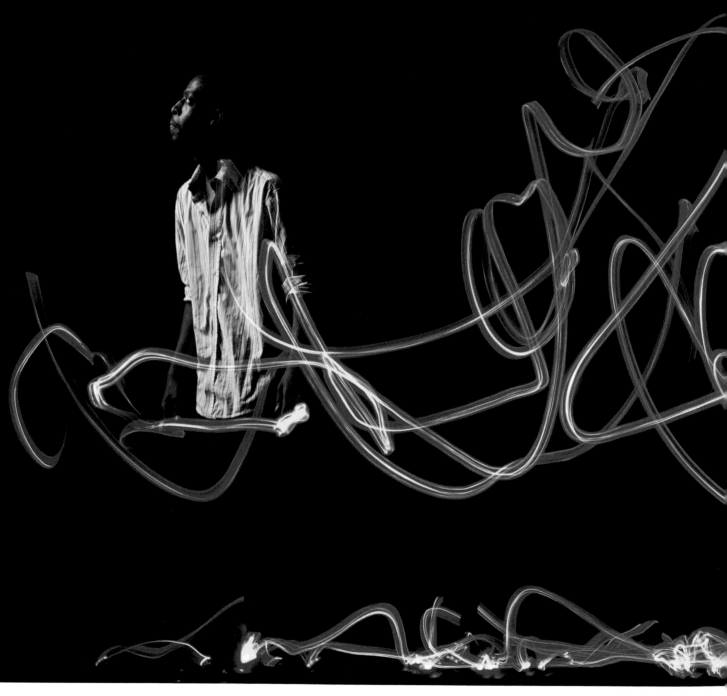

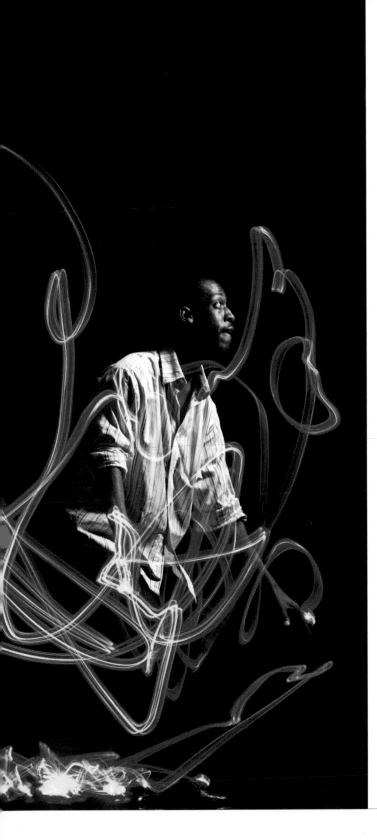

This Looks Hard, But It's Not

PICTURES LIKE THIS—with wildly swinging arcs of light, and two flashed images of the same person in the same frame—can often look like they should be wrapped in caution tape. They fairly scream *Don't Try This At Home!*

Or on location. Or in the studio. The fear is that it's like one of those airplane models you got as a kid. There's a picture of a cool-looking plane on the outside of the box, looking like it's flying and shooting tracer lines of heavy caliber ammo down at the bad guys. You get excited and dump all the parts out, and boy, are there parts. There are like 712 things that have to be glued together in exacting fashion, and the schematic instructional drawing is the size of the living room rug. You emptied the

box of the bits and pieces, and then filled it back up with, say, a year of your life.

A picture like this looks like it's got lots of moving parts that are complicated to put together, but it doesn't. Here's what you need to shoot this:

- Camera and lens (middle-ish telephoto).
- Sturdy tripod.
- Electronic cable release.
- Good dancer who's patient and willing to work with you.
- Black background. Blacked-out room. (This may be the toughest thing on the list to get!)
- Bicycle lights. Some black gaffer tape, or large safety pins. Some colored tape that can be seen in darkness.
- Two stands, two flashes, and an ability to trigger them independently of each other.

And here's a sequence of how this can come together to produce a pretty cool picture.

Find and define the frame. You need a helper to do this. Not even a photo assistant, necessarily, just a bud who can stand for you at either end of the frame you're setting up. Test the blackness of what you're about to shoot into by doing Bulb (open shutter) exposures up to about eight seconds. That way, you know you've got black, for real.

Get a low camera angle. Get the camera down near the floor or, in a perfect world, work in a theater or auditorium where your camera can literally be a member of the audience. There are tons of community theaters, grammar school and high school auditoriums out there, often available for an extremely reasonable rental fee. Or, rent a couple of risers.

By moving the camera to a low position, you do two simple, important things: you minimize the floor, which can have sheen or throw highlights; and you make the dancer big, which is a good thing. The reason you want very little floor in the picture is that it can build exposure, and thus brighten, during the time the shutter is open. The dancer is moving, and thus passing through your frame, remaining invisible until he or she stops and you pop your lights. The floor is static and just sits there, like a tea pot, building exposure heat until it whistles. You don't want stray highlights in a photo like this. Again, because the dancer is fluidly transporting through this space, and that floor highlight remains fixed, it will show right through the dancer's shape, turning your subject into a transparent ghost and giving away the game. It's a fine line. You need a little floor and a little sheen so that the subject is not just floating in blackness. But too much floor will kill the simplicity of the photo with stray detail all over the place.

Here's another tip if you are looking up at a stage. Often the edge of the stage will be in the very low part of your picture and, again, because it's static—and often painted—it will pick up tonal value during the long exposure. Bring some extra black material and line the edge of the stage with that. It will minimize that potential highlight line.

Work with the dancer to define both the gesture and its range. What type of moves do you want? Ask them what's possible, and observe them for several dry runs. The move needs to have its profile to the camera, and I usually have them move left to right. This panning activity has to have a starting and a

stopping point. Figure out a comfortable move with the dancer, and then hash mark the beginning and end of the move with tape on the floor that they can see in darkness. (Another reason to have the floor mostly out of your frame.)

With the dancer at their starting point, maneuver a light into a comfortable profile position, just outside your frame. This light is then wired to the camera via a long hard wire, a radio, or, if you are going small flash, via a commander hot shoe flash. Make sure the camera is set up for front curtain, or first, sync. That way the light will fire when you trigger the shutter.

Do the same thing for the light at the end of the dancer's move, and try to make the angle of both lights relative to the dancer as similar as possible.

Test fire these lights in both spots to get a good exposure. Because the subject matter is profile to the camera, there's not a tremendous need for oodles of depth of field. Something around f/4 will do. That relatively open setting will a) provide just enough depth and sharpness, and b) be open enough that the bicycle lights will read easily. (On the depth-of-field thing, dancers often freelance a bit as they make a move. One handy thing is to provide a straight line for them, again via colored tape, on the floor between their already marked start and stop points. This will give them a reference line to try to stick to.)

Your finger on that shutter is the equivalent of a film director shouting, "Action!" It sets everything in motion. Work it out with the dancer that the flash is their signal to move very quickly off their starting spot and begin their move. Give them a beat—one, two, three, flash! They move, move, move. Your shutter is open on Bulb, and you are holding it open via the cable release—not your finger on the shutter button. They come to the stopping point in whatever amount of time: 2, 5, 7.5 seconds. During that interval, you have taken in hand a radio trigger specifically programmed to fire the second light, or you have a helper on stage with the light, who manually

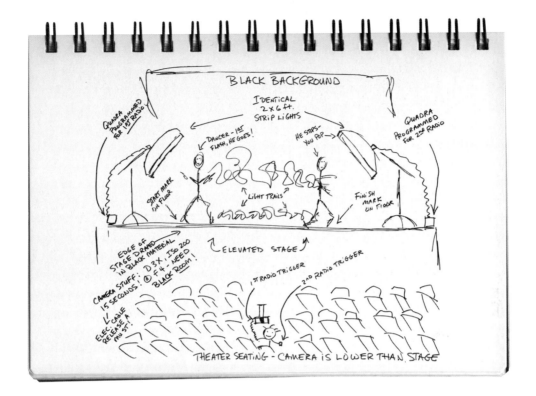

pushes the test fire button, flashing the dancer's ending move. Pop, move, pop. Done.

Make sure you use Bulb. That way, you are not locking yourself and the dancer into a specific time that they have to get to the end of the move by. No dancer I have ever worked with—especially a tap dancer such as you see here—ever gets there precisely in, say, four seconds every time. There is always variance. You accommodate that variance by using Bulb. As soon as they hit the final mark, at the camera you release, instantly, and the shutter closes. That way, the two of you are not left hanging, waiting and waiting for a specifically timed shutter to close after the final flash has been fired.

With today's tools, this is really very simple. Two lights and some bicycle lights in a black room. The LED lights can be attached to the dancer's shoes

with black gaffer tape or even hooked into eyelets with safety pins. If you get the small LEDs that affix to a kid's handlebars, they often come shaped like a large novelty ring and can be slipped on the fingers of your subject.

You can go much deeper into this kind of motion study, for sure. More lights will bring out details in the middle of the frame, during the dancer's move. Adding splashes of steady light—i.e., constant sources—in selective fashion can introduce blur. And, if you really, really want a big dish of self-inflicted pain, there' always...stroboscopic!

But I wanted to present this as a quick and dirty way to come up with a photo that addresses motion and employs some thoughtful camera work. It looks cool, and complex. It's actually cool, and simple.

HERE'S MORE GOOD NEWS: IT CAN BE EVEN SIMPLER!

If you haven't got a stage, or a big studio space, or a dancer with room to move, you can do a pretty cool write-with-light photo using all the tools and techniques I just described, but just eliminating the super-long exposure and your subject traversing your frame for about 15 feet or so. You can do it with your subject barely moving at all.

I tried this with a martial artist, as an example.

The weapons are important. If they're being used, attach the LED lights to those implements of death, as you see here.

Set up the lights just the way they were in the dancer photo, right and left, just off frame. (But obviously closer together. We are now talking about working in a small space.) The lights can be small flash or big flash, softboxes or panels. Or umbrellas—just be aware that umbrellas spread light and are less controllable. If you are working in a small space, they could have a tendency to light up the background, where it should be completely black. (Also, as noted before, the room must remain resolutely black.)

Have the athlete or performer stand to one side of the frame, in complete darkness, and while stationary, begin fast and furious move-ments with their sticks, or swords, or...whatever. Of course, you have opened the shutter, and the shutter is set to rear curtain, or second sync. They have to move fast. If their LEDs stay in one place too long, they will start to light themselves, and you will have a ghost in your photo.

So get them to move quickly. Think of Picasso, painting with light. They are tracing designs in the air. You are holding the shutter open at camera. Up to this point, there has been no flash, only darkness.

At your command, they stride in definitive fashion towards the other side of the frame, getting clear of the pattern they just created. They look at the flash source that is facing them.

You release the shutter, popping both the camera left and camera right flashes. Game over.

Here are a couple of things to remember.

It is best to have flashes on each side of the frame. That way, the subject will have a main light for their face and a rim light for separation. These will invariably run at very different powers. I did the photo of Maria, the martial artist, on a D3X, with a 24–70mm lens, zoomed to 70 mil. Three-and-a-half seconds at f/5.6, at ISO 100. There is Group A, which she is facing, and Group B, which is providing a rim light for her hair and leg. Both groups are in TTL mode, though you can obviously do the exact same thing in manual mode. I simply tried it this way, very quickly. The Group A light, which ends up being very close to her face in the final pose, is powered at −3 EV, believe it or not. The backlight, or Group B source, is set to 0.0, or "normal" rating.

You can do this quickly, cheaply, and in a relatively small space. Another quick tip: If you work in a small space where the ceiling is not too high, and it's white, that ceiling will kill you. Light will spray off of it and you will lose control. So make sure the ceiling's high, or you stretch black fabric over it.

Of course, to do a shot like this at all, you have to invite a person who can kill you with implements of death into a small, blacked-out room. Photography's just not a sensible thing to do. □

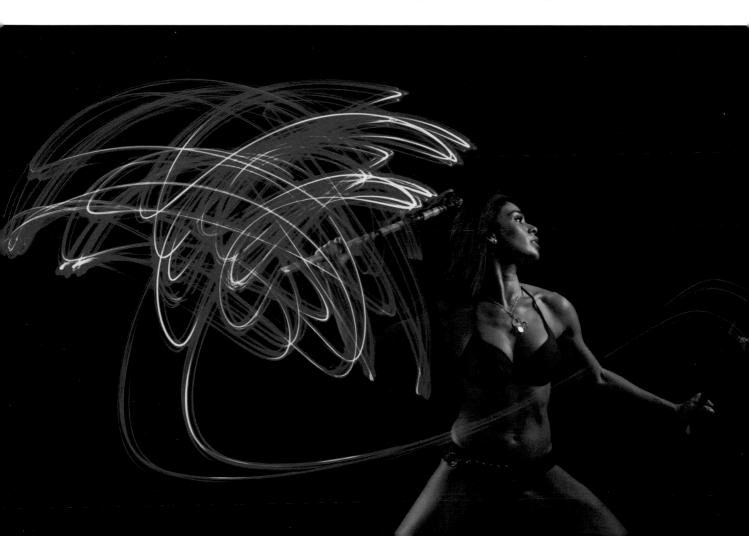

Flash Frenzy

IN ANOTHER STORY, I talk about how flash can kill your picture, and the fact that sometimes, in your perpetually unprepared photog state of affairs, you just have to bang away with bad technique because you're caught off guard or unexpected stuff happens, and that's what you have to do (see page 139). Life is unfolding around you, and it's hard enough just watching it, much less trying to document it effectively with this cumbersome machine in your hands.

It ain't your eyes. It's a machine. And it demands certain concessions. Unlike your eye, which sees and adjusts—continuously and fluidly—the camera needs to be worked. You have to choose lenses and settings, dial in numbers, modes of operation, exposure compensation, you name it. Talk about digital noise. This thing in your hands might as well be screaming at you, "You're not doing it right!" You can easily feel like a lousy lover.

And we get dumped into places and events, as I said, often as unceremoniously and abruptly as being handed a parachute and shown to the open door of an airplane.

You just have to jump.

And you could land in just about anything, and have to sort it out in immediate fashion. It could be a wedding, where you were told you'd have an hour with the bride, and it becomes three minutes. (They still want good pictures. "I mean, we're paying him good money!")

You show up for the reception, and the walls are mirrors, and the spotlights sweeping the dance floor are so strong they must have borrowed them from a guard tower at a Supermax penitentiary.

You try to cover a concert, or a football rally, and the loudspeakers blare so badly the decibel level precludes logical thought, and you're in a sweaty crush of revelers, one of whom just leaned into you with breath as fresh as low tide, burped a hello, and spilled beer all over your fastest lens.

You get dropped into a religious festival and you have no idea what is going on, but people are sliding sharp metal objects through their flesh, and the mixing aromas of incense, blood, sweat, and rotting fruit are so intense that you think any minute you'll barf into your eyepiece. And you worry about getting pick-pocketed, your exposures, and whether you should use flash or just jack the ISO into the stratosphere—and if your vaccinations are up to date. And not in that order.

Sometimes, this ain't easy. Sometimes, it's downright out of control. You think you're blowing the job, and there's no 1-800-HELP number for panicked photogs. What do you do?

I've covered lots of stuff that's outraced me mentally, physically, and photographically over the years. I've blown jobs, and come up empty. I've screwed up so thoroughly I've actually contemplated doing something else. But I don't, 'cause there's nothing else I know how to do. I don't actively want to seek out an endeavor that I'd actually be worse at than I am at photography, at least on occasion.

Here's what I think. If you blow a job, don't worry about it overmuch, and don't let that perceived failure destroy what's left of your already shaky confidence. There are other clients in the world, and the sun will come up tomorrow.

Obviously, try not to blow the job. Try to keep up. Here are some strategies.

Do your research. Do your homework. If you can gain even sketchy knowledge of the people or place you're about to cover, it'll be helpful.

Try to remember people's names. Even just a couple of them. At a wedding, if you're introduced around, tuck a couple of names into your noodle so that when you're doing a group shot, you can say, "Aunt Tilly, look this way and smile!" Everybody will be impressed, and it does sound better than, "Hey you with the hat!"

If you can bring a helper/guide/translator/VAL, do it. Even if it comes out of your fee. At least then you have somebody in the lifeboat, rowing with you. And, presumably, they will be able to hold your flash off-camera. Helpful.

We're past the "get there early, charge your batteries, and bring extra flash cards" stage of things. But yeah, do all that stuff.

If you're looking around, and things are moving fast, and you feel overwhelmed, just throw a dart at the wall and start shooting. Get your camera to your eye, and get with it, even if the frames are awful. It's like clearing your throat. You've got to start somewhere, and even bad pictures lead somewhere—most often to better pictures.

When you look around at the conditions, immediately do some testing, especially with your flash. Find a working shutter speed/f-stop combination that's reasonable. Use the advantages that the fancy-pants camera offers you. If it produces good frames at slightly elevated ISOs, go there. It will give you more breathing room, more DOF, a bit faster shutter speeds, and your flash will be less stressed.

If things get to a fever pitch, either at a street event or a reception, just jump into the mix of things. Don't hover tentatively on the outside, shooting Hail Marys. You'll end up with a lot of flashed pictures of the backs of people's heads and shoulders. Smile, nod, roll your shoulders, do a couple dance steps, say "Excuse me" a lot, and slide into the very heart of the matter. For events, I always use the old TV cameraman motto: Get in tight, go wide, hold your ground. Let everybody else shoot over your back.

When I cover something, and I'm confused—which is routine—I recite a mantra that is relatively soothing. I keep saying to myself, over and over, "What is the story? What is the story? What is the story?" At a wedding, the answer is easy—the bride. Everybody else is back story. At a religious festival, the story is passion and unbridled fervor. At an athletic event, it might be the game, but it could well be the pomp, the color, and the traditions, like tailgaters and cheerleaders.

I really do that chant. It calms me down. What is the story I have to tell here? Where are the pictures? I remember all those journalistic adages like, "Peel the onion," which means to keep peeling back the exterior layers of a story, thus getting closer and

closer to the heart of the matter. I also remember another time-honored directive: "Work entire to detail." Get the overall scene-setter photo. Get the personalities and the interaction. Get the portraits. Get the moments. Get the details. Get it all.

Shoot fast, but don't bypass stuff. Take the 30 seconds to shoot a table setting, or a pair of hands holding a cross or an icon.

Shoot a lot. Take chances. A corollary to getting in close and going wide is to shoot like mad. I am unabashed about this. Take chances, and know that you're going to lose frames. If you have lots of frames, then risk-taking is possible, 'cause even after you cull out the ones you lost, there are still

plenty to choose from. So keep your eye to the camera, and shoot like a banshee.

In the midst of the frenzy, the music, the noise, the sweat, and the anxiety, know when to knock down and turn the flash off, and shoot quiet moments without trampling them. You might be knocking out flash pictures so fast you look like a one-person disco, but remember the gift of available light is given, albeit selectively. You have to watch for it, and graciously accept it. You might be flashing the heck out of the first dance, but if you shut the flash down and let them be silhouetted in a spotlight, it could be, you know, better.

Enjoy the event, enjoy the moment. But keep your camera to your eye. Ever stand there, cameras around your neck, cheering while the home team scores the winning touchdown? I have.

GET A HELPER!

Having an extra pair of hands with you on the job—even unskilled hands—can be exponentially helpful. Make it part of your estimate. Try to be insistent. If the client won't spring for it, get one anyway. (Sigh.) I can't tell you how many times I've paid crew costs out of my own pocket. But, at the end of the day, I can walk away from a job knowing I pulled out all the stops to make it good, even if they didn't.

In the pics on the opposite page, I've got a helper at Thaipusam in Malaysia, the annual Hindu festival in honor of the god Murugan. It is a swirling mix of bodies, blood, and religious fervor. I needed help with knowledge of the ceremonies, language, and lighting. Here I've given a Shur-Line paint pole to my assistant, with an SB-900 on a Justin clamp, hooked up to an SD-9 external battery pack. The light shaper is a cool little box called the Ezybox Speed-Lite, which is about 8" square. I like it as a hot shoe

flash box because it has that rarity amongst small softboxes—an interior diffuser. So, if you leave your dome diffuser on, the light then runs through an interior baffle, and then the exterior diffuser panel. Pretty small light, but pretty soft, nonetheless.

The strategy I'm using here, light-wise, is to use my hot shoe flash as both a commander and a flash. It is pointed straight up in the air, with a dome diffuser on, running at minimal power. It is just a tiny bit of frontal fill. The strong light comes from the Group A flash in the box, at camera left. The finals on this shot are 1/25th at f/4.5, ISO 1600 on a D3S, with exposure compensation at −0.7. The Group A flash is at 0.0 and the master is at −3.0.

TAKE CHANCES! LET IT RIDE...

All you're going to screw up is a picture.

I often use Aperture Priority, and at a fast-moving event, that can be a touch dangerous. Things are moving too quickly to make EV adjustments, so you have to go with the flow and trust the camera's judgment. Sometimes, it'll screw up. Sometimes, you'll lose a frame, or even a bunch.

But getting out on the auto exposure tightrope can have rewards, too. The metadata on the two images on page 346 tell me they were shot precisely one second apart. I have dialed in a −1 global EV adjustment at the camera, and the flashes are running at −3 EV (the on-camera master) and +1.3 EV (the softbox).

In that split second, the camera shutter speed slid from 1/10th to 1/6th of a second. And somebody's flash went off in the background during the second exposure. These are not adjustments I can fine-tune myself—at least not that fast—in manual mode. I let the camera do the driving here, and hang on for dear life.

Sometimes, I get burned. Other times, I'm rewarded with a frame I didn't expect and could not have adjusted for.

THE THREE ZONES

Foreground, middle ground, background. In the studio, doing a portrait, you often place somebody out there in nowheresville—on a white, gray, or black seamless, devoid of information and any sense of place or activity. You got one thing you want your viewer to look at—the subject. Who is, presumably, in the foreground. And, at the camera, all your efforts go into making that happen.

But out there on the street, in the world, you don't have the luxury (or burden) of gray seamless paper. You have stuff. Lots of it. Front to back. From people to cars to buildings to power lines. A cluttered graphic environment, to put it mildly.

So, go with it. Try to populate the picture, front to back with some level of interest or gesture. If someone crosses the path of the lens in a way you didn't anticipate and might not like, shoot

(opposite page, top). You might find a certain serendipity in the chaos later. Anchor the frame up front with some measure of interest, and then pull the viewer through the zones, all the way at the back of the photo. Grab their eyes in the foreground, and then reward their attention with something going on all through the picture.

USE THE TECHNOLOGY!

The photo gods have seen fit to send us many pixels, and auto focus, auto advance, auto exposure cameras that talk to remote flashes at the speed of light. So why do you still have the camera set to "M"?

Nothing wrong with manual. I use it, as the occasion demands, quite a bit. But, I do revel in the fact that these bloody machines solve an awful lot of problems for us, and make shooting certain types of pictures that used to be problematic about as difficult as falling off a log, which I actually do quite well.

In the photo of the man carrying the FedEx package in Istanbul (opposite page, bottom), I am in full

chase mode. Stay with the package. Stay with the package. I'm trotting alongside the courier, and the intrepid Brad Moore is running ahead of both of us, off to camera left, handholding a raw flash. My commander flash is talking to the remote, and the camera is running on Aperture Priority, making second-to-second adjustments for me as we charge through highlights and shadows. 1/10th of a second, f/6.6, ISO 100, flash is at 0.0, no compensation.

I wasn't even looking through the lens here, and this shot ran on the FedEx website for quite a while, and proved to be a favorite of the client.

The new technology opens doors. Walk (or run) through them.

MAKE THE LIGHT LOOK LIKE IT BELONGS

Off the street, backstage, you might have a measure of control, even though you still have to work fast. The technology enables you to do that.

There were two sources of light in the dressing room (page 348, top). An overhead tungsten bulb, and the makeup lights surrounding the mirror, also tungsten.

I quickly popped a flash into the ceiling to simulate the overall room light, and taped a flash—with a dome diffuser on it—to the mirror, below her face, to mimic the makeup lights. Group A on the mirror, Group B for the room. Then, I just played the ratio game. My shutter speed gave me a baseline, the mirror flash gave me a key light (and cleans up the color), and the room bounce helps define the space. (The existing bulb was kind of murky.)

The exposure compensation is set to +1 EV. Reason for the overexposure is that in Aperture

Priority, the camera's brain reacted to the very bright makeup bulbs on camera left and pushed my shutter speed down accordingly. This is the way the camera thinks. It sees bright, and dials the exposure down. I have to fight that back at the camera by dialing in overexposure.

My shutter drag of 1/20th of a second pulls in some ambient from the room and warms the picture up, so I didn't have to play with gels and warm up my flashes. They are flashing into a blended light situation, and that mix is pleasingly warm. If I gelled them with CTO, I would have risked turning her

into the Great Pumpkin. And, the flashes here play nicely. Given the overall mix of the ambient light of the scene at +1 EV, they are dialed down at −1, effectively 0.0, given the mix of commands. They disappear, which is what I wanted them to do.

Flash that looks like it belongs. Flash that (almost) isn't there.

THE LIGHT OFF THE CAMERA IS HELPFUL

Even a simple shift of the light off the hot shoe, if possible, makes a difference in the quality of the light. Look for scenes, and let the gesture of the scene direct where you'll put the light. This devotee (right) is having his back pierced for the long, reverential climb up to the Batu caves. He is looking off in studied concentration while his helpers festoon his flesh with barbed hooks laden with fruit. I daresay my expression would not be as serene.

But his face is the key, so that's where my key light goes, just a couple feet off his nose, out of

frame. Shot at 1/13th at f/2.8, 19mm zoom setting. This is a Nikon D7000, at ISO 100, hence the shaky shutter speed. This shutter would be a no-fly zone for handheld available light shooting, but the flash—actually flash duration—makes it possible to shoot sharp. Experiment with different ISOs and hand-holding skills. Test yourself and push yourself. You'll be surprised at how working at holding your camera steady can enlarge your envelope of what's possible.

GET IN TIGHT, GO WIDE, SHOOT LIKE CRAZY

Slip and slide, shake and roll, boogie your two shoes, pierce your flesh with long, sharp blades— uh, no.

But do become part of the scene. At most events, people want to be photographed. You're not bothering them, so lose your reticence and hesitation. Don't be tentative. Get in their space. Trust me, they will let you know if you've overstepped.

Get in tight, rack the lens out wide, crank your hot shoe flash up into more of a bounce position, keep the dome diffuser on so it radiates, get a comfortable power rating, and go for it.

Be careful, though. You might get clocked by a pair of flying Christian Louboutins. (Actually, even though this isn't a "traditional" wedding picture, it's a great keeper.) D3S, 24mm on a 24–70mm lens, 1/20th at f/3.5, ISO 1600. Exposure compensation on the flash of −0.7.

And no matter how you think you're doing— whether you feel like you're crashing and burning, or on your way to the best take ever—keep your eye in the camera and stay with it. Just keep after it. Shoot lots of frames.

The shot of the bride and groom was pure luck. But good photo luck comes to those who shoot lots of pictures. I just managed to catch my wife Annie's flash (she is behind them) as they stepped down from the chuppa as man and wife. Samantha and Adam are a terrific couple, and this was my favorite—and luckiest—shot of the day.

And if you're shooting a Kavadi, which is basically a whirling dance of devotion with an elaborately crafted multi-tiered structure supported on the dancer's shoulders, look out. The strategy I often

employ when in a whirl-a-gig mix of a festival or rock concert is to center-weight my auto-focus, zoom the lens wide, and keep shooting without even looking through the camera. I do look, and see the rough framing, but then I back my eye off a bit. I try not to simply dive inside the tunnel of a DSLR to the exclusion of the world around me. This one was shot Aperture Priority, 19mm on a 14–24mm lens, 1/6th at f/5.6, ISO 1600. Exposure compensation of −0.7, with the on-camera master dialed in at −3.0 and the off-camera flash at 0.0.

That might be a harking back to the days when I consistently used Leica rangefinders for a lot of my coverages. The field of view of the 21mm lens, for instance, could not be accommodated by the actual focus prism you would look through for, say, a 35mm lens. Hence you had to look two places—the focus window, and the 21mm viewfinder attached to the hot shoe bracket atop the camera body. I often zone-focused the camera, and just looked over and past that finder to the world around me.

That was a strategy many rangefinder shooters would employ, and it kept you aware of the world around you. Doing this, your framing would be looser, maybe a little messier, which is not really the right word. Maybe...less ordered and cleaned up. Definitely more in the mix of things. Framing with a DSLR provides a more distilled version of the world. And looking solely through the pipe of a DSLR can disconnect you from events occurring just outside that frame. You need to be aware of those, because those developments might make for a better picture than the one you're concentrating on, or they can be the beginnings of your next frame.

Keep shooting, keep framing, but also don't just burrow into the tunnel view of the lens. Look around. Get into the mix. Keep your head on a swivel. And watch for flying shoes.

LOOK FOR EXTREMES OF LIGHT!

Look for odd light, shadows, and silhouettes. You don't need to show everything, just enough to get the idea across. A little bit of mystery can be a good thing.

FedEx campaign, downtown L.A. Aperture Priority mode, 1/1000th of a second, f/7.1, ISO 400, 17mm on a 14–24mm lens.

QUIET MOMENTS

In the midst of the rush and the anxiety, and the constant flashing, remember to stay with the story—in this instance, the bride. And, when she gets quiet, you should, too.

Calm down. Shut the flash off. Work quietly. Observe. Breathe through the camera.

DON'T PACK UP THE CAMERAS

Just because you think you're done doesn't mean it's over. So, don't be efficient and pack up your gear, use your hand sanitizer, put your lens caps on, and buckle up the straps of the fancy camera knapsack you just got—the one with three dozen compartments and the double-lined zippers. You know, the one that does everything except walk alongside you.

It ain't over till it's over, so no matter how tired you are, keep the cameras on your shoulders until you're well clear of whatever event you're shooting. I got this available light shot—ISO 800, D3S, 155mm lens zoom on a 70–200mm, 1/60th at f/3.5, exposure compensation of −1.3—walking back to the car. Stay alert. □

A Couple of Joes

JOE HODGES IS A DOWN-TO-EARTH, fun-loving guy. He's the very definition of "an average Joe." He's your neighbor—the guy down the block you might not even know that well, but you would call to help you move a really heavy piece of furniture, or some chore like that, just because you know he would.

I guess that kind of roll-up-your-sleeves-and-pitch-in attitude just goes with the turf of being a 27-year veteran New York City firefighter.

I met Joe after 9/11 and immediately liked him. It's just plain obvious that he's good-hearted and decent. Also, how can you not like a guy who goes fishing in the firehouse? Joe's style of firehouse fishing was to grab some filament line, tie it to an

old wallet, and rubber-band a couple dollar bills to it. Then he would crack the firehouse door slightly, slide the wallet out on to the sidewalk, and watch the fun from the small windows in the huge truck bay door. Most folks in the neighborhood knew the guys in the house, and caught on pretty quickly to the practical joke of this wallet getting pulled just out of their reach as they stumbled after it. It would drive kids crazy, for sure. Joe was once stationed in a firehouse next to a methadone clinic. "That was really fun," he chuckled, shaking his head.

A few years after 9/11, I asked Joe if I could visit him at the firehouse he had been assigned to out on Governor's Island, in the middle of the New York harbor. I needed a vantage point for the July 4th fireworks, and that lonely island out there is simply the best view of the New York skyline anywhere.

Joe, being the self-effacing type of guy he is, did a head tilt when I told him I wanted him in the photo, between me and the fireworks. He obviously thought the pyrotechnics up against the Manhattan skyline would be far more interesting without him in the mix. I felt otherwise. As I've always maintained, I've never met a landscape that I couldn't put a person in front of, and thus make more interesting.

That shot (page 357) is one-Speedlight, no-frills, line-of-sight triggering. When I say "no frills," I really mean it. I'm working by myself with a small light stand, stand adapter for the hot shoe flash, and an SB-800 unit with an SD-8A battery pack. Camera is on a tripod. D2X, ISO 125, and the lens is set to 19mm.

This is where line-of-sight TTL control is crazy simple—and highly desirable. Joe grabbed his walkie from the firehouse and clambered out on the rocks for me, allowing me to line him up in the path of the highlights the fireworks were blazing across the surface of the water. I put my light stand on a walkway to camera right, took off the dome diffuser, and zoomed the lens to 105mm, as tight as it would go. I put a couple of pieces of black gaffer tape on the bottom edge of the flash head, just to gobo—or cut—the light that might spill onto the rocks. Some light down there is necessary in order to establish where he's standing. But a lot of light would just be a nuisance and a distraction.

"The tracer line in the sky over the city, left of the fireworks, is made by a plane, not a radio-controlled drone I sent up there to achieve graphic balance."

If I had the light triggering off of a traditional PocketWizard, I would've been running back and forth between the tripod and the wooden dock where the light was placed, physically adjusting the power on the flash. Of course, now there is radio TTL, the updated Flex/Mini PocketWizards that speak the mysterious dialect of TTL and transmit it via radio waves. But, to be honest, even now, that technology has the glimmerings and glitches of future world photography. Now, and then—when I made this picture—nothing beats simple line-of-sight triggering at about 50 or 60 feet in the surrounding darkness, where there is no competition out there for the series of little, information-laden pre-flash pops. I got transmission and a flash every time. Out there, in the New York harbor, even straight-up radio signals could go a little haywire, given all the conflicting frequencies and channels in operation. Line-of-sight was simple, easy, and direct.

Another beautiful thing? If the fireworks—with their sporadic, dramatic highlights screaming across the sky and the water—were to wreak havoc with the camera's TTL thought processes, with a flick of a button on the hot-shoed commander flash I could tell that light to go manual. And, having done that, I could then adjust its manual value up and down as I see fit. All button-driven, and I never have to go near the light.

The camera's on a tripod, obviously. Even "da grip" has its limitations. Final readout: D2X camera, f/5.6 at 6 seconds. Flash is set to manual, at half power, no gel. The tracer line in the sky over the city, left of the fireworks, is made by a plane, not a radio-controlled drone I sent up there to achieve graphic balance. It was dumb luck, and fortuitously placed. Anytime you open your shutter at night in New York, the skies are busy. Planes will draw you a puzzle in the dark above the glow of the city.

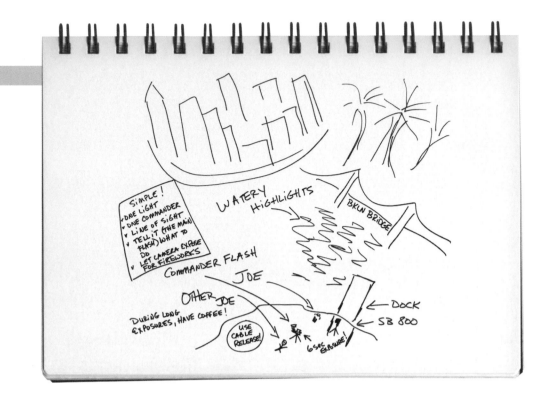

The little tracer line around Joe's form is subject movement at six seconds. Just a little vibration caused by him not remaining exactly still. The flash freezes his form but, given the lengthy exposure, just the outline of his body gets an edge, given the backlights out there on the water. I could have eliminated that by going to a more open f-stop, which would give me a faster shutter. (He's got a better chance of standing still for 3 seconds at f/4 than 6 seconds at f/5.6, right?) But, depth of field was important here. I wanted to squeeze as much sharpness as I reasonably could with that wide lens. I made the gut call to go with a healthy f-stop, which gave me a quasi-reasonable tripod-bound shutter speed. As always, you make decisions that prioritize what you feel is most important for the shot, and let the other stuff ride. Sometimes that "other stuff" bites you, damages your quality, or limits your number of useable pictures. At other times the compromises you make just plain and simple make you go white knuckle at the camera controls—holding on for dear life, and hoping the pixels smile on you while, as Sean Connery famously said in *The Hunt for Red October*, "Once again, we play our dangerous game."

Out there in dicey locations, working a camera at the whim of the world, there really aren't any compromise-free solutions. All the eggs are in the air, and you're just hoping to catch a few of them before they splatter at your feet and make your shoes messy. The day when technology completely overtakes the adventurous spirit of photography and makes

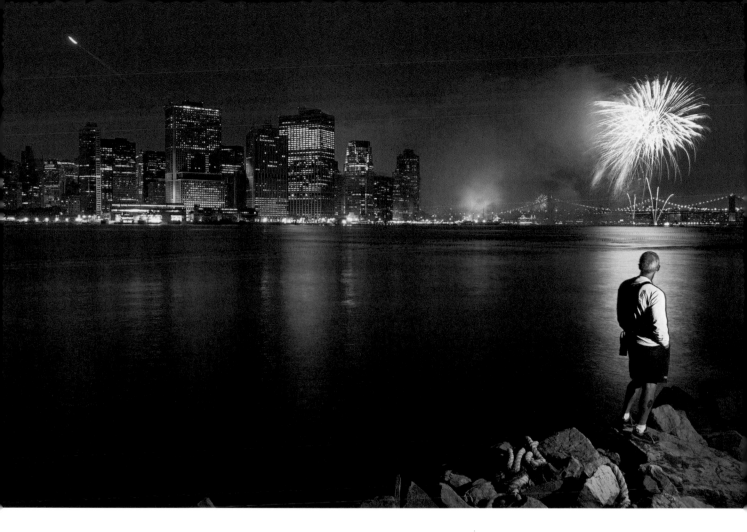

everything "easy" is still way off in the future, and when that day arrives I will, blessedly, be in a box somewhere, with a headstone that might read, "Push One Stop."

It's interesting being a shooter. The pictures you make are like a connect-the-dots game that becomes the line of your life, as real and vibrant as the lines on your face and hands. We tell stories with our pictures. In turn, our pictures tell our story—what we did, and how well or poorly we did it, and, very significantly, if we stuck with it.

I first met Joe when, in the days after 9/11, he came to East 2nd Street in Manhattan, which, at the time, was the location of the world's only Giant Polaroid camera. A unique beast of a photographic apparatus, it made life-size 40x80" images in a positive Polaroid print, 90 seconds after the flash of the strobes. (A lot of strobes.) Joe stepped in front of the 70-pound lens of this camera—which, according to legend, was cadged out of a U-2 spy plane—and instantly, simply, became a photograph, one of my favorites from the 9/11 project I did. Good guy. For his caption that ran with the photo, he struck a typically self-less note.

"I pulled myself off of medical leave and hitched a ride on a tugboat to Manhattan. Knowing that everyone I worked with was in the buildings, I had to go. There are so many young guys on the job now, older guys like me have to show them the ropes. It's a tradition in the fire department. Now's not the time to leave."

Joe eventually did leave the job, retiring just a couple years ago. In a "ten years later" revisit of the 9/11 project for a book called *One Nation*, I called Joe and visited him in his house on Staten Island, where he's thoroughly, completely, and deservedly enjoying a well-earned retirement. A decade after meeting him for the first time, I was about to connect another dot. I made the first image during a time of unbelievable stress and heartache. This go-round, it was time for a picture and a beer.

His living room was suffused with backlight from strong afternoon sun, which gave it a warm glow. I often take my cues for flash from existing light, so I just went with the flow. This wasn't the time for drama with a moody, introspective light. This was a time—for lack of a better word—for happy light.

I chose a shoot-through 34" one-stop-diffuser white umbrella and put it on a C-stand with an extension arm. I've got one SB-900 firing through it, and the arm gives me the ability to fly the light right over the camera lens, lining up with Joe's face and body language in a symmetrical way. And that language is exuberant, right? He survived 27 years of jumping into burning buildings, and has a wonderful wife and a new grandchild. His face is beaming into the lens, and he just owns the camera. His pooch, Lola, jumped up there with him, which completes the picture, but also gave me a problem—wonderful as the pup is, she is also a light sponge. I might have been able to skate with Joe on one light and a fill board, but to drive some light into that mop of dog hair, I brought out another flash.

I was trying to figure out whether to bounce the light down into a white or silver reflective surface, just below the lens, as a floor skip, when Drew, my first assistant, said, "Why not just bounce it into the floor?"

Yes, indeed. Right there, by the way, is a great expression of what a good assistant can and should do for the shooter on location. They keep you organized, and quell all that background noise that can rise up and muddle the photog's brain. (In my case, it's already too late for that, but let's not dwell, okay?)

The light bouncing off the wooden floor became, effectively, the same color as the sunlight bouncing around the warm surfaces of the room. In other words, it was no longer a neutral splash of flash; it was the color of the ambient. It actually disappears into the ambient, like a rabbit into the black hat of the magician. Poof! It's there, but then again, it's not.

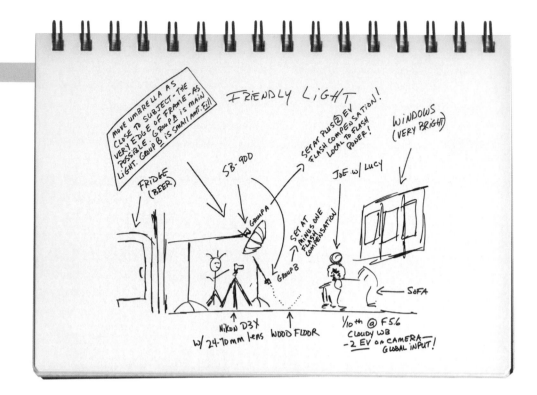

With that little dollop of low fill light emanating from the floor, I just squeezed a little detail out of Lucy. She repays the favor with an appropriate, tongue-hanging-out, "I'm happy I'm a dog" look.

The finals on this were 1/10th of a second at f/5.6, Aperture Priority, at −2 EV. That EV factor is another reason to pump some extra light at both Joe and the dog. If I had used straight-up 0.0 as an Aperture Priority meter value, those windows would have gone nuclear, and I'd have three enormous holes in the sensor. At −2 EV, they're pretty bright, but not intolerably so. Still some detail in the drapes and a touch of greenery behind Joe's head in the middle. Given that underexposure factor, obviously Joe and Lucy disappear. Hence, the two flashes gotta work pretty hard to light them back to life. The overhead main light is running at +2 EV, and the low bounce—again, just needing to be there without drawing attention—is running at −1. Combined with the under EV factor, which affects the scene and the flash power, that low light is low indeed. The upper light, with the +2 factor, is basically evening things out against the −2 that's programmed into the camera's EV setting. In this instance, the math works out: −2 at camera, +2 at the light. The first is a global exposure input, affecting the whole scene (including the flash), and the latter is an input local to the flash.

It doesn't always work out this way, which is something I know you know. But in this instance, the math of the light was even up.

"The picture simply works as a good-guy portrait. He supersedes flash faux pas, compositional trivia, and other assorted pixel madness."

So, here's a screw-up, If you will. See the highlights in the interior of the bookcase on camera right? Looks like it could be the windows? It's not. It's my umbrella, at least mostly. Now, when I saw that, I started thinking about changing things up, maybe going to a softbox, or shrouding the light, or just moving it. (Given the area of highlight, it would've had to have been a drastic move.) I decided against it, and just let the flash hit play. My reasoning?

It could be a highlight from the windows, at least to the untutored eye of a reader. All that stuff behind Joe is very highlight-y and bright. The flash bomber in the bookcase just becomes another piece of the highlight terrain. It doesn't blare, or look out of place. For your average Joe looking at this picture, does that highlight detract from the enjoyment of it? I think not. The Joe who's the star of the snap is front and center, bursting with both a smile and goodwill. He dominates the picture and grabs your eye immediately. (The white t-shirt he's wearing helps in this regard. Usually I nix a white shirt.) He is also bull's-eyed in the frame, another classic no-no. Call the composition police!

But it works. The picture simply works as a good-guy portrait. He supersedes flash faux pas, compositional trivia, and other assorted pixel madness. It's a picture about personality, not my lighting. Too often, as photogs, we get hung up on picture minutiae that we think needs fixing because some other shooter might notice it and send you a gotcha email. We strive for our pictures to be perfect, which is a great instinct, but hardly necessary all the time—or achievable any of the time. If I had labored over this flash hit, the sunlight busting through the windows might have disappeared, and the mood of the room would vanish with it. And Joe, patient as he is, would start to look at me a bit sideways, like, you know, this ain't a burning building, it's a picture. Enthusiasm and exuberance for the whole deal would start to wane.

So hang the highlight. Get the picture.

As I said earlier, this isn't the time for rough or edgy light. This isn't straight-flash, up-against-the-wall-and-give-me-attitude light. This ain't, after all, a CD cover for a leather-clad, screamin' East Village band that does their sets at 2 a.m. in a bar that smells bad. It's a warm light, with a friendly, forgiving quality. Easy on the eyes—and the subject. Nothing fancy, but nothing fancy is needed. An umbrella—a light I often disparage as boring—is perfect for this. Open, clean, and embracing. Friendly. Decent.

It's a light just like Joe. □

The Lady, the Light, and Some Luck

EVERY PHOTOGRAPHER OUT THERE, no matter how serious or casual, has, at least on occasion, cursed the light. Bad light, hard light, no light, muddy light, fluorescent light, dappled light, flash light. At some point, it's all horrible, and we curse the darkness or dimness or color or direction of whatever vexing quality of illumination we deem to be not up to our continuously needy and demanding standards.

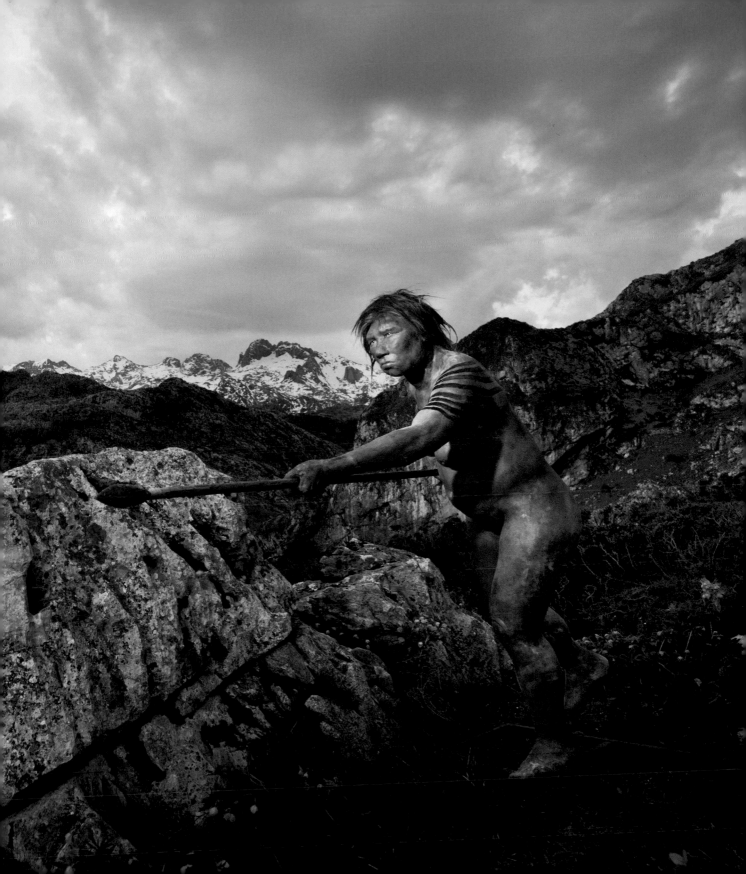

We forget last week, or even yesterday, when the sky was rippling with such color it looked like a mad painter's palette rather than a collection of nondescript smudgy clouds. We forget that last portrait session when the window light was an immediate and marvelous gift that made that particular job sweetly easy. We are, relentlessly, creatures of the moment, and when that moment arrives with an unfit quality of light, we curse the moon, the sun, and the stars, as if they had anything to do with it.

And there are those times when the light does arrive—quickly, beautifully, silently—and then vanishes in the same way. Like a fast-traveling shadow, it'll be gone almost before you notice it. It's there for a moment, and a moment only. It's our job to catch moments, right?

I had a moment of light like that, thankfully, in the midst of a series of moments I was having with Wilma, a Neanderthal lady of some fame and reputation. Created at the behest of *National Geographic*, who spent an enormous amount of dough on her splendid presence, she was short, kinda squat, big through the beam, and had a seriously no-nonsense look. Buck naked, brandishing a spear, skin pockmarked by frostbite, she had blue eyes and an unruly mass of red hair that had never seen a bottle of Clairol. She didn't laugh or smile. She was about 100-plus pounds of exquisitely crafted silicone wrapped around a steel frame. We dubbed her Wilma, in honor of her prehistoric cartoon counterpart. Thank God there wasn't a Betty, too, 'cause Wilma all on her own was a handful.

A bit like a blind date, I was assigned to shoot Wilma for a cover story for the *Geographic*. To do this, she had to be carried into the woods of northern Spain, to an area of caves where there had been

"Make the light part of the drama of the photograph, edge her out in a believable way, and there was a prayer you could wring a semblance of soul and anima out of her."

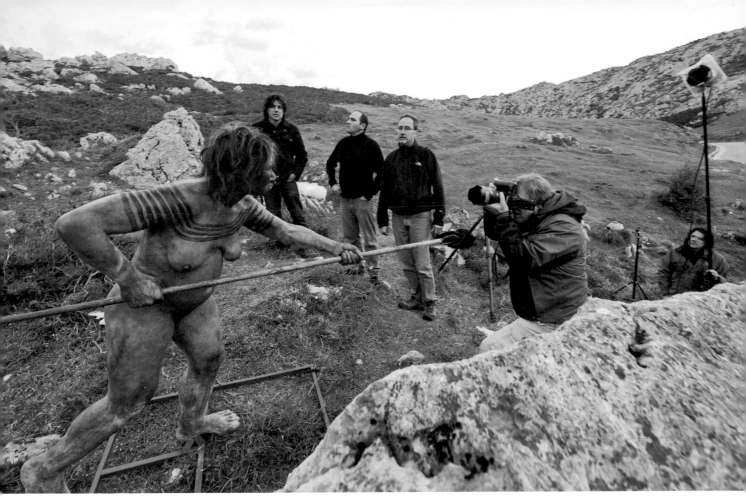

Brad Moore

new discoveries of Neanderthal DNA. These discoveries had prompted a reinvestigation of the Neanderthal lifestyle (trust me, you want yours, not theirs) and their relationship to Homo sapiens. (That's us.)

Geographic has always jumped on stories like this, and they did once again, by commissioning the creation of Wilma by two of the craziest, most talented tandem of twins I have ever met, the Dutch-born Kennis brothers. Their genius is to take things long since dead and, using scientific tools, precision, DNA evidence, and sheer artistic brilliance, make them look alive. From a short distance, Wilma

looks for all the world like she could just start walking around. It's only when you get closer that you find she's not long on conversation.

So how do you animate this bunch of plastic? She doesn't smile, or look around. Geographic asked me to make her look "less naked." She was aggressively brandishing a spear, so making her seem approachable was daunting.

The only thing I had going for me was light. If I used light well, I could at least make her look like she belonged. Make the light part of the drama of the photograph, edge her out in a believable way, and there was a prayer you could wring a

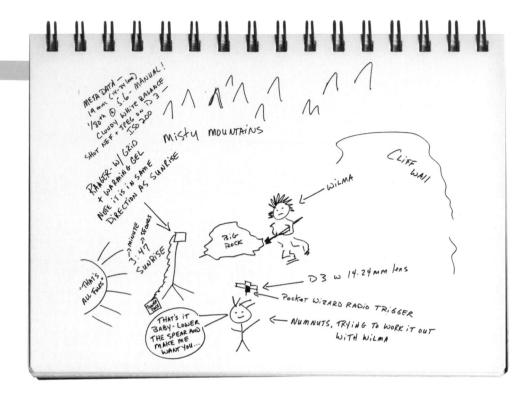

semblance of soul and anima out of her. Lighting her well and strategically also carried the promise of minimizing her nudity, and hiding the steel base she was stuck on—both necessary items.

While the bulk of her location shots were done in what is now the deciduous forest surrounding the caves, we did have to find a location that was more rocky and harsh, similar to the terrain she must have experienced back in her time. To do this, we put her in the back of a van, and found a good, barren stretch of mountainous hillsides—in a Spanish national park. A park we had no permit to shoot in.

But, often the early bird needs no permit. We got there basically in the middle of pre-dawn gloom and began sorting out the direction of the rising sun, her orientation, and the amount of flash to be brought to bear, which was, in fact, almost none at all. One light—with a tight honeycomb grid to locate it on her face, and a full CTO warming gel

to match the warm sunrise, which was bound to show up any minute now (right, light gods?). It was a big field flash, the Ranger 1100 Ws portable battery unit. One head, with a very controlled, defined spray of light, and color shifted via the warming gel.

In the darkness of that Spanish hillside, hit with this flash, Wilma looked like a caution light in search of an intersection (opposite page). Just a warmed highlight floating in a sea of shadows. I needed some assistance here, and it was not in the form of flash. It was in the rising volume of available, or ambient, light.

As I've pointed out numerous times, as a shooter, primed to do a flash picture, somewhat ironically, what is the most important picture you can shoot, right away? An available light shot. Absolutely. You need to get the weather report, if you will, for the location you are bound to, and the best (and only) way to do that is to assess the quality, condition,

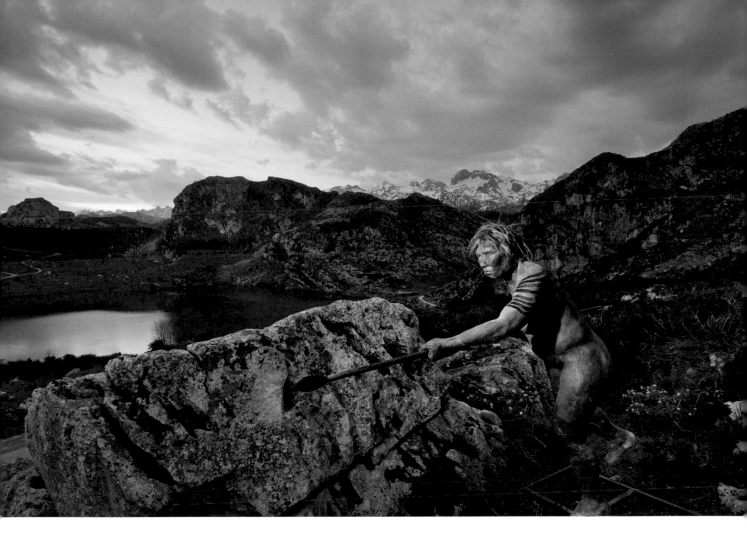

and level of the ambient. In a scene like this, the flash is just an accent. I can't light the whole mountain. My main light, if you will, is the ambient, which I control with my shutter speed, just the way you would control the window light in the room by lowering the curtains (fast shutter speed that eliminates light) or opening the curtains (slow shutter speed, allowing a lot of light into room).

So, you make a picture like this, on location, in front of the art director of the *National Geographic*, no less, who has spent a lot of dough to send you halfway 'round the world into the remote Spanish woods, because you are theoretically good at this,

and it sucks. What do you do? Babble excuses? Race back to the car to grab more lights? I will light the whole park!

No. You stay calm, and stay the course. You remain patient that something good will happen, and you make sure you are ready when it does. One of the big conundrums of a photo like this is that Wilma is standing on a whole bunch of dark ground, which has to be lit, 'cause it represents her environment. But the drama of the picture is in the sky, and even the pre-dawn murk up there in the heavens is several stops brighter than the earth. Expose for that sky, as you should, and she gets swallowed

up in darkness. The camera can't see into both places, i.e., exposure zones. They are too far apart.

There are those who will read this, and say, accurately, "Dude! Shoot HDR!" In today's world, given an inanimate dummy out there on the ground, with no possibility of motion or change of expression and attitude, it could be the way to go, certainly. Bail out of the burning plane of traditional one-shot exposure, pull the HDR ripcord, and start floating through a sky of bracketed exposures.

But this was shot before HDR was a common household name, the way it is now. It was before all sorts of truly simple, automated merging programs had really reached their full flower. Plus I'm not very good at that stuff, really, and even now, if it's not well done, there are telltale footprints on the picture—and in this case, they would've been mine, not Wilma's. As the shooter, I always, desperately hope to step out of the equation and simply let the reader enjoy the photo, and not instantly and uncomfortably wonder about how it was done and by what post-production program.

And then there are the ghosts of the Grosvenors, the originators of *National Geographic*, sitting on your shoulders, beckoning you to hew to the traditional path. Ever see *Animal House*? That scene where the young lady is passed out, and temptation is at hand?

HDR Devil: "Go ahead, click away, nobody'll know!"

One-Click Angel: "If you lay one finger on that slider I'll never talk to you again! Ever!"

You can argue this any which way from Sunday. For me, the deal, at that moment, was that I waited on light. And indeed, slowly the scene filled—with pukey, gray flatness. I was pulling in the ground and the rocks, detail-wise, and holding the sky, to a point. But my warmed flash was blaring and out of place.

I waited. Then, boom! Wilma's ancestors looked down on her kindly and let loose a sliver of warm light that illuminated the rock face in the distance, and it was exactly the same color as my flash—warm, beautiful, slanted sunrise light. I got 39 frames, and it lasted for exactly

"As the shooter, I always, desperately hope to step out of the equation and simply let the reader enjoy the photo, and not instantly and uncomfortably wonder about how it was done and by what post-production program."

3 minutes and 47 seconds, then was gone as quickly and silently as it arrived. But, after that blessedly small window, I had a two-page spread in the *National Geographic*.

Simply done, really. 1/80th of a second at f/5.6. Just enough to saturate the sky and hold the guts of the foreground. The hard flash pops Wilma's face, but shadows her body at the same time. I angled it slightly, so if there was any spill from the light, it would be on the near rock in front of the camera, giving that some detail. Lens was 19mm on the 14–24mm f/2.8. Cloudy white balance to help out the warmth of the sunrise.

We finished this picture and, foolishly, did not leave immediately, even though the sun was getting up there in the sky and there were cars on the road. We were trundling poor Wilma to another area—a rather indelicate process—when a car carrying two Spanish national park rangers arrived. I told Brad Moore, my assistant at the time (I lost him to Scott Kelby in a card game), to pull the CF cards and stash them, you know, somewhere.

A rather tense conversation ensued, which did not go well. I don't know the Spanish word for "kinky," but these officers were obviously put out that we were messing with an anatomically accurate, naked female in their pristine wilderness. At the end, though, they accepted the fact that we were shooting for *Geographic* and not, you know, *Maxim*. They let us, and Wilma, go.

Hmmm...I never did ask Brad exactly where he put those cards. Probably just as well. □

Lighting the Wind

IT'S TOUGH TO LIGHT THE WIND, RIGHT? At most shoots, the wind is not a welcome visitor. It knocks over your light stands, tousles the hair of carefully coiffed models, and funnels dust and grit right into your sensor. If it is strong enough, it can batter you senseless and mangle your thought process. It also limits your options. Ever try to put up a 74" Octa softbox in even a mild breeze?

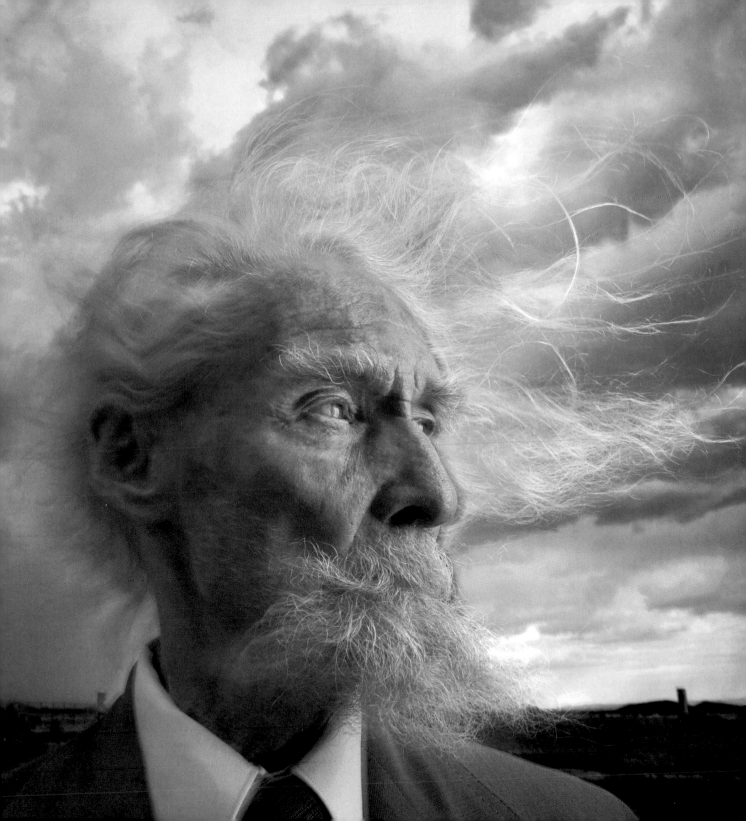

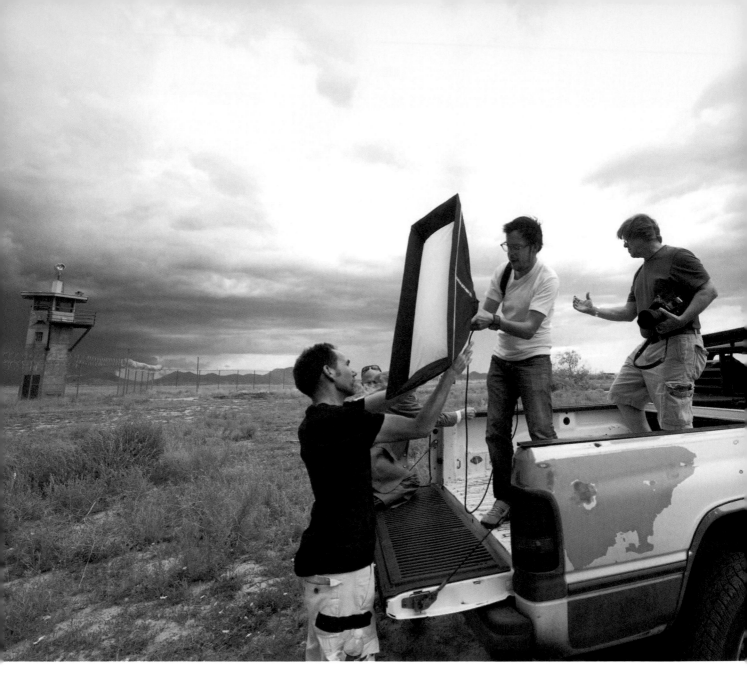

"Picture-making isn't prudent, or cautious, or even well thought out. The best of frames often result from the most illogical of actions."

Garrett Garms

But, when it starts whipping around in fearsome fashion, and you happen to have a Moses look-a-like in your company, you go for it, despite the degree of difficulty. When I looked at the storm gathering in the New Mexico skies, and felt the wind rattling through our location like the beginnings of a land-based perfect storm, I was thankfully in the company of my dear friend Donald, and asked him to stand up with me in the bed of a pickup truck.

Elevation is important here. The more you can get your subject clear of the ground, the less of that ground you have in the picture, and the more sky. The landscape behind him is just a bunch of dark, cluttered junk. The sky is where the drama is. The clouds spell storm. Luckily, we had a pickup handy.

(Why does photography call you to do the most unreasonable things in so many situations? When the wind starts knocking you about like a tenpin, prudence dictates the seeking of shelter, or at the very least, hunkering down. Instead, we all made ourselves more exposed by getting up on something higher. If a roof had been available, I would have gone up there. Picture-making isn't prudent, or cautious, or even well thought out. The best of frames often result from the most illogical of actions.)

As rash and ill-considered as it was, I still had a few synapses working, enough to remind me to not do anything fancy out there. The wind was up and the storm was comin'. So, as I have said to myself many times with camera in hand, Keep It Simple, Stupid! Use one light, and not a particularly big one at that.

Luckily, the wild, wise Donald has a face made for one light. Rugged and biblical, the lines of life are carved powerfully into his visage. These lines are earned, and deserve to be seen, and the way they are best seen is to limn them with light and shadow. If you floodlight them indiscriminately, you rob them of their depth and hard-won character, not to mention their nobility.

One light stands in service to a face like Donald's. In this instance, I chose the Elinchrom Quadra which, as been been described, is a potent (400 Ws) bundle of flash power in a small box. The flash heads

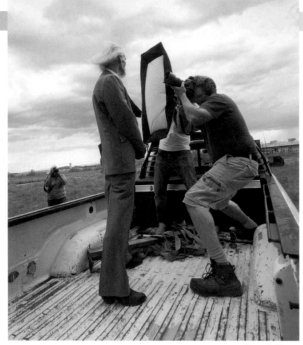

Garrett Garms

This little strip light doesn't mess around. It is beautiful and directional, and when used close in, has terrific falloff into the shadows. It hits the subject hard and soft, all at once.

Perfect for Donald, in other words. Moving the Quadra light in like this gave me a lot of control. I pushed the power right up to the max of 400 Ws and moved it as close to his face as I could. (The softbox is hovering about an inch out of the right-hand side of my frame.) The flash/ambient particulars of this shot ended up as f/20 at 1/8th of a second, ISO 100, on a D3X. Yowza!

Why f/20? Sounds like a lot of f-stop dude! True enough, and while I could have done with less depth of field, what I was really after was long shutter speed. Drawing the shutter speed out—dragging the shutter, in photo slang—gives me a chance at that most difficult of tasks: taking a picture of the wind.

Or at least the effects of the wind. I'm handholding the camera at a longish shutter speed, standing on an unstable platform, and behaving like one of those poor on-camera reporters for the Weather Channel who regularly have to get their ass kicked by an incoming storm while shouting something

are small but, with an adapter, they'll fit right into very cool light shapers. For this, I needed a good strong light—diffused yet directional, and concentrated. Given the wind, it also couldn't be big. A small (1x3') strip light worked.

(Seems I've always shot Donald with one light. The other frame, shown on the opposite page, is an SB-900 through a TriGrip diffuser. How could you ever tire of a face like this?)

"If I played it safe, and shot it at a "normal" shutter speed—something like 1/60th or so—you freeze everything and squash the wind-whipped possibilities of the photo."

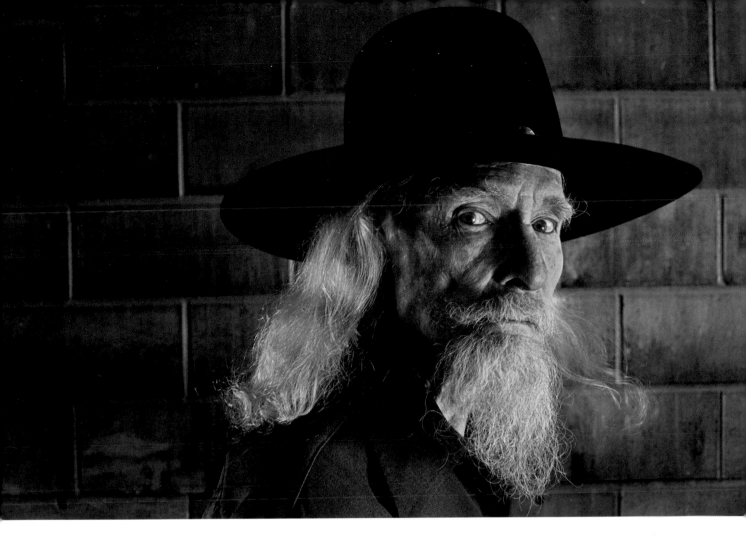

into a microphone that no one can actually hear. Again, not too bright, on a couple levels—first, to be out there at all, and second, to be risking critical sharpness by using an impossible-to-handhold shutter speed.

As always, though, flash to the rescue! There's enough flash in his face that I retain a core of sharpness there while the shutter drag allows Donald's wispy mane of hair to blow about like wildfire. I'm hoping for happenstance here. Hoping for the happy accident that accelerates his hair just so, and the snap becomes a wind-fueled portrait for the ages. If I played it safe, and shot it at a "normal"

shutter speed—something like 1/60th or so—you freeze everything and squash the wind-whipped possibilities of the photo. If I were to play it this way, might as well just take him inside where we all could have been much more comfortable.

That's the point, right? To not play it safe. To always seek out that little bit of difference, little bit of motion, light, color, activity, gesture—you name it—something to elevate the picture out of the "here's another portrait" category. That's the reason to do battle with the wind. That's the reason to not go inside. □

More Wilma

OBVIOUSLY, SHE LEFT AN IMPRESSION ON ME. I showered attention
on her, tried to impress her with lots of gear, and long lenses. She remained
indifferent, as women sometimes do. Noncommittal, to say the least.

I have to admit that my interests were not solely in getting to know her so I could best express her soul, photographically. I was under pressure to make a *National Geographic* cover story happen in less than a week. Considering the contract for my first cover for the magazine was for 26 weeks—this was in November 1992—I had to considerably adjust my pace and methods.

As a shooter for the *Geographic*, one of the true blessings they traditionally confer upon you is the gift of time. Sometimes things go well in the field. Other times, not so well—or not at all. Out there on location, it can be divine, maddening, miraculous, or one of the circles of hell, all in turn, and quite quickly. You have to have the patience to run the course of a job. Sometimes, you can't force it. Sometimes, you just have to wait for it to come to you. Time enables you to do that.

Well, on this one, Wilma wasn't going anywhere. She just stood there confronting me with a spear.

And I did not have the gift of time. I had to make a cover story out of a fancy mannequin and a bunch of greenery, and quickly. The quick part was okay. I mean, Wilma and I were not going to get to know each other better. It was going to be a slog. Shoot and move, shoot and move. It reminded me of that old joke about Harry and Sam, dear friends and golf fanatics who loved the game and played every week, rain or shine. Sam got home and his wife inquired about the day. "It was awful," said Sam. "Harry had a heart attack and died on the third tee!"

"That's terrible," replied his wife. "How awful!"

"You're damn right! After that, all day, it was hit the ball and drag Harry! Hit the ball and drag Harry!"

This was: set up the lights and drag Wilma. Set up the lights and drag Wilma. Which we did, reasonably well.

Even though Wilma wasn't real, the rules still applied. So first thing I did was get to know my subject. That meant doing a bunch of reading on Neanderthals and that period of pre-history, as well as reading about her creators, the Kennis twins.

Just to be conversational on the set. Then, I had to take a serious look at Wilma. I hung a painted backdrop in the garage of the hotel and placed her on it. She is just inside the garage doors, which effectively conceals her from direct sunlight. Soft, open shade is easygoing light, i.e., light I can control. Don't want to fight the sun here. I've got more important stuff on my mind.

Like, how to shoot this cover? Here, I chose a 74" Octa, the one-stop shopping of lights. I put it a bit of a distance from her, for two reasons. One, I wanted to have enough clearance so I could shoot both tight and full length, and two, I didn't want it so close that the light became all glowy and studio-like. From this distance, the light is soft but also hard enough to create a shadow and define her hard features. Wilma didn't have an easy life. I didn't want the light for her to be all that easy, either.

That distance also provided coverage for the painted backdrop, as well. Its muted tones react well to the spill of the big light. It's illuminated, but not overmuch. The backdrop remains properly in the background, both physically and in terms of tonality.

The only other light I used here was a small softbox as an "under" light, which is just barely there. Face it, Wilma ain't Kate Moss. I didn't want to overlight her, or make something too glam out of it. I needed a spark for interest and life—which she don't have much of—and to keep it real.

All of which sounds perfectly ridiculous, of course, because she herself is not real. I guess what I'm saying is that I went with the flow of the subject.

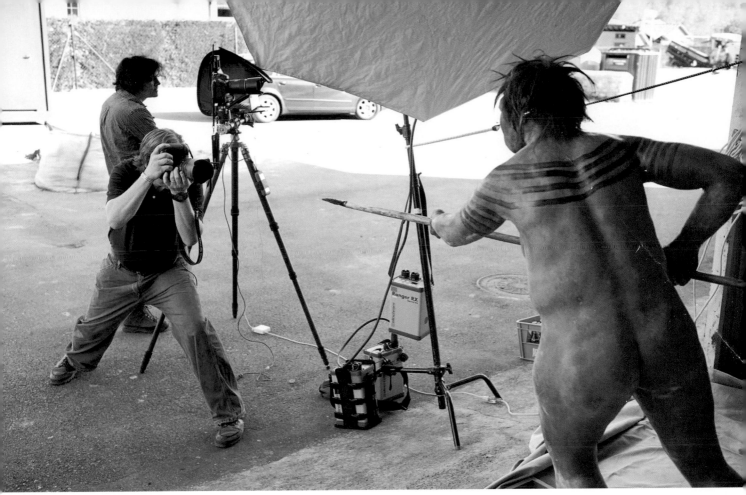

Brad Moore

Strong shadows for a tough face, hewn out of pre-history. Not too much pretty fill. The perfect reaction I could possibly get out of this picture would come many months later, when the cover would be on the newsstand and someone passing quickly does a double-take, one of those "Whaa'aat? Is she real?" moments where what they see provokes enough of a reaction and mystery to stop them and make them look.

 This is a very real and important point. When you shoot a picture and throw it out there into this visually saturated world, what are you asking of the potential viewers of your photo? Their time. You want them to spend time with your image, your

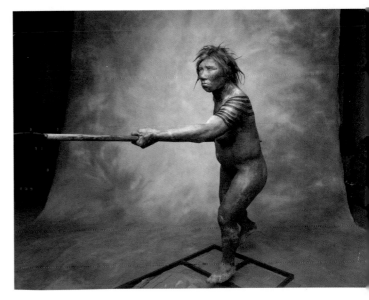

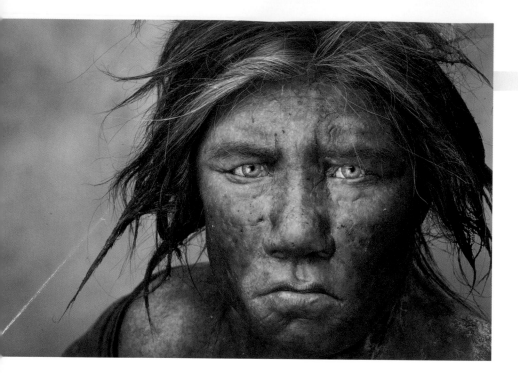

viewpoint, your take on something they have most likely already seen multiple times, and thus are not all that inclined to look at again. Unless, of course, you render it differently. You need to include some spark, quirk, nuance, or fillip of angle, light, charm, or information that separates your shot from the stampeding horde of pixels already out there. Face it, everybody's got enough diversions and competition for their precious time. If you present something different, and make them look, you've won more than half the battle.

Speaking of doing battle, back to Wilma with her spear. When using the big light only, as you can see, the results are simple and straightforward. The light drapes on Wilma in much the same way a big, soft window would on a cloudy day. A bit like a north light—directional, rich, and textured. (Though I doubt Wilma would have drawn the eye of many

of the famed Flemish painters who so effectively employed simple window light.)

Getting closer to her, though—shooting for opener/covers—is when I added the low light. It's just a hint, running at two full f-stops under my main softbox. You can see the catchlight of the lower strobe, and thus its positioning. It is placed under the main light and approaches from exactly the same direction, albeit at a lower angle. Kind of an over/under, clamshell lighting solution, off to the side and not on axis with the lens. Thus the cheek shadow remains but the eyes come more alive, which, I feel, is necessary for a close-up shot. It is from this series, and this light solution, that *Geographic* chose their cover and two-page opening spread for the story. Whew! I was very relieved when they liked it, 'cause I ain't much of a still life photographer, and essentially that's what Wilma

"You need to include some spark, quirk, nuance, or fillip of angle, light, charm, or information that separates your shot from the stampeding horde of pixels already out there."

was. Thankfully, I have an active imagination, and the gift of gab. In my head, I created roles for her to play, and imagined her very tough life. It helped make her seem more sympathetic, alive, and human, and thus easier to shoot.

Off to the woods! We trundled her, along with all the gear, into the area of the caves where the Neanderthal DNA had recently been discovered. We placed her near a rock wall, spitting distance from the mouth of what might have been her ancestor's domicile. This isn't available forest light. Really can't leave that to chance. Had to bring our own. The lighting strategy here is just about the polar opposite of the backdrop solution. Whereas for the "studio portrait" I brought a big Octa with a fill, fer chrissakes, here I put up a raw, small source, far away from my subject, and just blasted it.

As a location shooter, you often times have to let the location speak to you and inform your quality of light. True enough, sometimes you just override everything, slam dunk the ambient light condition, and create your own light. But most often that does not happen, as was the case here. I wasn't gonna light the whole bloody forest.

But you can mimic, bend, and augment the type of light you find in the forest, that kind of hard, dapple-y sunlight filtering around and through trees. To that end, I took a Ranger and ran the head up on the biggest stand and boom I had with me, getting it high in the air, which is where the sun was coming from.

Then I just blasted it at Wilma, and didn't like the results very much. It felt, well, too electric. I took the light down and put a diffuser over it. Traditionally, I would have used a sheet of "spun," which is what the movie guys refer to as an old-school diffuser. It used to be made out of spun fiberglass, hence the name. You can get pretty much the same results out of a gel type of diffuser, which I generically refer to as

"a piece of soft frost." Now, to a maestro of light—the way some lighting directors on movie sets truly are—this will sound like blasphemy, but you can get good, diffused results out of a piece of shower curtain material.

Ouch! As I said, some will cringe. There are nuances and niceties in the world of diffusion, and the resultant color casts that can result from one type or another. And there are many, many types. And just like so many things in this field—especially in the realm of gear and tech—there are folks for whom even suggesting they use an indiscriminate piece of whatever, or sharpen in Photoshop before curving in Photoshop, is downright fightin' words. Heads will roll!

Sigh. I think most freelance photogs tend to be in my camp, which is, use whatever works, even if it's your athletic socks. The point is, throwing that piece of diffuser over the light took the edge off of it, and made it more believable as loose-cannon sunshine knocking about in the forest. Wilma is strategically placed near a rock face and the light crosses her, forming a shadow over her, uh, parts. Wilma in the woods! And it's PG. (As you can see, I tried to help her out in the wardrobe department, but to no avail. Not her style.)

(Talk about using whatever. Note the pic of me using an Ezybox Hotshoe softbox as a viewing baffle for my computer. The Ezyview box, designed for this purpose, was forgotten. So we ripped out the diffusers from the softbox and popped it onto the computer. Worked well.)

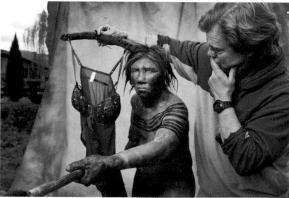

Brad Moore

"As a photojournalist, your radar has to be up and running all the time, and when I saw her, mine started pinging like crazy."

Then, I got fancy, but with good reason. We encountered the people who owned the land where all these Neanderthals once roamed. A modern-day Spanish farming family, and the lady of the house was a lovely, modern-day Spanish woman—with red hair. As a photojournalist, your radar has to be up and running all the time, and when I saw her, mine started pinging like crazy. Part of the story is the continuum: the history we are making now, and the pre-history that we have come through. Neanderthals, as it turns out, were very likely displaced by Homo sapiens, who were more aggressive and clever. The fact that we could perhaps relate the now and the then via Wilma and the woman who now presided over this land—both redheads—became a potentially powerful piece of the story.

First, we did a "safe shot." Something literal, explainable, and enjoyable for the reader. We set up the backdrop again, and made the production of the picture part of the picture. We showed our set, right there on the farmland, and put Marina, who currently lives there, on the backdrop with Wilma. Again, the light was simple and direct. One big Octa softbox, off to camera left. It filled the scene with light and allowed me some exposure control over the background.

That's what you're really doing when you light the foreground. You are formalizing it, to be sure, and making it look the way you want it to. But you are also introducing a powerful lever of control over the background. You can influence your up-front, foreground f-stop by how much flash power you unleash, and then, correspondingly, by dialing your shutter speeds up and down, you control how bright or dim the background becomes. In this case, I was blessed with a cloudy day, which was not difficult to tame. By minimally pumping flash at my characters, I was able to pull down the background enough that the clouds up in the sky looked like clouds, and not a giant, blaring highlight.

Brad Moore

The control that flash gives you out there in the unpredictable realm of location shooting became much more crucial on my next attempt to explain Wilma to the world we live in now. I had a notion to do an impromptu, in-camera double exposure, right there on the farm, with the pigs, the goats, the chickens, and my D3.

Digital technology makes this type of camera sleight-of-hand relatively easy, at least compared to the seat-of–the-pants stuff the iffiness of film imposed on shooters. Most high-end cameras nowadays have a feature where you can engineer a double or triple (or more) exposure inside the machine, and see it right then and there, on the LCD. Life amongst the pixels is good!

I thought that if I faced off Marina and Wilma together in profile, you could quite readily and profoundly see the differences in their

facial structure, depth of brow, and shape of chin and nose. In other words, how far we have come since that murky time, in terms of intelligence and refinement of our own personal infrastructure. (Well, some of us, anyway. Most photogs probably have a profile similar to Wilma.) This would be a challenge to shoot, but if successful, the effort could serve the reader well, and as a storyteller, the reader is the customer. Always remember that. It's not about us. It's not about how tough this was for us out there in the field. It's about what we come back with. Does it communicate?

Multiple-exposure photography is generally considered a denizen of the studio, a spawn of darkness and control. True enough. And there was no darkness or apparent control out there in that Spanish farm field. But there was a barn, and I had a black cloth. It was a start. And I had flash. Remember what I just said? That formalizing your foreground with flash can give you tremendous control over the background, and the ambient level of light? That premise was about to be tested.

What I needed to do here was completely dominate the available light. I had to blank out the effects of the sun. Happily, that was eminently possible because a) I had a couple of big power packs, and b) I was working very tight on my subjects' faces, such that I could move the lights driven by those packs very, very close to them. I created complete darkness in the foreground, and I shot into a black felt background up against the barn. Instant studio!

For this type of shot, symmetry is crucial, so I chose identical shoot-through umbrellas for each profile, and located them almost exactly at the same distance and angle to my subjects. The shoot-through aspects of the umbrellas gave me good softness and direction all at once, which resulted in immediate falloff on the camera sides of their faces, which is important in a double like this. You don't want conflicting strands of hair or the rimmed outline of the backs of heads to be discernible. It gets messy and gives away the game.

Naturally, you test this with your assistant as a stand-in. Brad Moore, who almost certainly has ancestral ties to Wilma, stood in.

Then, you do the real shot. I tried this a total of 10 times, and hit it on the tenth frame. Doing it was definitely a two-step, albeit not a fancy one. On each frame, I would program for two exposures. One

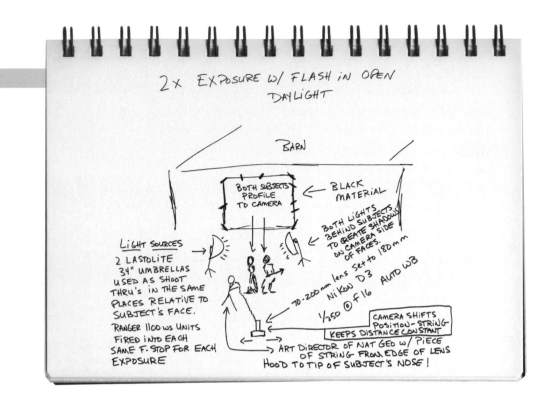

2x EXPOSURE W/ FLASH IN OPEN DAYLIGHT

BARN

BOTH SUBJECTS PROFILE TO CAMERA

← BLACK MATERIAL

BOTH LIGHTS BEHIND SUBJECTS TO CREATE SHADOW ON CAMERA SIDE OF FACES.

LIGHT SOURCES
2 LASTOLITE 34" UMBRELLAS USED AS SHOOT THRU's IN THE SAME PLACES RELATIVE TO SUBJECT'S FACE.

RANGER 1100 ws UNITS FIRED INTO EACH SAME F-STOP FOR EACH EXPOSURE

70-200 mm lens Set to 180mm
Nikon D3 AUTO WB
1/250 @ f 16

CAMERA SHIFTS POSITION- STRING KEEPS DISTANCE CONSTANT

→ ART DIRECTOR OF NAT GEO W/ PIECE OF STRING FROM EDGE OF LENS HOOD TO TIP OF SUBJECT'S NOSE!

pack would be shut off. (You want only one direction to the light. Both going off would light the backsides of the craniums of my folks, which again, would not be good.) So, here's the drill:

- Get the exposure right for each profile. This may not be exactly the same power rating for each pack. You'll most likely have to play with the levels.
- Program the double exposure in the camera menu.
- Power off one pack. Shoot one profile.
- Power down the pack you just shot, and power up the other. Shoot the other profile.

As a marker, when making the two shots, use single focus cursors and locate them on each subject's camera-side eye. With the camera framed vertically in this instance, I found one cursor that was compositionally comfortable resting on Wilma's eye. I then clicked over to the other side of the D3's focusing grid to find the matching cursor I could drop on Marina's eye. This process keeps the faces in register with each other, and at the same level in your frame.

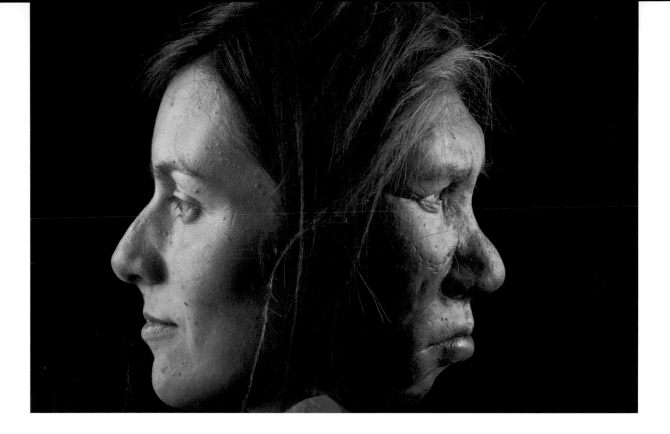

Also, get the art director of the *National Geographic* to waltz with you and your camera back and forth in a two-step shuffle between your subjects, all the while holding a string that's taped from the tip of the lens hood of your 70–200mm zoom to the tip of each of the subjects' respective noses. This makes sure you remain at the same distance to your subjects. (This particularly high caliber of assistant may be a little difficult to arrange for.)

On film, I would have easily shot a couple rolls—maybe 60, 70, 100 frames—most of them borne out of desperation and the sheer not-knowingness of it. With digital, 10 frames and done. The frame you see above came right out of the camera with no post-production. The image that leads this story has a little basic darkroom work. I had hopes this would be the cover, but alas, it remains unpublished. Till now!

The story of a cover story. Shot in three days, in Spain. I don't speak Spanish. Wilma doesn't speak at all. So we all chose the language of light, and had a quick conversation. At the end this shoot, as I watched Wilma get packed in bubble wrap and stuffed into the back of a van for her return to Holland, I admit I felt some pangs. Walter Mitty–like, I imagined myself togged out in trench coat and fedora, wind whipping away both my rakishly wrapped scarf and the exhaled smoke from my Tiparillo. "Don't worry, old girl," I'd say, "we'll always have Spain." The van doors close. □

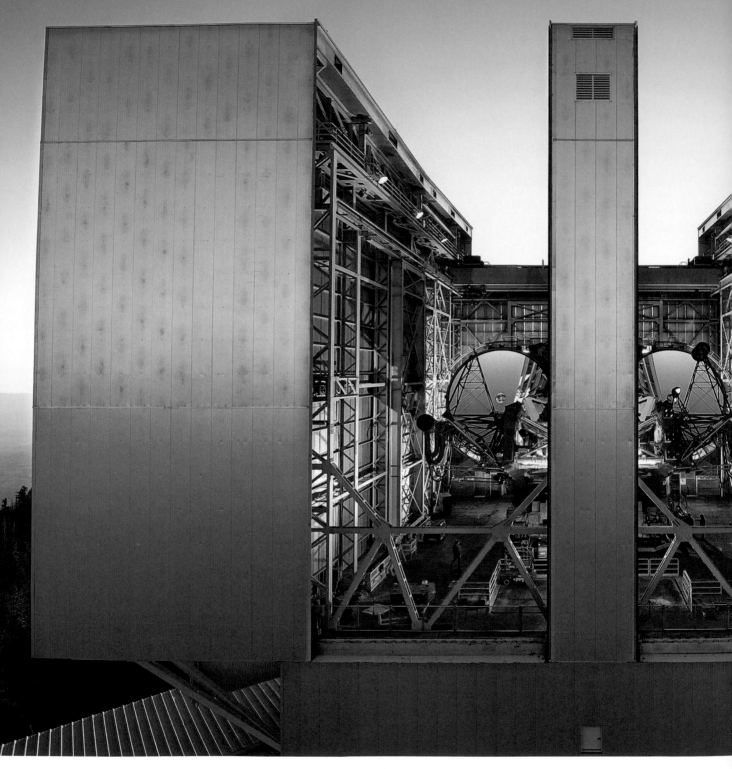

This Looks Hard, and It Is

A JOB OF THIS SIZE is all about confidence, really. It takes weeks to prepare for, and to think through. And it takes only a few short minutes to screw it up. And trust me, when you spend this much of *National Geographic*'s money on something, if you do, in fact, go off the rails, you will hear about it.

Having shot two major stories over the years for the yellow-border gang involving telescopes, I could reasonably put down on a resumé, "Good with large, strange-looking buildings on top of lonely, freezing-cold mountaintops." Bit of

a niche market, but with the photo biz being what it is nowadays, I'll take it. And as far as the afterworld goes, well, I'm sure to get to a higher place in heaven, 'cause shooting telescopes has got to be pretty close to being in purgatory.

The Large Binocular Telescope, or LBT, is indeed one of those strange buildings in the dark mountains. It's the equivalent of a 22-story structure, and it houses the world's largest ground-based telescope. It had "first light" (went operational) in October '05. Photographically, it was the lynchpin of the coverage that would update the magazine's take on these new behemoth scopes peering ever deeper into space. I had to figure out a way to shoot this thing.

First step is research. Find out as much as you can about what you're about to get into. The LBT

sits atop Mt. Graham in Arizona, which is inside a national park and smack dab inside a very sensitive endangered species zone. Evidently, the red squirrel likes to fornicate there. I can see why; it's a lovely spot. This poses problems, in that you need permits just to physically go up there and visit.

But visit I did. My first trip up, I was interested in just getting there, sizing it up, and, of course, shooting it. It's a binocular telescope, so visually the thing has great symmetry. I chose an angle up above the two mirrors and went to work lighting the interior. These big scopes nestle in a web of scaffolding and catwalks, which makes for handy platforms to stage lights that you can hide pretty easily. Charging up and down metal stairs and rung ladders with 2400 Ws power packs, heads, and a couple hundred feet of extension cord, at 11,000

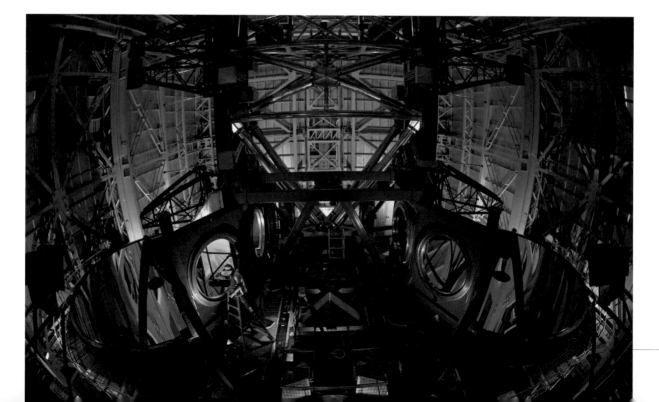

feet of altitude has its moments, obviously. But over the course of a very long day, we had this thing lit. I put a worker near the mirrors for scale, and he was very obliging. There's tons of light in this picture (opposite), on multiple stories of landings and ledges. It really doesn't bear discussing, because *Geographic* never published the photo. I knew they wouldn't while I was shooting it. I knew, right there, working my butt off on this shot, that the real picture was outside, and my camera position would somehow be in the air.

I delivered this take and my editor confirmed my suspicions by looking at me and saying, "You need to go back."

Okay, back to drilling through layers of permits and arrangements, which were considerable, as we brought up two truckloads of photo gear and a 175' boom crane truck. And, of course, now that everybody said yes, and we did all the prep work and signed all the documents, I had to actually go make a picture. I'd been there already and knew what I was getting into. And, fortuitously, I had identified the prime angle as being outside the scope, looking straight into its defining feature—the twin mirrors. That is the crucial step in every job, large or small: Figure out where to put the camera. Everything flows from that, particularly the lighting.

Scopes of this size are incredibly sensitive to light, and thus the slits remain closed until the edge of darkness. This put me on a rigorous timeline, and posed the essential difficulty of the job. I had to pre-light all day, without ever being able to test or even see what the effect of the light would be from the actual camera angle. I also had another timeline in my head. The huge mirrors of the scope would be looking right at me and my easterly vantage point. (I had the sunset sky directly behind the building.) That meant the mirrors were looking

into a rapidly darkening area of the sky. As soon as they went black, I had no more picture. The mirrors would just be holes in the frame. And the twin mirrors were the heart and soul of the scope, and the picture. Measuring 8.4 meters across, and acting in tandem, they're designed to bring deep space images down to earth with incredible detail. By comparison, my D3 was barely a point-and-shoot.

A principle I try to observe came into play here—don't light it, light around it. The lighting grid had to simply define the scope's massive superstructure inside this spaceship of a building. The lights also had to be hidden. Not too much of a problem, given the size of the beams and supports involved. One of the real easy things to figure out was the power rating for the lights. Full! Most of the packs were Elinchrom Digital RX 2400 units, each paired with a single head.

Many of the lights were tucked behind the telescope, 180 degrees from my eventual camera angle. There were several sets, or pairs of strobes, each positioned to radiate light around the mirrors, hitting the slightly reflective walls of the building. Each light going right had to have a light going left as well, creating symmetrical, equivalent highlights. This gaggle of strobes became the defining light, or the main light, even though it was at the back of the photo and didn't light the telescope, per se. This relatively huge pop of light was aimed at the walls. I gambled that the walls would then reflect and spread that light back into the chamber. The tougher lights to place, by far, were the accent or "kicker" lights. (When I say kicker, I basically mean a light that doesn't do much heavy lifting, but sparks an otherwise dead area of the photo. In this situation, my kickers were 2400 Ws packs and heads!)

These more frontal and filler lights on the camera side of the scope were the hardest to manage.

I had to put at least two hidden from camera behind the center post of the building, right in the middle of the photo. And they had to frontally light some of the structures supporting the mirrors, thus they had to ramp up, power-wise. As you can see in the shot that leads this story, a couple of low girders in the front of the scope are white-hot with exposure. Out there in the thickening darkness, blowing around in that bucket crane, I made the very quick, necessary decision to just let that set of highlights play. I couldn't really fix it, so I shot it. Thankfully, that blowout is right at the heart of the matter, an area that is bright to begin with, and pulls attention into the area of the scopes. (At least that's what I told the editors—wink, wink.)

There's another set of lights to the far left and right of the structure, tucked in close to the walls and bouncing off of them, pretty weakly, just to define the edges of the space. All this was

configured on the ground, before I headed up into the airspace outside the slits. That's when the real mayhem on this job occurred—when I boomed 175' up into the sky. Mt. Graham is just shy of 11,000 feet, and the crane at max extension has a wind tolerance of 25mph, which we flirted with all night. That bucket was rocking and rolling up there, and the boom was doing a corresponding shimmy. It really picked up the pace when it got dark enough to open the huge doors behind the mirrors. The building had been a bit of a wind blocker, and when those doors opened, it created two funnels of air coming straight at me. The first gusts pushed the whole bucket up and backwards. From that point on, it was yo-yo time up there in the night sky.

As dusk closed in, I did some fast talking on the radio, and the crew of three on the ground did some fast moving. When I finally got in position for a test shot, I realized about half the setup had

to be moved, if only slightly, but very, very quickly. Adjustments in power were made literally on the fly and I had to use my LCD to make the judgment calls on the power of the packs. Not too long ago, I would have been up there with a flash spot meter, but I've gotten away from using handheld meters.

Luckily I got a frame, and called it quits at darkness. I descended, and the four of us then engaged in the real joy of photography—packing up. We had to get out of there, 'cause we were driving the whole deal to California for the next stop on our celestial tour. We drove the trucks down the switchbacks at around 3 a.m., just a couple hours shy of 24 hours from the time we'd gathered to drive them up. Another day inside the land of the yellow border.

The job was wacked, scale-wise, but lots of photo basics applied. Research—know what you're getting into. Identify the camera angle. Huge. Everything flows from that. Pre-visualize the light. The shot came close to what I had in my head. Quick prayer to St. Jude (patron saint of lost causes, and therefore, photographers), and get in the bucket. Stay calm, even when it looks like hell at first. Move the pieces with logic, and correct each offending piece in turn. In other words, don't start moving everything at once. Concentrate on the big mistakes, and hope people don't notice the small ones. Convince the editors that your gaffes represent aesthetic intent. Get off the crane before the wind knocks you and the bucket off the mountaintop.

It was a keeper, and a one-of-a-kind picture that no one will get again. Nobody did a wild dance of gratitude back at the magazine, lining the halls and shouting, "Huzzah, he comes back from the wilds with a prize!" Nor did they gather around a simulated campfire in the cafeteria to listen to accounts of stirring, wind-whipped adventures atop the

mighty mountain. (They just do that for Harvey and McCurry.) They simply said thank you, perhaps we'll call again. Which is cool. I like dropping off a picture no one has seen before at the magazine that thinks it's seen everything.

Believe it or not, the same principles used for that shot on the mountain applied equally on a rooftop in NYC using a slew of Speedlights. It was a repeat, really, of my thinking in that bucket. Where's the camera go? What's the right angle for the subject? Then, figure out the light, step by step. And, there were a lot of steps. It doesn't matter if they're big or small.

I'm basically putting this shot in the book because I used 14 Speedlights. This will give ample fodder to those who decry such excessive practices, and cry out that it's a bogus approach that could be done more efficiently with a reasonable number of bigger flashes. Or one camera, one lens, and high ISO.

Indeed. I've mentioned more than once in this book that there are, in fact, many ways to approach any picture, and that has always been true. Given the populous nature of this industry and the multiplicity of technical options, there are now surely many, many, many ways to do just about any photo. Which is cool. You could substitute a few big flashes for 13 Speedlights any time. Using big lights, you could do this picture with less heartache and fuss, actually.

But I did it this way. It was a self-assignment. No one paid me to do this photo. I paid the ballerina, the makeup artist, and the assistants out of my pocket. (A case of nice wine was the location fee.)

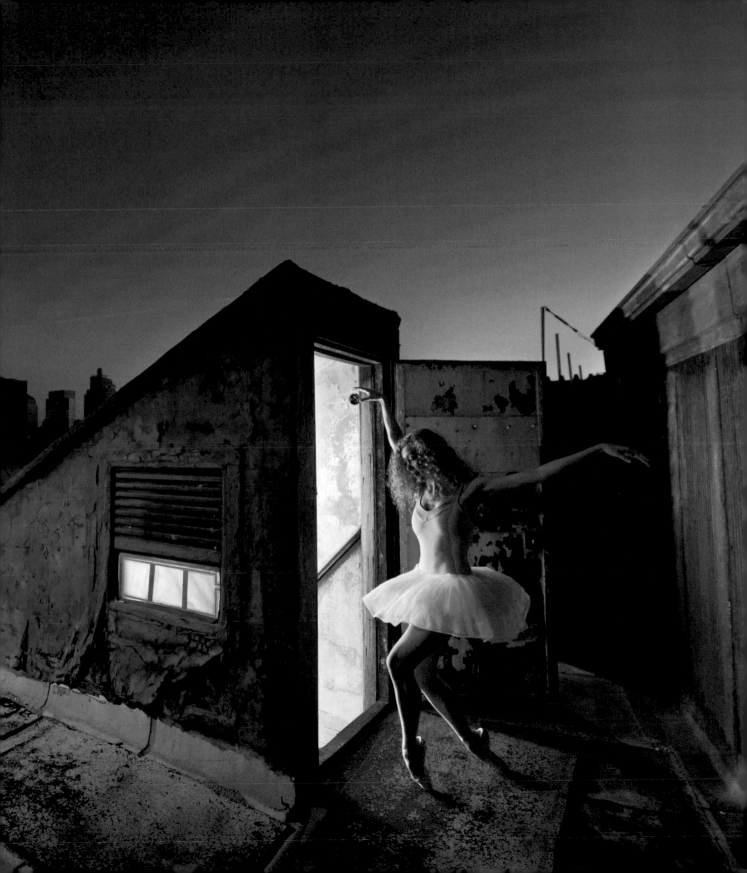

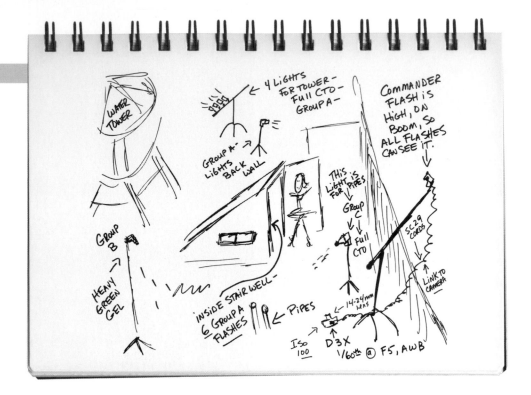

And I pushed myself to see if I could make this work using a bunch of the ragtag, very used Speedlights I have accumulated over a lifetime of wondering about whether I could do a certain picture or not. It was cool. It was fun. It almost didn't work.

But that's okay. I'd rather be out on a roof in the mix, feeling the breeze, looking at NY a few stories down, courting disaster and risking failure than in the studio with an umbrella to camera left, 10 feet from the subject. You know, the same place I had it yesterday—and last week, and the week before that.

The whole thing started when I saw the door to this roof, which was about a year before I got around to shooting this. Most rational, right-minded folks would look at it and say, "There's the door to the roof." I looked at it and said, "Main light." Everything built from there. I put six SB-900s in that stairwell. Yep, six. Reason being, they are facing away from the ballerina, into a white angled ceiling,

and a piece of foam core at the bottom of the short flight of steps. I wanted that stairwell to become a huge, glow-y softbox that my performer subject would step into, much as she steps into the foot-lights on stage.

And once she was that well lit, which basically matched the sky, everything else up there but the sky went dark. And needed to be flashed. I'll take it by steps.

The water tower has four flashes firing up at it. Just raw lights, no diffusers, zoomed to 200mm, gelled with full CTOs. Those lights pop the tower with a warm glow against the cool blue sky.

The foreground tar paper was just black. It needed defining. What about green? The spectrum of nighttime color on the streets of any big city is often greenish. I slapped a green gel on one flash, and ran it up high on a stand like a street light. No diffuser, no finesse. It just banged straight down

from the top of a 14' stand right into the black, black surface of the roof.

Those pipes to camera left. They have a function in the old building, so I couldn't just chainsaw them down. Instead, I lit them. One flash, tightened with a Honl Speed Grid, and colored with a full cut of CTO. Just a little warm rim of light on those twin columns of rusted metal.

Behind the ballerina's door. All that was blackness. So, two more lights went back there, behind the angled shape of the stairwell, firing towards the corrugated wall at her back. It brought a little detail out in that very dim area.

Truth be told, I would have popped another subtle light off her hair, if I had my druthers, but I ran out of Speedlights. (Yes, you heard it here first.)

The whole shebang is being driven by the commander flash, which is linked to the camera via three SC-29 cords and positioned on the end of a mini-boom on a C-stand to the immediate right of camera, and up high. Thus it can see all the lights, and they can see it.

Other details? See the little port window in the staircase wall? That had gone nuclear with all the light inside the stairwell, so I softened it by taping a TriGrip to the wall and then lining that with some neutral density gel, to take the intensity down further.

The lady in the stair light is Callie, by the way, who I shot for the cover of *Pointe* magazine some years ago. Grown up a bit now, and still a wonderful dancer. (She was also in *The Hot Shoe Diaries*. I stay in touch with people.)

Top of a roof, top of a mountain. A person, a building. Small lights, big lights. The shutter speeds and f-stops are different. The scale of the job changes. The lessons don't. □

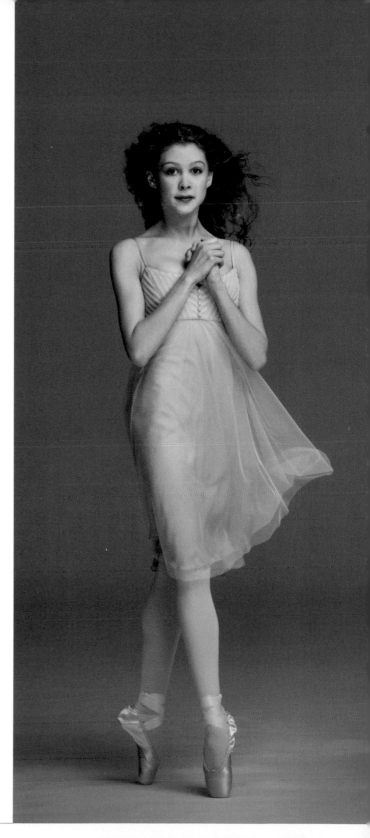

This Just In...

AS THIS BOOK WAS CLOSING, I got a call from the yellow and black shop in Melville, Long Island. "Uh, Joe, do you have any time available in the next few days?"

As a freelance shooter, you always pick up the phone, and your answer to that question is almost always yes, even if you don't really have any time in the next few days. You'll make some, find some, or manufacture some, somehow. Sleep is overrated, and as grandma used to say, you're dead a long time.

Seems they just got shipped a new flash and, as can happen with ultra-new gear just off the line, there were no pictures that had been shot with it. So, they were kind of like, "Cool! You got some time! Awesome! We need four pictures by Monday!"

As I recall, it was Sunday night. Or something like that.

So, this new flash. Astonishing. Groundbreaking. It's a monster. It sits in your camera bag, creaking and rumbling like the tank coming up the street at the end of *Saving Private Ryan*. When you deploy it—and trust me, you deploy it—you don't just use it; it totally changes the game and levels the playing field. The pre-flash is now not only a communication and information-gathering device, it has stun-gun technology incorporated into it. You make one test frame of your subject, and they lapse into a tractable stupor. Your promised three minutes with the bank president thus becomes two hours, should you wish.

It's metallic cherry red, and it has the ability to disengage from the hot shoe and hover. It operates on 30 AA batteries, but can also be hooked up to a series of 2000-kilowatt generators that follow you around on a flatbed rail car, which admittedly limits its portability but gives it the light power of an anti-aircraft searchlight.

It's also a walkie-talkie. And a phone. And, if you get the designer edition, with the camo canvas tote bag and the rhinestone toggle buttons, it has a Starbucks finder app.

It does none of the above.

In fact, it does the same thing its predecessor, the SB-900, does. It's the same old reliable (smile) TTL technology. It looks the same, too.

But it does have a few tweaks that are pretty cool. Tweaks, of course, are not a redesign, or an overhaul, or a revolution. They're tweaks. That's why this unit is not called the Nikon Avenger F12 Flash of the Future. It's called—drumroll, please—the SB-910!

Oh, those wild and wacky engineers.

Okay, so what's cool? Well, you may have heard the SB-900 can have a tendency to overheat. True enough. From the limited amount I know of the electronics of these things, the 900 is designed to recycle quickly, which can lead to heat buildup. Those engineers, being their blessedly clinical selves, incorporated safety features and gauges into the 900 that were meant to save the unit from turning into a hot shoe version of a frying pan.

With the way I push my flashes, I was always triggering the thermal cutoff, so I shut that down in all of my 900s. Which meant I did, in fact, burn up a couple over time. I've melted gels on the flash head, and I actually deep-fried one unit so badly the lens element went all solid and milky, as opposed to clear and crystalline.

So, the SB-910 is a substantial improvement in the area of overheating. It has no thermal cutoff. They just apparently manage the heat better, by

borrowing technology developed in the SB-700. (Please understand this: I'm not a Nikon engineer, and have no inside information on the electronics or the specifics of these units. At this writing, I've used them in the field for three days.)

During my recent, brief stint with a few of the 910 units, I pushed them pretty hard, at full power. They managed really well. This is not an endorsement or a guarantee. But I was very, very pleased. I pushed them into a zone where the SB-900 would have complained—loudly.

Couple other cool things. They are slightly sleeker, with some minor body alterations. The battery chamber has a push-down locking mechanism. They have clip-on gel holders that are actually themselves a color conversion gel. So, in the realm of fluorescent and tungsten color correction, no more "taping on the gel, coach!" These just snap onto the head. Very cool. The buttons are backlit, and easily readable. A few functions, such as the zoom, are managed by a button in a different location, which is a design thing that is consistent with the 700. Where the zoom button was on the 900, there is now a dedicated menu button. Okay. Is that better? Dunno. Just a new configuration to get used to, but it does seem a touch easier.

The On/Off/Remote/Master switch is slightly broader and bigger, but the lock button in the middle—at least in these initial samples—has to *really* be pushed in to change modes. Means I'm going to have to work on my one-thumb push-and-turn maneuver.

That's it. Tweaks, the most significant of which, for folks who use the flashes heavily, is obviously in the area of heat management.

I took these four flashes into a studio, a bar, a boiler room, and the streets of Brooklyn. Let's take a look.

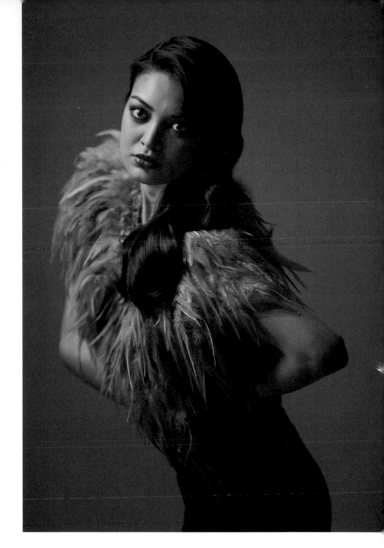

THE STUDIO

I tried two things—one simple, and one with a touch of complexity. In the feathery fashion shot, I put three SB-910s on a TriFlash and pumped them collectively into one of the new Lastolite 8-in-1 umbrellas, which has a Velcro port in the middle of the opaque backing. This creates something like a 2x2' softbox, basically. It's a strong, directional shoot-through light, but it's also contained by the substantial swatch of material around the edges of the 40" brolly. It collects the light in a concentrated but lustrous way right where you want it.

In this case, it was a good solution because I wanted the light to stay around her head and plumed shoulders, and not spread overmuch to the background. I let the camera ride on auto white balance, because the white studio wall in the distance took on a lovely warm tone, which complemented the fashion up front in the frame. The finals here read back as 1/250th at f/2 with a 200mm lens, and the three flashes set to manual at 1/32nd power. The three of them gave me wonderful coverage of that center window in the umbrella, and enabled me to run them at low power. Low power equals fast recycle, and when you have a model like Jasmine—who seemingly every second is rotating into ever more beautiful poses and looks—you are desperate to keep up.

Simple enough. On the next set, which does in fact look more complex, I actually used fewer flashes. There's an overhead main SB-910, zoomed to 200mm, and pushing through a Flashpoint beauty dish that's fitted with a tight grid spot. This Group A light is what is sparking her face—popping it, really—and lighting her very dark, au courant eye treatment. It's maxed—manual 1/1, full power. The skip off the floor is, well, the skip off the floor. It's in Group B, running on manual, 1/16th power.

That's it. That's all the flash. The rest of the drama comes from two steady light sources in the background, a smoke machine, and a wind machine. At 1/60th at f/5.6, the ends of her hair take off in the wind, just a touch, and the hot spotlights from the background not only provide rim light

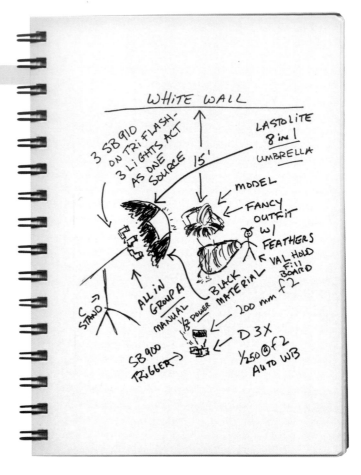

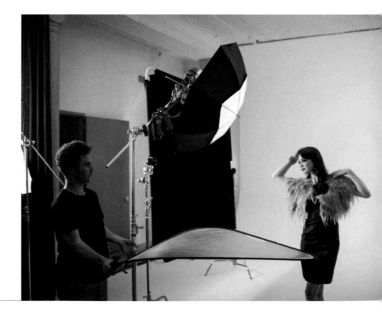

for her, but they also take on a bit of shape in the smokiness. Anytime you want light to show shape, it basically has to hit some sort of particulate matter in the air.

Jasmine's out there in the wind and the smoke, with dramatic backlights. But the only things going on for the foreground light are two simple Speed-lights. Main and a bounce fill.

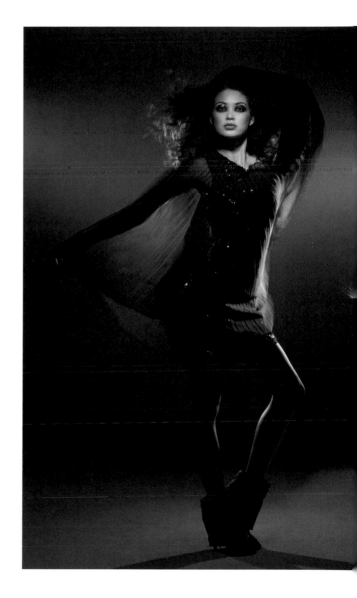

WHITE WALL

← STEADY → LIGHT SOURCES - NOT FLASH

GROUP A SB 910 MANUAL ⅛ (FULL POWER)

HAZER SMOKE MACHINE WITH GRID

FLASH POINT BEAUTY DISH

WIND MACHINE

THIS IS HARD LIGHT OVER HEAD OF MODEL

GROUP B BOUNCE DOWN MANUAL 1/16th POWER

SILVER REFLECTOR SHEET

ISO 400
1/60 @ 5.6 AWB

← 70-200 mm
← D3X
MANUAL MODE

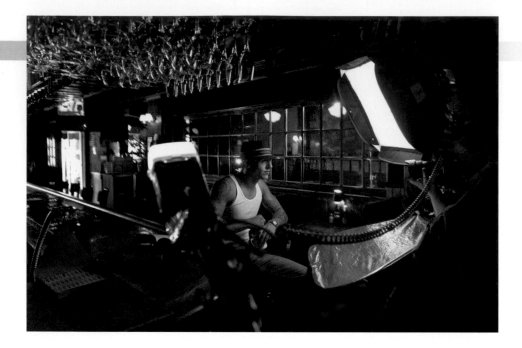

THE BAR

Why is it that I intuitively know how to light a bar so well? What does that say about me? Hmmm....

Best not to speculate. Jake, my coffee-drinking subject, is a great guy, with a rakish, wonderful look. I sat him at the bar, and then just lit around him. Your subject is the center of gravity in the picture. All your efforts to light the image revolve around what's necessary to show the reader his—the subject's—world.

Main light first. Easy, as in Ezybox Hotshoe softbox. Twenty-four incher, white interior. Shaped, but soft, and forgiving enough to just squeak some detail under the brim of that hat. Bring in a TriFlip as a warm, reflective fill board. Done—for the subject.

Why go to a bar and then not show the environment? Locations have power. They complement and set the stage for the subject. I'll discuss the lighting in the order of the physical areas that I felt were most important to light.

Behind the bar. I needed to show it, so I put two 910s on Justin clamps up behind the racks of wine bottles and glasses, with their dome diffusers on, bouncing up into the old wooden ceiling over the bar area. They are both sporting the tungsten clip-on plastic gel holders that are a new wrinkle of the 910, but I also slid another one of my regular CTO gels in there behind the clip-on. Why?

My camera was set to incandescent white balance. I made this move mostly because I wanted any highlights traveling through the doors and windows from the street to be cool and bluish. I thought that blue look would work well, and vibrate with the warm tones of this ancient, wooden pub.

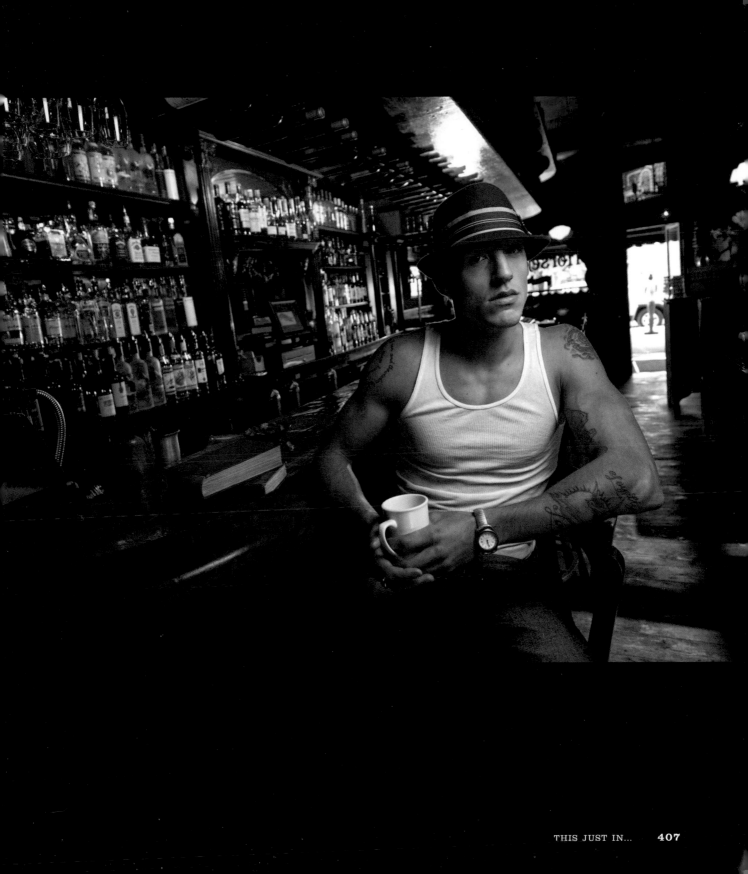

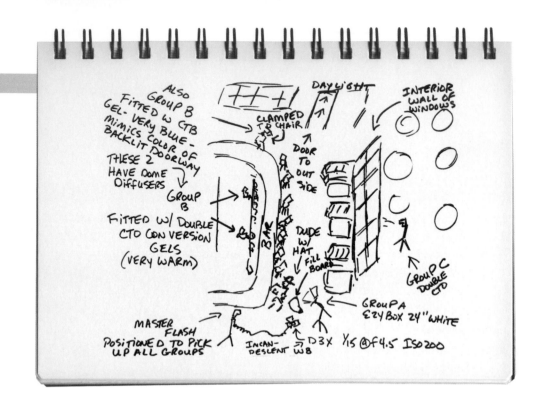

ALSO
GROUP B
FITTED W CTB
GEL - VERY BLUE -
MIMICS COLOR OF
BACKLIT DOORWAY

DAYLIGHT

INTERIOR
WALL OF
WINDOWS

THESE 2
HAVE DOME
DIFFUSERS

CLAMPED
TO CHAIR

DOOR
TO
OUT
SIDE

GROUP
B

FITTED W/ DOUBLE
CTO CONVERSION
GELS
(VERY WARM)

BAR

DUDE
W/
HAT
FILL
BOARD

GROUP C
DOUBLE
CTO

MASTER
FLASH
POSITIONED TO PICK
UP ALL GROUPS

INCAN-
DESCENT
WB

D3X ⅟₁₅ @ F4.5 ISO200

GROUP A
EZY BOX 24" WHITE

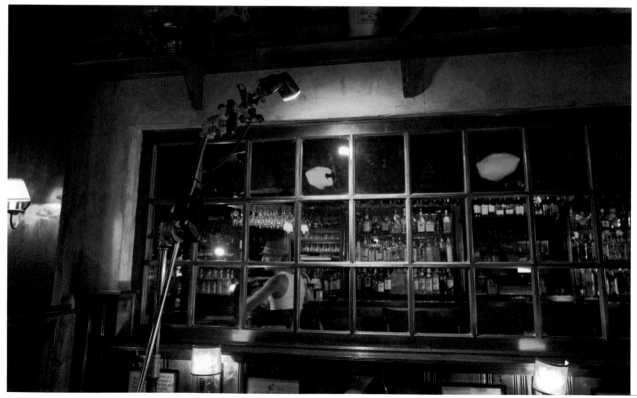

> "Why go to a bar and then not show the environment? Locations have power. They complement and set the stage for the subject."

Given that white balance setting, just one gel would not do. The light would simply be "normal" for incandescent. Neutral, in other words, and not golden warm like I wanted. Hence, the double gel. Two full cuts of CTO, or color temperature orange (some folks like to say "convert to orange"), pulled the bar behind him back into a pleasing warm tone.

I still wanted to amp up the blue feel, but locally, in an isolated way. Blue tones from the sidewalk daylight were faintly reading into the exposure, but not dramatically so. My answer here was to take another 910, gel this one blue, and clamp it to a bar stool, firing right into the back of my subject. Somewhat unexpectedly, that light put a nice, flaring highlight off the wood above the bar and Jake. It looked, well, cool. (Even more so because of the blue gel. It was already cool in appearance because it had no warming gel on it, and the naked Speedlight, balanced for daylight, fired into an incandescent white balance environment is already going to read bluish. My placement of the blue gel just amps up the cool factor.)

The last light I put up was a warm-toned light, again with two gels, in the other room of the establishment (the dining room). It fires through an interior window that separates the bar and the restaurant areas. It's simply a raw light with no diffuser, zoomed to a middle ground of about 35mm. It sprays across the floor on camera right, and gives me detail and separation down there in what would have been a very dark area of the picture.

How do you trigger this whole mess in TTL with a commander? By placing that commander in a remote position from the camera angle, via SC-29 cords linked together. The commander, as you can see in the sketch, is off to camera left, and from there it can easily see all the lights in the room. If I had left it on the hot shoe of the camera, there's no way that master flash would have fired all those remotes in the different dark areas of the bar.

THE BOILER ROOM

Bleu in the basement! I always take folks to the nicest places!

Let's take it from the back of the boiler room forward. I knew I needed light in that black hole back there, so I put up two steady sources—daylight-balanced 1K lights, which I rented. They provide a steady, dramatic stream of illumination back there.

The thing is, even though those lights are big and bulky, their output, relative to a still camera, is not overpoweringly bright. So I put up two 910 units back there, on either side of the boiler, in Group C. Their position is not all that deep into the chamber because they still need to see the commander flash, which I placed high on a stand, just to the right of the camera angle. This placement triggered both lights, and those tiny Speedlights are the ones really pumping the level of f-stop back there, not so much their much bigger, heavier cousins, the 1K lights.

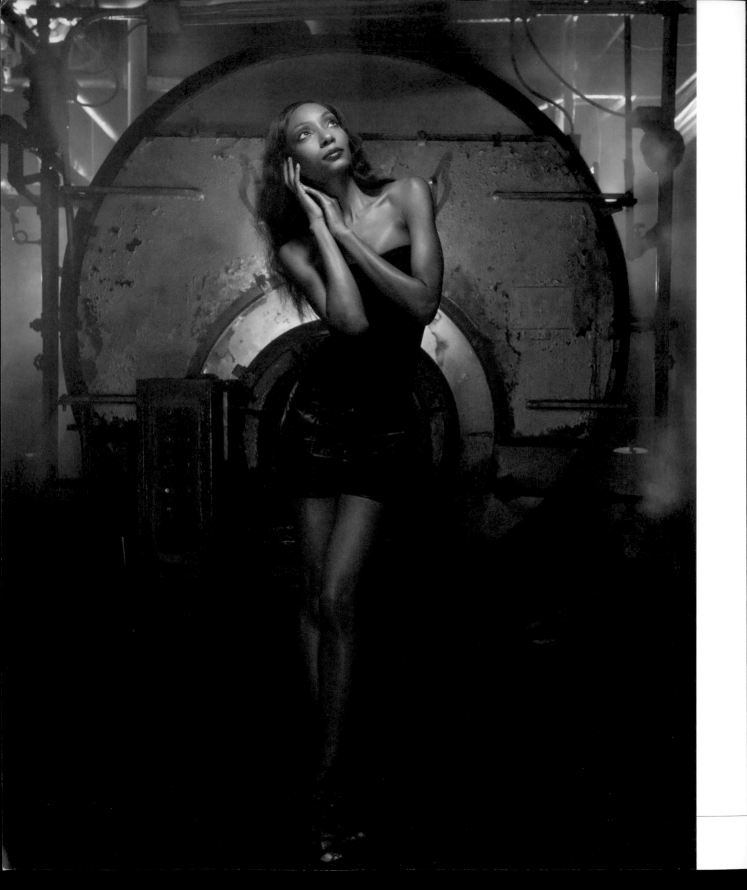

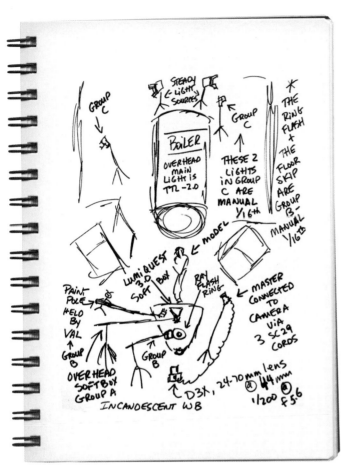

Handwritten lighting diagram:

GROUP C

STEADY ℓ LIGHT SOURCES

GROUP C

★ THE RING FLASH + THE FLOOR SKIP ARE GROUP B- MANUAL 1/16th

BOILER
OVERHEAD MAIN LIGHT IS TTL -2.0

THESE 2 LIGHTS IN GROUP C ARE MANUAL 1/16th

LUMIQUEST 3.0 SOFT BOX

MODEL

RAY FLASH RING

← MASTER CONNECTED TO CAMERA VIA 3 SC29 CORDS

PAINT POLE HELD BY VAL

GROUP B

GROUP B

OVERHEAD SOFTBOX GROUP A

INCANDESCENT WB

D3X, 24-70 mm lens Ⓐ 44 mm Ⓑ 1/200 f 5.6

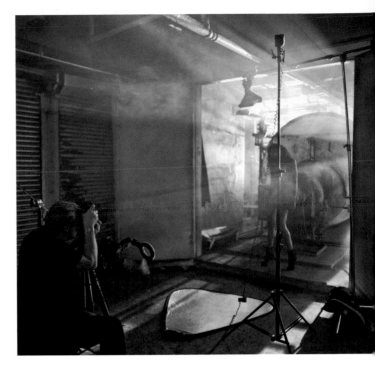

Up front, I remained in classic beauty light mode. There's a simple LumiQuest SoftBox III overhead of Bleu, and then, lower, a ring flash fill. Even with this combo, I still felt that I was losing too much detail in her legs, so I took another 910 and bounced it downwards into a reflective TriGrip. The frontal lights are all in the middle, nothing off to the side. Very symmetrically placed, matching up with the lens placement.

The trio of lights needs to be played with, in terms of power. There is one other 910 in the picture—kind of a luxury item—back behind Bleu, producing that warm highlight on the face of the boiler. If the foreground lights for her have too much power, they'll blow that light away. So everything for her has to be modulated and controlled so they don't blow everywhere and cause a mess. That's why, for instance, there are about two or three inches of gaffer tape around the edges of the little LumiQuest softbox. That homemade edge baffle helps control the spill of that already small light source.

The white balance here is incandescent, which means I once again played the game known as multiple gels. The interior chamber goes alien blue, and then I mixed and matched my gels with the full CTO 910 clip-on gel to get a good skin tone for my subject. Similar to the bar, lighting a scene like this is like figuring out a puzzle. You try different shapes and pieces until you finally fill in the dark spaces you need to. There's no blueprint for "small flash boiler room lighting." You just have to feel your way to a picture, down there in the steam.

ON THE STREET

Jonathan has a wonderful, physical style made for simple, run-and-gun shooting. For the most part, out there in Red Hook, in Brooklyn, I used one Speedlight.

To pin him to the yellow wall for the shot that leads this story, I used one SB-910 unit, linked to an SD-9 battery pack. I generally don't like to create multiple shadows, which is what the combo of the sun and the flash gave me, but I liked it. When he went up, and his legs flew out, and his mixed shadows played off the wall behind him, I saw a vibration I liked, which of course was a total accident. I didn't plan to see this building, in that particular light.

Then, of course, I had to get fancy. Jonathan can basically run up and down the sides of buildings, so I found some open shade, and some symmetrical columns, and asked him what he could do with them. His response was to basically become a smiling, exuberant Superman. It was such a soaring move, I didn't want to waste it.

Which, initially, is what I was doing by trying to use one hard flash. I was lighting him alright, but also spotlighting the building in an unattractive way. I almost was about to reluctantly drag out an umbrella, until I spied this parked white truck. Hmmm.

We put a TriFlash on a Shur-Line paint pole and bounced three flash heads up and into the side of the truck. Jonathan leaped into a big, impromptu wall of light. ISO 200, 1/250th at f/4. All three flashes in Group A, running on manual, at ¼ power. D3X, cloudy white balance, 70–200mm lens zoomed at 80mm.

You know you're in an amazing business when your day consists of taking pictures of someone flying through the air, lending physical reality to your imagination. When you're actually doing your job by making pictures of someone jumping off the sides of a building that you found by accident—when you made a wrong turn down a city block. And when the light you create comes from a battered truck that was parked in the right place.

Photography. It's a strange and wonderful thing to do. □

Index

A

all-in-one umbrella, 18, 19
ambient light, 48, 321, 329, 366–367
Aperture Priority mode, 212, 345, 347
Archbishop portrait, 316, 317–320
assignments
 offers for, 34–39, 401
 self-, 306–308, 310, 396
assistants, 57, 334, 359
available light, 23, 150, 344

B

background lights, 105, 108, 320
backlighting subjects, 290–295
ballerinas
 forest, 248–249
 Iceland, 59–63, 68–71
 rooftop, 396–399
 Venice, 148–151
 See also dancers
bar photo, 30–31, 406–409
"bare bulb" feeling, 119
beauty dish, 14, 16, 65, 155, 158, 215
bed sheets, 97–98, 323
bicycle lights, 334, 337
big flash
 examples of using, 315–325
 large spaces and, 290–293
 multiple flashes vs., 32–33, 67, 78
black room, 334, 337, 338
Blake, Donald, 304
blended exposure, 106
blue gel, 166, 409
boiler room photo, 409–411
bounce light, 321, 323–324, 359
bounce position of flash, 145
bracket, TriFlash, 74–75, 77, 79, 200, 294, 413
Bulb setting, 334, 336, 337

C

cable release, 336
Cali, Michael, 163
cameras
 film era for, 270–275
 staying prepared with, 351
 See also digital cameras
catchlight, preflash, 7, 8
character portraits, 164–169
clamshell lighting, 21, 380
cloudy white balance, 262, 369
color balance, 277–278, 322
 See also white balance
commander units, 8, 98, 399
composition, rules of, 324
compromise, art of, 44
Connery, Sean, 298, 356
corporate annuals, 65
C-stand, 23, 70, 285
CTO gel, 211, 260, 319, 399, 406, 409

D

dancers
 break dancer shots, 326–331
 dry lake bed scene, 308–309
 light streaks image, 333–337
 See also ballerinas
dawn light, 368–369
daylight white balance, 280–281, 322
Dean, Deidre, 303–304, 310–312
Deep Octa softbox, 47, 49–50, 315, 317, 322
Dempsey, Jack, 191
depth of field, 64, 202, 336
diffuser dome, 14–16, 319
diffuser panels, 117, 247
diffusing light
 bed sheets for, 97–98, 323
 diffuser dome for, 14–16
 multiple lights for, 32–33
 shower curtain material for, 382
 TriGrip diffuser for, 90, 118, 312, 412
 umbrellas for, 16–22
digital cameras
 double exposures with, 386–387
 LCD display on, 50, 79, 175, 183, 395
 new technology of, 275–279, 346–347
 white balance settings, 279–281
direction of light, 67, 323
dirty windows, 100–101
dispersion of light, 137
double exposures, 386–389

E

edge baffles, 251, 317
egg crates, 251
Eisenhower, Mamie, 266–267
Elinchrom
 Deep Octa softbox, 47, 49–50, 315, 317, 322
 Digital RX 2400 unit, 393
 Octa 74" softbox, 114–115, 127, 378
 Quadra unit, 50, 68, 248, 254, 315, 373
Erlendsson, Einar, 55
EV adjustments, 212–213, 345, 360
event photography, 139–145
Ezybox Hotshoe softbox, 25, 62, 105, 158, 382, 406
Ezybox Speed-Lite, 345

F

faces
 finding to shoot, 180–182, 187
 reexamining possibilities in, 304
 ways of lighting, 253–263
far-away flash, 136–137
farmer photos, 76–83

feathering flash heads, 248
Feherty, Dave, 143–145
fill light, 106, 107, 160
film photography, 270–275
filters
 magenta, 281
 neutral density, 202
firefighter portrait, 315, 316, 321–322
fireworks photo, 355–356
flash
 bounce position, 145
 duration of, 70
 far-away, 136–137
 handheld, 5–6
 high-speed, 65–66, 205–215
 limits of TTL, 2, 31
 natural-looking, 347–348
 overheating issues, 402
 pop-up, 7, 8
 power setting, 66
 ring, 220–225, 257–260
 straight, 5, 217–225
 sunlight with, 132–137
 zooming, 148, 218, 219–220
Flashpoint
 beauty dish, 14, 65, 215
 snooted grid, 174–175
Flex/Minis, 57–58, 95, 235, 236–237
floor bounce light, 359–360
fluorescent conversion gel, 281
fluorescent lights, 172, 174
fluorescent white balance, 279
foreground lighting, 105–106, 385
front curtain sync, 335
frosted glass, 85, 88, 97
f-stop
 high-speed sync and, 66
 ring flash and, 258

G
gaffer tape, 109, 281, 411
Gallico, Paul, 191
gels
 blue, 166, 409
 CTO, 211, 260, 319, 399, 406, 409
 fluorescent conversion, 281

power and color of, 161
 warming, 100, 148, 211, 316, 320, 321
Gitzo tripods, 45
glass
 frosted, 85, 88, 97
 wire, 98–100
gobos, 109, 119, 285
grid spot, 328–329, 399

H
hair, blowing, 122–123, 375, 404
handheld flash, 5–6
handheld light meter, 78–79, 274, 395
hard light, 129–130, 135–136, 328
HDR photography, 368
helpers, 345
high key shots, 223
high-speed sync, 65–66, 205–215
Hines, Gregory, 44–45
Hodges, Joe, 353–354, 357–359
Honl
 honeycomb grid spot, 399
 Speed Gobo, 109, 119
Hoodman loupe, 183
Horseshoe Canyon, 284–287

I
Iceland photos, 46–83
 ballerina in field, 68–71
 bikini model on boat, 51–54
 farmer in barn, 76–83
 model on volcanic rocks, 46–50
 thermal plant ballerina, 59–63
 Viking character, 55–58
incandescent white balance, 211, 411
indirect softbox, 68, 111, 114, 127, 129
industrial light, 171–175
IR shield, 8
ISO settings
 frenzied conditions and, 343
 high-speed sync and, 66
 portraits and, 322–323

J
job offers, 34–39, 401
journalism, 298
judgment calls, 213
Justin clamps, 86, 235, 285

K
Kelby, Scott, 269
Kennedy, Tom, 40
Kloskowski, Matt, 281

L
Large Binocular Telescope (LBT), 392–395
Lastolite
 all-in-one umbrella, 18, 19
 Ezybox Hotshoe softbox, 25, 62, 105, 158, 382, 406
 Ezybox Speed-Lite, 345
 Skylite diffuser panels, 117, 247
 TriFlash unit, 74–75, 77, 79, 200, 294, 413
 TriFlip reflector, 21, 27, 156, 211, 406
 TriGrip diffuser, 90, 118, 312, 412
 TriGrip reflector, 27–29, 111, 202
LCD display, 50, 79, 175, 183, 395
lens flare, 293
Life magazine, 191–197, 298–301
light
 ambient, 48, 321, 329, 366–367
 available, 23, 150, 344
 bounce, 321, 323–324, 359
 closeness of, 10, 12, 20
 dawn, 368–369
 diffusing, 16–22, 32–33
 direction of, 67, 323
 dispersion of, 137
 extremes of, 351
 fill, 106, 107, 160
 hard, 129–130, 135–136, 328
 industrial, 171–175
 natural, 47–48
 off-camera, 348
 quality of, 6, 10, 200, 348

light (continued)
 shape of, 244–251
 softening, 10–14, 20
 wall, 111–123
 window, 85–86, 97–101, 237, 239
 writing with, 338–339
 zooming, 148
light meter, 78–79, 274, 395
light shapers, 4, 246
light stands
 flexibility of, 9, 23
 sandbags for, 186
lighting
 clamshell, 21, 380
 overhead, 154–163
 tabletop, 154–163
 zone, 105–109, 346
line-of-sight TTL, 149, 235, 295, 354–355
location shots, 44, 381
locker room photos, 85–95
low camera angle, 334
LumiQuest
 SoftBox III, 9–10, 51, 52, 411
 SoftBox LTp, 11–12
Lundquist, Verne, 143–145
Lynch, Michael, 316

M

magenta filter, 281
Maisel, Jay, 299
manual mode, 107, 137
Marino, Katrina, 325
martial artist, 338–339
Masters Golf Tournament, 143–145
medium flash, 254, 260
meters, light, 78–79, 274, 395
middle ground lighting, 105, 106–108
Model Mayhem website, 176
moon in photos, 55, 58
Moore, Brad, 347, 369, 387
Morrissey, Mike, 316, 325
motion
 conveying, 337

stopping, 70
mountain biker, 284–287
mountaintop photos, 391–395
multiple-exposure photography, 386–389
multiple-flash setup, 67, 74, 78, 396
museum photo shoot, 227–231

N

National Geographic, 40, 227, 325, 364–369, 377, 391
National Press Photographers' Flying Short Course, 39–40
natural light, 47–48
Neanderthal lady, 364–369, 377–389
neutral density filters, 202
Newsweek magazine, 305
nudity, 126–127

O

off-camera light, 348
open shade, 148, 183, 378
optical slave mode, 58, 156, 161, 292, 320
overhead lighting, 154–163

P

pagers, 305
paint pole, 51–52, 412
painting with light, 338–339
Pearlstine, Norm, 192
People magazine, 45
Peterson, Moose, 283
Pfeiffer, Michelle, 178–180
photographers
 frenzied conditions for, 341–345
 self-assignments of, 306–308, 310, 396
 working life of, 34–41, 188–196, 297–298, 305–308
PocketWizard Flex/Minis, 57–58, 95, 235, 236–237
point of view (POV), 104, 293
Polaroids, 320, 357
pop-up flash, 7, 8

portraits
 character, 164–169
 double exposure, 386–389
 facial, 180–187, 253–263
 rim-lit, 158–162, 215
 sports, 85–95, 158–162, 290–295
 windblown, 370–375
postproduction, 286
power packs, 134, 248, 393
pre-flash catchlight, 7, 8
presence in photos, 182
press conferences, 270–275
prime lenses, 208
profiles, double exposure, 386–389
publication-driven photography, 325

Q

Quadra light unit, 50, 68, 248, 254, 315, 373–374
quality of light, 6, 10, 200, 348
quiet moments, 345, 351

R

radio systems, 50, 56, 93, 234–242
rangefinders, 350
Ranger flash, 98, 100, 312, 315, 366
Ray Flash, 220, 223, 257
reflective blanket, 185
reflector pans, 291
reflectors
 TriFlip, 21, 27, 156, 211, 406
 TriGrip, 27–29, 111, 202
research, 227, 231, 343, 392
rim-lit portraits, 158–162, 215
ring flash, 220–225, 257–260
risk taking, 34–41
rooftop photos, 396–399
rule-of-thirds, 290, 324
Russian space program, 298–301

S

sandbags, 23, 44, 186
SB-900 flash, 8, 58, 137, 149, 187, 402
SB-910 flash, 402–404, 406, 409, 411, 412

SC-29 cords, 6, 82, 86, 137, 409
scene-setter photos, 344
SD-9 battery pack, 187, 213, 345, 412
self-assignments, 306–308, 310, 396
shadows
 controlling, 326–331
 softening, 10–14
 symmetry of, 12–14
shape of light, 244–251
shower curtain material, 382
Shur-Line paint pole, 51–52, 412
shutter speed
 blowing hair and, 122–123, 375
 high-speed flash and, 65–66,
 205–215
 wind effects and, 374–375
silks, vented, 186–187
silver softbox, 25–27
Skylite diffuser panels, 117, 247
Skyport radio receiver, 50
small flash
 big flash vs., 32–33, 67, 78
 large spaces and, 290, 294–295
 punctuating scenes with, 315–317
 technological advantages of, 64,
 200–202
smoke machines, 291–292, 404–405
snooted grid, 159–160, 174–175, 320
softbox gear
 Deep Octa softbox, 47, 49–50,
 315, 317, 322
 Lastolite Ezybox Hotshoe, 25, 62,
 105, 158, 382, 406
 LumiQuest softboxes, 9–10,
 11–12, 51, 52, 411
 Octa 74" softbox, 114–115, 127,
 378
softboxes
 edge baffle for, 251, 317
 indirect, 68, 111, 114, 127, 129
 silver vs. white, 25–27
softening light, 10, 20, 24
Speedlights
 big flashes vs. multiple, 67,
 200–202, 396
 two-light portrait setup, 164–169

spill, controlling, 328–329
spontaneity, 141, 143
Sports Illustrated, 39, 40
sports portraits
 lighting large spaces for, 290–295
 locker room photos as, 85–95
 overhead lighting for, 158–162
spot, grid, 328–329, 399
Star City, Russia, 298–301
storytelling, 139–145, 191
straight flash, 5, 217–225
strip lights, 68, 162, 249, 251, 317, 374
SU-4 mode, 58, 156, 161, 292, 320
SU-800 commander, 8, 98, 149
sunlight
 dawn photos and, 368–369
 flash combined with, 132–137
 open shade in, 148, 183, 378
symmetry, 12–14, 319, 387

T
tabletop lighting, 154–163
telephoto lenses, 22, 55, 149
telescope photos, 391–395
thermal plant photos, 59–63
Tomasek, Dean, 31
TriFlash unit, 74–75, 77, 79, 200, 294,
 413
TriFlip reflector, 21, 27, 156, 211, 406
TriGrip diffuser, 90, 118, 312, 412
TriGrip reflector, 27–29, 111, 202
Tritt, Travis, 141–143
trust, importance of, 304
TTL flash
 limitations of, 2, 31
 radio controlled, 234–242

U
umbrellas, 16–22, 200, 338

V
Venice ballerina, 148–151
vented silks, 186–187
V-flats, 113, 114, 119, 130–131
Viking character, 55–58

W
wall light, 111–123
Walters, Barbara, 266–267
warming gels, 100, 148, 211, 316,
 320, 321
weather issues, 44, 370–375
wedding photography, 145, 342, 343,
 349
Westcott Spiderlite, 122
wet subjects, 157
white balance
 cloudy, 262, 369
 customizing, 212
 daylight, 280–281, 322
 fluorescent, 279
 incandescent, 211, 411
white softbox, 25–27
wind
 photo setup in, 370–375
 sandbags used in, 186
 shooting effects of, 374–375
window light
 bed sheets and, 97–98, 323
 dirty windows and, 100–101
 flash setup for, 85–86, 237, 239
 frosted glass and, 85
 wire glass and, 98–100
Wingate, Thomas, 33
wire glass, 98–100
wireless technology, 150
writing with light, 338–339

Z
zone lighting, 105–109, 346
zooming flash, 148, 218, 219–220